A HISTORY OF EUROPEAN AND AMERICAN SCULPTURE

A HISTORY OF EUROPEAN
AND AMERICAN SCULPTURE
FROM THE EARLY CHRISTIAN
PERIOD TO THE PRESENT DAY

BY

CHANDLER RATHFON POST

ASSOCIATE PROFESSOR OF GREEK AND OF
FINE ARTS IN HARVARD UNIVERSITY

VOLUME I

COOPER SQUARE PUBLISHERS, INC.
NEW YORK
1969

Originally Published 1921
Reprinted by arrangement with Harvard University Press
Published by Cooper Square Publishers, Inc.
59 Fourth Avenue, New York, N. Y. 10003
Standard Book Number 8154-0288-0
Library of Congress Catalog Card No. 74-76376

Printed in the United States of America

PREFACE

In writing this book I have constantly had in mind, as one of my purposes, the desire to supply the need of a history of the sculpture of our own era that could be put into the hands of students for collateral reading outside of the lecture-room. This need I have experienced in my own classes, and I shall feel that my labor has not been in vain if the two volumes prove to be of any assistance to others in solving one of the many difficult problems that at the present day still confront teachers of the Fine Arts. For the realization of such a purpose it was found necessary to exceed the limits of an ordinary textbook in the length of the introductory discussions of each period and in the detailed treatment of the important sculptural movements and personalities. My intent has been not only to give a comprehensive idea of the various epochs, but also to produce a book of reference in which should be traced the evolution of the several national schools and of the secondary as well as the principal sculptors in those schools and in which their chief works should be catalogued and described. But while I have thus sought to aid the student and to provide even the expert with a convenient companion to his studies, I have never been consciously neglectful of the demands of the general interested public. I have endeavored to make the book readable. It is as elementary and as non-technical as was feasible without boring the serious student; all but a few indispensable notes have been avoided; and the preliminary summaries of each period and of the art of each country in that period have been the objects of hard and special effort.

It is not only because I have not wished to prejudice the student at first in favor of one period or another, that I have attempted to approach each school and sculptor sympathetically. I have thought also of the general reader, who is likely to be unduly influenced by the quantity of books that are brought out at the present day with the aim of rehabilitating or exalting one age or artist above another. The writers of such books exaggerate the virtues of the subjects that happen to be their special interests, and emphasize the vices of rival epochs or personalities. It has been my honest desire to eradicate any preferences that I may have formed, to study each period with the same open mind, and to discover the absolute esthetic merits, as well as the faults, in whatever has at any time appealed to a large group of human beings. The French rococo has already been pretty well reinstated in

v

criticism. The baroque is at present the object of a cult of enthusiastic devotees who shut their eyes to any possible shortcomings of the style; and it is particularly to baroque and modern sculpture that I have striven to apply the standard of fairness.

The plan has been to apportion the space according to the esthetic significance of the epochs and masters considered. On this basis, for instance, the Early Christian and Carolingian periods are discussed with comparative briefness. It may appear that the principle has been violated by the assignment of an inordinate number of pages to the sculpture of the nineteenth and twentieth centuries; but whether or not one credits modern sculpture with so high an intrinsic value, the subject seemed naturally to suggest a rather extensive investigation, simply because it has hitherto been less frequently and fully treated than the production of the earlier centuries. In an American book, particular emphasis has been laid upon American sculpture, and for all the periods and countries I have tried to use specimens in American collections, whenever they were available, as examples of the statements that I have made and as illustrations.

Yet from the first the work has been conceived only as a *short* History of Sculpture. I have indulged in the utmost compression consistent with the aims that I had set myself. The output of certain peoples, such as the Portuguese, Scandinavians, and Slavs, has been included only in those periods in which it assumed a really great artistic importance. The individual reader will doubtless often miss the mention of some less celebrated master for whom he has a special cult or of some piece of sculpture that has always appealed to his particular fancy. But within the scope to which I have limited myself, it has been obviously impossible to refer to all sculptors who have acquired any prominence whatsoever or to all the works that they or any school have created. No movements or personalities that the general consensus of opinion would accept as universally significant have been intentionally omitted. In selecting from the plenitude of objects those that should be described or at least noticed, I have been actuated by the degree to which the examples are characteristic, by the fame that they have won, and by my own estimate of their esthetic worth.

In a general book like this, which attempts to comprise so much both geographically and chronologically, it is necessary to rely very largely upon the results of the research of other scholars, except in those one or two fields with which the author may himself have acquired some special familiarity. His task must consist to a considerable extent in a critical valuation of their conclusions, in interpretation,

in comparison, and in coordination. In cases where a topic has been
investigated by only one scholar or by two scholars in collaboration,
or where one book, such as Prior and Gardner's *Medieval Figure-
Sculpture in England*, stands out as preeminently authoritative, my
dependence upon sources is forced to become here and there very
close; and I gratefully acknowledge my indebtedness to many other
admirable publications among those listed in the bibliography. It
has been manifestly impracticable, also, especially because of the
war, to study on the spot all the original works of sculpture to which
reference has been made. I have, however, for many years spent
much effort in travel in order to obtain a first-hand knowledge of a
very large number of the examples; for the others I have been obliged
to resort to casts or photographs.

It has likewise been difficult to secure uniformity of detail in a book
that involves the names of so many persons and things. Perhaps the
kind of uniformity that I have sometimes sought will not always be
evident, as when, with the exception of the Teutonic countries, the
abbreviation for Saint has been ordinarily conformed to the usage in
the language of the nation concerned. If, according to the frequent
practice of the last century and a half, the sculptor, as for instance,
Houdon, has made several or even many replicas of his works, es-
pecially portrait busts, I have mentioned the most renowned or most
accessible example, preferably one in an American collection, if it
exists. Occasionally two or more replicas have been included, par-
ticularly, again, when the museums of our own country are fortunate
enough to possess them.

If I were to specify all those at home and abroad to whom I am
grateful for suggestions and courtesies of many kinds, the list would
swell to disproportionate size a preface that is already too long. I
trust that they will continue their kindly attitude by accepting this
general word of thanks. But I should be rude indeed if I did not per-
mit myself to mention the names of at least a few to whom I am par-
ticularly beholden. To my colleagues, Professor George H. Chase,
Professor Arthur Pope, Professor G. H. Edgell, Professor Paul J.
Sachs, and Mr. Edward W. Forbes, I am under obligation for ideas,
advice, and various friendly offices; Professor Sachs has united to his
scholarly interest that characteristic enthusiasm which has already
meant so much to the cause of the Fine Arts in this country. My
pupils, in the courses involving the subjects treated in this book,
have often furnished me with stimulating conceptions and significant
facts. A distinguished creditor, with many heavy scores against me,
is Miss Myrtilla Avery of the Art Department at Wellesley, who has

been indulgent enough to undertake the sorry task of reading proof with me and who has thus given me the benefit of her profound erudition and keen criticism. Mr. Joseph Breck, the Assistant Director of the Metropolitan Museum, not only has never turned a deaf ear to my many, importunate questions, but has allowed me to take advantage of his quick perception and his enviable store of knowledge. Miss Gertrude McCormick has cheerfully added to her important work in the Fogg Museum the burden of rendering me valuable assistance. Mr. R. L. Dunn and Miss M. J. Fenderson of the Library of the Boston Museum have been untiring in the generosity with which they have placed at my disposal their own bibliographical learning and the excellent catalogue of articles in periodicals. My indebtedness for photographs I have acknowledged in the legends under the illustrations.

C. R. P.

Cambridge, Massachusetts
September, 1921

CONTENTS OF VOLUME I

CHAPTER IV

CHAPTER V

CHAPTER VI

CHAPTER VII

CHAPTER VIII

GOTHIC SCULPTURE. ENGLAND.

CHAPTER IX

GOTHIC SCULPTURE. SPAIN AND PORTUGAL.

CHAPTER X

GOTHIC SCULPTURE. ITALY.

PART III

THE RENAISSANCE

CHAPTER XI

CHAPTER XII

THE RENAISSANCE IN ITALY. FLORENTINE SCULPTURE OF THE FIFTEENTH CENTURY.

CHAPTER XIII

THE RENAISSANCE IN ITALY. THE SCULPTURE OF THE FIFTEENTH CENTURY OUTSIDE OF FLORENCE.

CHAPTER XIV

THE RENAISSANCE IN ITALY. THE SIXTEENTH CENTURY.

CHAPTER XV

THE RENAISSANCE OUTSIDE OF ITALY.

LIST OF ILLUSTRATIONS
VOLUME I

NOTE ON TERMINOLOGY

The following short list includes a few technical terms that are often used in this book, with references to the pages on which they are defined.

	VOLUME	PAGE
Ciborium	I	107 (note)
Cinquecento	I	153
Contrapposto	I	218
Cosmati-work	I	142
Détente	I	57–58, 78
Epitaph	I	87–88
Exposition Sculpture	II	120
Neoclassicism	II	83
Pietà	I	61
Putto	I	161
Quattrocento	I	153
Retable	I	71 (note)
Schrein	I	103
Transi	I	71
Trecento	I	143

The terms *right* and *left* are referred to the spectator's right and left as he looks at the monument.

PART I

EARLY CHRISTIAN SCULPTURE

CHAPTER I

EARLY CHRISTIAN SCULPTURE

1. INTRODUCTION

THE period treated in this chapter extends from the first through the tenth century A.D. In the eastern empire it witnessed the rise of the first great art of Christendom, the Byzantine, and since Byzantine art may best be considered as a separate entity, the discussion in this instance is carried down to the fall of Constantinople in 1453. In the West, the absence of a strong, long-continued, and centralized government prevented the formation of any truly great or homogeneous school of art. Esthetically, it was an era of spasmodic groping after an ideal that was not realized until the Romanesque and Gothic ages.

The nominal conversion of the state to Christianity under Constantine by the decree of Milan in 313 meant the dawn of a new art, but as long as the Roman polity lasted, the Christians adapted to their own purposes the Hellenistic art and culture of the pagan empire. From the time of Constantine's transference of the capital to Byzantium, or, as it was now called, Constantinople, even the western empire tended to become more and more Greek. The final division into east and west at the death of Theodosius the Great in 395 might have been expected to stem this tide; but Honorius, the son who obtained the Occident, chose Ravenna on the east coast of Italy as his residence, and henceforth for a century and a half that completely Hellenized and orientalized city was the focus of western civilization. The sculpture of the fourth through the sixth centuries that was produced, apart from the regular Byzantine development, under the influence of this degenerate classical tradition may conveniently be treated first in a group by itself.

In the seventh and eighth centuries, when out of the anarchy resulting from the disintegration of the Roman Empire there were slowly emerging the beginnings of the modern nations, the obliteration of the classic tradition, though never complete, and the lack, on the part of the invading races, of anything but a very rudimentary art precipitated in the West a veritable Age of Barbarism in sculpture. The impetus given to art and letters by Charlemagne, in an attempt to revive something of the lost glory of Rome, has bestowed upon the ninth

3

century the title of the Carolingian Renaissance. The Carolingian dynasty soon decayed, and throughout the greater part of Europe the tenth century was artistically the most benighted period in what are sometimes denominated as the Dark Ages. Germany, however, remained united and soon rose to a commanding position. She preserved Carolingian culture through the tenth century, particularly under the members of the Saxon dynasty, Otho I, the Great, his two successors of the same name, and at the beginning of the eleventh century, Henry II, the Saint.

2. SCULPTURE, OTHER THAN BYZANTINE, UNTIL THE SEVENTH CENTURY

The first sculpture of the Christians, like their architecture and their painting, constituted another example of the unbroken continuity of art from the time of the earliest rude scratchings in prehistoric caves: it was generated in the decay of classical art. The adherents of the new religion in no sense created a new style but simply took the existing forms and adapted them to their own subjects. During the first centuries of our era, the field of art throughout the Roman empire was occupied by that late, somewhat debased, but still noble form of the Greek style known as the Hellenistic. It used to be the fashion to conceive this art as so largely dominated by the spirit of the capital, Rome, that it could be considered a unified product and defined as Roman; but recent research, especially in Egypt and the near East, has demonstrated that the Hellenistic style was differentiated in the several parts of the empire according to racial characteristics and indigenous esthetic tendencies. Syria, Asia Minor, Egypt, and the other provinces all impressed their respective features upon the common Greek inheritance. It is possible that for the short period of the empire's firmest coherence and greatest centralization the peculiarly stolid and grandiose tone that the Hellenistic manner assumed at Rome and in Italy enjoyed a certain vogue in other sections of the imperial territory, but no sooner had disruption set in at the end of the third century than the schools of locally modified Hellenism again everywhere reasserted themselves. Amidst such an environment and from such elements Christian art was born, and as it developed, the rapidly increasing lack of political unity only accentuated the divergence between the various styles.

Christian sculpture did not flourish until the fourth century, when under Constantine the new religion emerged from the catacombs in triumph, although there are a few isolated examples that may be dated earlier. The Hellenistic style was already degenerating, and

art was not yet realized as an important enough factor in Christianity to cause a reaction, so that with few exceptions, upon the collapse of the old civilization and the approach of the Dark Ages, in the fifth and sixth centuries there was a general retrogression.

SYRIA

Of sculpture in the eastern provinces, the most considerable remains, consisting of ecclesiastical decoration, are found in Syria, one of the great centers of early Christian civilization with its flourishing capital, Antioch. The Hellenistic style here naturally coalesced with influences imported by way of Mesopotamia from Persia, which today is coming to be recognized as one of the world's principal artistic hearths. Lintels of the sixth century from churches at Dana and at Moudjcleia may be taken as typical. It is the oriental strain that has reduced the high and round relief in which the Greeks had worked to a single plane of flat design, which seems to be obtained through the technical process of incision with a drill rather than through carving out with a chisel. The peoples of nearer Asia, who have always revealed a predilection for painting rather than for sculpture, are prone to treat the latter art in the mode of the former, aiming at violent effects of chiaroscuro through the contrast of the one lighted plane with the obscurity of the largely concealed background. It is oriental opulence of taste which, shrinking from empty spaces, has abandoned Greek chastity for an almost complete investiture of the given area with luxuriant ornamentation. The decorative *motifs* are unmistakably eastern. Admiring pure design more than naturalism, the stone-cutter has conventionalized the freer Hellenic acanthus into a series of formal swirls on the lower molding at Dana, and on the lintel of Moudjeleia he has coerced the Hellenic ivy into stereotyped spirals; the upper molding at Dana he embroiders thickly with the essentially Mesopotamian *motif* of conventionalized vine and grapes. For such a temperament geometric figures would have a special charm, and from the large Syrian repertoire, the origin of which is perhaps to be sought in textiles, there appears here the circle enclosing the cross. Of the animals, real or monstrous, which again are the property of the east, the peacocks, confronting a vase according to the usual disposition, are Christian symbols of immortality.

ASIA MINOR

In all this eastern art the human figure is conspicuous by its absence. When the inhabitants of the nearer Orient did employ it, they were servile pupils of the Greeks; but in the more strictly Hellenic Asia Minor, it became much commoner. The uninterrupted connection between pagan and Christian sculpture is here strikingly illustrated by

a peculiar series of sarcophagi, if, since about half of them were found in this territory, we may assume with Diehl that they are of Anatolian origin and not of foreign importation. Preserved in the Museum at Constantinople and in several European collections, they are known as the Sidamara group from the place where one of the most interesting was discovered, and save in one instance they are all decorated with pagan subjects, although some, by a not unusual custom, may have been employed for Christian burial. This one exception, a fragmentary relief of the fourth or fifth century, now in the Kaiser Friedrich Museum at Berlin (Fig. 1), is of great significance, for its identity in composition, adornment, and style with the rest of the group, which may be dated in the two preceding centuries, demonstrates that Christianity merely poured new wine into old bottles. The human figure has become so important in this series that it appears not only in a row of architectural niches but also between the niches. In our example the central place is held by an unbearded Christ, wholly in the Hellenic tradition, with the pose and drapery of the ancient orator which were to enjoy so great a vogue in later Christian art; at the sides are two Apostles. In other respects the correspondence to the pagan sarcophagi is exact: for example, there is the same curious architecture, which inserts a kind of dosseret between the capital and the pediment, and the decorative detail again consists in an oriental lavishness and conventionalization of Greek *motifs*, the technique of which is even more obviously incision by a drill into a flat plane. The combination of Hellenic feeling for the body with eastern ornamentation is what was to be expected in a country situated at the cross-roads between the two civilizations.

EGYPT

Alexandria, the most brilliant center of Hellenistic culture, had stood in pagan art for what is called the picturesque style, characterized by an emphasis upon episodic scenes and pretty or realistic detail. The love of *genre* persisted in Christian times, but tended to give way somewhat, under an augmented influence of the Orient and a more pronounced manifestation of indigenous Egyptian proclivities, both to monumentality and to an interest in narrative or sacred history. The picturesque note is still dominant in the so-called Sarcophagus of S. Costanza in the Vatican, which, like several other porphyry objects of the period, seems to be of Egyptian manufacture. A romp of little Cupids or *amorini*, engaged in the vintage and enclosed in a vine-scroll, strikes the modern as strange decoration for a Christian tomb, but it is paralleled in other contemporary Christian monuments, and reveals how impossible it was for the new convert to shuffle off at once

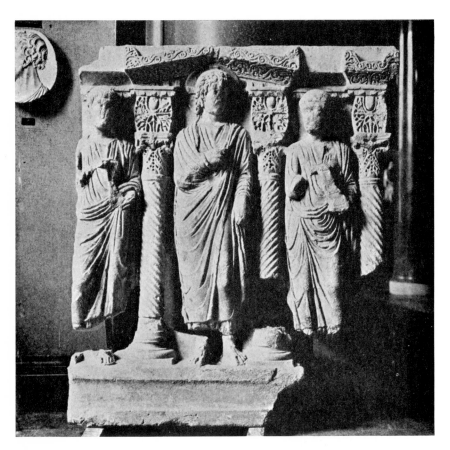

Fɪɢ. ɪ. SARCOPHAGUS. KAISER FRIEDRICH MUSEUM, BERLIN

(Photo. Photographische Gesellschaft, Berlin)

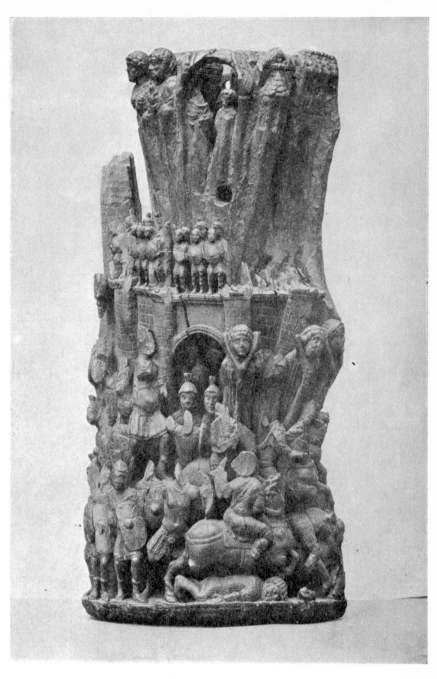

FIG. 2. PIECE OF WOODEN SCULPTURE FROM ESHMUNEÏN
KAISER FRIEDRICH MUSEUM, BERLIN

(Photo. Photographische Gesellschaft, Berlin)

the memories of those gaieties by which it had been his wont to allevi-
ate the gloom of the sepulchre.

On the similar but much better executed sarcophagus of St. Helen,
also in the Vatican, the livelier strain of narrative is sounded; but
this Alexandrian art of the fourth to the sixth century is better illus-
trated in all its aspects by a remarkable rounded fragment of wooden
sculpture found at Eshmuneïn and now in the Kaiser Friedrich Mu-
seum at Berlin (Fig. 2). It measures as much as 45 centimeters in
height and 22 in breadth. The subject is enigmatical. A company of
footmen are repelling an attack of horsemen from a stronghold, out
of which a rock rises sheerly, covered with architectural fragments,
revealing two figures beneath a central arch, and shaping itself into
three colossal forms at the left. It is usual to accept Strzygowski's
unsatisfactory allegorical interpretation of the scene as the defence of
the Fortress of Faith against barbarians, the three forms representing
the Triune God, the buildings, especially the projecting apse, the
Church, and the persons beneath the arch the imperial pair. Never-
theless, the treatment, according to the later Alexandrian standard,
is so realistic that it seems instead some event in Egyptian history.
The old picturesqueness lingers in the careful rendition of the walls
and edifices and in such details as the slain warrior beneath the horse
and the execution of four offenders by the local method of hanging on
forked gallows; but a certain monumentality is already obtained by
the formal composition of half-cylinders in a receding and rising series
and by the rhythmical repetition of the same posture through whole
groups of defendants.[1]

ROME

In the imperial city as elsewhere, the Christians merely forced the
Hellenistic style into their own service. The identity of the old and
the new stares one in the face in several statues of the Good Shepherd,
based directly upon the classical effigy of Hermes the Ram-bearer, the
best of which is the really noble figure in the Lateran Museum, Rome,
with a pouch slung at the side of his body.

The most signal objects of early Christian sculpture are a large
number of sarcophagi, the treatment of which was based directly upon
Graeco-Roman specimens. During the centuries of persecution, the
few Christians who had been able to afford such elaborate sepulchres
had been satisfied with those pagan examples in which the mythologi-

[1] The further production of Syria, Asia Minor, and Egypt during these centuries, especially
the ivories, will be considered under the heading of Byzantine Sculpture as more closely re-
lated to the general development of that sculpture and as more directly preparing the way
for the mature Byzantine style of the Second Golden Age.

cal subjects might be given a new meaning, as Cupid and Psyche transformed into emblems of brotherly love. One or two distinctly Christian sarcophagi may be dated in the third century, but it was not until the Peace of the Church in the fourth century that the new sculpture could be said really to exist. Certain of the tombs were embellished chiefly with pure design, especially the undulating flutes called strigils, and with an inscription; but even on these, figures were usually introduced in compartments at the center and ends. Of the completely figured examples there are two general types: one (in which the oriental elements are more apparent) with the figures ensconced in architectural niches, a *motif* derived perhaps from the custom of enshrining valuable Greek statues in arched recesses and destined to enjoy a long vogue in every medium of Christian sculpture (Fig. 3, Junius Bassus sarcophagus, Grotte Vaticane, St. Peter's, Rome [1]); the other with one unbroken plane of relief, in which, according to the curious mode that was to persist in many instances even through the early Renaissance, the scenes are not separated but merge confusedly into one another (Fig. 4, Lateran Museum, no. 178, where may be distinguished in the upper zone from left to right, the raising of Lazarus, the miracle of the loaves and fishes, the sacrifice of Isaac, the healing of the blind, St. Peter's denial, Christ between Adam and Eve, and in the lower, Moses removing his shoes, the healing of the woman with the issue of blood, the miracle at Cana, the story of Jonah, Daniel in the lion's den, St. Peter's arrest, and Moses striking water from the rock). In both classes, the carvings may be disposed in one or two bands, and the compositions range from the simplest, with the Good Shepherd in the middle and perhaps a single scene on either side, to the most elaborate. The subjects were at first derived from the painting of the catacombs, consisting largely in certain episodes from the Old Testament and in certain miracles of Our Lord, taken probably, after the manner of the early liturgies, as symbols of the Eucharist, or, in this sepulchral art, as symbols of deliverance from death and sin. The cycle was soon much augmented, particularly from the New Testament, to include, without any very evident symbolism, many of the compositions from Holy Scripture which, chiefly Syrian in origin, were to form the later iconography of Christian art.

The provenience of these sarcophagi has been the battleground of critics; but it certainly can no longer be held that they continued a purely Roman tradition of art. They are as Hellenistic as the early Christian sculpture of other parts of the empire. If an essentially

[1] The sculpture in the Grotte Vaticane is about to be installed as a new and separate collection in the Vatican.

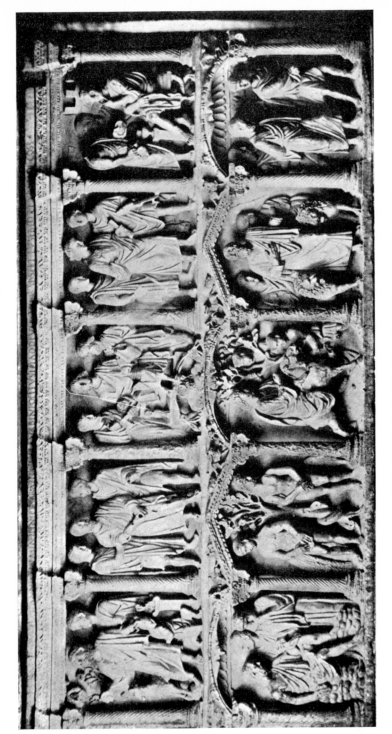

FIG. 3. JUNIUS BASSUS SARCOPHAGUS. GROTTE VATICANE, ROME

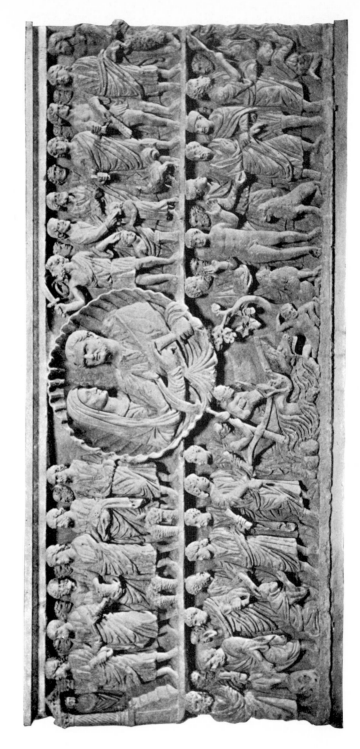

Fig. 4. SARCOPHAGUS, No. 178. LATERAN MUSEUM, ROME

Roman art had ever existed, Hellenism had triumphantly reasserted itself, and indeed in many cases the Asiatic and Egyptian developments had penetrated into the capital itself. The picturesque detail, the effects of landscape, the *genre* of the boy fishing and of the boy receiving a basket on the celebrated sarcophagus with the story of Jonah, no. 119 of the Lateran Museum, are unmistakably Alexandrian. The *amorini* engaged in the vintage on no. 183 of the same collection are likewise Egyptian in origin, and, in the oriental manner, are lavished over the whole space between the three figures of the Good Shepherd with the flat technique by incision. Hellenism, at Rome as elsewhere, however, did not remain wholly unaffected by indigenous traits. It would seem that many of the tombs were not manufactured abroad or executed by foreign sculptors resident in the city, but rather by native artists who had learned their craft from others but impressed upon their productions those qualities that have come to be associated with the Roman name — a strong feeling for the human form in three dimensions and a predilection for stockiness and solemnity. The portrait busts that often occur in medallions upon the face of the sarcophagus may be considered also to embody a trend towards a kind of realism, innate in Italy as well as in Egypt. Only in so far may we speak of a distinct Roman or Italian tradition now beginning in Christian sculpture.

The large number of sarcophagi at Rome, covering a period from the fourth to the sixth century, afford an exceptional opportunity to observe the gradual decadence of style. In the earlier examples, from which the illustrations are taken, the forms and draperies retain much classical grace and dignity, the nude is treated with correctness and beauty, and there is a good sense of design, as in the above mentioned Jonah sarcophagus; but the proportions soon became defective, the delineation inexact, the poses awkward, and the technique so slovenly that, as already in no. 164 of the Lateran Museum, the folds of the drapery are largely represented only by drilled lines. From the sixth century, for a thousand years, Rome ceased to be an important center of sculptural production.

RAVENNA

This flourishing city on the eastern coast, which in the fifth and sixth centuries was the seat of government for Italy, produced an important group of sarcophagi, varying considerably from the Roman examples. Even the shape, with the rounded top, is different. The reliefs may be grouped in two general classes, one employing human figures, the other beasts, foliage, or Christian symbols. In both the space may be divided into niches but not into two zones. The second

class, which, broadly speaking, seems to postdate the former, is un-
deniably of oriental provenience. In the midst of luxuriant vegeta-
tion, in a single flat plane of relief, pairs of symbolic animals, such as
peacocks or lambs, confront a vase or a sacred emblem exactly as upon
the Syrian lintel of Dana, and the formal and symmetrical design is
often very beautiful (Fig. 5, tomb of St. Theodorus, S. Apollinare in
Classe, probably to be dated as late as the seventh century). In the
other class, the composition is not crowded as at Rome, and there is
only a single scene consisting of a few figures. The symbolical episodes
from the catacombs are absent, and even narrative subjects from
Holy Writ are rare. The most usual subject is Christ enthroned and
surrounded by saints, the whole framed between two palm-trees. Our
Lord either receives the martyrs' wreaths or, in the representation
called *Traditio legis*, hands the Gospel, the new Law, to St. Peter
or St. Paul. Even this first class of reliefs is probably Asiatic. The
Italian qualities that appear in the Roman sarcophagi are not to be
discerned. The forms are not so firmly modelled nor the draperies
so successfully disposed as at Rome; more symmetrical formality is
given to the design; in the oriental fashion the sculptor looks upon
the space as an opportunity for decoration rather than for realistic nar-
ration. The *Traditio legis* is probably derived from Syrian iconography;
the palm-trees likewise suggest the Levant. Moreover, the other un-
questionably eastern type of ornamentation on the other class of sar-
cophagi often occurs on the back and sides of sarcophagi the front of
which is figured, although in some instances the pure design may have
been added later. All things considered, it can hardly be doubted that
virtually all the sepulchres were either imported from the Orient, with
which Ravenna was so closely connected, or executed in the town
itself by foreign artists and their local disciples.

CHRISTIAN SARCOPHAGI IN OTHER PARTS OF THE WESTERN EMPIRE

In almost all other places of the western empire, where, as especially
at Arles and in Spain, sarcophagi are found, the local divergences
from the Roman norm are not great enough to merit separate atten-
tion; but those of southwestern Gaul, in which the rudeness of the
forms proclaims a later date than the fifth century, are yet more ob-
viously Asiatic than the series at Ravenna.

3. BYZANTINE SCULPTURE

THE FIRST GOLDEN AGE

It is usual to speak of all east-Christian art as Byzantine, but
Byzantium did not attain an artistic position equal to that of such

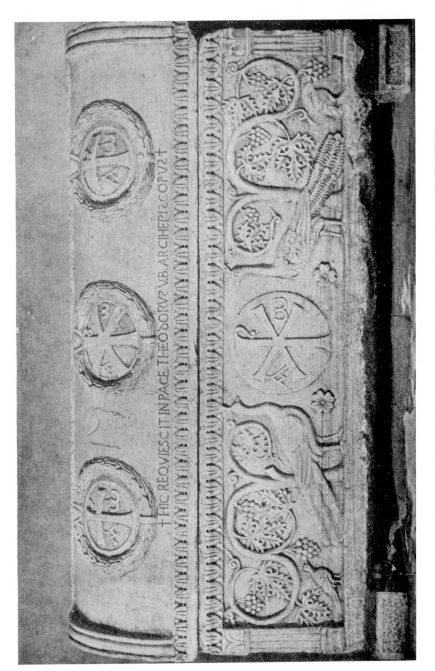

Fig. 5. SARCOPHAGUS OF ST. THEODORUS. S. APOLLINARE IN CLASSE, RAVENNA

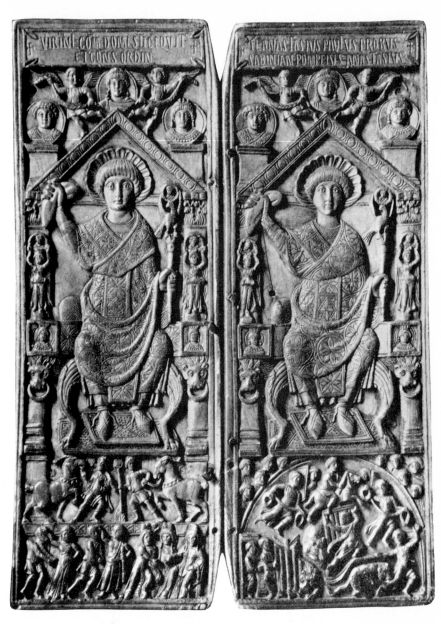

Fig. 6. CONSULAR DIPTYCH OF ANASTASIUS.
BIBLIOTHÈQUE NATIONALE, PARIS

(Photo. Giraudon)

other great oriental cities as Antioch, Ephesus, and Alexandria until about the sixth century, when under Justinian the church of St. Sophia was built, and it was not until later, when the energy was crushed out of these latter capitals by the Mohammedan conquest, that she acquired an ascendancy. The fifth and sixth centuries, culminating in the brilliant reign of Justinian, are known, by reason of the high cultural level attained, as the First Golden Age; but at least in sculpture, even during this period, Syria, Anatolia, and Egypt were more productive centers than Constantinople, and the adjective *Byzantine*, if it is to be taken as a true description of the First Golden Age, must be applied to the whole eastern empire and not restricted to the imperial city. On the other hand, one must be on his guard against debasing Constantinople to an altogether inferior position. Byzantinism was compounded of Hellenism and Orientalism, and the capital served as a melting-pot in which these elements, pouring in from the different parts of the east through the channels of commerce and monasticism, were fused with the Greek contribution into a harmonious whole.

The most disastrous effect of Orientalism was to provoke a distaste for monumental sculpture in the round and for bold relief, so that by the end of the First Golden Age they became almost extinct. Other influences made for the same end, especially the increasing disfavor with which the Church, partly because of its Hebraic derivation, looked upon "graven images," the forms in which paganism had chiefly clothed its false gods. Their place was taken by the ivories, and it is only in these and in metal and enamel work that later Byzantine sculpture may be effectively studied. Originally colored and gilded, and thus regarded as a species of embossed painting, they did not shock the Byzantine religious sensibilities, and often indeed in composition and form were based upon contemporary miniatures. Here again Constantinople had a rôle to play, in preserving to the end, at least in these small objects, some Greek feeling for salience against the encroachment of oriental flatness. Apart from the ivories, the output of the several eastern provinces in the fourth century, and in some instances, in the two succeeding centuries, has already been discussed. A few other larger carvings in stone and wood might arrest our attention, such as a pulpit from Salonica, now in the Museum at Constantinople, the two anterior columns (and, according to the most recent views, also the two ruder posterior columns) of the *baldacchino* in St. Mark's, Venice, for which a Syrian origin has been asserted, or the manifestly oriental doors of S. Sabina at Rome; but it is the ivories that most typically and beautifully represent the sculpture of the First Golden Age.

Ivory was commonly used for the decoration of such pieces of ecclesiastical furniture as episcopal thrones, covers for the Gospel, and rectangular or circular reliquaries. It enjoyed special favor as the material for the small circular receptacle for the hosts known as the *pyxis*. Among the most interesting articles made of ivory were the consular diptychs, presented during the fifth and early sixth centuries by new consuls and other dignitaries on their assumption of office to the emperor and other high magistrates and adorned with such appropriate subjects as the functionary presiding at the circus (Fig. 6, diptych of the consul Anastasius, Cabinet des Médailles, Bibliothèque Nationale, Paris). Out of the consular diptych was evolved the religious diptych with sacred scenes, employed at first for the lists of prominent personages and of saints to be read in the ritual, but by the eighth or ninth centuries simply as an object of private devotion. Although in the First Golden Age ivories were produced all over the Mediterranean basin, some few even at Rome, and while the capital, Constantinople, naturally enjoyed a virtual monopoly of the consular diptychs, the centers of manufacture were Syria and Egypt.

Two main divisions may be discerned in the ivories according to the preponderance of Hellenistic or oriental features. The finest example of the former class and, probably, the finest ivory in existence, placed by some even as early as the fourth century, is the angel in the British Museum (Fig. 7), originally constituting one of the leaves of a religious diptych, in which there still persist the bold relief, the majestic and idealized beauty, the monumentality emphasized by an impressive architectural setting, and the elegant draperies of ancient Greece. Even here the luxuriant decorative foliage recalls the East. In the other class the Syrian provenience is much more evident. Of this class, the so-called throne of the Archbishop Maximian in the Archiepiscopal Palace at Ravenna is the most eminent example, with panels of St. John Baptist and the four Evangelists on the front and many small scenes from the life of Joseph and of Our Lord on the sides and back (Fig. 8). The inequality of style is perhaps to be traced to the cooperation of two or more hands. The partisans of an ascription to the region of Antioch adduce as proofs the elongation of the saints into eastern ascetics, and the ornamentation in incised technique with confronted beasts amidst the richest leafage. The partisans of Alexandria stress the predilection for the story of Joseph, the love of the picturesque in the perspective of landscape and buildings, and of the naturalistic in such details as Egyptian costumes or the contrast in attitude between Jacob and Rachel at the news of their son's supposed death (cf. Fig. 8). The figures, the still noble drapery, and the compositions,

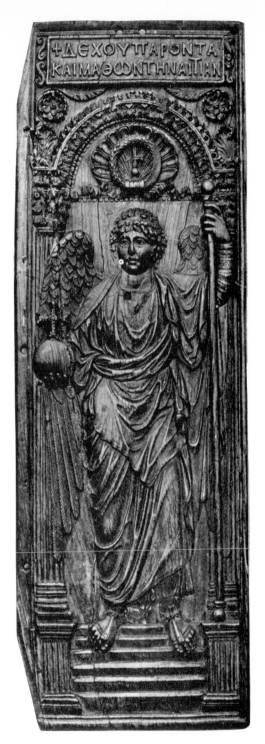

FIG. 7. ANGEL ON LEAF OF DIPTYCH.
BRITISH MUSEUM, LONDON

(Photo. Mansell)

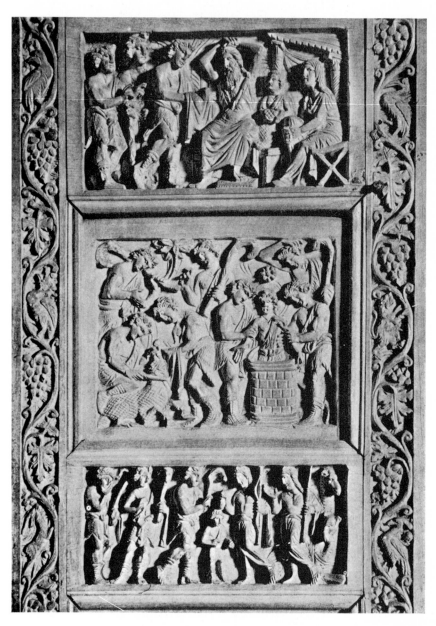

FIG. 8. SCENES FROM LIFE OF JOSEPH, THRONE OF MAXIMIAN.
ARCHIEPISCOPAL PALACE, RAVENNA

(Photo. Fratelli Alinari)

especially those from the life of Joseph, are reminiscent of the Christian sarcophagi, upon which the early ivories in general so closely depended. Enough Hellenic sap remains to endow the throne with life, freedom, and beauty, but the eastern atmosphere has almost totally withered the forms in a subdivision of this oriental group, of which one leaf of a religious diptych (or a book-cover) coming from Murano and now in the National Museum at Ravenna is the most notable member. It is separated into the usual compartments. The gaunt angularities, the staring eyes, the more slovenly execution find their counterparts in contemporary Syrian manuscripts. If one leaves out of account a small number of masterpieces, such as the angel of the British Museum, the general history of sculpture during the first period may be described as a gradual decadence towards forgetfulness of the principles of ancient Greek art, especially in the proportions of the human body, and a failure as yet to realize clearly and completely within itself the principles and possibilities of a new Greek or Byzantine art.

THE SECOND GOLDEN AGE

The national decline of the seventh century put a quietus upon art. The iconoclastic disturbances of the eighth and early ninth centuries might have been expected to complete the devastation; but although for a time the representation of sacred figures and scenes was tabooed and in strictly Byzantine territory large sculpture in the round was permanently suppressed, the net result, curiously enough, was a kind of Renaissance, which, beginning at the end of the ninth century and extending to the establishment of a Latin dynasty at Constantinople in 1204, is known as the Second Golden Age. The attack upon icons naturally diverted energy into secular art, for models of which it was necessary to look to antiquity. A revived interest in historical art brought with it the desire for the realism and especially the portraiture of Hellenistic Alexandria. Ecclesiastical decoration had to return again to the luxuriant subjects of the early basilicas, flowers, animals, and geometric designs, and thus, as well as through the influence of Islam, the sluices were once more opened to an oriental influence. Even hunts, races, and spectacles from the Hippodrome intruded themselves upon the walls of churches. When the restrictions of iconoclasm were once abolished, and when under the Macedonian and Comnenian dynasties during three centuries the empire recovered its prosperity, artistic enterprise felt, as it were, a new youth, which received additional stimulus from the fresh contact with Hellenism and with the East. Secular art had risen again to prominence under the patronage of the imperial and other noble families. Religious art shared for a time the salutary antiquarianism and the vigorous realism

of the other school. The iconography, which had been fundamentally Syrian in origin, set itself with revived energy to the process, begun in the First Golden Age, of modification and development, lessening, especially, the importance of the Old Testament and increasing that of the Apocryphal Gospels. Finally deriving, like the modern French church, increased enthusiasm from the past persecution, religious art became in the eleventh century more hieratic than ever before, and, considering it a sacred duty to repeat again and again the forms and compositions that had been so lately proscribed, ended in a paralysis of theological conventionalism.

Existing monuments of sculpture in the large are virtually confined to a few religious and mythological low reliefs preserved in the walls of St. Mark's, Venice, and imitated by native Venetian sculptors until as late as the fourteenth century, and to decorative marble slabs with the old oriental *motifs* of foliage, animals, and geometric designs, serving for screens, pulpits, and the like, exported throughout the Mediterranean, and well exemplified in the cathedral of Torcello, near Venice, as well as at St. Mark's. The ivories again must be the criteria. The secular school may be illustrated by a series of some fifty caskets, of which the best example, perhaps dating even from the iconoclastic period and formerly in the cathedral of Veroli, is now in the Victoria and Albert Museum, London. The faces of these caskets are adorned chiefly with mythological episodes, personages, and monsters, but the general repertoire of hunting, sportive, and battle scenes is also included. For instance, the example from Veroli is divided into representations of the Rape of Europa and of a dance of Centaurs and Maenads. The compositions and figures are all reminiscent of ancient reliefs, but the remoteness of the past often caused a misinterpretation of mythology, as when on the Veroli casket Bacchus carries a whip instead of a thyrsus. The higher relief, although it should not lead us, with Venturi, to assign the series to the First Golden Age, indicates a resuscitation of Hellenistic models. The contortion of the bodies, the involution and swirling of the drapery suggest even an interest in Neo-Attic sculpture of the second and first centuries B.C. The elaborate borders, embodying the velleity for luxury characteristic of the epoch, afford concrete evidence of the two influences that combine to form the imperialistic school in the Second Golden Age, the medallions of heads being derived from ancient coins, and the conventionalized floral decoration and geometric rosettes from the Orient. Three caskets of the series may now be seen in the Morgan Collection of the Metropolitan Museum, New York.

It was the ecclesiastical school of the Second rather than of the First Golden Age that evolved those characteristics ordinarily connoted by the term "Byzantine Art." The principal monument is the Harbaville Triptych in the Louvre (Fig. 9), one of a group of eleventh century ivories related in style and uniform excellence. In the upper central portion is the oriental subject known as the *Deesis* (the bearded and ascetic Syrian Christ, who had now supplanted almost completely the beardless and Hellenic type, enthroned between the Virgin and St. John Baptist); in the other sections are companies of saints, some of them in medallions; on the back are a central design and other saints in pairs. It is an epitome of the virtues of fully developed Byzantine art with the shortcomings as yet only prophesied. The holy personages have a reserved dignity consonant with the formal religious theme and not yet frozen into the stiffness of the decline. The sculpture and painting of the Byzantines may fail to arouse the emotions, but the ceremoniousness of their life at least steered them off the rocks of rhetoric. There is a similarity in pose that belongs to troops of sacred ministers in a stately liturgy, but it is subtly varied, especially by a realistic portraiture in the heads that betokens a second immersion in the springs of Alexandrian art. The postures are studied from nature and have not become mere reiterations of others' achievements; they do not possess the rigid monotony of a century or two later. The gestures are often derived from the type of ancient orator, and the draperies, although they are approximating the ordinary Byzantine type with minute, multiplied, and parallel folds, retain much classical nobility and grace. However deficient in originality, however narrow and stereotyped through subjection to theological prescription, Byzantine art of the two great periods was distinguished by exquisite fineness of technical detail, and there is no better instance of this quality than the Harbaville Triptych. The tradition of skilful execution was gradually to be forgotten, the extremities particularly were to lose correctness of proportion, and the bodies were to suffer an excessive elongation and emaciation, already dimly foreshadowed in the St. John Baptist. If, however, the Christian East produced few masterpieces, it seldom failed throughout its history to maintain a high average and was saved by its very immobility from sinking to those banal and vulgar depths that are the pitfalls of a more inspired art. The best religious work of the Second Golden Age is also well illustrated by a Crucifixion in the Morgan Collection of the Metropolitan Museum.

THE BYZANTINE RENAISSANCE OF THE FOURTEENTH
CENTURY

It is not necessary to carry our investigation into the partial Renais-
sance of Byzantine art in the fourteenth century, after the disasters
that befell the Empire during the thirteenth had brought to an end the
Second Age of Gold. During this period, when the position of Con-
stantinople as an artistic center was usurped by such provinces as
Macedonia, Servia, and the Peloponnesus, a slightly greater activity
may perhaps be discerned in larger decorative sculpture; but com-
paratively considered, the monuments are of little significance, and
the more restricted means of patrons banished the expensive mediums
of ivory and enamel.

THE INFLUENCE OF BYZANTINE ART IN EUROPE

The influence of Byzantine art, in general, was perhaps of greater
importance than the actual productions. Byzantine handicrafts en-
joyed a wide market throughout Europe; the dearth of employment
resulting from iconoclasm caused many artists to emigrate in search
of new spheres of activity. Alone in the western world preserving
an ability to render the human figure, Byzantine art inspired the
most tolerable carving of the barbaric age, instructed the Carolingians,
and abundantly contributed both forms and compositions to Roman-
esque sculpture. It is no exaggeration to maintain that the dominant
note in European sculpture, to say nothing of the other arts, was By-
zantine from the sixth to the beginning of the thirteenth century,
when, with the rise of Gothic, France acquired the hegemony.

4. THE AGE OF BARBARISM

After the collapse of Roman culture in the west, it required two
centuries, the seventh and the eighth, for the barbarian invaders to
find themselves. In the ninth century occurred the Carolingian
Renaissance, but the revival in sculpture was confined, at least in ex-
tant monuments, to the minor arts of ivory, bronze, and gold; and
with one or two exceptions, until the beginning of the Romanesque
period in the eleventh century, what carving in the large there was,
resembled the mere groping of a child. Typical are the molded bricks
found in certain French churches and often copied in stone and marble,
and the slabs employed for decoration in various parts of Italian and
Spanish churches, as, in the eighth century, on the screen of the Bap-
tistery of Callixtus at Cividale in Friuli. The flat relief, the sensibility
to design in the midst of a puerile ignorance of form, the constant
recurrence of oriental *motifs*, seem to point to a contact of the barbari-
ans with eastern art at some period in their history; but it is hard to

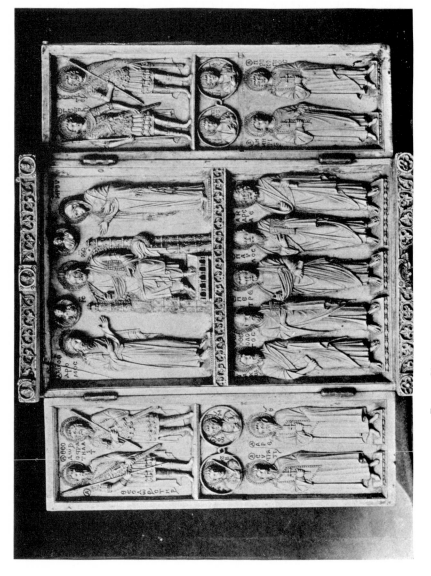

Fig. 9. HARBAVILLE TRIPTYCH, LOUVRE, PARIS

(Photo. Giraudon)

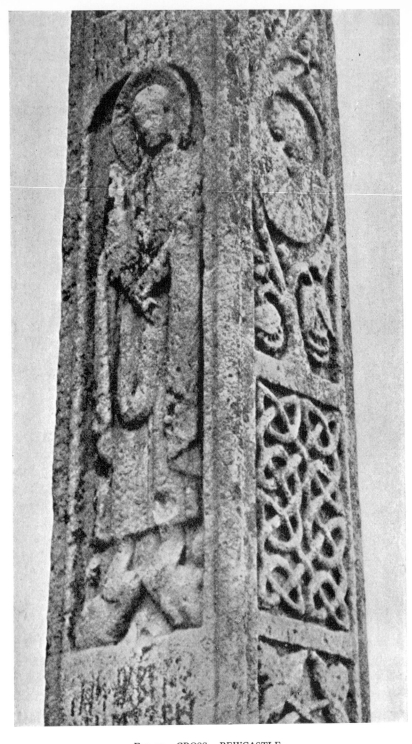

FIG. 10. CROSS. BEWCASTLE

(From " Medieval Figure-Sculpture in England " by Prior and Gardner,
with the courteous permission of Mr. Prior)

say just how many of the elements in all this art of the seventh and eighth centuries, especially the decorative details, were due to as yet undefined native esthetic traditions of the several barbarian races. It may be that the Lombards in certain instances were roughly imitating the sarcophagi at Ravenna. The inexhaustible fantasy, revealed in the ever new and ever varying combinations of the old *motifs*, is not Byzantine, and betokens a certain originality which perhaps is to be traced to the fresh vigor of the more or less problematical guild of Lombard architects and sculptors, known as the *Magistri Comacini*, who even then may have been playing that important rôle in the evolution of Lombard-Romanesque architecture, which is sometimes accredited to them.

In Great Britain, and if we may accept traditional datings, also in Italy, a more pronounced dependence upon east-Christian models created a few sporadic exceptions to the general debasement. The stucco figures upon the canopy over the altar of S. Ambrogio, Milan, and the feminine saints of the same material above the door of S. Maria in Valle, Cividale, have been assigned by some critics to the ninth and eighth centuries respectively,[1] and may have been suggested by metal work of the eastern empire. At Cividale, however, the stronger relief and the greater simplicity of drapery are already indicative of much Italian feeling.

The English examples are found in Northumbria, which at the end of the seventh century was the most enlightened of the seven kingdoms into which the Angles and Saxons were at first separated. They consist of a group of fragments, chiefly great stone crosses, of which that at Bewcastle, belonging to the end of the seventh century, is the most notable (Fig. 10). The plasticity and justness of proportions in the figures, as in the Christ of the Bewcastle cross, are so unusual at the time as to postulate at once a rather intimate connection with the only Christian art still retaining knowledge of the human form, the Byzantine, with which the sculptors were familiar through the wide dissemination of miniatures and ivories; and the assumption is corroborated by the eastern character of much of the ornament, such as the vine-scrolls framing doves. The *motifs* of the knob and chequer, however, are Celtic and Scandinavian, and the peculiarly tall and slender shape helps to bestow upon the crosses a distinctly British effect. This Northumbrian development probably owed much to the art of Ireland, which under monastic patronage flourished greatly and achieved high distinction in the centuries marked in the rest of western

[1] A. Kingsley Porter (*Lombard Architecture*, I, 302) dates both monuments at the end of the Romanesque period.

Europe by the Age of Barbarism and the Carolingian Renaissance. Irish art was compounded of elements drawn from the Christian East, and, especially in ornament, from the rude esthetic inheritance of the Celts. Its most conspicuous product was the illumination of manuscripts, but there was also much excellent work in metal and stone. It does not appear possible to ascribe the extant stone crosses in Ireland to a date before the tenth century, but early Irish examples that have perished may have constituted precedents for the English and Scottish specimens. The Northumbrian movement, which seems to have centered about Wilfrid's evangelization of the province and his consequent architectural enterprise, was as short-lived as it was brilliant. Though animated slightly by the rude but vigorous savagery of Norse zoomorphic carvings, English sculpture soon lapsed again into the barbaric degradation which obscured art in the rest of Europe. From this decline England was not rescued until the Romanesque period, unless certain much debated reliefs from southern England, especially a series of Crucifixes and two panels now in the cathedral of Chichester, representing the story of Christ and Lazarus, are to be reckoned as proof of a kind of Saxon Renaissance prior to the Norman conquest.

5. THE CAROLINGIAN RENAISSANCE

If, as the chroniclers and poets declare, the partial revival of esthetic interest under Charlemagne and his successors in the ninth and tenth centuries expressed itself in any monumental pieces of sculpture, at least none are preserved that can with certainty be assigned to this period, and we must still rely for our conceptions upon the minor arts of ivory and bronze. The Byzantine influence was as potent as ever, especially in ornamental detail, and the renewed emphasis upon Roman antiquity, which was the mainspring of all forms of cultural activity during this Renaissance, was bound to turn the eyes of sculptors with fresh enthusiasm to the ancient remains and to the early Christian adaptations of the Hellenistic style. But the most striking characteristic of the ivories was their almost absolute dependence upon Anglo-Saxon miniatures. The vigorous monastic life of England and the peculiarly intimate relations with Byzantium and the Orient had kept burning the flame of artistic enterprise, which in the rest of Europe was flickering almost to extinction. The great stone crosses were one manifestation of a movement that distinguished itself most in the illumination of manuscripts, the style for which had been originally derived also from Ireland. By contact with the eastern empire England had preserved a tradition, however convention-

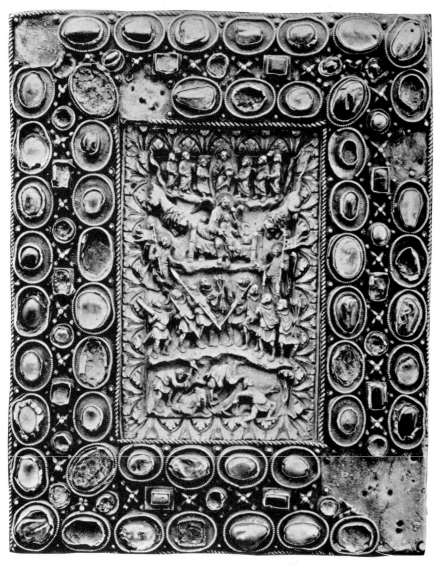

Fig. 11. COVER OF PSALTER OF CHARLES THE BALD.
BIBLIOTHÈQUE NATIONALE, PARIS

(Photo. Giraudon)

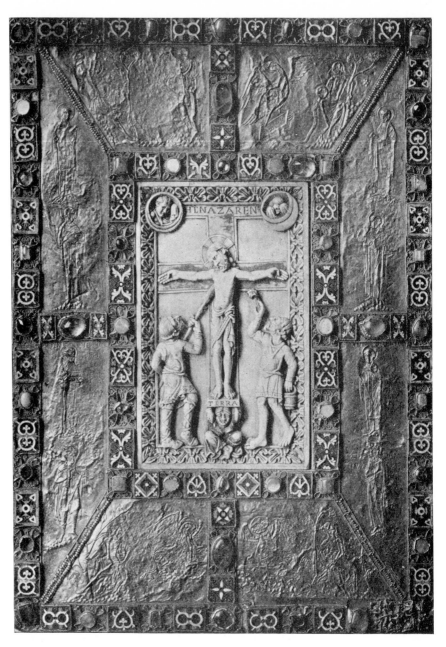

FIG. 12. GOSPEL–COVER FROM ECHTERNACH. LIBRARY, GOTHA

(Courtesy of Dr. K. Pungold)

alized, for delineating the human form; and, once stirred by artistic ambition, the Carolingians naturally had recourse to the models nearest at hand. The Carolingian Renaissance was ecclesiastic, and it was inevitable that monastic prototypes should create the artistic fashion. The indebtedness of sculpture to painting has never been more pronounced, and if the technique of the latter had been more developed, the result would have been an even more pictorial treatment of relief than in Ghiberti.

The imitations in ivory seem to have run the whole gamut of the Bible, but the most startling parallelism is found in the covers for psalters, which illustrate very literally and naïvely the verses of the psalms. The stock example is the cover for the Psalter of Charles the Bald, now in the Bibliothèque Nationale at Paris (Fig. 11). The figures of speech in the fifty-seventh psalm are reduced to matters of fact. The soul, symbolized as usual by a child, finds refuge beneath the shadow of the wings of God's angel. The lions assault from either side. The "sons of men, whose teeth are spears and arrows, and their tongue a sharp sword," appear beneath as Carolingian soldiers, threatening the soul; and on the lowest stratum "they have digged a pit before me, into the midst whereof they are fallen themselves." The scenes are reproduced exactly from the miniatures of well-known Anglo-Saxon psalters at Utrecht and in the Oxford Library. The plastic style for the human figure and draperies is a rude reflection of classical Roman models, the memory of which had been transmitted from century to century by the monastic illuminators of England. The bodies are bent and slightly contorted, as in the painted models, and the straining after violent movement is almost feverish. The Byzantine influence perhaps diminishes the robustness of the forms and provokes conventionalization, but it is particularly responsible for the symmetrical design in which the composition is cast. Or it may be that the English knew classical art only as transmuted into the Byzantine formulae. The barbaric origins of the Carolingians have left their traces in the jewelled inlay of the covers.

The recent authorities on the Carolingian Renaissance distinguish national schools in the works in ivory and in the national schools local tendencies; but this criticism has not as yet attained anything like final and definite results. The sculptors had a predilection for the subject of the Crucifixion, of which there exists a series of representations marked by an elaborate symbolism. The name of one ivory-worker of the period is preserved, Tuotilo, a monk attached to the abbey of St. Gall at the end of the ninth and beginning of the tenth centuries. Several works of his are recorded, and the covers of the so-called

Evangelium Longum in the library of the monastery are still conjectu-
rally ascribed to him. The under binding, which there is more reason
for attributing to Tuotilo himself, represents the Assumption and St.
Gall's encounter with a bear. The stylistic qualities seem to be largely
those of the Psalter of Charles the Bald, although some critics would
assign the latter monument to a school of Reims and the work of Tuo-
tilo to a German school of the Upper Rhine. The ornamentation of
conventionalized foliage is imported from Byzantium. The multiplied
plaits of the drapery are also Byzantine, and the concentric folds that
clothe the abdomen of St. Gall are a mannerism of Anglo-Saxon
miniatures.

Of the goldsmith's work, the most eminent example is the golden
casing or *paliotto* for the altar of S. Ambrogio at Milan, ordered in 835
by the Archbishop Angilbertus II from a certain Wolvinius.[1] The four
sides, representing Christ and saints in glory and scenes from the life
of the Saviour and of St. Ambrose,[2] are executed with that greater
delicacy and sensibility to classical beauty, particularly in the drapery,
which one might expect in Italy. But the forms have still the slight-
ness and partial contortion of Carolingian art. The *paliotto* of S.
Ambrogio is typical of the general and international style in painting,
ivory, bronze, and gold, created by the coalition of so large a part of
Europe under the single sceptre of Charlemagne. Somewhat excep-
tional are the bronze equestrian statuette, purported to represent the
Emperor himself, now in the Musée Carnavalet at Paris, and the small
golden and bedizened idol of St. Faith in the church of Ste. Foy at
Conques.

It was, however, in Germany that the sculpture of the Carolingian
Renaissance attained its most effective and individual expression. A
more correct appellation, perhaps, would be the Renaissance of the
Othos, for the foundation of the movement was the prosperity of Ger-
many under the three sovereigns of that name during the tenth cen-
tury; but the plastic style was a continuation and development
from the models evolved under Charlemagne. Great centers of activ-
ity were Saxony, Franconia, and the banks of the Rhine, especially
Trèves during the episcopate of Egbert (977–993) (upon which the
artistic production of Reims and other parts of northern France closely
depended) and Hildesheim during the episcopate of St. Bernward

[1] A. Kingsley Porter (*Lombard Architecture*, I, 300 ff.; II, 546 ff.), on stylistic grounds,
assigns the *paliotto* to the end of the twelfth or beginning of the thirteenth century, and be-
lieves the inscription to be a reproduction of an earlier one.

[2] The Resurrection, the Ascension, and Pentecost were done in the sixteenth century to
replace reliefs that had been destroyed.

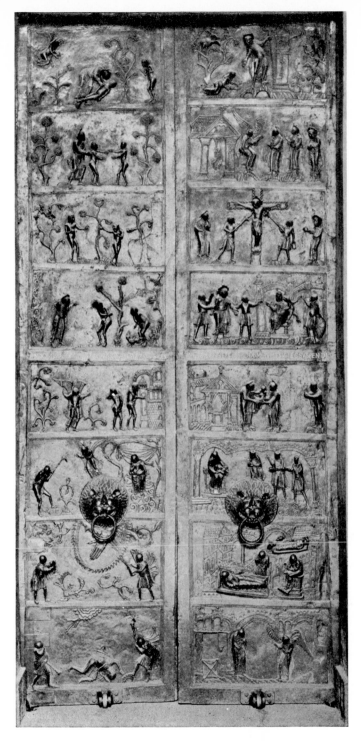

FIG. 13. BRONZE DOORS, CATHEDRAL, HILDESHEIM

(Photo. Neue Photographische Gesellschaft, Steglitz)

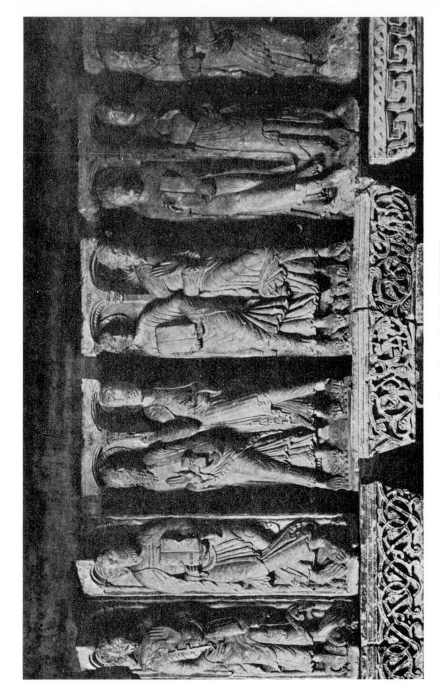

FIG. 14. APOSTLES. MUSEUM, TOULOUSE

(993–1022). Certain critics have sought to explain this Teutonic su-
periority by the supposed intrusion of many Greek craftsmen in the
train of the Byzantine princess, Theophano, the wife of Otho II. Some
of the monuments indeed are very eastern in their feeling, notably the
technically superior but rather uninspired bronze Easter column, with
scenes from the Gospels, in the cathedral of Hildesheim, imitated
from that of Trajan, and said to have been set up by St. Bernward,
and the gold altar given by Henry II to the cathedral of Basel (now in
the Musée de Cluny, Paris). But the nature and number of these
Byzantine artists are hypothetical, and the best and most typical
work of the period is far removed from the conventionalities of the
East. It is permeated by a crude but powerful realism, striking already
that popular note which has given the distinctive tone to German art
from first to last. An important example is the gospel-cover, coming
from the abbey of Echternach and now in the library of Gotha, on the
golden border of which are represented Otho III and his mother Theo-
phano (or perhaps Otho II and his wife, Theophano) (Fig. 12). In
contrast with these figures on the border, which are still quite Byzan-
tine, the executioners in the ivory Crucifixion in high relief at the
center, the composition of which is characteristic of the series of Caro-
lingian Crucifixions, are frankly men of the people with stolid pro-
portions and brutal heads that look directly forward to the figures of
Stoss, Krafft, and Riemenschneider in the fifteenth century. The
bronze doors of Hildesheim cathedral, produced under the patronage
of St. Bernward, constitute another renowned example of the same
style (Fig. 13). The few agitated figures in each compartment,
sometimes even with flying draperies, are sharply distinguished from
the staid and crowded narrative, half Byzantine, half classical, of the
Bernward column. Such subjects as the meeting of Adam and Eve
and Christ before Pilate are conceived in a refreshingly popular spirit.
In a naïve but praiseworthy struggle with the Byzantine tradition of
low relief, the artist causes the heads and torsos to project far out
from the plane of the lower bodies. This and many other works of the
Carolingian Renaissance prove that the process of bronze-casting was
understood throughout the period, especially in Germany. The
bronzes of Romanesque Germany owed their beauty to the fact that a
tradition of craftsmanship had already been developed under the
Othos and St. Henry. Several of the examples that have been men-
tioned belong already to the eleventh century, and generally, in Ger-
many, the connection between the Carolingian and Romanesque ages
was peculiarly uninterrupted.

PART II

THE MIDDLE AGES

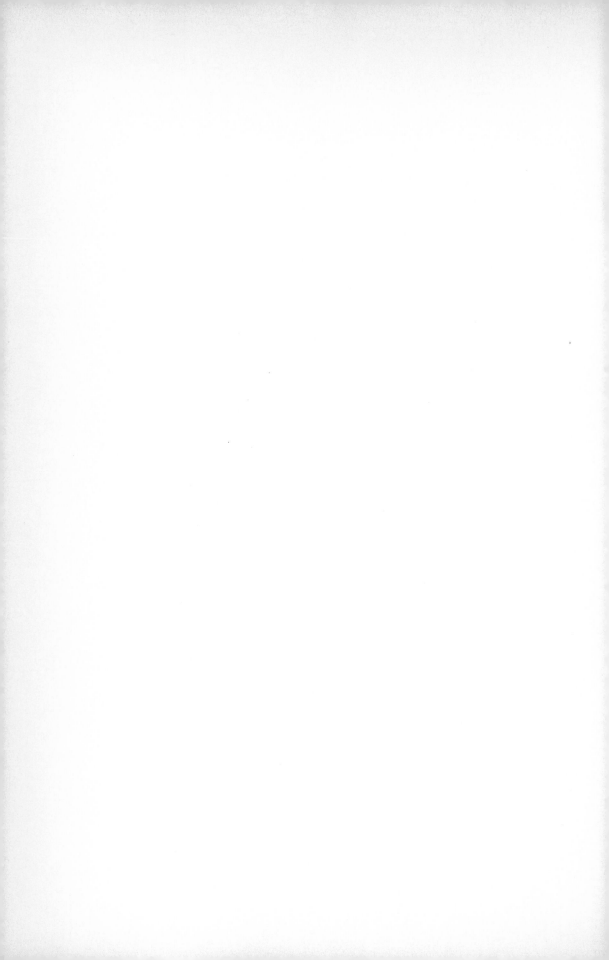

CHAPTER II

THE MIDDLE AGES. INTRODUCTION

For the purposes of this book, the Middle Ages may be extended from the eleventh through the fifteenth centuries, except in Italy, where the Renaissance is usually considered to have been inaugurated at least as early as 1400. In some districts the Gothic style lasted on during a part or the whole of the sixteenth century. Whatever be the dates that various historians choose for the beginning of the Middle Ages, it is certain that in the eleventh century the dawn of another epoch was signalled by many new phenomena in civilization, coincident with the slow rise of Romanesque art. As a solution to the political and social anarchy that ensued upon the death of Charlemagne in the ninth and tenth centuries, feudalism was now so well established as to render the highways of Europe safer and thus to promote the development of commerce. The lofty ideals of chivalry, which ennobled European society from the eleventh to the fifteenth century, helped to create the highly spiritual atmosphere that fostered the art of the Middle Ages. The cult of the Virgin, which was now much emphasized and became a vital and altogether lovely aspect of medieval art, received additional stimulus from the chivalric code. The knight or the troubadour, conceived as the vassal of his lady, stood in a sublimated and even more devoted relationship to her who was the queen of women.

No sooner, however, was the feudal system securely constituted, than it began to be undermined by the rise of the free communes. During the eleventh and twelfth centuries, throughout the greater part of Europe, their industrial and commercial development and the resulting power of their wealth cooperated with many other reasons to enable them to obtain charters and to shake off all but a nominal dependence upon their feudal lords. Although the patronage of the Romanesque epoch still remained monastic, the towns had acquired such importance by the thirteenth century that the great Gothic churches were usually communal enterprises, and the spirit of freedom, ambition, and rivalry evolved in the municipal atmosphere energized, in varying degrees, the whole history of Gothic art. Despite the fact that in certain places, as in France and Italy, the towns, by 1400, had in different ways been deprived of their liberties, the middle class had grown so rich and influential that they were now the

principal patrons and bestowed upon the art of the period, especially in Flanders and Germany, the characteristic tone of *bourgeois* realism. The emergence of the middle class was assisted by many other causes that conspired for the decay of feudalism in the fourteenth and fifteenth centuries. The prerogatives of the nobility were fast succumbing to that centralization of power in the monarchy, or in Italy in local despots, which was to be the normal political environment of the Renaissance.

The strongest motive force in medieval art was religion. The robust, sincere, fervid, and concrete faith that remained in unimpaired soundness at least until the fourteenth century made it the greatest essentially Christian art that the world has produced. The vigor of Christianity overflowed into many channels. Monasticism swelled to colossal proportions. The ebb of Benedictinism was stemmed by many Reforms of the Order. The first, that of Cluny in Burgundy, founded in 910, became so powerful that it was one of the chief agents in the dissemination of the Romanesque style. In the eleventh century, several other Reforms were instituted, most notably the Carthusian and the Cistercian, the latter, owing to its austere aversion to architectural decoration, of little import to sculpture. The beginning of the noblest century of the Middle Ages, the thirteenth, was marked by the appearance of the two great mendicant orders of the Franciscans and Dominicans. The former, through the life and precepts of its founder, eventually helped to achieve the humanization of art and a more appreciative study of nature. Another beacon light of the thirteenth century was the typically Christian philosophy of scholasticism, which then shone brightest with such famous names as St. Thomas Aquinas, Duns Scotus, and Albertus Magnus. An exact parallel to its categorical subtleties is found in the elaborate iconographical arrangements of sculpture and stained glass in the early Gothic churches. The Crusades, extending from the end of the eleventh to the end of the thirteenth century, were not wholly political and economic in their aims, as some prejudiced historians would have us believe, but they were also a sincere expression of religious enthusiasm. Incidentally, they fostered commerce between the east and west, especially for Genoa, Pisa, and Venice, and the closer contact with the productions of Byzantium and the nearer Orient contributed to the flowering of Romanesque art.

The heart of medieval Europe was France. The varied aspects of medieval culture there found the highest and most characteristic expression. French institutions, customs, manners, schools, literature, and art were the patterns and ideals for the rest of the Christian

world. Certain facts in French history have a special significance for the development of medieval sculpture. Southern France in the twelfth century had been the seat of the most brilliant literary movement of the time, the Provençal, and of the most vital school of Romanesque sculpture, that of Languedoc. This splendid civilization was utterly destroyed by the drastic Crusade against the Albigensian heresy, which unfortunately had centered in these districts. The whole southern region was so paralyzed that it had little energy left to contribute to the Gothic movement. The height of Gothic in France was represented by the reign of Louis IX, the Saint (1226–1270), in many respects the typical medieval prince. At the failure of the Capetian line, the accession of the Valois dynasty, in the person of Philip VI, brought with it distinguished patrons of art, especially Charles V (1364–1380), but it brought also the Hundred Years' War with England. During the first half of the fifteenth century, while northern France was well-nigh completely overrun by the English, Paris as an artistic center was superseded by Burgundy, which had just acquired an influential position by the annexation of the Low Countries. Burgundy was not long to enjoy her prominence, for the crafty Louis XI (1461–1483) seized the western part or Duchy proper and thus hastened the decadence of the Burgundian school of sculpture.

In the Low Countries, the advent of a Burgundian overlordship only augmented the wonderful commercial activity which had already distinguished them and which has always afforded a propitious environment for the rise of a great art.

Conditions in German territory do not call for special comment. Although Switzerland by the last years of the fourteenth century had heroically freed herself from the domination of Austrian dukes, still, as a nominal part of the German Empire, she was artistically, except on the French boundary, a Teutonic province. Poland, also, until the beginning of the Renaissance, eagerly cultivated German art, especially in the fifteenth century. The Romanesque period in England really began in 1066 with the Norman conquest, which brought to an end both the Saxon dynasty and the Danish invasions. The French influence on sculpture, however, did not effectively manifest itself until the second half of the twelfth century with the accession of Henry II and the Plantagenets. The Romanesque, Gothic, and Renaissance periods in Spain fall very neatly, broadly speaking, within the limits of certain historical circumstances. In the two hundred years during which the kingdoms of Leon and Castile were sometimes combined and sometimes divided, from 1037 to 1230, the Romanesque held sway. The eastern domains of Catalonia and Aragon were not

amalgamated until the days of Alfonso II (1162–1196). The Gothic accommodates itself to the epoch of the permanent coalition of Leon and Castile from 1230 until in 1479 the whole peninsula, with the exception of Portugal, was united under the dual monarchy of Ferdinand and Isabella. This union was to be the felicitous background for the Renaissance, which already was looming on the horizon. Much of the energy of the Middle Ages in Spain had been devoted to driving out the Moors, who staid long enough to infuse a Mohammedan strain into the artistic tradition of the peninsula.

The history of Italy apart from the struggle of pope and emperor consisted largely in the entrance of new powers into the country, the fatal beauty of which has always attracted foreign invaders. The Normans in the eleventh century conquered the Byzantine Exarchate of southern Italy and the territory immediately adjoining on the north, and they wrested Sicily from the Saracens together with parts of the mainland that the Mussulmans had occupied. In the twelfth century, the great Norman King, Roger II, and his successors, William I and II, with their capital at Palermo, fostered artistic endeavor with great munificence. At the end of the century the southern kingdom passed into the hands of the Hohenstaufen, and Frederick II, by his enlightened patronage of learning, antiquarianism, literature, and art, created there a kind of Pre-Renaissance. Charles of Anjou substituted an Angevin dynasty in 1265. By the beginning of the fourteenth century, the Aragonese had seized Sicily, and the Angevins were left only southern Italy with the capital at Naples. This city King Robert (1309–1343) and his court beautified with many splendid monuments of art, but after his death the Angevin dynasty and Neapolitan culture steadily degenerated until in 1443 the sceptre of Naples likewise passed to the Aragonese.

In the rest of the peninsula, no sooner had the towns won their freedom from the emperor than they fell victims to the new tyranny of local despots. By the end of the thirteenth century, such government was already general in northern Italy: the families of the Visconti, the Gonzaga, the Este, and the Della Scala, for instance, were established respectively at Milan, Mantua, Ferrara, and Verona. Venice, already a definite oligarchy, was a great commercial power, but she was unable to outdistance her rival, Genoa, until the close of the fourteenth century and attained the fullness of her glory only in the Renaissance. The towns of central Italy usually preserved their democratic constitutions longer, but as the year 1400 approached, it was evident that the body politic could not long endure the constant internal upheaval and that the only salvation lay in despotisms. Pisa,

through the ascendancy that she had gained as a seaport and through her naval victory, in league with Frederick II, over the Genoese in 1241, had enjoyed, until the end of the thirteenth century, the hegemony in Tuscany and had decked herself in the magnificence of art. The tables were now turned against her. Defeated, in turn, by the Genoese in 1284, and enfeebled by the attacks of her Guelph neighbors, she resigned the leadership to Florence, which henceforth for two centuries was also the literary and artistic head of the peninsula.

CHAPTER III

ROMANESQUE SCULPTURE

1. GENERAL CHARACTER OF ROMANESQUE SCULPTURE

THE Romanesque period witnessed the revival of monumental sculpture.[1] Through Byzantine influence, through fear of idolatry, and through the general cataclysm of the principles of ancient art during and after the barbaric invasions, the technique of large sculpture in the round and in high relief had been lost, and Europe in the eleventh century was obliged to serve a laborious apprenticeship before recovering it in the twelfth. The first efforts were only a little better than the puerile hackings of the barbaric age, especially in the human figure, the construction of which had been almost completely forgotten. The models from which the stone-cutters learned were the fragments of ancient statuary, particularly the sarcophagi, large Byzantine paintings and mosaics, oriental fabrics, and the small pieces of Byzantine and Carolingian craft, such as the ivories and, above all, the illuminated manuscripts; but these they put to such new uses and transfused with so new a spirit that Romanesque sculpture was virtually an original manifestation. Perhaps, according to the theory of the great French critic, Courajod, it was the youthful vigor of races so lately barbaric that gave the dry bones life. The Crusades not only opened the eyes of the West more widely to the productions of the Christian East, but also increased the importation of specimens of its minor arts. The dependence upon the minor arts and painting tended at first to low and flat relief and to a reproduction in stone of the designs and technique of these prototypes, especially to a rendition of detail by incised lines, but sculpture gradually emancipated itself, realized its own aim of modelling in the round and in many planes, and became self-sufficient. The style was uniform throughout Europe, but there were national and local differentiations according to historical conditions, racial characteristics, the nature of the models and the medium, and the purpose for which the work was intended.

The movement was called forth by the necessity of decorating the new Romanesque edifices, and the same craftsmen were builders and carvers. The key both to the interpretation and to the charm of

[1] With the minor arts of ivory and the goldsmith's craft, upon which hitherto we have so often been forced to rely, we can no longer concern ourselves in a book of this scope, except in so far as reference to them is necessary for an understanding of larger sculpture.

Romanesque sculpture is that it always remained the handmaid of architecture. The figures are conceived as parts of the general architectural system, and the separate groups are coerced into designs as formal as the curves of the vaulting or as the plan of a portal. The shapes are consequently treated with a license that rivals the work of the most extreme Post-Impressionists. Human bodies are elongated until at a short distance they appear as much mere lines in the composition as do the colonnettes or the arches, increasing the desired architectural impression of verticality. The figures on capitals are arranged in patterns and twisted into forms required by the symmetry of the Corinthian norm, which was usually in the artist's mind. The drapery is commonly plaited in long, narrow folds, and in places, in order to contrast with the rigid architectural lines, it is thrown into artificial spirals suggested by models in miniatures. Often, indeed, for this same purpose of variation, the sculptors created with the figures, as well as with the drapery, elaborate curvilinear rather than rectilinear designs. Not having attained to realistic representation, they did not value it so much, and were ready to sacrifice it to esthetic exigency. Certain very recent movements in art, which have adopted this Romanesque attitude, suffer under the blight of the perfunctory, because the distortions of the human form are disassociated from an architectural scheme. The same neglect of realism for the dictates of formal beauty, but not always for an architectural purpose, is found in the sculpture of archaic Greece, though the license is not carried so far as by the Romanesque carvers or by their modern imitators. Because of this and because of certain similarities in detail, such as conventions in the treatment of the drapery, especially the use of many parallel folds, and such as, at times, even the archaic smile, the works of the eleventh and twelfth centuries often recall with curious vividness those of the sixth and early fifth centuries B.C. From one standpoint, Romanesque production may be considered to have constituted an archaic or primitive art, which the Gothic age developed to full realization. Despite Romanesque idiosyncrasies, there is reason to believe that the school of each region had a regular system of proportions for the human form.

This is perhaps as good a place as any to set down what little is known of the universal practice of coloring sculpture in the Romanesque period and indeed throughout the Middle Ages. The false and tawdry modern attempts, in restorations or in original work, to reproduce medieval polychromy are calculated to give to the uninitiated a derogatory conception of the custom and to leave him with the impression that the paint was laid on in garish tints and in thick coats

that concealed the quality of the stones and thus militated against the glyptic feeling of statuary. Nor is his appreciation of this polychromy likely to be enhanced by the faded and dirty tones into which the few remnants of color on medieval sculpture have now degenerated. But a comparison of the glories of medieval glass with the vulgarity of their modern imitations and even a cursory examination of medieval frescoes ought to put the student on his guard against accepting the color of modern Gothic statuary as a criterion of the chromatic values of sculpture in the Romanesque and Gothic epochs. Two facts seem now to be established: that the tonality of color, at least in the Romanesque period, in the thirteenth century, and in the majority of places, in the fourteenth, was subdued, and the scheme of color was conventionalized. The tones for the flesh were very delicate. The predominant colors in the rest were brownish red, yellow ochre, indigo, white, purple, dark brown, dark green, and black. The gamut of the draperies seems to have been fairly well confined to white, black, purple, and the dark greens and browns. The backgrounds were commonly of indigo or dark red. Except on bronzes, gilding was admitted only very chastely and sparingly. It was used here and there for creating accents, as on a crown, a star, or a halo, and for designs on borders of garments or for making a light and simple pattern over the whole or a part of the vesture. Other tints might be employed for the pattern or might be combined with the gold. The range of the gilts themselves varied, but a brownish tone and a dull lustre seem to have been preferred. For representing such things as the trimming of costumes, colored bits of metallic foil were sometimes inset, and each piece was covered with transparent glass. By conventionalization of polychromy it is meant that the colors and arrangement of colors were not chosen with the purpose of reproducing closely those observed in actuality but rather with the idea of creating agreeable decorative effects. The attitude towards color was probably much the same as in the best Byzantine mosaics. Nor was the feeling usually lost that it was sculpture with which one was dealing: although sometimes the stone was covered with the preparation of plaster of Paris called *gesso* before the polychromy was added, ordinarily the pigment was applied in so thin a layer that the texture of the surface of the stone or even of the wood was preserved. The bronzes were gilded, but there was often also an elaborate ornamentation by enamels. The changes in polychromy that came with the fifteenth century will be considered in the general discussion of Gothic.

The subjects of Romanesque sculpture were drawn primarily from sacred history and legend. The monuments, especially the portals,

were often the objects of elaborate iconographical schemes, though by
no means so elaborate as in the Gothic church. A favorite Roman-
esque scheme, as at Autun, was the Last Judgment, or if this concep-
tion was not fully carried out, at least the tympanum was occupied by
the Apocalyptic Christ surrounded by the signs of the Evangelists.
Allegories were not uncommon, the Virtues and Vices occurring with
notable frequency in Auvergne and western France. The characteris-
tic labors of the different months were often carved in compartments
upon church portals. The richest variety of subject is found in the
capital, surely the loveliest product of the period (cf. Fig. 19). Here
profane matter of every sort obtruded itself, particularly in Spain, so
that a Romanesque cloister is the most valuable kind of a document
for the study of contemporary social conditions. Knights tilt and
woodsmen hunt; the panorama of popular life passes before our eyes,
even to the jugglers of the streets; the different crafts ply their trades
from the stone-cutter to the butcher; the sculptor indulges himself in
Esopic fables and even in satire. But the beasts of fable were not the
only ones that found a place. A very important part of the Roman-
esque repertoire consisted of the fiercest animals and the most prodi-
gious monsters, employed sometimes in symbolic significance but
more often with no further thought than a decorative purpose. Parts
of several creatures are fused together into combinations more exotic
and terrible than the chimaera, and the normal and abnormal alike
engage in the most sanguinary combats. Much of this savage and
fantastic *ensemble* is to be traced ultimately to the Orient. Acquired
by the European races in their migrations from Asia or later in their
new settlements through the contact of commerce and the Crusades,
it reflects their barbaric origins, still bursting through the veneer of
civilization. In the distribution of all this material, it is possible to
discern the following tendency, which has too many exceptions to
prove the rule: the portal was reserved for sacred subjects; in the in-
terior, to these might be added *motifs* of foliage and animals; and the
secular naturally obtained entrance in the cloister.

It was in the Romanesque period that there appeared the first tombs
sculptured with a representation of the deceased, for which such a won-
derful history lay in store in future centuries. Comparatively few in
number, they consist merely of a slab of stone or bronze containing the
effigy executed in high or low relief and naïvely conceived simply as a
standing figure laid on his back. The earliest extant examples, of the
second half of the eleventh century, are German. Drawings of de-
stroyed specimens show us that such sepulchres were made in France
as early as the first half of the twelfth century; all the existing French

instances date from the second half of the century. Only the German examples have any esthetic significance.

2. FRANCE

It was France of the twelfth century that embodied most essentially the idea connoted by the word Romanesque, and to a very considerable extent taught the rest of Europe. The several regional and slightly differentiated schools of sculpture, the boundaries for which cannot be drawn with any geographical exactitude, may be divided into two large groups, the one highly progressive, comprising Languedoc and Burgundy, the other more conservative, including the rest of the country and reaching its culmination in Provence. The latter group often held more tenaciously to the forms of the ancient Roman monuments; the former, having learned all that it could from its models, soon evolved more original forms and ideas.

LANGUEDOC

The school that was most comprehensive in its scope developed in Languedoc. It was possibly because of this comprehensiveness that the achievements of Languedoc had a greater vogue than those of any other province and furnished a considerable share of the foundations upon which were built the mature Romanesque schools, not only in many sections, if not all, of France, but also in a large part of the rest of Europe. The artistic center was Toulouse, and the plodding but earnest efforts of a whole line of sculptors finally resulted in an esthetic attainment that is represented by the Apostles, from a portal of the church of St. Étienne, now in the Museum of that city (Fig. 14). The disposition of the figures in niches, conversing with one another singly or in pairs, demonstrates that the sculptors recovered the human figure by studying the Roman sarcophagi that were still preserved in this important province of the ancient empire. It must be remembered, however, that, perhaps in imitation of the sarcophagi, the personages are ensconced in niches also on the ivory diptychs and turned towards one another also on the ivory coffers. The proportions are the same as on the Roman monuments, the drapery is classical, but the rhythmical plaiting is derived from Byzantine prototypes. Although the Apostles are well distinguished from one another, the modelling is confined to essentials. Realistic representation is not carried so far as to violate the feeling that the sculptured effigies must have the same elemental simplicity as the architecture of which they were a part. The gestures retain a rigid directness. In order, however, to avoid an excessive and too obvious stiffness, the artist takes refuge

sometimes in two peculiar mannerisms that mark the whole school of Languedoc: the crossing of the legs, derived from the models in the minor arts, and the agitation of the edges of the garments in formal scrolls, suggested by similar flourishes in the manuscripts.

The best examples of monumental compositions in this style are the tympana of St. Étienne at Cahors and the church at Carennac (Department of the Lot), both interesting from the close dependence of the glorified Christ upon Byzantine prototypes. The masterpiece of the workshop, already influenced perhaps by the embryonic Gothic movement of the north, is the Annunciation of the Museum at Toulouse.

The comprehensiveness of the school of Languedoc is demonstrated by the somewhat different character of the portal of St. Pierre at Moissac, a church which in its several parts affords an opportunity to study all phases of Romanesque plastic development. The Apostles and the effigy of the abbot Durand on the pillars of the cloister, executed early in the twelfth century, are little more than laborious but successful translations of Byzantine ivories into stone. The capitals of the cloister, dating from about the same time and in the same manner, are typical specimens in their rich medley of subjects and in their subordination of figures to architectural outlines. The great portal, from about the middle of the century, exhibits the height of Romanesque attainment. The tympanum (Fig. 15) contains the Apocalyptic Christ, framed by the signs of the Evangelists, flanked by two angels, and adored by three tiers of the twenty-four Elders. On the lintel are a line of rosettes of foliage, a *motif* here resurrected from debased Roman sarcophagi into a new, exquisite, and vigorous life. Beneath, the opening is subdivided by one of the piers that are characteristic of this region, built of conglomerations of real and imaginary wild beasts and human forms. On the jambs, at either side, are the figures of St. Peter and Isaiah. The exuberance of decoration is completed by a series of reliefs on the walls under the vault of the porch, representing the parable of Dives, the punishments of Avarice and Lust, and scenes connected with the birth of Christ. The plaits of the drapery are fewer than at Toulouse, and all the lines throughout the portal are sharper and deeper-cut, producing an effect of greater crispness. The accommodation to the architectural function and to the architectural space is brilliantly achieved, especially in the attenuated angels and in the sacred personages upon the jambs. Even the features have a more pronounced geometrical cast. The whole monument is enlivened by an increased effort for expressiveness, which appears also in the analogous portals of Beaulieu and Souillac.

BURGUNDY

The school of Burgundy outdid that of Moissac in its predilection for excessively emaciated figures, elongated into architectural lines, and in its bizarre conceptions. The models were usually objects of the Byzantine minor arts rather than Roman sarcophagi, but the great compositions, as at Moissac, may be translations of frescoes into stone. The distinguishing qualities are a great richness of ornamental detail, a high degree of animation in forms and draperies, finding expression particularly in the calligraphic swirls at the bottom of the garments, and a powerfully developed dramatic sensibility. In the patronage and dissemination of the style, the influential monastic Order of Cluny, which had its center in the province, played an important rôle.

A church belonging to these monks, the abbey of Vézelay, contains the most celebrated examples of Burgundian sculpture. In the central tympanum of the portal that opens from the narthex into the church, finished in the second quarter of the twelfth century, the glorified Christ in the vesica, the ordinary Romanesque subject for such spaces, is curiously combined with the Apostles at Pentecost, upon whose heads He casts the rays of the Holy Spirit (Fig. 16). The first of the luxuriant archivolts contains scenes from the lives of the saints in eight rectangular compartments, or according to Enlart, the messages to the Seven Churches of Asia. Mâle, however, interprets this and the perplexing lintel as representing the different peoples of the world, normal and abnormal, to whom the Gospel after Pentecost was to be preached. On the pillar beneath is a large St. John Baptist between two Apostles, and on either jamb is the *motif* of a pair of Apostles engaged in excited dialogue. All the characteristics of the Burgundian school are brilliantly illustrated. The lines of the drapery are repeated at such minute intervals and conventionalized into such designs that the models in manuscripts are unmistakable. The long protruding legs are so spare as to seem little more than bones. The reception of the Holy Ghost becomes an agitated drama — a drama, however, which, in the solemn majesty that even the most vivacious of the Romanesque sculptors never fails to preserve, suggests rather the religious tragedy of the Greeks.

Although technically less skilful and less exquisite, the allied portal of St. Lazare at Autun, representing the Last Judgment, is of surpassing interest as the most extravagant example of Romanesque license in the manipulation of the human form. It is their architectural function that obviates in the elongations the impression of caricature. Another late and superb portal, that of Charlieu, embodies especially the decorative opulence of the Burgundian style, here very oriental in its lace-like delicacy.

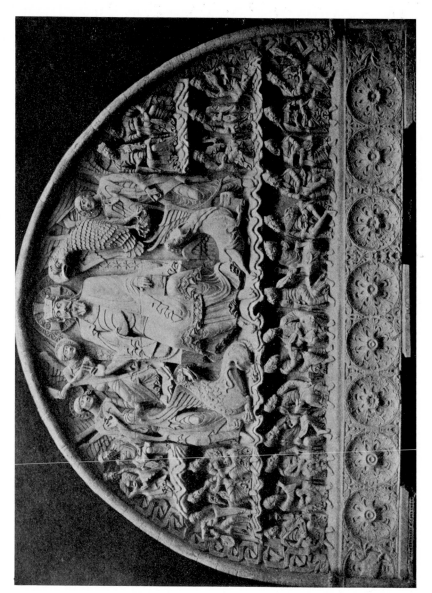

FIG. 15. TYMPANUM, PORTAL OF ST. PIERRE, MOISSAC

(Photo, from a cast)

FIG. 16. TYMPANUM, PORTAL OF NARTHEX, ABBEY OF VÉZELAY

PROVENCE

The presence of a greater number of antiques in what had been for a time the most flourishing province of the Roman empire made it natural that its school, more than any other of the conservative group, should retain the old characteristics. The façade of St. Trophime at Arles, executed in the third or even fourth quarter of the twelfth century, is typical (Fig. 17). Christ the Judge is in the tympanum, on the lintel are the Apostles, and on the frieze at either side the blessed and the damned. The heritage from Rome may best be discerned beneath in the larger figures of saints in niches — bodies of squatty proportions, heads of an inordinate magnitude and stolid expression, classical draperies, an absence of the technical delicacy that distinguishes the carvings of Languedoc and Burgundy. The heaviness carries with it, however, its compensation in a certain senatorial dignity, and accords well with the solid spirit of Romanesque architecture. The sculptors of Moissac and Vézelay took a different attitude, seeking to alleviate the ponderous impression of the buildings by lightening the forms with which they adorned them.

Other influences were at work in Provence. The crouching lions of the doorways are derived from the contemporary art of northern Italy, but the benefit from the relationship was mutual, for the great Lombard-Romanesque sculptor, Benedetto Antelami, seems to have caught some elements of his style from a study of Provençal art, especially the other great monument of the district, the portal of the church at St. Gilles. The occasional crossing of the legs and other details may show that the school of Provence learned something from Languedoc. The carvings of St. Gilles, dating from the middle to the end of the century and perhaps earlier than those of St. Trophime, are distinguished by good proportions, freedom of pose, and grace of draperies. It has been supposed that the early Gothic sculptors of northern France used the high attainments of this southern school as a stepping-stone to their own achievements. The truth seems to lie in exactly the opposite direction: the aged school of Provence was invigorated, in these its last days, by contact with the youthful school of Chartres. The inclined and truncated bases, for instance, upon which the saints of St. Gilles stand appear to be adaptations of the column-heads employed for the statues of Chartres to the needs of figures enclosed in niches. The most striking reminiscence is found in the vertical and parallel folds of the figure of St. Trophimus at Arles, executed, probably, with the rest of the sculptures in the cloister, about 1180, but superior to the majority of them. The differences between the two schools, nevertheless, always remained greater than the similarities.

Other important Provençal examples are: the frieze on the façade of the cathedral at Nîmes, representing scenes from Genesis and absolutely Roman in its "squattiness" and obtuseness to delicacy of detail; the similar frieze on Notre Dame des Pommiers at Beaucaire with scenes from the Passion (both of these dating from about the middle of the twelfth century); the two figures in the church at St. Guilhem-le-Désert (end of the twelfth century), recalling in their greater attenuation the productions of Languedoc; and the four Apostles in the portal of St. Barnard, Romans (1160–1180?), equal to the best work of St. Gilles.

OTHER SCHOOLS

The output of the other conservative provinces is not distinguished by such clearly defined features. Normandy and the Ile-de-France did not play a significant rôle until the rise of Gothic, perhaps because the invasions of the Vikings in the tenth century crushed any elements of the Carolingian Renaissance that might have served as a basis for the revival. It is generally stated that Auvergne did much of the road-breaking in the recovery of plasticity. Among the most interesting monuments in this section of France are: Notre Dame du Port at Clermont-Ferrand, the lateral door of which, in the large figures, betrays less stubby proportions than were usual in the region; the abbey of Mozac; and (not strictly in the province) the great tympanum of Ste. Foy at Conques, which combines elements of the style of Auvergne with analogies to the portals of Languedoc. The Metropolitan Museum at New York contains a Madonna and Child of colored oak (accession no. 16.32.194), one of a number of such wooden groups belonging to Auvergne, whether executed by craftsmen of that region or not, and characterized, in its rigid parallelism of folds and general solidity of impression, by that Egyptian monumentality which is associated with the Romanesque period. The Loire is very rich in sculpture, famous specimens of which exist at Selles-sur-Cher, St. Benoît-sur-Loire, and Azay-le-Rideau. The tympana of the Cluniac abbey of La Charité-sur-Loire are remarkable, not only because of the obvious derivation from the compositions of ancient sarcophagi, but also because the combination of stylistic analogies to Burgundian art with iconographic analogies to the lateral tympana of the main portal at Chartres suggests that Burgundian ideas may have filtered through the channels of the Loire to become a source of northern Gothic sculpture.

In the interdependent schools of Saintonge and Poitou, the carvings, lavished over the archivolts and often over large sections of the façade, possess more decorative value than technical fineness. The relief on

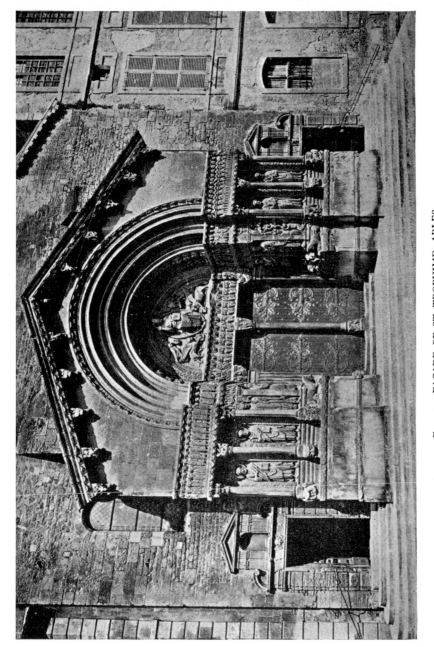

Fig. 17. FAÇADE OF ST. TROPHIME, ARLES

FIG. 18. FAÇADE, STA. MARÍA LA REAL, SANGÜESA

(From a photograph that belonged to the late Mr. Hervey Wetzel)

the archivolts tends to an oriental flatness, creating the effect of a rich embroidery. Since the portals ordinarily had no tympana, in compensation it was the arches that were very extensively carved with human forms, vying with *motifs* of monsters and vegetation. The human forms might be disposed side by side or in such a way that the feet of one are above the head of its lower neighbor. For the latter arrangement, which seems to have been first evolved in this region, a long Gothic history lay in store. In figure-sculpture the influence of Languedoc is as apparent as in other provinces. The most accessible example of these schools is perhaps the façade of St. Pierre at Angoulême, representing in its *ensemble* the Last Judgment and dating from the first part of the twelfth century. Here, as throughout Saintonge, the upper façade is relieved by much arcading; in Poitou, as at St. Jouin-de-Marnes, the three great arches of the lower façade are simply surmounted by three others. The *motif* of the mounted cavalier, embodied in the Sts. George and Martin on either side of the main door of St. Pierre, is frequent in the repertoire of the region, and in some instances has been denominated as Constantine. Other important centers for the Romanesque sculpture of Saintonge and Poitou are Saintes, Châteauneuf-sur-Charente, Bordeaux, Aulnay, Ruffec, Surgères, and especially Notre Dame la Grande at Poitiers, where, as often, the two different systems of arcading peculiar to the respective provinces are confused and where the comprehensive iconographic scheme is analogous to the parts of a Mystery Play on the Nativity.

3. SPAIN

For the ordinary student of art the Iberian peninsula connotes distinction in painting and suggests at once such names as El Greco, Velázquez, Goya, and Sorolla. Recent travel and investigation, however, have revealed a sculptural tradition, flourishing from the Romanesque period through the seventeenth century, at least as important as the pictorial; nay, taken as a whole, for uniform excellence in contrast to the few isolated great names in painting, it may well be judged more important. One of the pleasantest tasks of the modern critic is to restore Spain to her proper exalted position in the history of sculpture.

It is true that the Spaniards have always been good imitators. In the Middle Ages they drew very largely upon France, and in the Renaissance upon Italy; but they so infused what they borrowed with the national spirit that the results were virtually original. During the Romanesque and early Gothic periods the Spanish genius had not yet fully asserted itself, and the dependence upon the art across the

Pyrenees was more pronounced. The few carvings of the barbaric age are not different enough from the output in the rest of the continent to detain us. Sculpture still continued to be rare, rude, and insignificant in the eleventh century, prior to the introduction of the Gallic models through the Order of Cluny and through the incessant flow of pilgrims to the great church of Santiago de Compostela. The capitals in the atrium of the church at Gazolaz, Navarre, and the baptismal font in S. Isidro at Leon are characteristic examples.

The great period of the Romanesque included the end of the eleventh and the whole twelfth century, when the progressive school of Languedoc became the dominant influence as in almost all other parts of Europe. One of the best illustrations of this relationship exists in six reliefs on the corner piers in the Cluniac cloister of Sto. Domingo de Silos near Burgos. The subjects, the last episodes of the Gospels, are the same as those upon the piers in the cloister of St. Trophime, Arles, but the style recalls the portals of Moissac and Souillac. The headdress of all the women is a local Spanish touch. The two reliefs at the southwest angle, the Annunciation and the Tree of Jesse, belong to the early Gothic. Another example, somewhat more primitive and in this instance connected more closely with the actual school of Toulouse, is the south portal, the Puerta de Platerías, of Santiago de Compostela.[1] In its bipartite division, it resembles the main door of St. Sernin at Toulouse; in its disposition of carvings in and above the tympanum, it reproduces the lateral portal of the same church; but the tendency to conceal every inch of the surface with reliefs is an indigenous characteristic, occasioned by proximity to the prodigal art of Moorish Spain. Even though some of the panels were imported from the north door, destroyed in the eighteenth century, yet neither did the Puerta de Platerías nor other Spanish portals in their original condition possess that lucidity and logicality of iconographic scheme which even at so early a date were an expression of the French devotion to *raison*. A better example of the complete and peculiarly Spanish investiture of the whole façade is afforded by the church of Sta. María la Real, Sangüesa, Navarre, the statues on the portal of which, possibly of later date than the rest, are certainly influenced by the early Gothic of the school of Chartres (Fig. 18).

Occasionally other schools found favor in the southern peninsula. At Ripoll in Catalonia the superabundant sculpture is arranged in bands as in the Lombard-Romanesque of northern Italy. The façade of Sto. Tomé at Soria, Castile, is reminiscent of Poitou, Saintonge, and

[1] The main portal, the magnificent Pórtico de la Gloria, will be considered as an example of the transition to Gothic.

western France. The main portal of S. Vicente, Avila, one of the loveliest achievements of all Romanesque art, signalizes a fleeting influence of Burgundy. The foliage *motifs* of the archivolts are paralleled at St. Lazare, Avallon, the elongated Apostles incline toward one another in conversational pairs as at Vézelay. From a naturalistic standpoint, especially in the delineation of the form beneath the clinging drapery, they, like the figures of the Annunciation upon a jamb of the lateral door, are superior to their Burgundian prototypes, and have already felt the breath of Gothic life.

The Romanesque capitals of Spain rival, if they do not surpass, those of France. The adjoining plate (Fig. 19) includes instances from four different cloisters, brilliantly exemplifying both the range of subject in the art of the period and the manner in which the carving is made to conform to an architectural design. The more pronounced oriental character of the monsters, the geometrical interlacing on the abacus, the occasional Arabic *motifs* of pine-cones and thick plants, bestow upon the work at Sto. Domingo de Silos a Moorish flavor that sometimes sifted into southern France, as in the cloister of Moissac, reciprocating the Gallic influence that lies at the basis of Spanish medieval sculpture. The capital from S. Pedro, Huesca, Aragon, represents the Via Dolorosa with the soldiers in contemporary costume. But such Biblical scenes are less frequent in the more original carving of Catalonia, giving place to a greater number of secular subjects and consequently to a greater freedom from tradition and a more evident naturalism. The capital from the entrancing cloister of S. Cugat del Vallés near Barcelona introduces an exhibition of street-acrobats; the abacus of the example from the cathedral of Tarragona illustrates the fable of the cat and mice.

4. GERMANY AND RELATED COUNTRIES

The best Romanesque work of Germany is found in her bronzes, continuing the tradition of the Carolingian Age, and in her sepulchral effigies. The monumental decoration of churches in stone is inferior to that of France, but through a dependence either upon French prototypes or upon similar sources and conditions, it is often reminiscent of the several French schools. Generally speaking, the craftsmanship is ruder, the proportions are more puerile, tending towards a stubby plumpness, and the forms are less instinct with life. In the few places in southern Germany where sculpture was produced, as at Basel and Ratisbon, some Lombard influence is naturally to be discerned both in the forms and in arrangement in bands. Virtually no carving seems to have been done anywhere before the middle of the twelfth century.

No portals or façades have the magnificence of Moissac, Vézelay, or Angoulême; the cathedral of Basel and the church of St. James at Ratisbon are the only examples of importance. Usually it was merely the tympanum that was embellished with sculpture. The Rhine country, the center of German monasticism in the early Middle Ages, was more concerned with painting; the sculpture of Westphalia was the most progressive and enlivened by a certain poignancy of feeling. In the former region, the St. Gallus portal of the cathedral at Basel, from the end of the twelfth century, is significant for the elongation and conventionalization of the Evangelists at the sides and for the more painstaking execution, indicating possibly a contact with Burgundy; the relationship of statues and columns reveals a knowledge of Provençal façades; and there is considerable feeling, as throughout German Switzerland, for the value of sculpture as architectural decoration. Other good instances of Rhenish Romanesque are the tympanum from Constance, now in the Ducal Collection at Karlsruhe, the relief of Our Lord standing between Sts. Peter and Eucharius in the Museum at Trèves, and the reliefs from an altar or choir-screen in the church at Gustorf. Of Westphalia, characteristic examples are the tympanum of Christ and the signs of the Evangelists in the church of St. Patroclus at Soest and the large Deposition carved out of the living rock over the grotto of the Holy Sepulchre near Detmold, the so-called Externstein, an absolute transcription of some Byzantine or Carolingian ivory. Another interesting imitation, in this case of an ivory casket, is the stucco adornment of the shrine in the abbey of Gernrode, Saxony. The best German specimens of the typical separate Romanesque representations of the Virgin and Child are the seated example (in wood overlaid with gilded silver plate) in the Minster at Essen and the standing example (in wood) in St. Maria im Kapitol, Cologne.

It was for her bronzes that Saxony won a reputation. Her workshops attained such popularity that they exported doors like those of Hildesheim even to Verona in Italy, to Novgorod in Russia, and to Gnesen in Poland. In this as in other phases of German Romanesque sculpture, either through Byzantine or French influence the forms gradually became more correct, but on the other hand there was a partial loss of the old Teutonic realism. The two valves of the door of S. Zeno at Verona are now a conglomeration from sections belonging to the first half of the eleventh century and sections of a subsequent enlargement in the twelfth century. The sections of the earlier period are recognizable by an artistic childishness unworthy of the Saxon prototype; those of the later period recall more truly the bronzes of St.

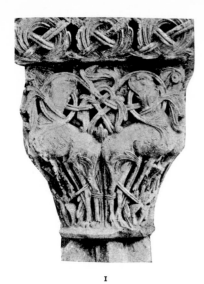

1

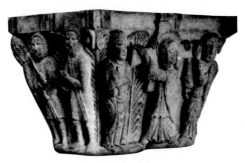

2

3

4

FIG. 19. SPANISH ROMANESQUE CAPITALS

1. STO. DOMINGO DE SILOS 2. S. PEDRO, HUESCA
3. S. CUGAT DEL VALLÉS 4. CATHEDRAL OF TARRAGONA

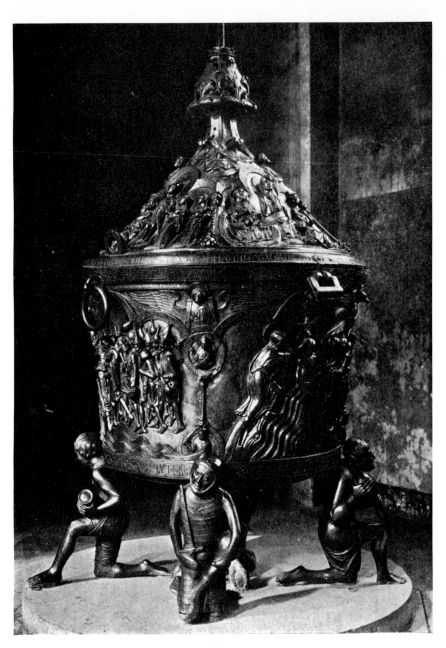

Fig. 20. FONT. CATHEDRAL, HILDESHEIM

(Photo. Dr. Fr. Stoedtner, Berlin)

Bernward and are slightly more advanced in style.[1] Of the two doors in Slavic territory, that at Gnesen, dating somewhat later in the twelfth century than the other, tends toward an excess of Byzantinism that is unusual in Saxon products. A more developed knowledge distinguishes also the bronze doors of the cathedral at Augsburg and the oaken doors of St. Maria im Kapitol at Cologne.

Often the work in bronze was technically superior to that in stone. In the lion set up by Henry the Lion as his emblem in 1166 at Brunswick, heraldic conventionalization is tempered by naturalistic study, and Germanic pride exults in a superb consciousness of strength. The font in the cathedral of Hildesheim, as ornate in decoration as it is elaborate in iconography, was executed at the beginning of the next century, but still belongs to the same Saxon tradition (Fig. 20).

Saxony was likewise a center for the production of grave-reliefs in bronze. As in the series of doors, crude realism, represented at the end of the eleventh century by the effigy of Rudolf of Swabia in the cathedral at Merseburg, gave way in the twelfth to a desire for correctness, repose, formal beauty of draperies, and idealism, represented by the slab presumed to be the monument of the Archbishop Frederick I, in the cathedral at Magdeburg (Fig. 21). Much the same evolution may be traced in the succession of sepulchral effigies in stone carved for the abbesses of Quedlinburg.

5. THE LOW COUNTRIES

From the region that later became Belgium and Holland, little Romanesque sculpture remains. Their art was dominated chiefly by France, though Germany also exercised some influence, especially in the adjacent districts of Holland and of the Meuse. Over the few tympana and other monuments, our scope does not permit us to tarry. Tournai was the most important sculptural center, because its black marbles were made into fonts and sepulchral slabs and enjoyed such popularity in the twelfth century as to be exported into northern France and England. The font of Tournai stone at Zedelghem, with scenes from the life of St. Nicholas, betrays the elementary state of figure-carving in Belgium during the eleventh century; but the craft never rose much above the level of mere shopwork, and even in the exported examples of the twelfth century, such as that of the cathedral of Winchester, the forms are rather childish, the relief flat, and the technique primitive. The sepulchral slabs are in the same tradition,

[1] A. Kingsley Porter (*Lombard Architecture*, I, 266) doubts that the Verona doors are derived from those of Hildesheim, and surmises that both sets of doors may have been suggested by some Italian prototype.

for instance, that conjectured to be the memorial of Bishop Roger in the cathedral of Salisbury.

The loveliest monument of Romanesque sculpture in the Low Countries is the bronze font now in St. Barthélemy, Liége, executed in the first half of the twelfth century by Renier de Huy and decorated chiefly with a series of famous baptisms, skilfully varied in compact compositions. If the figures did not exhibit a sensitiveness to ideal beauty uncommon in near-lying Germany, one would be more tempted to connect this work with the great Saxon activity in bronze that at the beginning of the thirteenth century was to produce the very similar font in the cathedral of Hildesheim; but since Dinant was probably already distinguishing herself for the production of objects in this medium and was soon to make the term "dinanderies" famous in Europe, it is perfectly possible that Renier de Huy learned his technique in bronze-casting at home and that he acquired his Romanesque ideas of the human form in France.

6. ENGLAND

Romanesque sculpture in England as in the rest of Europe may be divided into two periods, the first consisting of a rude and arduous apprenticeship in the art, the second resulting in actual attainment. During the first period, which in England may be considered as extending from the Norman Conquest in 1066 to about the middle of the twelfth century, French sculpture in general had not yet advanced far enough to arouse much interest across the channel; during the second, in which may be included the latter half of the twelfth century, French models were the prevailing fashion.

The early Romanesque style of England was an amelioration of the forms and conceptions inherited from the barbaric productions of the ninth and tenth centuries. These were constructed of elements drawn from the Celtic tradition, but particularly from the ideas of the Scandinavian raiders. The Normans in their final conquest naturally suppressed the Saxon Renaissance in sculpture, if indeed there had been a Renaissance in the south based upon Carolingian precedents; but being Scandinavians themselves and finding the Irish-Viking style more to their taste, they adopted it, developed it, and employed it for the decoration of their parish churches in mid-England and the West, which during this period were the centers of sculptural activity. A Scandinavian continuity with the barbaric age existed in the first Romanesque sculptures of England, as a Carolingian continuity with the Othonian age existed in the bronzes of Germany. The monsters of Norse mythology lived on and were endowed with Christian symbo-

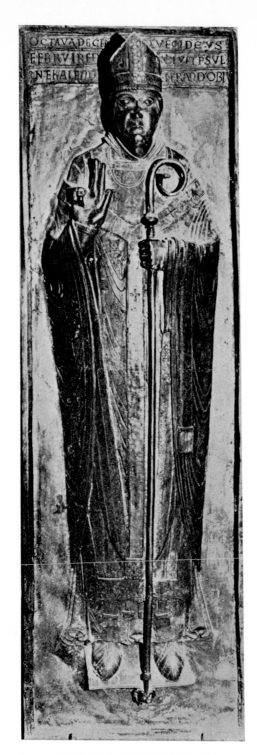

FIG. 21. TOMB OF ARCHBISHOP FREDERICK I.
CATHEDRAL, MAGDEBURG

(Photo. Dr. Fr. Stoedtner, Berlin)

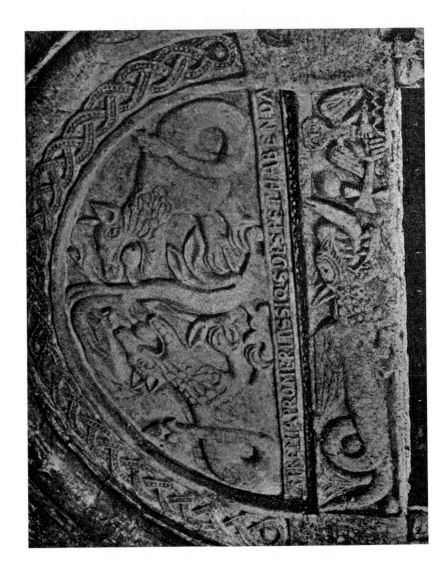

Fig. 22. TYMPANUM, CHURCH AT DINTON

lism, the fighting warrior became a St. George or a St. Michael, the old ornaments of knob and interlacement remained the stock in trade of the stone-cutter. The tympanum of the church at Dinton (Bucks) is characteristic of this English carving in the early twelfth century (Fig. 22). "The beasts are the souls of the righteous vigorously battening upon the 'Tree of Life' (the world-ash of the Sagas) and below the bat-like 'St. Michael' (in the fashion of Odin) is engaged with the 'Dragon' (the Helworm)." [1] The relief is low and flat with no pretence at modelling in the round, the rendition of the human form in the St. Michael is inferior even to the usual standard of the period, but the Norse spirit has contributed a certain rude force. Occasionally, as in a capital in the chapter house of Westminster Abbey, portraying the Judgment of Solomon, the "grooving" into the plane suggests a study of the paintings that decorated the Anglo-Norman churches. More often the technique of the metal or ivory-worker was the model. In the relief of the Virgin and Child in the church at Fownhope, the ground is filled with an intertwined band, suggested by a metal or wire design, and the treatment of the drapery in a series of parallel incisions is learned from the goldsmith. The qualities of the early Romanesque manner appear also in a large number of fonts.

It may well be doubted how far these clumsy beginnings would have progressed, if, in the second half of the century, the importation of the more mature and refined French style had not come to the rescue of the native craftsmen and assisted them in developing the embryonic elements that they possessed, through the unity of monastic enterprise, in common with the rest of Europe. Now finally flat relief and the rendering of detail through incised lines were abandoned for modelling in the round, better proportions became the general rule, and the old symbolistic beasts and combats gave way to the more humane subjects from the Bible. Nevertheless, perhaps because of the sculptural sterility, in contrast to the architectural achievements, of Normandy, upon which English art depended more closely than upon other French provinces, the Romanesque sculpture of England was less distinguished than the architecture, and its amount was comparatively limited. For their models the English stone-cutters usually had to turn to other districts of France, which in certain instances taught them particularly how to use the portal as the vehicle of an iconographic system. In southeastern England, which now again became conspicuous in the history of sculpture, the west doorway of Rochester resembles examples in Poitou and Saintonge. The luxuriant ornamentation of the archivolts is almost iden-

[1] Prior and Gardner, *Medieval Figure-Sculpture in England*, p. 154.

tical; the tympanum, representing Christ enthroned between the signs of the Evangelists, and the statues on the jambs (Solomon and the Queen of Sheba?), though usually absent from western France, can be paralleled in many other parts of that country. Other important monuments of a similar nature are the south portal of Barfreston, Kent, the Prior's Doorway of Ely cathedral, and the south porch of Malmesbury Abbey, in the lateral spandrels of which the Apostles have the lively attitudes of the twenty-four Elders at Moissac.

The fonts reveal the same improvement in style. Many are of lead, especially in the Severn country south of Gloucester, and upon the peculiarities of these depend a certain number of stone imitations, for example, the font of Hereford Cathedral.

A somewhat different movement in the north derived its methods rather from Languedoc and surpassed the south in the realization of form. At Lincoln it is represented chiefly by a series of small panels set into the west façade and portraying scenes from Genesis and the Last Judgment, still rather heavy and slovenly in execution, but establishing the precedent for the anecdotal friezes of English Gothic. Of the several fragments at Durham, four reliefs in the Cathedral Library, containing episodes from the Passion and Resurrection, and the scenes upon the Kelloe Cross in the churchyard are executed with an extreme sensitiveness and delicacy that are extraordinary amidst the callousness of Romanesque England. The most astounding work is found in the Museum at York. The large statues of Apostles and Prophets, originally belonging to a portal in the ruined abbey of St. Mary, permit the supposition that the sculptor may have gained his knowledge of Toulousan methods through the form that they assumed at the great pilgrimage church of Santiago de Compostela in Spain. The figures have shaken off the bonds of relief and have stepped forth into a full plastic roundness. In nobility of type, in differentiation of personality, in ease of posture and sober grace of drapery, they stand already upon the threshold of Gothic.

England produced very few sepulchral monuments prior to the Gothic period. The Romanesque examples were imitations, in Purbeck marble, of the slabs imported from Tournai, but they were more successful than their prototypes in the realization of modelling in the round. The tomb of Bishop Jocelyn in the cathedral of Salisbury may be taken as typical.

7. ITALY

Until the sixteenth century and particularly during the early Renaissance the art of Italy ran a somewhat separate course. In the Middle Ages, the environment of a far larger number of antiques, the

closer contact with Byzantinism, and the barrier of the Alps partially isolated plastic development from the rest of Europe and produced artistic conditions that were more indigenous and peculiar than in other countries. In contrast to the attitude that found its highest expression in France, Italian obtuseness to structural feeling in architecture tended to disassociate exterior carving from the general organic scheme, to look upon it as mere decoration, and therefore to employ for it slabs of marble inlay rather than the local stones of which the fabric itself was built. The iconographic schemes of France were paralleled only sporadically, and then under Transalpine influence. Although Italian sculpture was destined to so glorious a history, the eleventh century was as arid and unpromising as in Spain, and it was only at the end of the century that signs of a revival began to appear. The sculptural output of Italy is usually described as Romanesque until a date considerably later than elsewhere — to the middle or in places even to the end of the thirteenth century; but the stylistic differences from the European norm, especially in the southern peninsula, make the name more or less of a convention. The production of the period may conveniently be treated in three geographical divisions, the northern or Lombard, the southern, and the central or Tuscan.

NORTHERN ITALY

The output in the north was naturally more analogous to that of France than in the rest of the peninsula. But it started rather differently with what might be expected of the fierce Lombards. A more than usual addiction to the savagery of Romanesque subjects resulted in ruthless battle and hunting scenes and in a nightmare of grim beasts and revolting monsters, often tearing one another to pieces. Good specimens are afforded by the capitals of S. Ambrogio, Milan, and by the façade of S. Michele at Pavia, where, according to the Lombard custom, the lower section is covered with a series of carved bands, disposed without any apparent order. At the same time that S. Michele was building, the beginning of the twelfth century, a similar arrangement was used by another school, centering about MASTER GUGLIELMO at Modena, not so much inclined to these brutal medleys, and preferring the human figure in sacred and secular subjects. His work, in the former instance accompanied by his signature, may be seen upon the façade of the cathedral of Modena, and probably in the Prophets of the main door of the cathedral of Cremona. The illustration (Fig. 23) is from a monument in the same general style, the portal of S. Zeno at Verona. Although the rendering of form is still defective, the sculpture is distinguished by a rude Lombard vigor. This monument

conforms to that Lombard convention of supporting the columns of
the porch upon the backs of beasts, usually lions, which may have be-
gun at Modena, where the architect utilized for the main portal two
ancient lions unearthed in the excavations for the new cathedral. A
certain Guglielmo, whether the master of Modena or not, has signed
his name to the reliefs from the New Testament on the left, a certain
NICCOLò to the less heavily proportioned and more flexible reliefs
from Genesis on the right. Niccolò has carved his signature also upon
the main portals of the cathedrals of Ferrara and Verona. Possibly by
the same hand are the sculptures on the two lateral portals at the front
of the cathedral of Piacenza; and these are only a few among a num-
ber of works in the district that belong to the same movement.

The reproduction of ancient *motifs*, as in two winged and naked
funereal genii on the façade of Modena, would imply that the Lom-
bard school learned to model the human body partly from a study of
the classical fragments that were particularly numerous in Italy and
were constantly built into the churches; but the more pronounced
classical reminiscences, as well as other characteristics of Guglielmo and
his many followers, have been traced also to the school for the illumi-
nation of manuscripts that flourished in the valley of the Rhine in the
immediately preceding centuries and spread its influence into Italy
through commercial and political relations. The combat from the
Arthurian cycle upon the archivolt of the lateral Porta della Pescheria
at Modena, the figures of Roland and Oliver upon the portal of the
cathedral at Verona, suggest, furthermore, a relationship to France.
The style of Guglielmo of Modena resembles that of the cloister of
Moissac, which was decorated about the same time; but the analogy
may be explained by the use, in both instances, of similar models of
the minor arts. In the case of the slightly later Niccolò, the depend-
ence upon the school of Languedoc appears more likely. Although the
Italian examples in general seem to be prior to the greatest French
Romanesque monuments, Guglielmo and his followers may have ac-
quired something from the more progressive beginnings across the
Alps. It is always possible, however, that these Italians largely
trained themselves and that the major influence operated in the op-
posite direction. In any case, small effigies of Prophets on the vertical
supports of the archivolts in the splayed doorways of the cathedrals at
Ferrara, Cremona, and Verona may have assisted to set the precedent
for the similar treatment of portals on a larger scale in early French
Gothic, and the sculptured capitals in the cloister of S. Orso at Aosta
in Piedmont seem to antedate the capitals at Arles and Elne that they
resemble. This extremely northern province of Piedmont and the ad-

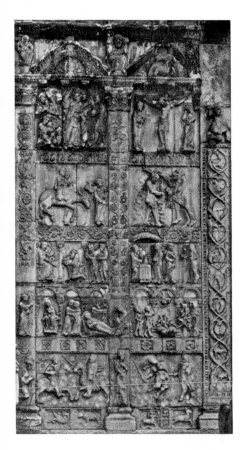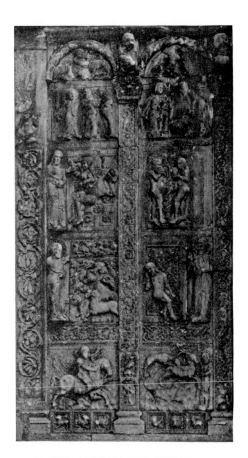

Fig. 23. RELIEFS FROM OLD AND NEW TESTAMENT BESIDE THE PORTAL
OF S. ZENO, VERONA

(Photo. Fratelli Alinari)

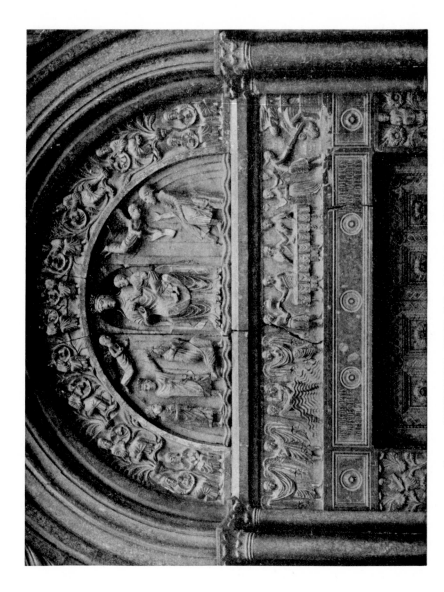

FIG. 24. BENEDETTO ANTELAMI. PORTAL, BAPTISTERY, PARMA

(Photo Fratelli Alinari)

joining eastern district of Montferrat constituted the channel of artistic communication between the two Latin countries. Even later, the reliefs on the screen of 1189 in the church of S. Maria at Vezzolano in Montferrat have all the earmarks of a French provenience.

The Gallic influence becomes indubitable at the end of the twelfth century in the person of BENEDETTO ANTELAMI [1] of Parma, one of the most appealing of Romanesque sculptors, whose activity began in 1178. His works, especially at the end of his career, exhibit so many analogies to the carvings of Arles and St. Gilles that it is necessary to assume that he studied in Provence, and his draperies suggest that he may have even seen the early Gothic carvings of Chartres. A Deposition built into the Boiardi chapel of the cathedral at Parma, a fragment of a destroyed pulpit, ambo, or altar, exhibits his *début* in a rather cramped but charmingly conventionalized style. He models lank figures in clinging garments, the multiple folds of which tend to strict parallelism and to perpendicularity and open into the shape of a bell at the bottom. But soon abandoning these mannerisms, he created ampler forms and more natural draperies that reveal the body beneath and follow its movements, although he always retained an unarchitectural solicitude for the elaboration of small detail. This more mature style is exemplified in his extensive decoration of the Baptistery at Parma, the interior statues of which have preserved their polychromy. Two of the three doorways that have carvings are elaborated into the iconographic systems of France. The one chosen for illustration (Fig. 24) is devoted to the Holy Family, reserving the lintel for the story of St. John Baptist, whose life was so closely connected with theirs. In the tympanum are enthroned the Virgin and Child, flanked on their right by the three Magi and on the left by the vision of St. Joseph. The interstices of the foliage on the jambs contain the ancestors of Sts. Mary and Joseph, and those of the archivolt the twelve Prophets. The flying angels possess a solemn grace that is one of Benedetto's most delightful qualities and is more strikingly embodied in the larger angels accenting some of the arch-heads in the interior. All of his characters are pervaded by an intimate mysticism that reaches its climax in his masterpieces, the Solomon and Queen of Sheba, which, with other sacred figures, he used to relieve the spaces of the outer wall. In these and in the Prophets on the cathedral of Borgo San Donnino, which likewise is adorned by his chisel, he achieved true monumentality and most closely approximated his

[1] For the sake of convenience I use the surname Antelami that has usually been given to Benedetto of Parma, although there is good reason for believing that the word *Antelami* was not a surname but the title of a guild of builders and sculptors derived from the valley of Antelami in the Apennines.

prototypes on the façades of St. Trophime and St. Gilles; but, with the virtues and vices of a true Italian, he was never able to harmonize his creations with their architectural setting. Benedetto Antelami used foreign borrowings only as suggestions for the creation of an original and personal style. Even from the first, when in other countries art was still largely the product of groups of craftsmen, Italian sculpture was distinguished by the constant assertion of the master's own individuality.

He was assisted, of course, by many pupils, and much of north Italian carving at the end of the twelfth and beginning of the thirteenth centuries can be traced to his school. The lovely equestrian statue of Oldrado da Tresseno in the Palazzo della Ragione, Milan, dated in 1233, is ascribed by Venturi to his actual chisel. In St. Mark's at Venice, the Prophets of the Cappella Zen and the colloquial and imaginative representations of the common Romanesque subject, the activities of the different months, upon an archivolt of the main portal, though still in Benedetto's manner, transport us into the greater knowledge and freedom of early Gothic.

SOUTHERN ITALY

The sculpture of the southern peninsula has a peculiar significance as the probable training-school of the first world-famous master in Italian art, Nicola d'Apulia. In its greater enthusiasm for the antique, it was more truly Italian than the contemporaneous output of the north. At the same time much work was the result of an unusually potent Byzantine inspiration, partly because a large section of southern Italy had been included in the old Exarchate and partly because in 1066 the Benedictine abbot of Monte Cassino, Desiderius, as an energetic patron of the arts, summoned to his service a group of craftsmen from Constantinople, who diffused Greek forms throughout the district. An important manifestation of this Byzantine interest was a series of bronze doors. In the eleventh century many were imported directly from Constantinople with the figures not executed in the round but by the process which was the extreme expression of the oriental distaste for relief, damascening,[1] the filling of grooves incised in the bronze with silver or enamel. In addition, much projecting metal ornamentation was used upon the doors. A rich merchant of Amalfi, named Pantaleon, endowed his native town with a pair before 1066, his son Mauro gave another to the abbot Desiderius for Monte Cassino, and his later descendants continued the magnanimous family precedent for S. Paolo fuori le Mura at Rome, for the shrine of St. Michael at

[1] The term *damascening* is here extended somewhat beyond its usual sense of an inlay only of gold or silver.

Monte Gargano, and for Atrani near Amalfi. Similar doors were procured by others for Salerno and for St. Mark's at Venice. The next step was the imitation of these models by Italians — by ROGER OF AMALFI for the Mausoleum of Bohemond at Canosa and by ODERISIUS OF BENEVENTO for the cathedral of Troja. The final stage was the substitution of reliefs for the damascening. The Italian craftsmen may have been influenced by the doors of S. Zeno, Verona, which are generally believed to be of German derivation. A certain BARISANUS OF TRANI, in the second half of the twelfth century, executed three doors of this kind — for his own town, for the cathedral of Ravello, and for the lateral entrance of Monreale. The panels usually contain single effigies of saints or such profane figures as centaurs, sirens, dragons, cavaliers, or archers. Occasionally Biblical scenes are admitted. The subjects in all cases are faithfully copied from Byzantine ivories or goldsmith's work, and the same mold, as at Augsburg, is frequently repeated twice or oftener, even on the same door. A closer analogy to the German examples is afforded by the doors of BONANNUS OF PISA for a side entrance of his own cathedral and for the main entrance of Monreale. Sacred episodes now intruded into all the panels, ultimately of Byzantine suggestion, but treated with the Italian feeling for rounder relief and with a popular *bonhomie* that recalls the school of Hildesheim and Verona. The technique is less exquisite than in the more slavish imitations of the Greek prototypes.

It remained to combine Italian vivacity with Byzantine skill. This task was achieved at the end of the twelfth century in the bronze doors of the cathedral of Benevento, with scenes from the life of Christ. The narrative is clear and eloquent; postures and expressions are varied; the accessories of landscape and architecture are given their due importance, so that the effect approaches the picturesque; the superb dramatic qualities of the Gospel are realized. Worthy of particular note in the illustration (Fig. 25) are the fine characterization and individualization of the lax body of the dead Judas and of Peter going forth to weep bitterly. The anonymous sculptor of Benevento, by pouring new life into the old Byzantine compositions, prophesied the similar achievement of Duccio in painting a century later at Siena. Of analogous importance are the ivory reliefs upon the altar of the cathedral at Salerno.

The portals of Apulia and the adjoining districts have an opulence that is probably Saracenic but seems almost Indian. They are laden with Byzantine *motifs* of foliage and beasts, usually in a single plane of relief, and with details that are even more oriental. Apes (embracing human forms) on the portal of the cathedral at Acerenza, for in-

stance, and elephants on the great apsidal window of the cathedral at
Bari, take the place of the lions supporting columns in Lombardy. It
is only occasionally that scenes with human figures appear. Sporadi-
cally these are of north-Italian derivation, such as the combat of horse-
men against a citadel on the archivolt of a lateral door of S. Nicola at
Bari. Even the Arabic technique for sculpture, perforation of a plane,
is met with in the Abruzzi, for example, on a pulpit at Cugnoli. The
variety of stylistic elements is evidence of the racial conglomeration
in this section of the peninsula.

Campania and Sicily were the seats of a school that outdistanced the
rest of Romanesque sculpture in its knowledge and reproduction of
the antique. The carving of this school is found principally on pieces
of ecclesiastical furniture, such as pulpits and Paschal candlesticks.
The robust bodies, the poses and the costumes, the vigorous relief,
are suggested by fragments of Roman sculpture, but like the Byzan-
tine forms of the door at Benevento, the classical borrowings are revivi-
fied by an appreciation of every-day life. The style appears in a long
series of monuments, famous among which are the ambos at Salerno,
the ambos, candlestick, and archivolt of the porch of the cathedral at
Sessa Aurunca, the reliefs with the lives of Joseph, Samson, and others
in the chapel of S. Restituta in the cathedral of Naples, and (of the
late thirteenth century, possibly already influenced by the related
achievements of Nicola d'Apulia in Tuscany) the candlestick in the
porch of the cathedral at Gaeta. The artists were inspired by the
antique even to an astonishingly successful study of the nude, as nota-
bly in the human figures which, according to the usual south-Italian
convention, support the bowl of the Easter candlestick in the Palatine
Chapel, Palermo. The tunic upon the boy and its graceful disposition
over one shoulder are taken from some ancient figure of an ephebe, but
the body and the highly individualized head are studied directly from
the living model of some fisher-lad, such as may be seen even today
upon Sicilian quays. The archaizing proclivity is curiously united to
an acquaintance with southern French prototypes in the cloister at
Monreale above Palermo.

Antiquarianism became even more pronounced under the emperor
Frederick II, who inaugurated so many humanistic enterprises in every
field of culture. His chief sculptural undertaking was the decoration
in 1234 of a castle or work of defence in the form of a Roman triumphal
arch at Capua with statuary and with reliefs. Fragments of this have
now been gathered in the Museum: a decapitated effigy of the Em-
peror with the dignity and the toga of a Roman senator (Fig. 26);
busts of his ministers, Pier delle Vigne and Taddeo da Sessa, reproduc-

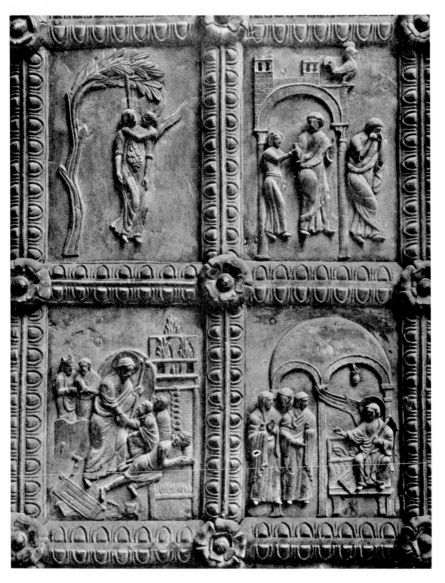

FIG. 25. DETAIL OF BRONZE DOORS, CATHEDRAL, BENEVENTO

(Photo. Fratelli Alinari)

FIG. 26. STATUE OF FREDERICK II. MUSEUM, CAPUA

tions of Roman busts; and a noble head of the personified city of
Capua, copied perhaps from an old Juno. All these sculptures imitate
their models so closely that they have deceived even some fairly recent
critics. The same school worked upon the ornamental heads of the
edifice at Capua that are now in the Museum, upon the embellish-
ment of Frederick II's residence called Castel del Monte near Andria
in Apulia, and as late as 1272 upon the portrait-reliefs and superb
feminine bust of the ambo of the cathedral at Ravello. If Nicola
d'Apulia was conversant with such productions, his creation of the
Pisan pulpit is a less inexplicable phenomenon.

CENTRAL ITALY

In central Italy, Tuscany was the only province of sculptural signifi-
cance. Even here the addiction to adornment by effects in marbles of
different colors partially usurped the important place occupied by re-
liefs in the architecture of the northern and southern peninsula. The
Romanesque development came even later than in other regions.
Florence was particularly sterile, and in reviewing the output of the
period, one would never have suspected the great plastic future that
lay in store for the valley of the Arno. Tuscan carving appears chiefly
on pulpits and lintels of doors. Much of it seems to have been done by
Lombard craftsmen. In 1250 GUIDO DA COMO made a pulpit for
S. Bartolommeo in Pantano at Pistoia, and he or another northern
sculptor of the same name (sometimes called Guidetto da Como) had
been active in the district from the first of the thirteenth century,
decorating about 1235 the cathedral of Lucca. Similar, though ruder,
pulpits, whether by Lombards or native Tuscans, exist at Barga near
Lucca, in the cathedral of Volterra, in S. Leonardo in Arcetri, Flor-
ence, and (with very little figure-carving) in S. Miniato of the same
city. The whole series substituted an interest in religious narrative,
treated in rows of panels, for the symbolic representations on south-
ern ambos, and even northern sculptors, when their hand is to be
discerned, succumbed to the old Etruscan tradition of this part of
the peninsula, modelling stocky forms and humorously large heads.
Another pulpit of 1194 at Groppoli near Pistoia, though of the same
general style, is yet more puerile. The figure-carving in the sacred
episodes represented upon the architraves of portals at Lucca and
Pistoia is not much better than on the pulpits, but in both kinds of
monument the decorative elements often are of great skill and beauty.
The Romanesque sculpture on the tympana, lintels, and façade of the
cathedral at Lucca, representing the lives of St. Martin and St.
Regulus, the labors of the months, and the glorified Christ, is much
more successful in its rendition of form and drapery. The mounted

St. Martin and the beggar, corresponding to the cavaliers on western French façades, constitute a group astounding in its naturalism and in its emancipation from primitive convention. The Byzantine reliefs on the lintel and sides of the east or main portal of the Baptistery at Pisa, the Romanizing feminine figures in the foliage on the flanking columns of the same monument, and the storied columns of the porch of the cathedral at Lucca are the only other Tuscan sculptures that, in technical attainment, prepared the way for Nicola d'Apulia.

CHAPTER IV

GOTHIC SCULPTURE. INTRODUCTION

The Gothic age in sculpture as in architecture lasted, over the greater part of Europe, from the thirteenth through the early sixteenth century. Originating in the Ile-de-France, the new style reached its highest development during the first hundred years of its history. Now that art had become communal rather than monastic, the burghers, in a fine spirit of local pride, contributed their money and the craftsmen their labor to the construction and adornment of the cathedral. The latter were chiefly laymen, although many still joined the orders as lay-brothers. The freshness and freedom of life in a medieval town attached itself to the sculpture, in contrast to the austerity and constraint that the monastery bestowed upon even the wildest and most agitated examples of Romanesque work.

Although the carvings did not cease to be considered a part of the whole architectural scheme, the statue tended to emerge more from the mass of the building, to stand forth in the round, and to be the object of more special attention. The Gothic sculptor took advantage of the knowledge gained by his Romanesque predecessor, but he largely abandoned the models of antiquity and of the minor arts and the resulting conventions. He studied nature itself, and attained much greater skill in its reproduction. He thought no more in the derivative terms of a small ivory, but in the absolute terms of the finished and monumental stone figure. The output of the thirteenth century was genuinely sculptural because it was conceived in the genuinely sculptural medium of stone. As far as any movement in art has ever been original, the Gothic period evolved this plastic sense and its own forms from its own esthetic consciousness. For the lack of superficial finish possible to the marbles of Greece and Italy, it compensated by the vigor and facility of style derived from its freestones. Despite the advance in truth of representation, however, the artist used for his forms the simple, noble lines and the idealization proper to the severity and formality of architectural decoration. Simplicity and idealization, these were the dominant notes of the thirteenth century, and these were the qualities that could fitly express its lofty and robust religion. The sincerity of this religion as an artistic inspiration was invigorated by the new and popular Order of Franciscans, who lived among the

people rather than in the seclusion of a Benedictine monastery. The whole Gothic period, indeed, as the most essentially Christian of all artistic epochs, laid the emphasis not upon the beauties of the body, but upon the expression of the thoughts and emotions of the soul. The nature of the expression varied between degrees of idealism and realism in the several centuries, and diverse treatments of the drapery partially took the place that the body and the nude had occupied in ancient art as aids to artistic utterance or as objects of purely esthetic delight. For all these reasons Gothic sculpture appeared as a new thing in the world, different from Romanesque sculpture, more different from the classical, the greatness of which it rivalled.

When by the first quarter of the fourteenth century the towns had completed their great churches, it was natural that the office of patronage should pass to individuals, at first to the feudal lords, but in the latter part of the fifteenth century to the "enriched middle class." The monumental decoration of the churches was largely finished, and the chisel was confined more and more to such separate articles of ecclesiastical furniture as retables and devotional statues or to the tombs by which individual patrons sought to perpetuate their fame. The shops of such cities as Paris or London, supplanting the local corporations of cathedral-workmen, made a regular business of catering to commissions throughout the respective countries. By the middle of the fourteenth century, indeed, a kind of international style had developed, the radiating center of which was probably France. Towards the end of the century, even the individual and more conscious artist began to assert himself and to become the recipient of honors and preferment at the several courts. Wherever the figure was still employed in architectural adornment, it was altogether disassociated from the building, it lost its architectural lines, and was a detached entity. The broad and generalizing manner that was suited to architectural function inevitably gave way to "fussiness" of detail and here and there to further individualization of the figures. Even at the end of the thirteenth century, idealism, having exhausted itself, had already, by a natural evolution, begun to incline towards excessive refinement or to react towards a more careful reproduction of actuality. In other words, the sculpture of the fourteenth century was characterized by mannered idealism and by prognostications of the coming realism.

The fifteenth century cultivated a profounder realism, but sloughed off part of the mannerism. Although it was the expression of mental states that still received the principal stress, even the body began to be outlined beneath the garments to a somewhat greater degree than in

the earlier Gothic period. The drapery itself was now often treated with varying pictorial effects of light and shade. Realistic training was chiefly acquired by the execution of portrait statues or sepulchral effigies for the residences or chapels of the newly arisen personal patrons. Sculptors were led to look upon the sacred personages and events as more real by actually seeing them with their physical eyes in the Mystery Plays, which were now at the height of their popularity and exerted an influence upon art that has been variously estimated.[1] The realistic tone of the religious theatre, especially in the matter of contemporary costumes and episodical *genre*, was certainly reflected in sculpture and painting. The augmented influence of Franciscanism inculcated the familiar attitude towards religion and approximated the sacred subjects more and more to every-day life. It accentuated also the growing tendency of religion to appeal rather to the heart than the head. The intellectual faith that had been embodied in the scholastic philosophy of the thirteenth century and had animated the spiritualized figures upon the cathedrals was submerged in the fifteenth century beneath an emotionalism that infused sentiment into the objects of its devotion. One of the chief vehicles of the Franciscan attitude was the book called *Meditations on the Life of Christ*, written by an Italian friar as early as the thirteenth century, but the tenderness and homeliness which it instilled into the stories of the New Testament seem to have filtered down to artists through the intermediary of the Mystery Play. Realism was the distinctive feature of the fifteenth century, and the realistic tendency was ubiquitous; but Flanders, eventually, played an important part in the dissemination of the style, and Germany gave it the most pronounced expression. The internationalism of the fourteenth century now once again gave way to national styles and in these national styles, with the emergence of the personal artist, even to local schools based upon the achievements of individual masters. While retaining certain common European elements, such as realism and a very general allegiance to Flemish standards, the Gothic art of the several countries became more differentiated. Italy, though she too shared in the universal realism, separated herself even more than hitherto from the rest of Europe and became the torch-bearer of the Renaissance.

At the end of the century, the tumultuous storm of realism abated, a sudden lull once more spread the calm of idealism and simplicity over the graven images of France, as if in expectation of the new breath of

[1] For a recent, succinct, and judicious discussion of this whole important subject of the relation between the medieval drama and art and for a good bibliography, see Eugen Lüthgen, *Die Niederrheinische Plastik*, pp. 8–16, and 440–442.

the Renaissance from Italy, and thus occurred what has been called
the relaxation or *détente*. The tendency may be discerned sporadically
in the Low Countries, Spain, and even Germany.

The persisting exercise of sculpture by builders in the thirteenth
century helped to preserve the architectural character of the carvings.
Even when the master-builders did not actually hew the stone them-
selves, they made drawings of the statuary to be used by the stone-
cutters. A large number of the craftsmen, however, must have special-
ized in sculpture. The joint practice of both professions continued in
the two subsequent centuries of Gothic, but here other influences
operated to diminish the architectural feeling of the figures. The
general Gothic custom was to carve the sculpture before putting it in
place. The natural results were, on the one hand, ever increasing
correctness and fineness of detail, and on the other, in contrast to the
Romanesque period, when much of the stone-cutting was evidently
done upon the building itself, the constantly developing tendency,
which culminated in the fourteenth and fifteenth centuries, to make
the figure stand forth from the background and to treat it as a separate
object. It is significant that, whereas in the majority of places during
the twelfth century the carving was still done *in situ*, on the west
portal of Chartres, where Gothic really begins in the same century
and where the technique is already more delicate and the rendition of
form more accurate, the statues were apparently executed before they
were set in the façade. Naturally there were many exceptions to this
rule, especially in the later Middle Ages. A certain breadth and free-
dom of manner and a certain virility in attacking the stone, which the
Gothic artist never completely lost even in the intricacies of the
fourteenth century or in the more varied and sophisticated styles of
the fifteenth century, are partially to be traced to the fact that, like
the Greeks, he worked directly on the stone from a drawing or at most
from a small model or *maquette* and did not ordinarily construct also
a large clay model of the size intended for his completed work in order
to facilitate the transfer of his conception to the final medium. The
normal procedure throughout the Gothic age was to hew all parts of
a statue from a single block, and the amount of agitation and conse-
quent projection of members were thus so far restricted as to afford
an additional reason for the repose of the thirteenth and fourteenth
centuries; but even in the thirteenth century there were numerous
departures from this habit.[1] The method of casting in bronze em-
ployed during the Middle Ages and indeed until the end of the eight-

[1] For a catalogue of some of these exceptions, see Wilhelm Vöge, *Die Anfänge des monu-
mentalen Stiles im Mittelalter*, p. 319, n. 2.

eenth century was the less easy but more satisfactory process known by the term, *cire perdue*.[1]

Romanesque polychromy apparently underwent no important changes during the first two centuries of Gothic. The general realism of the fifteenth century entailed a partial abandonment of the earlier conventionalism of color and a desire to approximate more closely the appearance of nature. Flanders began to delight in a gayer, not to say more gaudy, color, and with the spread of Flemish fashions this less subdued tonality won a footing in the rest of Europe. In one respect the fondness for brilliancy gained a point even over realism, for it lavished gold over the figures in places where it did not appear in actuality and with a profusion that could not have been paralleled in contemporary life. Premonitions of this deterioration of taste occurred in certain regions in the fourteenth century, especially in the Low Countries and in Spain, where gilt began to be used more widely and vermilion and more pronounced blues were added to the available colors.

With some important exceptions, the subjects of early Gothic sculpture continued the same as in the Romanesque period. The great innovation was that the superb intellectualism of the thirteenth century coordinated all the carvings and stained glass of each cathedral into one mighty iconographic scheme. The effort had already extended itself during the preceding century over single portals or even façades, but now the different subjects that had been scattered separately through many churches were collected into the ornamentation of one cathedral, the decoration of the whole edifice was brought within the system, and the scope of each section was enlarged. The constituent parts of the scheme were arranged with stricter logic, and yet much ingenuity was exercised in varying the disposition from town to town. Educated members of the clergy, thoroughly imbued with scholastic theology, prescribed the plans that the lay workmen executed. France, with her great scholastic university at Paris, was the mother of this artistic rationalization, Chartres is the most complete extant specimen, and results only less perfect were produced in other countries of Europe. Probably, also, the shops and craftsmen played their parts in creating a tradition of popularity for certain subjects that lent themselves readily to treatment according to the esthetic principles of the time. The cathedral became a compendium of the universe, or, in the terminology used by Vincent of Beauvais at

[1] For good short descriptions of this process, see the article in the *Encyclopaedia Britannica* on Metal-work; Edward Lanteri, *Modelling*, vol. II, London, 1904, pp. 145–148; Albert Toft, *Modelling and Sculpture*, Philadelphia, 1911, pp. 175–191; G. Baldwin Brown, *Vasari on Technique*, London, 1907, pp. 158–166, and 199–202.

this same time for his similar encyclopaedic undertaking in literature, a Mirror (*Speculum*) of the universe. Our Lord, as the source of all things, is ensconced on the central pillar of the main portal or in the Last Judgment on the tympanum above. All ancient history prepares the way for His coming or is symbolic of His life upon earth; He is therefore surrounded by the Prophets and by His ancestors according to the flesh, and their stories are enshrined in reliefs or in the windows. All subsequent history tells of Him or is derived from Him; He is therefore accompanied by the Apostles and saints, and, without and within, are figured the episodes of the New Testament, of sacred legend, and occasionally even of profane history, so far as it is connected with the development of Christianity. Since Christ's mother was an object of even dearer devotion in the thirteenth century, at least one of the doors is allotted to her, and her images and the events of her life are multiplied throughout the church. A third door is given to the patron saint or saints.

To attain the redemption wrought by Christ, knowledge and action are necessary, and the cathedral spreads before the worshipper the Mirror of Science, the Liberal Arts, and the Mirror of Morality, the Virtues and Vices. The labors of the months inspire to wholesome industry. Nature is Christ's handiwork, and so the artist may carve his capitals and moldings with the loveliest and most varied foliage of his native land. The storied capital is much more infrequent, vanquished by this love of the natural world, and even when figure-subjects still remain, they are combined with foliage. The sculptor repudiates the conventionalized Romanesque plant, and returns to nature, not only for a study of the human form, but also for decorative *motifs* of flower and leaf. Sometimes he fills the interstices with birds. Less often he introduces the other animals into his iconographic plan. The wonders of the Bestiaries are related amidst the verdure of the capitals. Not unusually the birds and beasts have a symbolic significance, like the four emblems of the Evangelists, or the pelican indicative of the Atonement. The monsters and savage scenes of Romanesque imagination have disappeared, except in rare instances, and in their stead the barbaric blood that still ran in Gothic veins created the gargoyles. Although the fantasy that found expression in these effigies was wild and brutal, yet nowhere, during the idealistic period of the thirteenth century, did it descend to the vulgarities or obscenities in architectural decoration of which it has sometimes been accused.

The hieraticism of the Romanesque period also yielded. The tympanum was no longer occupied by Christ enthroned amidst the signs

of the Evangelists but by the more animated Last Judgment, which became much commoner than heretofore. The more touching Coronation of the Virgin took the place of the haughtily enthroned Queen. For the single space of the Romanesque tympanum were substituted zones of sacred figures and narrative.

By the fifteenth century, Gothic iconography had suffered some losses but had made compensating gains. In those few churches that received an extensive sculptural adornment, the scheme of arrangement was somewhat less carefully thought out than by the synthetic minds of the thirteenth century. The Sibyls, whose popularity originated in Italy, were joined with the Prophets. The growing velleity for the pathetic and for subjects connected with death multiplied abnormally the scenes from the Passion. Just before 1400, it added to the sacred repertoire also the Pietà, the dead Christ upon His mother's lap, and between 1420 and 1450, the Entombment or Holy Sepulchre as a large separate work of art. The ordinary activities of mankind, which had appeared on Romanesque capitals and occasionally had found their way into the small decorative details of earlier Gothic, now obtained a new and fuller lease of life on the misericords of choir-stalls. But it was especially the comedies of every day, such as the wife beating the husband or the teacher beating the schoolboy, that here intruded themselves. The range of themes on the misericords is in itself a Mirror of the universe: Biblical stories and classical lore, bits of medieval romances, fables, moralities drawn from the life of beasts as reported in the Bestiaries, satires, even on the clergy, and heraldry. The monstrosities of the Romanesque period were resurrected to adorn, together with a bewildering infinitude of other grotesques, these and other parts of the choir-stalls.[1] The rather astonishing iconographic uniformity of the fifteenth and sixteenth centuries in the several countries of Europe, always, of course, excepting Italy, is perhaps to be explained by the general similarity of the Mystery Plays, for which France set the standard and upon which works of art depended.

[1] Cf. Figs. 55 A and B for examples of English misericords and pp. 121 and 124 for an analysis of some of the subjects in these illustrations.

CHAPTER V

GOTHIC SCULPTURE. FRANCE

1. THE TRANSITION FROM ROMANESQUE TO GOTHIC

THE qualities of Gothic sculpture were already embryonically present in the Ile-de-France and the immediately adjoining territory by the middle of the twelfth century. From another standpoint, therefore, since the carvings of this region were still marked by a considerable degree of stiffness and conventionality, and since representation was still readily subordinated to esthetic exigency, it would be possible to denominate them as Romanesque; they certainly constituted the archaic preparation for developed Gothic more truly than the Romanesque work of the other schools. Much confusion exists as to where the impulse to the new movement first appeared. In any case, it is most satisfactorily illustrated by the west portal of the cathedral of Chartres, embodying, within the same general style, different stages of attainment that date from about 1140–1165, and perhaps containing even slightly later work in the Apocalyptic Elders at the springing of the main archivolts. Gothic sculpture is more than prophesied. The designer has gathered about the three doors a vast iconographic *ensemble* consecrated to the glorification of Our Lord. The idea of decorating the deeply splayed openings with rows of statues, foreshadowed by the Romanesque artists, especially, perhaps, in Italy, and henceforth to be so common a Gothic *motif*, is here fully matured in the effigies of Christ's ancestors. They have so far emerged into separate entities as to be set upon pedestals, and they are largely realized in the round (Fig. 27, statues from main and left doors). With the arms pressed closely to the trunk, they seem to be hewn out of columns like those to which they are attached. This partial rigidity, which even declares itself in *frontality*,[1] and the repetition of gesture

[1] This term, which is derived from the German and has lately come into vogue with critics of art writing in English, especially with the historians of ancient art, is thus elucidated by Julius Lange (*Darstellung des Menschen in der älteren griechischen Kunst*, Strassburg, 1899, pp. xi and xii): "Whatever position the statue may assume, it follows the rule that a line imagined as passing through the skull, nose, backbone, and navel, dividing the body into two symmetrical halves, is invariably straight, never bending to either side. Thus a figure may bend backward or forward, . . . but no sideways bending is to be found in neck or body. The legs are not always symmetrically placed. . . . The position of the arms presents greater diversity, yet it is strictly limited by the attitude of the rest of the figure." (Translation of Percy Gardner, *Grammar of Greek Art*, p. 56).

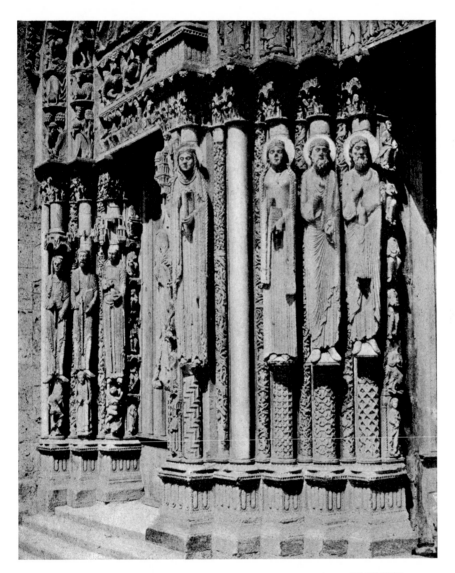

Fig. 27. SCULPTURE ON WEST PORTAL OF CATHEDRAL, CHARTRES

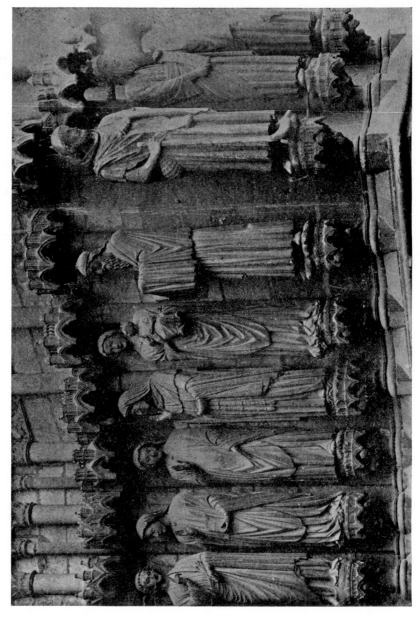

Fig. 28. PORTE MÈRE-DIEU, CATHEDRAL, AMIENS

are architectural and primitive rather than copied from a contempo-
rary life in which, according to Viollet-le-Duc, stiffness of dress bred
constraint in action. But naturalism has made conquests everywhere,
especially in the highly individualized heads, which have lost the ap-
pearance of masks, and in the hair, which no longer gives the impres-
sion of stereotyped wigs. The gripping figures of the royal lineage are
instinct with a wonderful personal life and nervous tensity that go
beyond the usual idealism of the thirteenth century and gained for
them, of yore, identification as the kings and queens of France. The
countenance now and again softens into the archaic smile. The
"queens," especially, have an impelling charm, which is enhanced by
a costume and coiffure studied with extreme delicacy from the modes
of the time. The greater naturalism of the narrow, clinging draperies
may be gauged by a comparison of those upon the central door with
those on the outer pillars of each side door, which are still highly sche-
matized in the ordinary Romanesque fashion. A good example of the
better adaptation of the folds to the action of the body is afforded by
a contrast of the noble Christ in the central tympanum with any of
the Romanesque prototypes by which He is suggested. Although
the figures are not so absolutely bound up with the architecture as in
true Romanesque work, the whole monument is pervaded by a ma-
jestic repose consonant with the architectural function and often
lacking in the agitated schools of Burgundy and Languedoc.

The carvings of Chartres and of related churches, however, create no
such rupture with prior or contemporary tradition as to violate the
general principle of the continuity of artistic development. The ques-
tion of dates is so difficult that it is hard to say how far these works
exhibit a derivation from the achievements of Burgundy and Langue-
doc or how far they exhibit a parallel evolution. Certainly some im-
portant, though not definitive, characteristics of the northern school
appear also in these other provinces. The iconography of the tympana,
especially the central one at Chartres with Christ between the Evan-
gelistic symbols, the elaborately wrought colonnettes, the storied capi-
tals, are more Romanesque than Gothic. The progress from relief
to modelling in the round had already begun in the Romanesque art of
other regions. The excessive elongation of Vézelay, Autun, and
Moissac is here bestowed upon the larger statues in order that they
may have the same architectural effect as the supporting pillars. The
treatment of the garments in minute plaits recalls Burgundy; such
peculiarities in drapery as the crescent folds upon the chest and the
designation of folds by double lines are native also to Languedoc.
The masculine types throughout the region of the Ile-de-France dur-

ing this period, except in the most realistic heads upon the central door of Chartres, are analogous to those imagined by the craftsmen of Toulouse. Even the crossing of the legs is found once at Chartres and frequently in the drawings of the destroyed west portal of St. Denis made for the scholar Montfaucon [1] in the seventeenth century. The arrangement of statuettes following the curve of the archivolts had perhaps already appeared in Poitou and Saintonge. Stylistic and particularly chronological grounds prevent us from accepting Vöge's theory of a primary dependence upon Provence; the influence apparently moved rather from the north to the south. Whatever precedents the exponents of the new manner had, the innovations were so many and so significant as to promise more originality for the movement than for any previous epoch of Christian sculpture.

There are many other monuments, dating from about the middle to the end of the twelfth century, which were produced by the same school that worked at Chartres and St. Denis. Of the Porte Sainte-Anne, the right opening in the west portal of the cathedral of Paris, at least the tympanum belongs to this class; the august Virgin and Child are almost identical with the similarly placed group at Chartres. The king and queen, now in the left transept of St. Denis, happily saved from Notre Dame at Corbeil but unhappily subjected to restoration, are the highest types of the royal race upon the pillars of Chartres. The earliest stage of the movement, as in the outer statues at Chartres, is represented by the south portal and by two displaced figures now in the choir of Notre Dame at Étampes. On the south portal of the cathedral at Le Mans, we can actually see the evolution taking place: the two inmost figures of Sts. Peter and Paul are still in relief, the other figures are in the round but do not stand forth from the backing columns so bluntly as at Chartres. The proportions of the body, which already at Le Mans are less exaggerated, become normal in the rougher provincial work from the very end of the transitional period on the portal of the cathedral at Angers. Such elements as the interruption of the line of statues by purely ornamental shafts or the use of complete capitals as supports for the statues are explained in the side portals of Bourges by the proximity of the town to Burgundy.

2. THE THIRTEENTH CENTURY

In the great century of the Middle Ages, the thirteenth, Gothic sculpture attained its apogee, and the principal cathedrals received or finished their plastic decoration. Thrilled with enthusiasm at having rediscovered the art of carving in the round, sculpture burst into

[1] The portal at present *in situ* is an almost complete modern restoration.

a youthful exuberance and spread itself in statue, statuette, and relief over every feasible part of the sacred edifice. The esthetic ideals which were innate in the Gothic genius and which had already been foretold in the school of Chartres were now realized. The balance was struck between sculpture and architecture. Whereas in true Romanesque work the statues of the portals were embedded in the building and completely subordinated, they now assumed an even more independent life than at Chartres; but at the same time by their position in projecting shrines and by their stateliness they preserved a connection with the architecture and an architectural feeling. All the sculptures of a church continued to be executed in the stone of the district, of which the edifice itself was constructed. The columns against which the statues were set receded far into the wall so that there was a more uninterrupted space from which they could stand forth, but they themselves still maintained such restraint in pose that their principal outlines might be inscribed within imaginary upright piers. Disembarrassed of the wall, they often turned to one another and grouped themselves for such scenes as the Annunciation or Presentation. Two kinds of stuff may be seen in the draperies of the thirteenth century — a thinner material falling in smaller, more numerous, and almost parallel folds, as on the lateral portals of Chartres, and a heavier fabric falling in larger, fewer, and more curving folds, as on the front portals of Amiens; but in either case the Byzantine subtlety of the earlier draperies loosened from the body and expanded into freedom and nobility of line confined within a solemn grace (Fig. 28, statues at right of south portal of the façade, the so-called Porte Mère-Dieu, Amiens). The costume either was copied from contemporary dress, or was an ideal garb imitated from antiquity but modified by existing fashions. A study of nature put to flight the Romanesque conventions in the treatment of the human body and head, but the transitory breath of keener realism that had distinguished the best carving on the façade of Chartres succumbed everywhere to a high religious idealism that reached its ultimate expression in the rightly named Beau Dieu of Amiens, the Christ on the pier of the central door. The countenances were carved in large, simple planes with a truly sculptural aversion for subtle effects of chiaroscuro.

The same qualities, adapted to different situations and functions, are found in the sculpture on other parts of the churches. In the small reliefs, narrative was treated with an architectural simplicity. The episode was reduced to its lowest terms, the fewest possible figures were used, the setting and accessories were not realistic, but restricted to a merely suggestive scale and number, the controlled postures and

gestures aimed, not at drama, but at an unvarnished exposition of the tale. Lovely examples exist in the long double series, combined with representations of the Virtues, Vices, and Months, beneath the statues on the façade of Amiens. The section chosen for illustration includes the scenes appropriately placed under the figures of Herod and the three Wise Men (Fig. 29).

The sober elegance of Gothic in northern France during the first half of the thirteenth century may best be studied on the transept portals of Chartres, on the much injured and restored portals of Laon, where only the tympana and the archivolts retain their original decoration, on the central and left doors of the main portal of Paris, excepting always the large statues, which are modern, and on the west façade of Amiens. The magnificent sculptural assemblage of the cathedral of Reims presents [1] a less unified style than any of these monuments. Many of the statues belong to the above-mentioned class; among the best are those on the two portals of the north transept and the Samuel, Abraham, Moses, Isaiah, St. John Baptist, and Simeon on the right door of the portal of the west façade.

But the majority of the sculptured figures at Reims, notably the other statues of the doors of the west façade and the many statues scattered over the upper parts of the building, date from the second half of the century and reveal several different styles. The Virgin and St. Elizabeth of the Visitation, on the central door of the façade (Fig. 30), are in an archaistic manner, which is exemplified, as a sporadic phenomenon in France, by many of the other statues on the cathedral and which, emanating from Reims, became popular in Germany. The classic heads, the marked contrast between the firm, supporting leg and the other bent leg, the drapery, in its amplitude, minuter folds, and disposition, are directly copied from relics of Graeco-Roman sculpture. At this same time in Italy Nicola d'Apulia was superimposing the antique upon the Gothic.

The angel of the Annunciation on the central door (Fig. 30) embodies still another sculptural fashion, which is also frequently encountered at Reims. The face, smiling almost with the subtlety of Mona Lisa, is characterized by realistic expressiveness, the hair is curled with a *préciosité* that is strikingly different from the broad, simple lines of earlier coiffures, the body begins to assume a mannered curve, the drapery is more swollen and involved. Another excellent instance at Reims of greater individualization is the St. Joseph of the Presentation on the central door; more sinuous drapery is united to

[1] In writing of Reims, I use the present tense for the sake of convenience, although, of course, much of the sculpture has been destroyed.

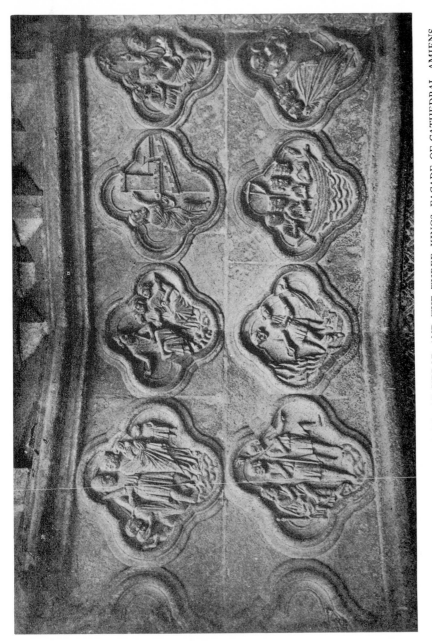

Fig. 29. RELIEFS BENEATH STATUES OF HEROD AND THE THREE KINGS, FAÇADE OF CATHEDRAL, AMIENS

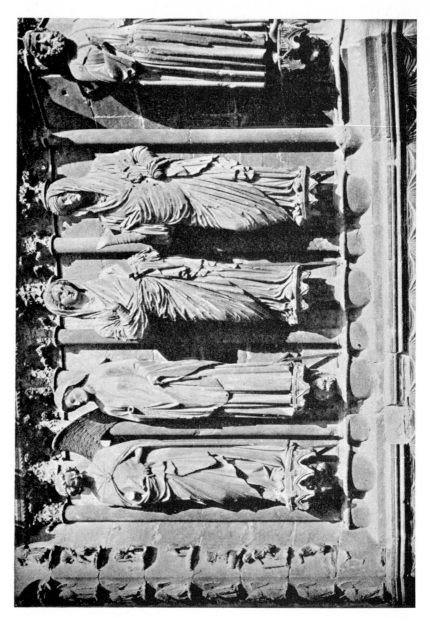

Fig. 30. STATUES, CENTRAL DOOR OF WEST FAÇADE, CATHEDRAL, REIMS

the decided bodily curve in the personification of the Synagogue beside the rose-window of the south transept. These later stationary figures of Reims, as well as the archaizing statues, exemplify the tendency, the first stages of which may be seen in the lateral portals of Chartres, to gain greater freedom by bending one leg and allowing the weight to rest more upon the other. The device carries still farther the violation of frontality that had begun at the first of the century by the turning and inclination of the body and head. In other words, much of the carving of Reims leads directly into the art of the fourteenth century. This more fastidious style of the second half of the thirteenth century, in its various phases, is well represented, with more or less emphasis, by the tympanum with the life of St. Stephen in the portal of the south transept at Paris, by the still beautiful, idealized Virgin and the tympanum of the portal of the north transept, by the Apostles on the inner pillars of the Sainte Chapelle, and by the Madonna, tympanum, and archivolts of the Porte Dorée at Amiens.

Having cast its spell over all of northern France in the first half of the thirteenth century, Gothic sculpture in the second won the center and south of the country to its allegiance. The style everywhere was much the same; only Burgundy showed anything like individuality. The renowned and captivating Last Judgment of the main tympanum at Bourges not only possesses a superlative iconographic interest, but adds to the expressiveness of Reims the taste for animated and realistic episode that was to characterize the succeeding century. The somewhat stockier forms, broader heads, and fuller draperies of Burgundy may be illustrated by the main portal of Auxerre and by a lateral tympanum at Semur with scenes from the life of St. Thomas. The Burgundian manner is less pronounced in the Porch of the Apostles at Lausanne in Switzerland. Still further south, well-known examples are the porch of St. Seurin at Bordeaux, the reconstructed portal in the left transept of the old cathedral at Dax, and the portal in the sacristy of the cathedral at Bayonne.

The few French tombs of the twelfth century adorned with a sepulchral effigy were not important enough to fall within our cognizance. The figures now very generally emerged from relief into the round. By the thirteenth century, through the relaxation of ecclesiastical laws forbidding lay burial in churches, the number of interior tombs was much augmented, but a vast quantity were ruthlessly destroyed during the Revolution. The high idealism of the century manifested itself also in the mortuary effigies, especially in the choice of early manhood or womanhood for representation, no matter at what age the decease had taken place. Not until the end of the cen-

tury did the first signs of realism begin to spell portraiture. The terror and decay of death were excluded; the eyes were usually opened as in life. Although the body was regularly placed in the recumbent posture, neither now nor until considerably later were the artists able to break with the Romanesque convention of representing it like a prostrate standing figure. At the feet was a symbolic animal. The cleric treads upon the dragon of evil, the knight stands upon the lion of courage or the hound of the hunt, the woman upon the dog of fidelity and domestic virtue.

The sculptured tombs may be divided into three general classes: the slab of stone or bronze embodying the effigy of the deceased; a high base surmounted by the effigy, isolated or against the wall; and the niche in the wall, more or less elaborately adorned and containing the effigy, likewise upon a base or sarcophagus. The two latter classes were often carved with the scene of the funeral and occasionally with the deceased's relatives. In the niche were sometimes represented the Last Judgment and episodes connected with the death and reception of the deceased into heaven. Of the class of slabs, the two most notable examples, raised on the backs of lions in the German fashion, are preserved in bronze figures at Amiens of the bishop Évrard de Fouilloy (1222) and Geoffroy d'Eu (1236), cast perhaps in the popular shops at Tournai, Belgium. They are in the same serene style as the figures on the façade of the cathedral at Amiens, differentiated from each other, to be sure, but idealizations of types rather than portraits. The two other classes, the former and simpler of which is more numerous, are well represented in the royal mausoleum, the abbey of St. Denis, by the sixteen tombs that in 1264 St. Louis caused to be constructed for his predecessors from Dagobert to Louis VI and by the two tombs of his eldest son, Louis, and his brother, Philip, that have been transferred from the abbey of Royaumont. In the posthumous series, the noblest figure is perhaps that of Constance of Arles, wife of Robert II, the Pious. The monuments of St. Louis's son and brother, the bases of which are embellished with the procession of their obsequies, resemble each other. The fine statue of the former is already beginning to be felt as reposing in the sleep of death (Fig. 31). Even earlier in the century, in the tombs for the English kings and queens in the abbey of Fontevrault, the upright figure is forgotten, and the bodies are conceived directly in the terms of recumbency. Other interesting sepulchral effigies, imbued with the solemn grace of the thirteenth century, were carved posthumously for Rollo and William Longue-Épée in the cathedral of Rouen. The interment here of Richard I's lion-heart has left us another similar tomb, unfortunately

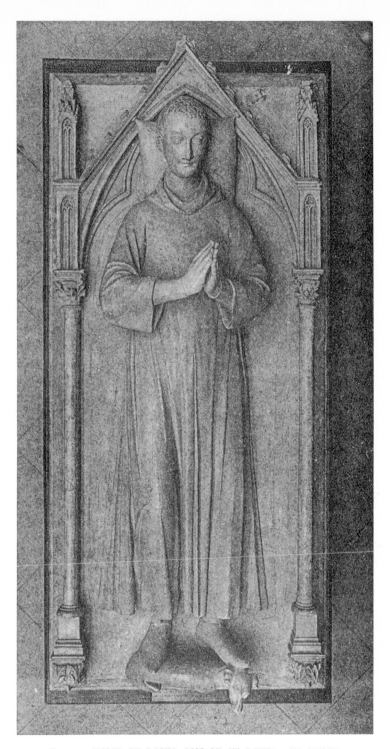

Fig. 31. TOMB OF LOUIS, SON OF ST. LOUIS. ST. DENIS

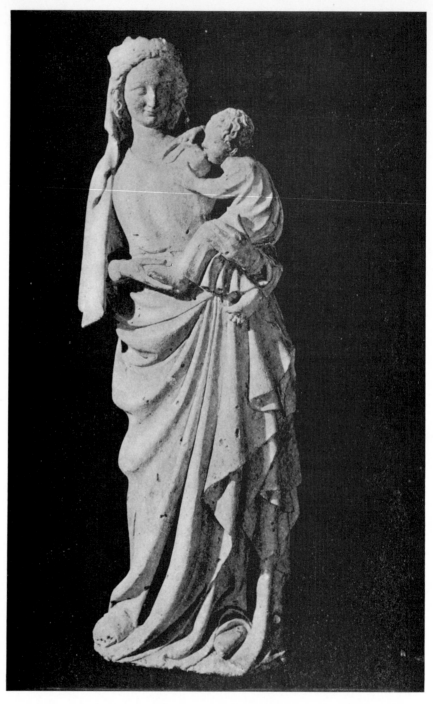

Fig. 32. VIRGIN AND CHILD. FOURTEENTH CENTURY.
FENWAY COURT, BOSTON

(Courtesy of Mrs. John Lowell Gardner)

much restored; the monument of his wife, Berengaria, is now in the cathedral of Le Mans. Portraiture is already begun at St. Denis in the white marble figure of St. Louis's successor, Philip III, who died in 1285 but whose tomb was not commenced until 1298.

3. THE FOURTEENTH CENTURY

The fourteenth century was a period both of decadence and of transition. It debased the older idealism into mannered grace and delicacy, but on the other hand it went far towards developing the realism that was to be the distinctive note of the fifteenth century. Paris, especially, in the second half of the century, was a focus of realistic endeavor, in the development of which many resident Flemish artists had a share. The decoration of the cathedrals went on until the second quarter of the century, but the statues both in spirit and in fact broke away from the building. The columns that had hitherto bound them to the backgrounds were suppressed, and as if in compensation, for the sake of making some show at connection with the edifice, they were sunk in architectural niches in place of the protruding shrines of the thirteenth century. It was a desperate subterfuge, for the statues, like the smaller figures on the church, had largely renounced their architectural feeling. The suppler bodies, obtuse to columnar erectness, often bent to the side and backward; the heads aimed at an individualization discordant with architectural simplicity. The ampler draperies, though more naturalistic in texture and folds than those of the thirteenth century, were conceived as opportunities for the display of ingenuity in design. Winding hither and thither, they separated into more minute plaits, and sought effects of chiaroscuro through deeper indentations.

A typical example is afforded by the decoration of the more easterly part of the cathedral at Bordeaux, undertaken by Pope Clement V, who had been archbishop of the city. The portal of the north transept contains at the center a restored effigy of the pontiff and at the sides six prelates, whose relationship to him is a moot point. Although the heads of the six prelates are somewhat individualized, the figures are still in a rather sober style. It is in the tympanum and especially in the statues upon the buttresses of the apse that the new forms, the new drapery, and the new feeling appear. Other important monuments in this mode are: the Porte de la Calende and the Porte des Libraires of the cathedral at Rouen, dating partly from the end of the previous century; the gable of the main door at Reims; the statues upon the ruined front of St. Jean des Vignes at Soissons; the façade and portal of the church at Candes; the statues on the piers of the choir and

transepts and especially the heads upon the corbels of the choir-cornice of St. Nazaire at Carcassonne; the St. John Baptist of the Morgan Collection in the Metropolitan Museum at New York; and, already far advanced towards the manner of the fifteenth century, the Apostles from the chapel of the Collège de Rieux at Toulouse, now in the Museums of Toulouse and Bayonne.

The mode of the fourteenth century is most characteristically illustrated by the separate devotional statues of the Virgin and Child which the popular shops now multiplied and sold broadcast throughout the country. Much more often standing than sitting, they all are so similar that the type of the Madonna of the fourteenth century is one of the most easily recognizable objects in our museums. Slight variations may be discerned in pose and drapery, in degree of daintiness, in stress upon maternity or upon the growing inclination for pathos. In general, the kindly queen of the early thirteenth century has gradually assumed the mien of a more ordinary woman. The curve of the body is very apparent. It is partially due, as in other figures of the time, to a desire to break with primitive rigidity, and not, as has sometimes been said, to an imitation of ivory statuettes, in which it is falsely supposed to have been provoked by the bending line of the ivory tusk. The vast number of ivory representations of the subject, reversing the order of borrowing that had prevailed in the Romanesque period, are imitated from the larger statues. In the Madonnas, furthermore, the curve created a balance for the Child, which was usually held on the left arm. By the second half of the century, the even more elaborate drapery was caught up in great masses of billowy folds about the hips. Many statues were the mere hackwork of ordinary pious trade. Good examples that fall within the realm of art may be found in the Louvre, in the cathedral of Paris, in St. Denis, in the cathedral of Troyes, in the cloister of the cathedral of St. Dié, in the church at Orcival, in St. Just at Narbonne, in the Boston Museum, and in the collection of Mrs. John L. Gardner, Boston (Fig. 32, from the abbey of Valoire near Amiens). The sitting posture in stone is illustrated by the Virgins in the church of Taverny and in the cathedral of Sens, and in wood by the Vierge Bossy of the Louvre and the specimen of the Metropolitan Museum (accession no. 16.32.183).

The tendency to subtlety rather than to monumentality augmented the number of small anecdotal panels in architectural adornment. Notable instances are: the Porte des Libraires at Rouen, especially the grotesques; the scenes from the life of the Virgin set into the exterior chapel walls of the east end of Notre Dame at Paris, in which the narrative is rendered with a charming combination of popular feeling and

sensitive delicacy; the façade of the cathedral at Lyons, including illustrations of contemporary short stories and *genre* from every-day life. A lovely instance of the anecdotal interest applied to interior decoration is the series of reliefs from the life of Christ on the choir-screen of the cathedral of Paris by JEAN RAVY and his nephew JEAN LE BOUTEILLIER. The interest expressed itself also, during the fourteenth century, in the creation of retables[1] with the narrative distributed through compartments, a form of ecclesiastical furniture that was imitated in the large from the minor arts of the previous periods. Some few Romanesque retables exist, but the great century of their manufacture was the fifteenth.

The tombs continued without much change from the norms of the thirteenth century except for the progress towards portraiture, which was definitely achieved in the monument of Charles V at St. Denis by ANDRÉ BEAUNEVEU, who was a favorite sculptor of the second half of the century and executed for Charles V the sepulchres of his immediate predecessors, Philip VI and John II. The advance of realism was assisted by the practice of making death masks, and its definitive triumph at the end of the century was signalized by the earliest representation, in place of or together with the effigy, of a *motif* that constantly gained in popularity, the mortified cadaver, or to use the medieval French term adopted by the critic, André Michel, the *transi*. Idealism, however, died hard, and for the first half of the century it was still customary to represent elderly women, if not men, with the beauty of youth. The draperies were somewhat more flowing and involved than before, but the rigidity of death imbued them with more conservatism than was retained in the decorative sculpture of churches. Even the stiff parallel folds of uprightness were preserved, and the feeling of recumbency was not generally developed until the end of the century. Occasionally the use of symbolic animals was confused; they might embody puns on names or become mere heraldic emblems. The different types of tombs grew somewhat more elaborate. The relatives now appeared garbed in the heavy cape and enveloping hood of the formal mourner, and to them were added the Evangelists as authors of the gospels and the Apostles as the authors of the creed, to signify the faith of the deceased. In the niche type, above the effigy, even reliefs from sacred history were admitted. Of these more elaborate sepulchres, excellent examples are those of the popes at Avignon (one or two of them carrying elaboration to the point of constructing an opulent canopy over the effigy on a free-standing

[1] The word *retable* is used throughout this book in the sense more frequently expressed in English by the term *reredos*.

base), of Hugues de Châtillon at St. Bertrand de Comminges, of Pierre
de la Jugie in St. Just at Narbonne, and of Bernard Brun in the cathe-
dral of Limoges. The fixed type of the French knight, clad in armor,
with shield at side and hands pressed together in prayer, is well exem-
plified in St. Denis by the effigies of Robert d'Artois, Charles, Comte
d'Étampes, and the two constables and brothers in arms, Bertrand du
Guesclin and Louis de Sancerre, who died respectively in 1380 and
1402. In both these instances, the portraiture is more realistic than
in the figure of their master, Charles V. With a slight variation, the
knights of Burgundy hold in their hands a lance.

In the latter half of the century, the dynasty of the Valois, and par-
ticularly Charles V, made Paris more than ever a center of sculptural
production, in which a colony of Flemish masters played a leading part.
These foreigners had been establishing themselves at the French capi-
tal since the beginning of the century; Beauneveu and many other
sculptors of tombs belonged to the group. To them it has been the
custom to ascribe the more decided realism that marked the ebbing of
the fourteenth and the incoming of the fifteenth century. But it can-
not be demonstrated that Flemish sculpture up to this moment had
revealed any greater predilection for realism than that of the other
countries of Europe, and native French sculptors were also prominent
in Paris. Two authentic works, indeed, by one of the most prominent
Flemings under Charles V, JEAN DE LIÉGE — the sepulchral stat-
ues of Charles IV and Jeanne d'Évreux in the Louvre — still retain
the old idealism of the thirteenth century. A sounder criticism would
conceive of the proclivity towards realism as a generally prevalent
characteristic of the period, developing into a more emphatic form at
Paris because the vigorous artistic atmosphere of the great city fos-
tered all new movements. The Flemings, since they were then the
most active sculptors of the capital, contributed largely to the evolu-
tion, but they were the products rather than the creators of the Pari-
sian *milieu*. The realism of the French court was as much Parisian as
it was Flemish. It sought an outlet not only in sepulchral effigies, but
also in portrait statues, which now began to be popular. The figures
of Charles V and his queen Jeanne de Bourbon were erected not only
at one entrance to the old Louvre but also at the portal of the chapel
of the Célestins. The two latter statues, by an unknown sculptor, are
still extant in the Museum of the Louvre (Fig. 33). Both are superb
examples of the best medieval portraiture. The queen, instead of be-
ing rejuvenated as in earlier idealistic sculpture, is represented as much
older than she actually was in order that the realism may seem more
unsparing. She is clad in the contemporary costume that is a familiar

Fig. 33. CHARLES V AND JEANNE DE BOURBON. LOUVRE, PARIS

(Photo. Giraudon)

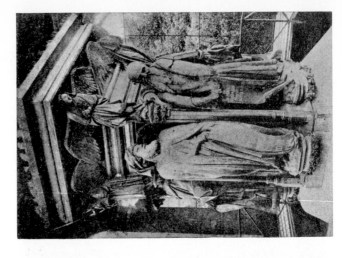

Fig. 34. CLAUS SLUTER AND CLAUS DE WERVE. PEDESTAL FOR CALVARY OVER A WELL. CARTHUSIAN MONASTERY, CHAMPMOL, NEAR DIJON

token on the feminine tombs and in so much of the art of the period. The heavier stuffs form ampler plaits, and the elongated skirt falls in masses about the feet. In the same style are the statues of the royal family and other noble personages executed about 1375 for the buttresses on the north tower and on the chapel of St. John Baptist of the cathedral at Amiens. Even the St. John Baptist is more realistic than the average ecclesiastical decoration in the first half of the century. The Franco-Flemish masters of Paris also worked extensively after the death of Charles V for his brother, Jean, Duc de Berry, carving especially the portrait statues on the exterior and interior of his palace at Poitiers (now the Palais de Justice).

4. THE FIFTEENTH AND SIXTEENTH CENTURIES
THE SCHOOL OF BURGUNDY

The Hundred Years' War gave Burgundy the opportunity to usurp the artistic leadership of which the military calamities deprived Paris. The achievements of the Burgundian School were so distinguished that its style dominated the greater part of France in the second half of the century, although other tendencies are also to be discerned and at the very end of the century occurred the *détente*. An important constituent of the Burgundian style was a strong Flemish or German strain. The chief master of the school during its early period, CLAUS SLUTER (d. 1406?), was probably of Dutch extraction, but he may have had German blood in his veins. Certainly, during the previous history of Gothic, Germany had developed more absolute analogies than any part of Flanders to the powerful realism of Burgundy. At the very period, however, that saw the rise of the Burgundian school, realism began to be a pronounced characteristic of the Low Countries and doubtless had some effect upon its development, for direct Flemish influence was constantly exercised at the Burgundian court through the political connection with the Netherlands and through the presence at the capital, Dijon, of a series of Flemish artists. On the other hand, no sudden change took place in the tradition of French sculpture. Throughout the preceding century, it had been slowly moving toward this consummation. The Franco-Flemish school of Paris and the sculptors of the Apostles in the Chapelle de Rieux at Toulouse had approached so near that no great distance remained for Claus Sluter and his followers to travel. Indeed, the immediate predecessors of Sluter in the employ of Philip the Bold, DROUET DE DAMMARTIN and JEAN DE MARVILLE, had been drawn from the Parisian school; and the only piece of sculpture that can be ascribed with any degree of surety to the latter, the Virgin on the portal of the Carthusian mon-

astery at Champmol in the environs of Dijon, does not differ essentially from the work of Sluter on the same monument, although, in this instance, Jean de Marville may have learned from the Dutch master. However the problem of origins be solved, the borrowings were transformed, elaborated, and treated with a new spirit, so that it is possible to speak of a distinct Burgundian school. Inasmuch as somewhat more massive bodies and copious draperies had already differentiated Burgundian sculpture even in the earlier Gothic period, it is perhaps possible to distinguish a native Burgundian strain in the work at Dijon during the fifteenth century.

At the death of Jean de Marville in 1389, Claus Sluter brought the portal of Champmol to completion. Besides the statue of the Virgin, it includes at either side the portraits of Philip the Bold and his wife, accompanied by Sts. John the Baptist and Catherine. He next erected a magnificent well in the cloister of the Carthusian monastery, of which the pedestal for the Calvary has been preserved. He himself did all except the angelic caryatides, for which he drew the designs but the execution of which he left to his nephew and assistant, CLAUS DE WERVE (d. 1439). The statuary is a crystallization of the kind of Mystery Play known as the *Judgment of Jesus*, in which the Prophets upheld in debate the necessity of the atoning sacrifice on the cross. The six Prophets of the pedestal hold phylacteries on which are inscribed the sentences from their own writings that they recited in the theatre. The illustration (Fig. 34), reading from left to right, represents Moses, David, Jeremiah, Zachariah, Daniel, and Isaiah. The individualization and realism of the heads and postures are more penetrating and more pronounced than in previous French sculpture. Sluter does not hesitate to make the types Israelitish. Although the realism is carried even to the careful rendition of such details as the veins and wrinkles, the hardness of the Burgundian stone encouraged a certain boldness and vigor of carving. The rather stocky proportions of Moses's body are characteristic of the school, and they are accentuated by the great breadth of drapery. The heaviness of the stuffs with deep-cut folds reproduces the Flemish fabrics that were then the vogue, and their all-enveloping amplitude is also derived from contemporary costumes. The involution, however, is less than in some work of the fourteenth century, and the folds are not so broken as in Flemish art. The sweeping and comparatively simplified draperies combine with the massive forms to create, as in the figures of the Italian sculptor, Jacopo della Quercia, or the Italian painter, Signorelli, the effect of majesty at which Claus Sluter aimed. By thus realizing the dignity of man and by imbuing the Prophets with a lofty

intellectuality, he ennobled his realism and differentiated it from the homely naturalism of the Flemish. The angels embody another purpose of the school, dramatic emotionalism. Their poignant manifestations of grief for the Crucifixion are forcefully varied; one of them violates Sluter's usual elevation of mood by actually wiping the tears from his eye.

Two other famous Burgundian monuments, now in the Museum at Dijon, are the almost identical tombs of Philip the Bold (Fig. 35) and of John the Fearless and his wife, Margaret of Bavaria, both ordered before the dukes' deaths. The former, designed possibly by Jean de Marville, was begun by Sluter, but after Sluter's death, the greater part remained to be executed by his nephew and to be brought to completion in 1411. The latter tomb, ordered from Claus de Werve as early as 1410 and probably designed by him, was begun sometime after his death in 1439 by a wandering artist of fortune, the Aragonese, JEAN DE LA HUERTA, and not finished until 1469, long after the Duke John's decease, by ANTOINE LE MOITURIER (d. 1497). The tombs in form are more pretentious examples of the type employed in St. Denis for the son and brother of St. Louis. The mourners are emphasized, much augmented in number, and given a more definite stamp. The mourning costume is more conspicuous, and its capabilities of variation and gyration in the Burgundian mode are ingeniously used to stress the endlessly and wondrously differentiated expressions of sorrow, which embody once more the dramatic emotionalism of the school. Like the angel who wipes his eye upon the well of Champmol, some of the cortège, especially one who blows his nose, approach dangerously near to the *bourgeois* quality of Flemish realism.[1] The ducal tombs at Dijon constituted such effective *ensembles* that they were the models of many another sepulchral monument of the fifteenth century even beyond the confines of France.

After about 1440 the sculptural production of this school, in Burgundy itself, had already begun to languish. Among the comparatively few other monuments, the impressive tomb of Philippe Pot, seneschal of Burgundy, executed perhaps by Antoine le Moiturier between 1477 and 1483 and now transported from the abbey of Cîteaux to the Louvre, is distinguished by the anomaly of employing the traditional mourners as larger figures carrying the effigy of the deceased. The first extant detached Entombment or Holy Sepulchre of 1454 at Tonnerre is in a Burgundian style that already inclines somewhat towards the mildness of the *détente*. One of the finest Virgins in the

[1] Several statuettes of mourners in the Burgundian style may now be seen in the Metropolitan Museum.

manner of Claus Sluter exists at St. Jean de Losne near Dijon; with
the confusion that crept into the iconography of the subject in the
fifteenth century, allowing either disposition for the Child, she here
holds Him on the right arm.

The influence of the Burgundian movement was felt throughout
almost all France, particularly in the second half of the fifteenth cen-
tury. The Ile-de-France and Champagne alone were virtually exempt
because the wars with the English and with the Burgundians stifled
artistic activity, because the French sovereigns forsook Paris to dwell
on the Loire, and because Louis XI was not prone to adopt the man-
ner of the hostile court. The region of the Loire clung to the older
Gothic manner, early manifesting signs of the *détente*, so that it gave
only an indifferent welcome to the foreign style. In the Chapelle
Neuve at Souvigny in the province of the Bourbonnais, which bor-
dered on Burgundy, the sculptor JACQUES MOREL of Lyons, the
uncle of Le Moiturier, executed between 1448 and 1453 the tomb of
Charles de Bourbon and his wife, upon the model of the sepulchres at
Dijon. The two battered effigies, which alone have remained, reveal
Morel as working in the very best Burgundian traditions. Of his
other extensive production, nothing has been left, unless we ascribe
to him the sepulchral statue of Agnes Sorel, the mistress of Charles
VII, which has at last found a resting place in a tower of the château
of Loches, and which already, in the modified realism of the head,
looks toward the *détente*. The further peregrinations of the move-
ment it is not necessary to follow. The Burgundian traits, which
even in the masterpieces were peculiarly pronounced, early lent them-
selves to exaggeration. The figures on the splendidly flamboyant
choir-screen of the cathedral at Albi translate the massiveness of
Sluter into a stubby stolidity. The draperies in the Sepulchre of
Semur (Fig. 36), in Burgundy itself, tend toward the excessively
broken and angular folds of Germany; but the haunting beauty of the
youthful types and the mysticism of all the personages, again inspired
by a breath of the *détente*, here surround the frequent theme with a
singular fascination. Realism sometimes degenerated into vulgarity,
as in one of the Holy Women in the Sepulchre at Moulins, who gives
a disagreeable turn to the Burgundian *motif* of blowing the nose.

THE SCHOOL OF PARIS

The other sculpture of France in the fifteenth century may be divided
into three classes: the persistent Franco-Flemish work of the Parisian
school, the Flemish importations or the imitations of these, and the
group of monuments leading directly to the *détente*.

Despite the national disasters, the Parisian masters still found some

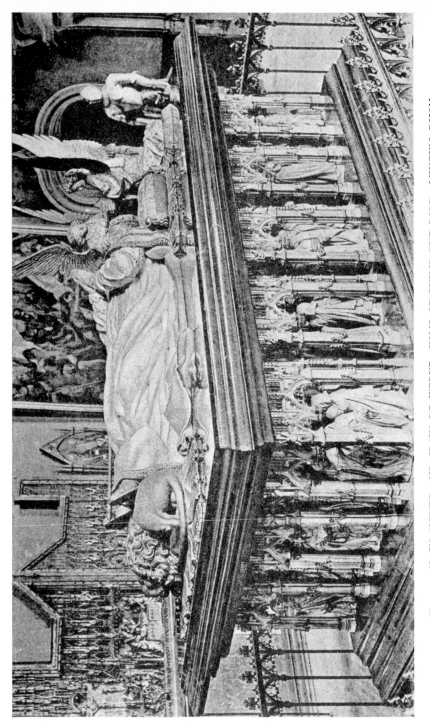

Fig. 35. CLAUS SLUTER AND CLAUS DE WERVE. TOMB OF PHILIP THE BOLD. MUSEUM, DIJON

FIG. 36. HOLY SEPULCHRE. NOTRE DAME, SEMUR–EN–AUXOIS

employment at the first of the century. To this fact we have good witness in the tomb of Charles VI and his incontinent queen, Isabella of Bavaria, the two effigies of whom are now separated in St. Denis, and in the tomb of Louis II of Bourbon and his wife Agnes of Auvergne in the Chapelle Vieille at Souvigny. The effigy of Jean de Berry's tomb, now in the crypt of the cathedral of Bourges, was the work of Beauneveu's pupil, JEAN DE CAMBRAI; the mourners, now dispersed in several collections, were done in the Burgundian style by ÉTIENNE BOBILLET and a Fleming, then enjoying French favor, PAUL MOSSELMAN. Probably also by Jean de Cambrai are the two kneeling statues of the Duke and Duchess, now in an apsidal chapel of the same church. The more essentially religious work of the school is represented by one of the loveliest creations of French genius, the Coronation of the Virgin, in the castle of La Ferté-Milon, built by Louis de France, brother of Charles VI. The draperies have the greater amplitude, simplicity, and rhythmic flow, which developed in the sacred sculpture of northern France about 1400 as well as in Burgundy; but here and elsewhere in Parisian work, they are less swollen and cumbersome, more delicate and keen-edged than in Burgundian examples.

FRANCO-FLEMISH WORK OTHER THAN PARISIAN

The foreign sculptures imported from Flanders need not detain us. Both for retables and tombs, the artists of the Low Countries found an eager market in France as elsewhere in Europe. A long series of monuments, extending even into the first half of the sixteenth century, were produced by French artisans working in the Flemish manner by themselves or together with Flemish masters. Typical is the relief above the door of the chapel of the château of Amboise, dating from the end of the fifteenth century and representing St. Christopher and the Vision of St. Hubert, in which the stress upon landscape setting, upon scenic properties, and upon elaborate composition is peculiarly Flemish. It was partly under the same spell that in the sixteenth century many façades, such as those of the cathedral of Rouen, the abbey of St. Riquier, and the church of Neuville-lès-Corbie, were overladen with decoration and given pictorial tympana. A sphere in which the anecdotal and picturesque reliefs of the Low Countries were very popular was the furniture of churches. Of choir-screens, the cathedral of Amiens possesses a good specimen, executed at the end of the fifteenth and the beginning of the sixteenth century. The choir-stalls are perhaps more characteristic, because the manipulation of wood was a national gift of the Flemings, and their French imitators readily adopted their peculiarities. Some few sets of these had been carved

in the earlier Gothic period, but they were now multiplied from one end of the country to the other. Every available part of the stall was covered with figured or purely ornamental sculpture, from the canopy above to the misericord below; the amount of sculpture and the situation of the figured work varied with the different churches. Sacred personages and episodes often appeared, but grotesques and subjects from every-day life dominated the decoration and gave scope to the weirdest and most startling flights of fantasy. Among the best of many French examples from the second half of the fifteenth century may be mentioned those of the cathedrals at Rouen and St. Claude and the Church of the Trinity at Vendôme. A few Renaissance details entered at the first of the sixteenth century, as in the two series at Amiens and at the church of Brou, a suburb of Bourg, but the style continued virtually unaltered until 1600.

5 THE DÉTENTE

The *détente*[1] was a partial return, not to the mannered idealism of the fourteenth century, but to the loftier and simpler idealism of the thirteenth, which, indeed, had never been quite eclipsed; but it was only a partial return, for its exponents could not be oblivious to the intervening conquests of realism. They drew their types from actual life, even from popular life, but they ennobled them, avoiding the extremes and the eccentricities both of the Burgundian and the Flemish schools. The *détente* manifested itself particularly in utterly captivating feminine figures, and here it is easy to recognize the starting point in the French woman of the middle or peasant classes, who compensates for a failure to realize the highest standard of classical beauty by a whole-heartedness, a healthy geniality, and a piquancy all her own. The draperies of the *détente* reacted against the ponderous elaboration of Burgundy and the angular pettiness of Flanders towards naturalism and a comparative simplicity. The realistic interest was concentrated upon a free adaptation of contemporary costume and upon an attention to precise detail rather than upon the individualization of figures. The style of the *détente* may thus be described as a modified idealism or a discreet realism. Although the Italian Renaissance occasionally supplied ornamental details to French monuments, and although the sculpture of Italy in the Quattrocento afforded certain analogies to the creations of the *détente*, especially in tempered realism, during the fifteenth century the foreign style had not sufficiently penetrated France or produced enough distinguished examples in the country to have had any part, as has sometimes been alleged,

[1] For a definition of this term, see above, pp. 57–58.

in the formation of the movement. The *détente* was the better and truer side of the French genius reasserting itself; it issued from the very heart of the French people. If ever an artistic movement has been popular, the *détente* was popular. Its types were of the people, its qualities expressed the essential nature of the French race, and the consequent enthusiasm with which it was received may be gauged by the vast number of works in which it resulted. Their great charm and importance have been properly appreciated only within the present generation.

By the end of the fifteenth century the *détente* was general throughout France, extending even to Burgundy, but its center was the region of the Loire, especially Touraine, which, of all provinces, is the most essentially French. Here, however, the term *détente*, or in English, "relaxation," is a misnomer, for the asperities of Burgundy had found but little favor in a region distinguished for the soft lines and colors of its landscape and the gentleness of its feminine types, and the older tradition of French sculpture was uninterrupted. The few specimens extant from the first three quarters of the century show that the artists of the Loire continued to work in the style of the fourteenth century, but with the help of good sense, the precious birthright of all Frenchmen, they gradually learned to abandon the mannerisms of intricate drapery, studied pose, and winsome countenance with which jaded idealism during that period had cloaked its *ennui*, and they adopted a mild realism. The most notable monuments are a Mater Dolorosa of the Archaeological Museum, Tours, the tomb of Jeanne de Montejean at Bueil (about 1456), the statues of feminine saints in the chapel of Châteaudun (about 1464), and, in the same manner as these, a St. Catherine in the Metropolitan Museum (accession no. 07.197).

By the last quarter of the century the movement in the district of the Loire had become very prolific. It won its way into architectural sculpture, as in the exquisite little figures on the archivolts of the portals of the cathedral at Nantes, or into the medium of bronze, as in the charming angel formerly in the château of Le Lude and now in the Morgan Collection. The guilds vied with one another in multiplying separate devotional statues of saints, whose contemporary costume and often *bourgeois* character endeared them to the affections of the common people. To take instances of varying ages and sexes, we may mention the Sts. Cosmas and Damian of the Archaeological Museum, Tours, the head of the adolescent St. Maurice in the Museum at Orléans, the Magdalene and two elderly bishops in the church at Limeray, and the baby St. Cyr in the church of Jarzé. The sub-

ject of the Holy Sepulchre was in such demand in the latter part of
the century that many examples exist throughout France which can-
not be assigned to any one school but are carved in a kind of conglom-
erate style, sometimes explained by the theory of nomad workshops.
Of the Sepulchres that have a more definite stamp, the justly famous
group in the abbey of Solesmes (1496) embodies the best traditions
of the *détente* as it declared itself along the banks of the Loire. Some
Burgundian influence has slightly amplified the garments, and, espe-
cially in the Joseph of Arimathaea, the two crucified thieves at the top
of the monument, and the two Roman soldiers outside the cave, it has
added a stronger touch of naturalism; but the sitting Magdalene real-
izes the highest esthetic possibilities of the *détente* in feminine figures
and in restrained expressiveness. Italianism has already decked the
architectural setting with pilasters of the Renaissance.

The Sepulchre of Solesmes has sometimes been ascribed, with more
or less reason, to MICHEL COLOMBE, the greatest exponent of the
détente in Tours, where, though he was born at Saint Pol-de-Léon in
Brittany about 1430, he had set up his shop at least as early as 1473.
His only undoubtedly authentic works that are extant were done in
his old age. Over the medal struck for Louis XII on his entry into
Tours in 1500, we need not linger. His greatest achievement was be-
gun about the same time, the tomb of Francis II of Brittany and his
spouse, Marguerite de Foix, now in the cathedral of Nantes (Fig. 37).
The general form, with the recumbent effigies upon a high base, is
medieval, but by a pretty piece of invention, the little traditional
angels hold, instead of escutcheons, the cushions upon which rest the
ducal heads. Both the material, white marble, and the architectural
decoration are Italian; and the painter, Jean Perréal, who seems to
have designed the monument and had indeed accompanied Louis XII
to the southern peninsula, superimposed certain Italian items upon
the French sepulchral iconography — the twelve Apostles in niches
on the longer sides and, too far disassociated from the central part
and attracting too much attention, detached statues of the four
cardinal Virtues at the corners, which had hitherto not been admitted
to French tombs. Prudence and Justice are even distinguished by their
customary Italian attributes. The mourners had to be relegated to
rows of smaller medallions beneath the tier of the Apostles and other
saints. It was also Italian influence that now and henceforth closed
the eyes of the deceased, which in France had been regularly left open
except in the sepulchres of the fourteenth century in the south. The
actual execution of the design, by Michel Colombe and his pupils, is
thoroughly French, and constitutes the loveliest expression of the

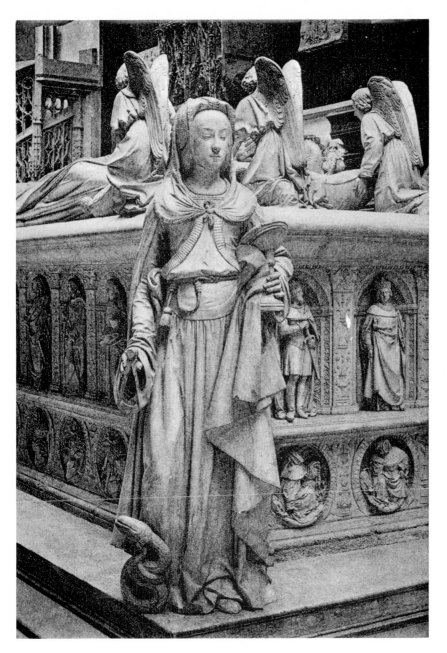

FIG. 37. COLOMBE. TOMB OF FRANCIS II OF BRITTANY, WITH FIGURE
OF PRUDENCE. CATHEDRAL, NANTES

(Photo. from a cast)

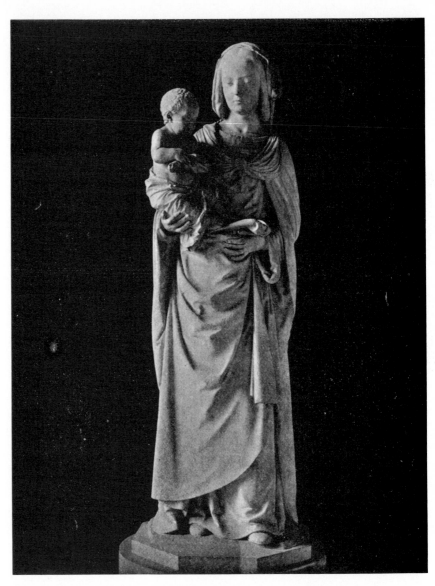

Fig. 38. VIERGE D'OLIVET. LOUVRE, PARIS

(Photo. Giraudon)

détente. Even the Apostles are only slightly, if at all, affected by the mannerisms of the Renaissance. The Virtues are among the most memorable figures of French sculpture. Their draperies are an excellent instance of the usual clever and beautiful accommodation of contemporary costume to the purpose at hand. Their heads, like those of the portraits and the little angels, illustrate that subtle and utterly delightful balance between realism and idealism which was attained only for a few short years at the height of the movement.

The only other certain work of Michel Colombe is the marble panel of St. George and the Dragon done between 1508 and 1509 and now in the Louvre. Though it was ordered by the Italianate cardinal, Georges d'Amboise, for the chapel of his Italianate palace at Gaillon near Rouen, though the frame itself was made by Italians, and though it is remotely possible that the composition was indirectly derived from Donatello, the spirit and all the essentials of the relief are free from Italian influences. If the reason for the pictorial perspective must be sought abroad, Flanders would be the natural explanation. The monster, in particular, is a triumphant vindication of French medieval imagination in the sphere of the *merveilleux.*

After Colombe's death between 1512 and 1519, his style lived on through the first quarter of the century with almost undimmed loveliness in the hands of his immediate followers. Among these, the only one who can be absolutely connected with a definite monument is his nephew, GUILLAUME REGNAULT, the author of the recumbent forms of Louis Poncher, Treasurer of France, and his wife, Roberte Legendre, for the tomb the fragments of which have now been gathered in the Louvre. The only two statuettes of Virtues that remain were carved by a master of Champagne, JACQUES BACHOT, in a manner that already was affected by Italianism in its partial abandonment of contemporary costume and of the simple naturalism of Colombe's drapery; but the figures of the deceased by Regnault, especially, as was usual in the school, the feminine effigy, retain all the characteristic beauties of the *détente.* With a high degree of probability the three statues of Sts. Peter, Susanna, and Anne from the demolished castle of Chantelle and now in the Louvre, the last of which has a peculiarly alluring charm, may be assigned to another of Colombe's disciples, JEAN DE CHARTRES. A similar group of St. Anne and the young Virgin, a subject that was very popular during the *détente,* may be seen in the Metropolitan Museum (accession no. 16.32.31); it is perhaps to be assigned to the contemporary school of Champagne rather than to that of Touraine. In many tombs of the period, which in other respects belong to the dawning French Renaissance, certain

sections were executed by the *atelier* of Colombe: the Virgin and the Virtues on the monument of Georges d'Amboise in the cathedral of Rouen; the angels and effigies on the sepulchre of Charles VIII's children in the cathedral of Tours (by Regnault?); the statues of Louis XII and Anne of Brittany at St. Denis in the kneeling posture that became as common now in the sixteenth century as it had been rare in the tombs of the preceding centuries. The appeal of the movement is perhaps felt most irresistibly in a series of Virgins, the best of which, worthy of Michel Colombe himself, is the Vierge d'Olivet in the Louvre (Fig. 38). The distaste of the *détente* for all affectation appeared in this subject in a more or less successful repudiation of the slouch that bends the body of the Madonna in the fourteenth century.

In other districts of France, as early as the middle of the fifteenth century, the *détente* began to assert itself here and there in a resuscitation of the calmer old French manner or in a relaxation of Burgundian harshness. A great fondness was developed for the gentle little forms of angels on the arches of portals, as in the cathedral of Vienne or the abbey of St. Antoine-en-Viennois. The sculptor of the small figures of the latter monument was in all likelihood the Burgundian-trained Le Moiturier. The Burgundian style is obviously softened in the carvings upon the house of Jacques Coeur at Bourges and in the exquisite Madonna of the Bulliot Collection at Autun. At the end of the century and through the first quarter of the next century, the movement became ubiquitous, probably through a spontaneous evolution and not necessarily through the influence of Touraine. From a multiplicity of examples may be mentioned: in the region of the Bourbonnais and the Forez, a group of statues of the Virgin and Child, the most distinguished in the Museum at Moulins, in the church of l'Hôpital-sous-Rochefort, and in the chapel of la Chira at St. Marcel-d'Urfé; from the Château de Biron, between Périgueux and Agen, the Holy Sepulchre and Pietà, now in the Metropolitan Museum, New York; in Normandy, a large number of works in Notre Dame and the Madeleine of Verneuil, especially the Sepulchre of the latter; at Chartres, the first four reliefs on the south side of the choir-screen, episodes from the life of the Virgin, by JEAN SOULAS of Paris.

But it was Champagne that harbored the most vigorous school of the *détente*, outside of Touraine. Recovering from the disasters of the fifteenth century and rejoicing now in great material prosperity, the capital Troyes and the surrounding towns began about 1510 to be energetic centers of artistic activity. The highest achievements of this school, almost Hellenic in their purity of taste and intimate idealism, were produced by the *atelier de la Ste. Marthe,* so called from one

of the definitive statues of the workshop, a St. Martha in the church of the Magdalene at Troyes itself. Its masterpieces are two Holy Sepulchres at Chaource and Villeneuve-l'Archevêque. The statue of a feminine saint at Princeton University belongs to the same period and perhaps to the same workshop. Of the almost countless figures, in Champagne, of the Virgin and of other saints, many suffer little by a comparison with the output of the *atelier de la Ste. Marthe;* some, perhaps slightly later than the others, partially sacrifice the naturalism of the drapery of the *détente* for a more studied complication and deeper indentation of the folds. Two examples of this class, in which the fascination exercised by the French feminine type amply compensates for what simplicity the garments have lost, are the Virgin of St. Urbain and the Visitation of St. Jean, Troyes (Fig. 39). The latter is an excellent instance of the general richness of feminine attire in the sculpture of Champagne. The increased complication of the drapery may have been due to Flemish influence or to advancing Italianism. In any case, although sculptural activity continued in Champagne unabated, the French style of the *détente* succumbed before the conquests of the Renaissance.

CHAPTER VI

GOTHIC SCULPTURE. THE LOW COUNTRIES

THROUGHOUT the thirteenth and for the first two-thirds of the four-
teenth century, the sculpture of Belgium continued, as in the Roman-
esque period, to be chiefly an offshoot of the production of France, to
which, indeed, Tournai then belonged and upon which the so-called
county of Flanders then depended. Even when the later vandalism
of the Protestants is taken into account, the small amount of monu-
mental plastic decoration that remains indicates that it was here
never so enthusiastically cultivated as in France itself. Of the thir-
teenth century, the two principal examples are the sacred figures in the
lowest row upon the façade of the cathedral of Tournai and the double
tympanum of the Hospital of St. John at Bruges, carved with the
glorified Christ and the Death, Resurrection, and Coronation of the
Virgin, an imitation of similar French portals with the stockier pro-
portions and the less delicate technique of provincial work. The
separate groups of the Virgin and Child are no exception to the general
rule of French borrowing: the seated statue in St. Jean at Liége is
an impressive performance in the hieratic manner of the early thir-
teenth century; the standing representation in wood in St. Pholien of
the same town, "Notre Dame du Val-des-Écoliers," is an utterly
captivating prototype of the *minauderie* introduced into the subject
in the next century; and a smiling Virgin of the same material and
period may be seen even in the Archiepiscopal Museum of Utrecht in
Holland.

The proximity of Holland and of the region of the Meuse to Ger-
many, however, introduced a Teutonic strain into the sculpture during
the Gothic as during the Romanesque period. The great south portal
of St. Servatius at Maastricht belongs to the group of the early
thirteenth century that comprises such doors as those of Freiberg and
Münster. Adriaan Pit, in his publication of the sculpture in the Na-
tional Museum of Amsterdam, finds that throughout the fourteenth
century Holland was dominated by those productions of Germany in
which the indigenous spirit overruled French mannerism.

It was once the fashion to ascribe to Flemish initiative the realism
that appeared in European art at the end of the fourteenth and begin-
ning of the fifteenth centuries, and to discern a proclivity towards this

consummation even in the earlier production of the Low Countries. But realism is now recognized to have developed gradually and spontaneously throughout Europe, and both the Belgian and French artisans, who in the Paris of Charles V were the first great exponents of the phenomenon in sculpture, simply fell into line with the general esthetic trend of their day. It may even be doubted whether the sculptors who stayed at home in Flanders advanced so far in the new fashion during the fourteenth century as their countrymen who had gone to France. If realism was to manifest itself anywhere, it might be looked for first in an attempt at portraiture in sepulchral effigies, but an unprejudiced eye fails to discern it in the Flemish tombs either of the thirteenth century, such as those of Henry I of Brabant and his family in St. Pierre at Louvain or of Didier d'Houffalize in the Musées des Arts Décoratifs at Brussels, or in those of the first seventy years of the fourteenth, such as two in the Archaeological Museum of Mons from the abbey of Cambron or that of Jean de Walcourt in the church of Anderlecht near Brussels.

Nor does the monumental decoration of the fourteenth century proceed any further along the road towards realism than the contemporary work of France. The principal extant specimen is the door of Notre Dame at Huy, the tympanum of which contains scenes from the infancy of Christ. Since Huy is situated on the Meuse, the sculpture is perhaps more German than French, for instance in its draperies and in such a homely detail as the hanging of the first Wise Man's crown upon his arm. The well-known ornamental heads of wood from the Salle Échevinale of Ypres, now in the Museum,[1] are less expressive even than certain French examples. The usual mannered Virgin of the fourteenth century may be illustrated, in an extreme aspect, by the statue in the Baptismal Chapel of the cathedral of Antwerp, and in a simpler and more tenderly intimate aspect, by a statuette of the Museum at Lille. Even the late and peculiarly French types of realism at the end of the fourteenth and beginning of the fifteenth centuries were sporadically imitated in the Low Countries: the Franco-Flemish manner of Beauneveu and the Parisian *milieu* by the superb St. Catherine of Notre Dame at Courtrai, the compound tombs of Jean de Melun and his wives in the château of Antoing near Tournai and of Guillaume de Melun and his mother in the château of Beloeil in the same district; the Burgundian manner by the Virgin on the south portal of Notre Dame at Hal, the Prophets from the portal of the tower of the Hôtel de Ville at Brussels, now in the Musées des Arts

[1] As in the case of certain other Belgian sculptures, in regard to the preservation of which I am in ignorance, I permit myself, for the sake of avoiding unnecessary words, to use phraseology that applied before the war.

Décoratifs, and the Mourners of the tomb of Guillaume van Halewin in St. Sauveur, Bruges.

Realism was not, then, a creation of the Low Countries; but the tendency that manifested itself everywhere in Europe at this time also assumed in Flanders a peculiarly Flemish form. As was to be expected from a nation of merchants and craftsmen, Flemish realism was calculated so as to meet the appreciation of the middle class, and it was because of the popularity of the Mystery Plays with the common people that, even more than in France, artists were led to reproduce them in their works. As in the theatre, the sacred scenes were staged after a more colloquial norm, the personages were most frequently *bourgeois*, their postures and gestures were not in the "grand" manner but were adapted from the ordinary sights of every-day experience in the home, in the church, in the marketplace. For representing the lower classes, a thoroughly vulgar type was evolved, "with colossal nose and mouth." The Flemings had a *bourgeois* awe for the pomp of the ruling house of Burgundy, and naturally invested their representations of sacred story with this pomp in the form of the opulence of gold and color upon the exuberant Gothic frames. Instead of large and impressive statues, the mind of the middle class found satisfaction in little figures, multiplied, on the retables, into the familiar crowds of the streets, repeated on the portals with that addiction to rhythms of small objects at short intervals which is characteristic of Flemish art. The retables were divided into many compartments, each of which was covered by canopies of luxuriant Gothic lacework, the settings were cluttered with the furniture of the household, and the details of costume and jewelry were studied with the minutest accuracy. To give the impression of actual human beings, the figures in the retables were usually detached in the round. Flemish draperies were broken into numerous small and complicated divisions in contrast to the great sweeping expanses of Burgundian realism, and this "tormenting" of the folds, taken in conjunction with their angularity and their marked projection, had the additional advantage of creating a violent chiaroscuro, a kind of patchwork of light and shade.

The sculptors carried their realism so far as to call into service, not only all the resources of their own art, but also those usually considered peculiar to painting. The pictorial accessories of landscape and architecture were freely introduced; the figures were set upon deep, foreshortened planes; pictorial perspective was occasionally attempted, with the more remote forms diminished in size; sporadically landscape was actually painted on the flat surface of a piece of the background; the groups were arranged in pictorial compositions. The perspective,

however, as well as the juxtaposition of a series of compartments containing episodical scenes, may have been influenced by the stage of the Mysteries. In some instances, the sculptors apparently had definite paintings as their models. The Flemings were consumed with a desire for the dramatic, and with the sister art in mind, they permitted themselves the violence of gesture and movement that is commonly deemed inconsistent with the mediums of sculpture. The somewhat stereotyped polychromy of the earlier Middle Ages they sacrificed to a more realistic system of color. For the sake of brilliancy they indulged only in the one convention of a profusion of gilt, not only upon frames and canopies of retables, but even upon the costumes, and in general their polychromy was toned to a loudness consonant with plebeian taste. It may, indeed, be maintained that the great school of Flemish painting preceded in its rise and set the example for the great school of Flemish sculpture and that, not only the realism, but also the principal other qualities of the latter, were learned from the former.

The commercial environment made the art of sculpture itself into an industry. The producers were shops with their trade-marks rather than great individual artists conscious of their high calling. Among the trade-marks of Brussels, for instance, were the hammer and the shell; among those of Antwerp were the castle and the outspread hand. Each *atelier* would repeat again and again the same compositions and forms; and the articles manufactured were sold broadcast throughout Europe — the sepulchral slabs of Tournai, the bronzes of Dinant, the wooden retables of Brabant and Antwerp. Wood, indeed, was the favorite Flemish medium because of the greater ease with which it could be exported. The manufacture of retables became so highly developed an industry that one set of workmen did the frames, another the scenic accessories, another the gilding and painting, and still another the figures. It was owing partly to the mercantile enterprise of the Flemish masters and partly to the harmony between their esthetic ideals and the general artistic spirit of the fifteenth century that in a large part of Europe their influence was now substituted for the French, which had hitherto held the field.

The first signs of this realism may be discerned in a peculiar kind of sepulchral relief manufactured at Tournai, which in the latter part of the fourteenth and the beginning of the fifteenth centuries was the most original and important sculptural center of the Low Countries. The dead man, often with his family, is represented as kneeling before some sacred personage or personages, ordinarily the Virgin. Mortuary tablets, in which the deceased usually kneels in adoration before some religious subject, now became very common substitutes

for the more pretentious tombs in many districts of Europe. Subsequently they often developed into great structures against the wall, sometimes with figures in the round, and the themes were not always drawn from the sacred repertoire. In its simpler or more ambitious form, this type of memorial has enjoyed a constant vogue almost to the present day, and may conveniently be described by the word *epitaph* in the technical German sense of the term. The output of Tournai was soon imitated by the craftsmen of other Flemish towns. For the well established effigies of the saints, the sculptor naturally clung to the old traditions of his shop, but the figures of the dead, whether actual or imaginary portraits, offered opportunity for the cultivation of the new realism. One of the earliest *epitaphs*, if not the earliest, is that of Jean du Pluvinage, Pierre Sakespée, and Marie Augrenon in the Museum of Arras. The two latter had died over fifty years before, but the portrait of Pluvinage, who died in 1376 when the work was executed, is a faithful characterization of a Flemish *bonhomme*, a rather uninspired and materialistic exponent of the household virtues. Other good examples are the tablets of Lancelot de Bertaimont (1418) in Ste. Waudru at Mons, and of the canon De Quinghien (1429) in the Museum of Tournai, the latter perhaps by the great painter, Roger van der Weyden. The same unconscious *bourgeois* note is perceptible in the homely crouching attitudes of the friars at the bottom of the *epitaph* of Jean de Fiennes or Fiesne (Fiévez?), now in the Musées des Arts Décoratifs at Brussels, which varies from the norm of Tournai in relegating the Virgin to the small compass of an apparition at the top of the relief and in appropriating the main section for a typically Flemish transmutation of the theme of the mourners into the picturesque scene of the actual obsequies.

On another splendid series of sepulchral monuments, done for the ruling house of Flanders and Burgundy, the sepulchral effigies, clad in the sumptuous costumes of the court, are of bronze, exhibiting the perfect mastery of the Flemish over this material. The series includes: in Notre Dame at Bruges, the monument of Charles the Bold, erected in 1559, long after his death, and that of his daughter, Mary of Burgundy, from the end of the fifteenth century; and in the cathedral of Antwerp, the monument of his second wife, Isabella of Bourbon, executed about the time of her death in 1465. One of the best of those who supplied the ducal taste for sepulchral slabs of bronze was JACQUES DE GÉRINES of Brussels, who completed in 1455 at Lille for Philip the Good the tomb of his ancestor Louis de Mâle. The monument perished in the French Revolution, but Montfaucon's drawings of the surrounding statuettes, representing the members of

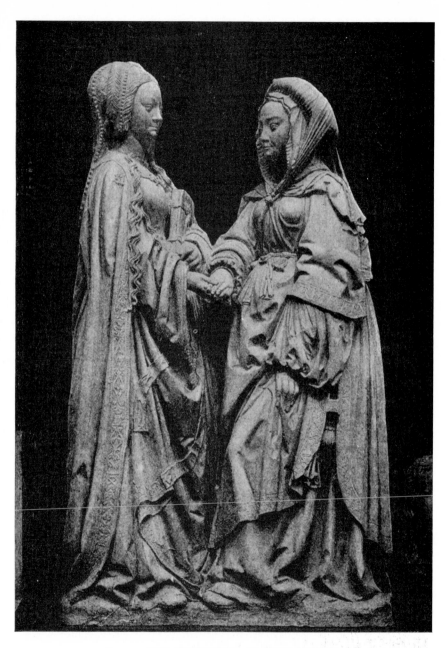

FIG. 39. THE VISITATION. ST. JEAN, TROYES

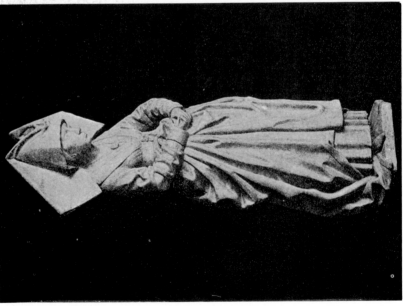

FIG. 40. JACQUES DE GÉRINES. STATUETTES FOR A TOMB. RYKS MUSEUM, AMSTERDAM

the Burgundian family, make it possible to identify the ten bronze figures now in the Ryks Museum of Amsterdam as designed for this tomb, although replaced by others, or as executed by Jacques de Gérines for some other destination in an identical style (Fig. 40). They are among the most appealing examples of Flemish realism, especially the feminine effigies, and suggest vividly the painted portraits of Jan van Eyck.

The principal ecclesiastical decoration of the fifteenth and early sixteenth centuries consisted no longer in the monumental statuary of portals but in the application of small figures and especially small scenes from sacred story in large numbers to the elaborately wrought articles of religious furniture, such as rood-screens, pulpits, tabernacles, fonts, and stalls. Characteristic specimens are: the screens of Aerschot, Dixmude (Fig. 41), Lierre, Notre Dame at Walcourt, and St. Pierre at Louvain; the tabernacle of Notre Dame at Hal, dating from as early as 1409 but already intimately realistic in the panels of the Last Supper and the Washing of the Feet; the ornate bronze font of 1446 in the same church by GUILLAUME LEFEBVRE; the tabernacle in St. Jacques, Louvain; and the choir-stalls of Ste. Gertrude at Louvain and of the church at Breda.

The earliest wooden retables, like the earliest reliefs of Tournai, developed the characteristic realism only step by step; but even at the very first, the Flemish passion for story-telling ousted the figures of saints from the chief places that they still held upon the altarpieces in Germany and Spain, gave to the narrative scenes the positions of honor, and finally came near to suppressing the separate statuettes altogether. The commonest themes for retables were the Passion of Our Lord and the life of the Virgin. In the two famous examples executed between 1390 and 1392 by JACQUES DE BAERZE of Termonde, at the command of Philip the Bold, for the Carthusian monastery of Champmol at Dijon, and now to be seen in the Museum of that town, the panels are still shallow, not achieving an impression of depth, as in the later period, by arranging the Gothic decoration above in receding rows, one below the other; the planes upon which the personages stand do not rise gradually in an effect of foreshortening; and the stage is not usually crowded. In the better of the two, however, the Crucifixion of the central section already begins to be thronged with small figures; and in both, some of the statuettes are vividly individualized, especially the St. George of the more distinguished altarpiece. For the separate saints of the retable from Hakendover near Tirlemont, now in the Musées des Arts Décoratifs at Brussels, carved probably at about the same time or slightly later, the

artist could use time-honored models, but for the crowded panels re-
lating the delightful legend of the foundation of the village church by
three virgins, he had to resort to his own gentle and homely invention.

It was not until the last quarter of the fifteenth century that Brus-
sels and Antwerp became busy emporiums for the manufacture and
exportation of wooden retables. Among the best known products of
the former city, the specimen of the Benedictine abbey of Ambierle in
France, with scenes from the Passion, is to be assigned to an early date;
one of the examples in the church of St. Léonard at Léau in Belgium,
dating from 1478–1479, is even more than usually pictorial. Three
masterpieces of the school are in Brussels, the first two in the Musées
des Arts Décoratifs, the last in the Communal Museum. The earliest,
perhaps contemporary with the specimen at Léau and containing
scenes from the Passion, was ordered by the Italian Claude de Villa.
The portrait of his wife, Gentine Solaro, as kneeling donor, and some
of the other feminine figures have a poignant and lingering charm;
their author reveals a sensitiveness to ideal beauty that is not uncom-
mon at Brussels even in the midst of Flemish realism. The second
and most interesting of the three retables, especially from the stand-
point of dramatic composition, embodies the legend of the tortures of
St. George, and was made by the greatest craftsman of the city, JAN
BORREMANS (Fig. 42, central portion). The third, composed of epi-
sodes from the life of the Virgin and executed for the Italian family of
Pensa di Mondari, already exhibits in single figures signs of the oncom-
ing Renaissance.

The retables of the shops at Antwerp are somewhat inferior to
those of the rival town. Her *bildemaker* may have had less taste, but
it must be remembered that the great majority of the examples came
from a later period than the best work of Brussels, from the very end
of the fifteenth and the first half of the sixteenth century, when the
qualities of Flemish sculpture in general had become exaggerated.
The panels were more crowded with actors, violence of posture often
degenerated into frenzy and homeliness of gesture into vulgarity, the
drapery was thrown into a seething mass, the figures and their frames
are heavy beneath the gaudy color and the lavished gold. The wide
diffusion of objects in this later and rather debased style throughout
Europe has created the false impression that such are the character-
istics of all Flemish realism. Even the earlier retables of Antwerp
betray only premonitions of extravagance. A weaker sensibility to
beauty of form, to existence in three dimensions, and to correctness of
modelling also helped to differentiate the products of Antwerp from
the masterpieces of Brussels. A familiar example, with the defects not

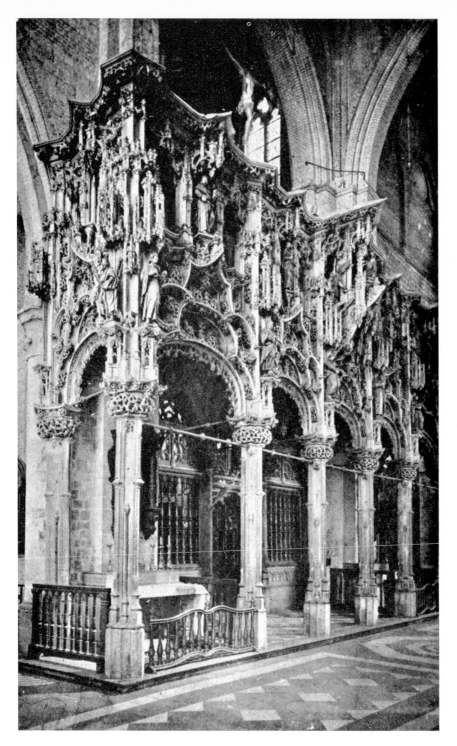

Fig. 41. ROOD–SCREEN, ST. NICOLAS, DIXMUDE

(Photo. Nels, Brussels)

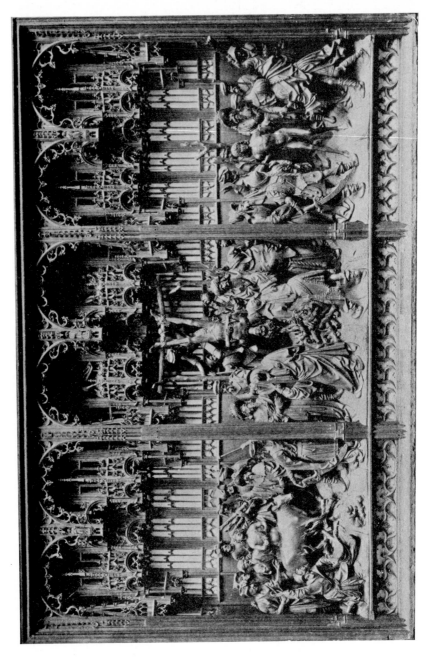

FIG. 42. JAN BORREMANS. CENTRAL SECTION OF RETABLE OF ST. GEORGE.
MUSÉES DES ARTS DÉCORATIFS, BRUSSELS

yet pronounced, except perhaps in the soldiers in the several scenes from the Passion, who are caricatures of movement, is in the castle of Ponthoz. Another good early example may be seen in the church of Ste. Materne, Tongres. Whether the retable in St. Denis at Liége was executed by local artisans or not, the brutalities in the Passion are convincing tokens of the style of Antwerp. Sweden, especially, provided an enthusiastic market for the retables of Flanders. During the greater part of the fifteenth century, that country had imported examples from northern Germany, especially Lübeck, but about 1480 turned rather, first to Brussels, and then to Antwerp. The school of Brussels is represented by excellent specimens in the cathedral of Strengnäs, the church of Jäder, and the Museum of Vesteräs, the last perhaps the work of Jan Borremans's son, Passchier. The school of Antwerp was still more popular and is well represented by works now in the National Museum of Stockholm.[1]

Mention has already been made of several monuments in Holland connected with the general Flemish development. The Dutch critic, Pit, would discern in other monuments from the fifteenth and sixteenth centuries certain slightly differentiated national traits — heavier but simpler draperies, the familiar Dutch cast of countenance, a still further accentuation of the homely realism characteristic of the whole region of the Low Countries. Such works as the Epiphany of the Episcopal Museum at Haarlem or the Visitation and organ panels of the Ryks Museum at Amsterdam foreshadow the great Dutch *genre* painting of the seventeenth century. Both in Holland and in Belgium, the French scholar, Vitry, has observed at least some signs of the same *détente* of realism that occurred in contemporary France, pointing, for proof, to a lovely wooden figure of the Magdalene in the Museum of Amsterdam and to a Virgin in the Musées des Arts Décoratifs at Brussels. In general, because of an inferior culture and the lack of great patrons, the production of Holland was much less extensive and distinguished than that of Belgium.

[1] Nos. 59, 65, and 67 of the Catalogue of Montelius, Stockholm, 1901.

CHAPTER VII

GOTHIC SCULPTURE
GERMANY AND RELATED COUNTRIES

1. INTRODUCTION

THROUGHOUT its history Gothic sculpture in Germany was more realistic than in any other country of Europe. In the thirteenth century it was less idealistic; in the century of realism, the fifteenth, it out-Heroded Herod. There was always in German Gothic a lack of harmony between the exalted tone of the sacred themes and the blunt realism with which they were presented. As if to obviate this difficulty, for the essentially spiritual forms of France and Italy was substituted from the first a tendency to greater expressiveness, which finally degenerated into emotional extravagance. If good taste includes restraint, then the ardor of German sculpture is a defect. The restlessness permeated even the drapery. Already agitated in the early Gothic period, it subsided in the developed art of the thirteenth century, but it ended by committing the wildest and most capricious excesses. Compensation for this relative lack of taste may be sought in the energetic strength of the figures and in a technical skill that occasionally surpasses the attainments of other Europeans. The territory comprised within the former Austro-Hungarian Empire, except the Tyrol, was comparatively sterile until the seventeenth century; what sculpture there was, usually owed its genesis to German artists.

2. THE TRANSITION FROM ROMANESQUE TO GOTHIC

The Romanesque style of Germany might, of itself, have developed into the Gothic; but, as a matter of fact, there was a new importation of Gallic influences, and in the thirteenth and fourteenth centuries, German sculpture was dependent upon French, though with very pronounced national traits. Sauerlandt adduces the German epic as a literary parallel in which French borrowings were Teutonized. In the thirteenth century, the greater realism and expressiveness, the livelier postures and draperies, partially destroyed the architectural lines that were still preserved in the carvings of France. The straining after these characteristics also created in the stone-cutters a state of mind that conceived the statues as detached objects of artistic effort. The

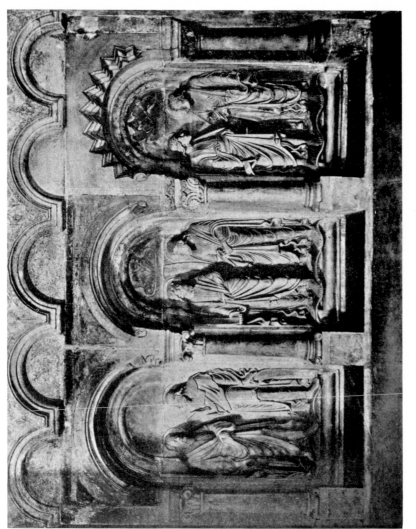

FIG. 43. SECTION OF CHOIR-SCREEN, CATHEDRAL, BAMBERG

(Photo. B. Haaf, Bamberg)

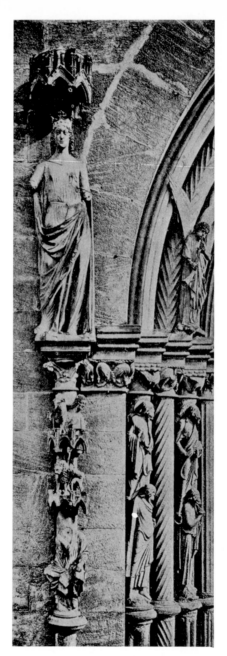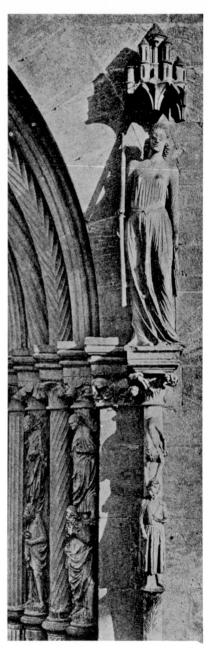

Fig. 44. APOSTLES, PROPHETS, FIGURES OF CHURCH AND SYNAGOGUE,
PORTAL OF THE PRINCES, CATHEDRAL, BAMBERG

(From Dehio and Von Bezold, "Die Denkmäler der deutschen Bildhauerkunst")

architectural feeling in German Gothic sculpture was never strong enough to cause such elongation of the forms as in the early school of Chartres. The realistic proclivity introduced into the carved decoration of religious edifices more secular matter than was admitted in France, especially effigies of the noble founders of the churches. The subject of the Wise and Foolish Virgins enjoyed a peculiar popularity in Germany as a compromise between the sacred and the profane.

The great centers of monumental Gothic sculpture were Saxony and the adjacent districts in the contiguous provinces, especially Westphalia and Franconia. Here, at the end of the twelfth and beginning of the thirteenth centuries, in a series of examples, chiefly choir-screens, it is possible to observe that gradual infusion of German Romanesque forms with naturalism which might have ended in Gothic without foreign interference, if the importation of the vigorous new style from France had not stunted the movement. The series includes chiefly: the parapet of the gallery from the abbey of Gröningen, now in the Kaiser Friedrich Museum at Berlin, dating from as early as about 1170 and still very conservative; and the choir-screens of St. Michael, Hildesheim, the Liebfrauen-Kirche, Halberstadt, and the cathedral of Bamberg (Fig. 43). The first three monuments are executed in stucco, the last, in stone. The subjects in the former group are sitting or standing figures of Christ or the Virgin accompanied by the Apostles; in the slightly later screen of Bamberg, Apostles and Prophets are arranged in pairs and an Annunciation and a St. Michael are added. The incipient liveliness and variety of gesture in the parapet from Gröningen, the crossing of the legs at Halberstadt, the twisted or spiral folds at Halberstadt and Bamberg, the coupling of the sacred personages in conversation at Bamberg, suggest that these sculptures owe something to Romanesque France, but they certainly owe as much or more to the ivories of Byzantium, which, because of relations between Germany and the court at Constantinople, continued in the twelfth century to exercise a potent influence. With the transitional school of France there is not necessarily any connection. The Byzantine folds of Hildesheim and Halberstadt, the much increased actuality of the heads, particularly at Bamberg, can be paralleled in the *atelier* of Chartres; but the developments may very well have been independent, since the sculptors in both cases were breaking the bonds of the same Romanesque models and were working in the same growing international spirit of Gothic naturalism. In the stucco monuments, the attitudes, expressions, and draperies are calmer, the naturalism is less pronounced. In the sinewy stone figures of Bamberg, the varied postures and countenances are dramatic and intense; the backs are

occasionally turned to the spectator; an attempt to represent walking is sometimes indicated; the realistic cast of the features is more frankly Teutonic, one head is actually bald; and the folds of the garments are contorted, as it were, by electric currents, one of the most characteristic effects of which is a series of plaits in concentric rings over arms and legs. In other words, the masters of the choir at Bamberg have already either achieved or adumbrated the typical qualities of German sculpture in the thirteenth century. The door of the northeast tower, the tympanum of which represents the donation of the church by the sainted king, Henry II, and his queen Kunigunde, is still very Romanesque and similar in style, although the mood and the draperies are less vehement and the date is probably later. On the columns at the left of the Portal of the Princes, at least the majority of the Apostles and the Prophets (Fig. 44) would also seem to belong to the earlier workshop of Bamberg.

Intermediate between this movement and the fully developed style of the thirteenth century lies another large group of monuments in which, generally speaking, the Byzantine and Romanesque elements are fewer and less pronounced, the familiar earmarks of Gothic more apparent, and the influence of early French Gothic is clearly perceptible. The productive centers were still Saxony and the adjoining territory. The examples date usually from the first third of the century, some of them doubtless contemporary with the screen at Bamberg; the south door of Paderborn, however, perhaps retained the archaic manner as late as 1250–1260. In Saxony, the sculpture of portals in this group is principally represented by the sections of an ancient door now built into different parts of the choir of the cathedral at Magdeburg and by the Goldene Pforte of the cathedral at Freiberg. The elaborate iconographical scheme of both monuments is suggested by the Gothic of the Ile-de-France. The large saints, now high exalted on the choir-piers of Magdeburg, are similar to those of the west portal at Chartres without the elongation; the queenly Virgin of the tympanum at Freiberg has prototypes in the right tympanum of the same portal at Chartres, in the tympanum of the Porte Ste. Anne at Paris, and especially in the Virgin with the Child built into the wall of the north transept of Reims, which is slightly less archaic than the other two French examples. The parallelism between these tympana at Reims and Freiberg is extended even to the presence of angels of death on the arches above the Virgin. Some Romanesque mannerisms have lived on in this intermediate group, such as the minute folds of the draperies or the occasional crossing of the legs. At Magdeburg the edges of the garments are apt to fall into the old conventional swirls.

In the example at Freiberg, really the first great portal of German Gothic, the spirit is quieter and more solemn. The primitive formalism of drapery has given way to much freedom and flowing grace, for the sake of which the mantles are made more ample. The slim types of Romanesque sculpture are replaced in the tympanum and in the larger statues below by more substantial German figures, impressive in their solid and practical piety. The more provincial artisans who executed in Westphalia the south portals of Paderborn and (with the exception of five later statues) Münster were ruder workmen than their Saxon brothers. They had emancipated themselves less from Romanesque conventions, and they vented their restless temperaments in a slight perturbation of the drapery.

Gallic taste and poise have calmed the ebullition in several important examples of ecclesiastical furniture, which may be assigned to the same early Gothic group as the portals. In the abbey of Wechselburg, the admirable reliefs on the pulpit, the four worthies of the Old Testament on the screen, and two others now placed at the crossing are analogous to the statues of Freiberg, but of an even more obvious Teutonic stockiness. The Calvaries of wood for the screens of the cathedrals of Freiberg and Halberstadt and the abbey of Wechselburg (the first now in the Museum of the Antiquarian Society, Dresden) are slenderer in proportions and distinctly more French. The restraint of the thirteenth century, felt even in Germany, makes the Virgin of the group at Halberstadt one of the loveliest instances of German emotionalism (Fig. 45). The Calvary of Wechselburg stands on the very threshold of developed Gothic.

3. THE DEVELOPED STYLE OF THE THIRTEENTH CENTURY

The mature sculpture that dates from the last two thirds of the thirteenth century may be divided into two broad classes: the Saxon, more directly related to the previous carvings of the province, more German in temper, and, in the midst of the general French influence, often revealing a particular dependence upon Reims; and the Rhenish, produced by a more immediate but far from servile study of the French models, which were closer at hand, especially those of Paris and Chartres. Bamberg, though not absolutely in Saxon territory, affords the best illustration of a connection with Reims. The sculpture of the cathedral that belongs to this period includes the allegorical figures of the Church and the Synagogue and the tympanum of the Portal of the Princes, the Portal of Adam in the southeast tower (where it is perhaps German realism that has the temerity to select

the nude Adam and Eve for representation as large figures), and a series of statues within the church. Of numerous instances of a relationship so direct that it is necessary to assume that the artists of Bamberg spent a long period of apprenticeship at Reims, the following must suffice to prove the point: the allegorical figures of the Church and the Synagogue (Fig. 44), derived from the similar personifications beside the rose of the south transept at Reims; the superb equestrian statue of St. George (St. Stephen of Hungary or Conrad III?) in the interior, suggested by a young standing King on the exterior of the north transept of Reims; and the group of the Visitation, also inside the church, imitating the curiously but nobly archaizing style of the identical subject on the central door of the French cathedral.

The very parallelism between these two supreme examples of two nations' art throws into stronger relief their differences. On the German monument a higher degree of individualization in the figures is distinctly evident. The individualization often takes the form of an almost tragic intensity, as if the personages already realized the burden of the *Weltschmerz*. On the tympanum of the Portal of the Princes, the German velleity for exaggeration manifests itself, in the sphere of expressiveness, by transmuting the captivating smiles of Reims into the smirks of the blessed, and by contorting the faces of the damned into grimaces that resemble the masks of the ancient stage. The general reliance upon German types of humanity may be gauged by comparing the Marys of the two Visitations. The greater size and weight of the Teutonic bodies appear to best advantage in the Church and the Synagogue, who possess the heroic beauty of Valkyrs. Germanic technical skill here reaches its acme in the wonderful delineation of the diaphanous fabrics and the lovely feminine forms emerging everywhere beneath them. Even the eye-balls are outlined under the bandage around the head of the Synagogue. Although these two statues are among the highest creations of all sculpture, the opulence of the women's bodies is unsuited to architectural decoration, and the evident delight in it to the religious purpose. Their grace, however, is a rather isolated phenomenon at Bamberg, the absence of which is particularly unpleasant in the Portal of Adam. The gestures of Queen Kunigunde on a column of this door and of the participants in the Last Judgment on the Portal of the Princes are as jerky as those of mechanical dolls. What Bamberg loses in grace, it gains in Teutonic energy, and in any case it is enough for a monument that some part of the glory of Reims should be shed upon it.

Developments from the earlier Gothic manner of the pulpit at

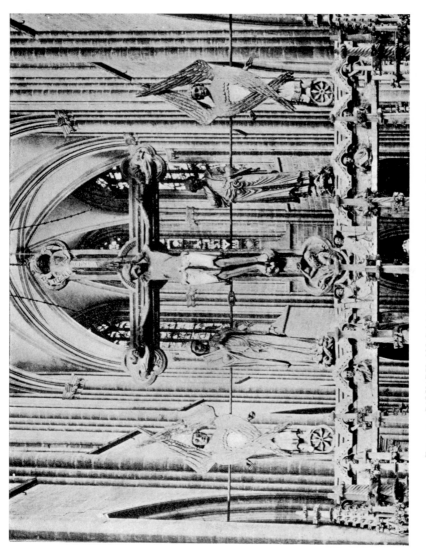

FIG. 45. CALVARY ON ROOD-SCREEN, CATHEDRAL, HALBERSTADT

(Photo. Dr. Fr. Stoedtner, Berlin)

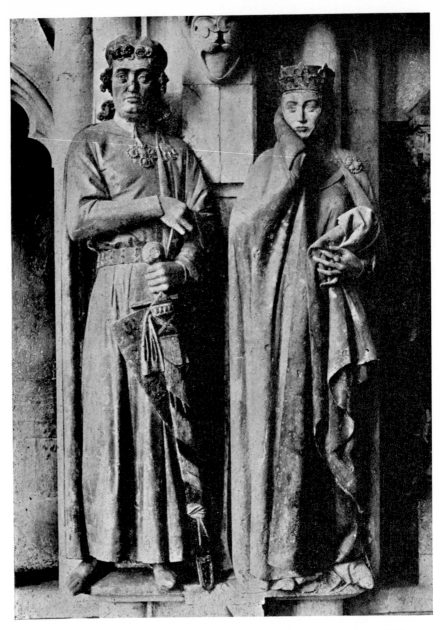

FIG. 46. EKKEHARD AND UTA. WEST CHOIR, CATHEDRAL, NAUMBURG

(Photo. Dr. Fr. Stoedtner, Berlin)

Wechselburg occur in Saxony in the rather slovenly tympanum of the north or Paradise Portal at Magdeburg and in the frieze of scenes from the Passion and the larger Calvary on the screen of the west choir at Naumburg. The Assumption of the tympanum, however, contains such details of homely German realism as the brazier to light the incense and the stretcher upon which the angels uplift the Virgin's body. The Wise and Foolish Virgins at the sides of the door are superior in style, but German emotionalism sways their bodies and arms out of architectural lines and sporadically brings their expressions into a dangerous proximity to caricature. In the Church and Synagogue of the same portal the old agitation of the drapery reappears. The twelve statues of benefactors of the cathedral in the west choir of Naumburg, though not strictly portraits, are the most imposing instances of powerful individualization in the thirteenth century. They perhaps have some relation to the King and Queen of the Portal of Adam at Bamberg; at least, the impression of majesty in both cases is increased by the heavy folds of the thick garments. The masculine figures are more forceful than attractive, the straining after expressiveness has rarely proved successful, but one or two of the women, especially the Markgräfin Uta, have true physical and spiritual beauty (Fig. 46). As dependent upon the school of the Naumburg choir may be reckoned the more provincial effigies of saints and donors in the choir of Meissen, and, from the later statues of the south portal at Münster, at least the Knight and the Magdalene.

The cathedral of Strassburg is the most important monument, for the sculpture of this period, in the southern district of the Rhine. To the first half and middle of the century belong the Church, the Synagogue, and two tympana with the Death and Coronation of the Virgin (Fig. 47) on the portal of the south transept, and a pier of the south transept adorned with the participants in the Last Judgment arranged in three tiers. Since the sculptors of these works must have been actually educated among the masters who in the thirteenth century executed the carvings of Chartres and Paris, their productions possess slimmer proportions and greater refinement, elegance, and simplicity than those of their Saxon rivals. It was, in part, the softness of the stone employed that permitted more delicacy in detail. Occasionally, however, as in the Death of the Virgin, a poignant intensity suggests the German strain. The wealth of sculpture on the triple portal of the west façade dates from the end of the thirteenth and the beginning of the next century. On the central door, the Prophets form the chief *motif*; on the south door, the Wise and Foolish Virgins; on the north door, the Virtues triumphant over the Vices. Although the statues

retain much of the exquisiteness of France, they are not only more German than the earlier group but already slightly infected with the spiritual aridness of the fourteenth century and with its mannerisms in pose and drapery. The zones of the tympana also have much of the early fourteenth century's gentle but still noble charm in narrative. The frieze on the south and north towers of the façade has less significance as a technical performance than as a most inclusive and vigorous series of episodes of Gothic *genre*.

About the same time and in a similar but inferior style was executed the prodigal sculptural adornment of the porch of the cathedral at Freiburg in the Breisgau. In the two rows of Wise and Foolish Virgins, allegorical figures, and saints along the inner sides of the porch, the Teutonic type is unmistakable. The statuary on the west portal of Trèves belongs to an earlier date in the thirteenth century, and is perhaps more French than any other of these Rhenish monuments, recalling the productions of Amiens but now and then betraying the less facile chisel of a provincial.

The tombs of the thirteenth century generally do not exhibit, in type or in treatment, any radical difference from the French, except that the effigy was still executed in relief much more commonly than in the round. The monument of Duke Henry IV of Silesia in the Kreuz-Kirche at Breslau exemplifies the class in which the figure is placed upon a high base carved with the ceremony of the obsequies. The base of the posthumous sepulchre of the pope Clement II in the cathedral of Bamberg is so unusual in its subjects — St. John the Baptist at one end, balancing a vision of the Pontiff at the other, and curious representations or symbols of the Virtues along the side — that certain critics have guessed at an Italian origin. The absent effigy of the deceased has sometimes been identified with a statue now upright beside the east choir. The base and figure are surmounted by an imposing canopy in the monument of the Count Palatine Henry II in the abbey of Laach. Occasionally the bases are very low. As already in the Romanesque period, the figure was sometimes set in a kind of open box, sometimes was left unframed. It is surprising, when one remembers the architectural statues of the period, that there was little more attempt at portraiture than in France. Some individualization may perhaps be here and there discerned, for instance, in the tombs of Dedo and his countess at Wechselburg and of Henry the Lion and his duchess at Brunswick, but these belong to a small group that differ in a more essential respect from French examples: the extraordinarily free and ample draperies have the agitation that has been noted in the architectural sculpture of the transition from Ro-

manesque to Gothic, with which the mortuary series is probably contemporary. These sepulchres, together with the more ideally conceived effigy of Wiprecht von Groitzsch in the monastery of Pegau, are exceptional in Germany also because they begin to recognize the recumbent posture. The monument to Otho the Great in the Old Market of Magdeburg is commemorative rather than funereal. The two allegorical females who accompany the emperor are in the style of the Synagogue of the cathedral; the idealized equestrian figure itself is a worthy brother of the mounted saint at Bamberg.

4. THE FOURTEENTH CENTURY

During the fourteenth century, in Germany, as elsewhere, the local divergences that we have observed in the thirteenth century were effaced, and everywhere the single international style was employed, which Germany joined with the other countries of Europe in borrowing from France. The process, unfortunately, did not consist in elevating all sculpture to the greatest heights of the preceding period, but rather in leveling to a norm of comparative mediocrity. The vibrant energy and noble beauty of the forms yielded to a weaker and more mannered idealism. Correct proportions and truth to nature gave way to a certain degree of slovenliness and to an accommodation of the statue to the Gothic slouch. The greater individualization of the personages that had been the distinction of Germany in the thirteenth century was abandoned for fixed types, which differed from the French only in the choice of Teutonic features as a starting-point for the conventionalization. The wonderful use of the garments to define the character and thought of the figure was sacrificed to the familiar amplification and undulation. The action of the body that had been accentuated by the manipulation of the drapery or sometimes revealed by its diaphanous texture was now concealed by thick and heavy folds, and the imaginative variety of the drapery was forgotten. The loss of monumentality in the statues implied also diminished size, and in the same spirit the small scenes from sacred narrative were multiplied, often exhibiting the tendency to homely realism that in the next century was to become so characteristic of Germany. Saxony and the north in general, with the exception of the region of the Rhine, resigned the important rôle that they had hitherto played in the history of sculpture. Here and there indigenous tendencies put in a timid appearance amidst the universal style. Among the chief examples of sculptural decoration for churches in the fourteenth century may be mentioned: the Annunciation, Visitation, and Apostles on the pillars of the choir in the church of St. Victor, Xanten, obviously

under strong French influence; the Christ, Virgin, and Apostles on the
pillars of the choir of the cathedral at Cologne, distinguished by the
expression of mystical intensity which is so characteristic of the art of
this city; the statues from the Ueberwasser-Kirche now in the Mu-
seum of Münster; the double north portal of the cathedral of Erfurt;
the south portal of the cathedral of Worms; in Swabia, where already
there began to manifest itself that tendency towards softness and sen-
timent that in the next century was to develop into a kind of *détente*,
the south and west portals of the Kapellen-Kirche at Rottweil, the por-
tals of the Kreuz-Kirche at Gmünd, the portals of the cathedral of
Ulm, and the north and south portals of the cathedral of Augsburg;
the three portals of the Marien-Kapelle at Würzburg; the major part
of the exterior and interior statuary of the cathedral of Ratisbon; and at
Nuremberg, which through industrial prosperity was already embarked
upon the way to its high artistic destiny, the southwest, northwest,
and northeast portals of the church of St. Sebaldus, the somewhat
inferior and probably later portal of the church of St. Lawrence, the
rich decoration of the church of Our Lady,[1] the statuettes of heroes
and saints from the Schöner Brunnen (the place of which on the
fountain has been supplied by copies and the original fragments of
which are now distributed between the Museums of Nuremberg and
Berlin), and the seated Apostles of terracotta, six in the Museum of
Nuremberg and four in the church of St. James. It was especially
amidst the vigorous civic life of Nuremberg that even more than at
Cologne or in Swabia indigenous qualities reasserted themselves. The
heads of the heroes from the Schöner Brunnen have more reality, the
Apostles of terracotta are strongly individualized, the sacred narra-
tive in the tympana of St. Lawrence and St. Sebaldus is related with
Teutonic *bonhomie*. The statue of Otho I at the center of the west
door of Magdeburg recalls the contemporary Franco-Flemish style of
Paris.

Germany has also her mannered and often charming Madonnas of
the fourteenth century. Typical specimens may be seen in St. Ursula,
St. Gereon, and the Museum of Industrial Art at Cologne, in the par-
ish church at Herzebrock, on a pier of the cathedral of Würzburg
(with the three Magi), and, with the seated posture, in the parish
church at Goch and in the Museum of Rottweil (from Ueberlingen).
The wooden retables began to appear as early as about 1350, but they
did not become numerous or usually anything more than clumsy pieces
of handicraft until the next century. They comprised first only a
series of small figures or of groups with a few actors.

[1] The porch perhaps belongs to the early fifteenth century.

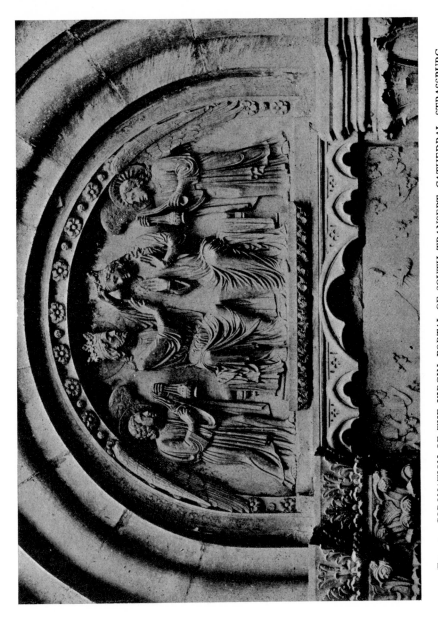

FIG. 47. CORONATION OF THE VIRGIN, PORTAL OF SOUTH TRANSEPT, CATHEDRAL, STRASSBURG

(From Dehio and Von Bezold, "Die Denkmäler der deutschen Bildhauerkunst")

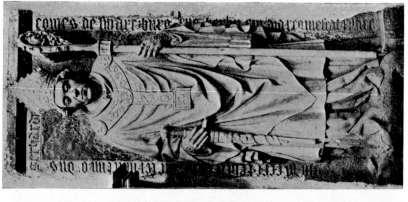

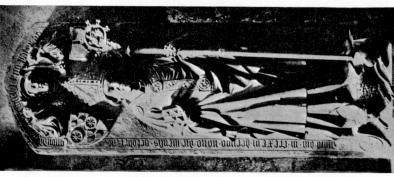

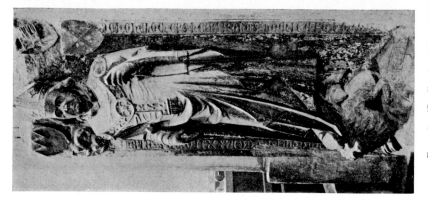

Fig. 48. (*Reading from left to right*) TOMBS OF ALBERT VON HOHENLOHE, CATHEDRAL, WÜRZBURG; KONRAD VON WEINSBERG, CATHEDRAL, MAYENCE; GERHARD VON SCHWARZBURG, CATHEDRAL, WÜRZBURG,

The tombs, which now greatly increased in number, perhaps afford more important pieces of sculpture than the monumental decoration of churches. Already in the fourteenth century, the simple slab was occasionally exalted from its former place on the pavement to an upright position on the wall. The *motif* of the mourners around the sides of the raised base became common in Germany as elsewhere. For the ordinary high base there were now sometimes substituted four pillars, or more rarely two vertical planes or the bodies of lions, so that the tomb looks like a table upholding the effigy. Now and then, on the floor beneath the table, was placed another slab with another effigy. So in the Wilhelmer-Kirche at Strassburg, the canon Philipp von Werd is represented beneath his brother, Count Ulrich. Although the figure was still sometimes enclosed in a kind of case and sometimes was left unframed, in many other instances it was surrounded by Gothic architectural detail, giving the effect of a body ensconced in a shrine, occasionally with statuettes in the lateral sections or with a projecting *baldacchino* above the head. In other examples the Gothic ornament was combined with the old casing. The archiepiscopal slabs of Siegfried von Eppstein (end of the thirteenth century) and Peter von Aspelt in the cathedral of Mayence indulge in a curious bit of sepulchral iconography, which represents the bishop crowning kings or emperors. In accordance with the prevalent addiction to "fussiness," there was a multiplication, in Germany particularly, of such decorative elements as escutcheons and helmets. It cannot be said that the artists were yet able to render the recumbent attitude. The draperies have the usual mannerisms of the period.

The significant fact about the tombs is the development of portraiture earlier than in the rest of Europe, betokening the reassertion of the German spirit. Among the most impressive examples are the effigies of the following persons: the Bishop Ludwig von Marronia in the Augustinian Church at Erfurt, Johann von Holzhausen and his wife in the cathedral of Frankfort on the Main, the Bishops Mangold von Neuenburg, Albert von Hohenlohe, and Gerhard von Schwarzburg in the cathedral of Würzburg, the Bishop Konrad von Weinsberg in the cathedral of Mayence (Fig. 48), and the Bishop Wolfhart in the cathedral of Augsburg. The desire for expressiveness reappears even more than in monumental sculpture, notably in the tombs of Ekro vom Stern in the Bürgerspital at Würzburg and of the Empress Uta in St. Emmeram at Ratisbon. As evidence of the esthetic possibilities sometimes realized in these sepulchres should be mentioned also the monuments of the blessed Aurelia in St. Emmeram, Ratisbon, of Friedrich von Truhendingen in the cathedral of Bamberg, of Engel-

hard von Weinsperg (?) in the Dominican church at Wimpfen am Berg, of Otto III von Ravensberg and his family in the Marien-Kirche at Bielefeld, and of Anna, the first wife of the Emperor Rudolf of Hapsburg, in the cathedral of Basel.

5. THE FIFTEENTH AND SIXTEENTH CENTURIES

German sculpture of the fifteenth and early sixteenth centuries possesses the qualities that were common to the greater part of Europe during the period, but with certain indigenous modifications. The realism was more accentuated and more brutal, but it was ordinarily restricted to the heads and extremities, for the Germans interested themselves in anatomy scarcely more than in the earlier centuries and substituted for it the drapery as a vehicle of expression. Individualization was carried to such a point that occasionally it verged on caricature. Grimaces and extravagant gestures are likely to take the place of high dramatic expression, which the Germans were seldom able to attain. In lieu of the dramatic, however, the figures, especially in the school of Swabia, were often infused with intense and even tragic feeling. The rise of the people in the great industrial towns to the position of patrons gave the realism a tone that was perhaps even more *bourgeois* than in the Low Countries. The types are frankly popular; and the general German tendency to excess often cooperated with the fondness of the middle class for ostentation to exaggerate the expressiveness of face and body, to transform grace into affectation, and to overload the monuments with ornament. The curious thing is that the naturalistic heads were combined with highly conventionalized drapery. The European epidemic of complicated folds was accentuated by German extravagance, partly in a desire for pronounced pictorial impressions of chiaroscuro. Once granted the schematic arrangements, it must be acknowledged that the details were realistically rendered. The nature of the favorite material of the age, wood, played its part also in breaking up the drapery into small, brittle, knotty folds, often intersecting in confused patterns. The ease with which wood could be worked betrayed its manipulators into considering an expanse of fabric as a legitimate object for the exhibition of their virtuosity, a thing apart, without any necessary relation to the body that it adorned, but here again the contemporary love of ostentation might have produced the same result. The peculiarities of wood were either transferred to other mediums, or appeared there spontaneously. At the beginning of the sixteenth century, such men as Riemenschneider and Backofen were more or less inclined to return to a more orderly and dignified arrangement of longer folds, but between these folds the old disease

still retained a certain hold. The late Gothic of Germany, especially in its love of display and pictorial effect, may be conceived as the baroque stage of early Gothic; and though it has the defects of the baroque, it also has the merits of the style, a compelling emotional abandon and an impressive grandiloquence.

As elsewhere, sculpture largely lost its monumental function in architectural decoration. It was now confined chiefly to tombs and to articles of ecclesiastical furniture, such as choir-stalls, tabernacles, and particularly the great wooden retables that are so characteristic of Germany. The fourteenth century types of tombs remained; but the class with high base became much rarer, and by the sixteenth century the kneeling effigy of the deceased was a common theme on the upright slab. The impression of recumbency was sometimes attempted. The *epitaph*,[1] which had been introduced in the preceding century, now entered upon a general vogue. The deceased, as a kind of donor, was usually dwarfed in the *epitaph* to small proportions in comparison with the sacred figures, and the individualization of his features was therefore not so scrupulous as in the other sepulchral types.

The essentially German retable was evolved in the south. The center is occupied by a large box, usually rectangular (*Schrein*), containing the representation of a sacred scene, a row of sacred personages (the central one raised slightly above the others), or a combination of both *motifs*. Very commonly the top of the *Schrein* breaks at the middle to give place to a small, additional rectangular elevation. The space of the *Schrein* is sometimes divided into a horizontal series of large compartments, but in the south the vertical superimposition of one compartment upon another is very rare. The *Schrein* is flanked by single (sporadically double) wings, which ordinarily open and shut. The painted subjects connected with the main theme of the *Schrein*, which seem to have been the earlier custom on the wings, are often replaced by carved reliefs, which may be single large representations or, much more rarely, a set of smaller representations or figures side by side or above one another. The subject of the *predella* is not necessarily related to the main theme. Above the *Schrein* rises an elaborate Gothic structure of florid turrets and open-work, the *Aufsatz*, enclosing statues or even scenes; the most usual subject for the *Aufsatz* is the Crucifix or the Ecce Homo accompanied by other personages of religious history. The *Schrein* and other sections of the altarpiece are filled with the most opulent decoration of Gothic foliage, and gold predominates in the polychromy. In the retables of northern

[1] See above, p. 88.

Germany, which imitate the Flemish, the *Schrein* and wings are sep-
arated into a larger number of compartments, occupied by crowds of
smaller figures in animated episodes. Sometimes on northern retables,
under the influence of southern Germany, effigies of sacred personages
were ranged beside the scenes. All German sculpture of this epoch
was much influenced by contemporary painting in its predilection for
narrative reliefs and for picturesque detail; but by emphasizing this
tendency, the retables of the north sacrificed that monumentality, of
which a certain degree lingered on in the south, transferred from the
portal to the altarpiece and partly obtained by the frequent substitu-
tion of a row of statues for the relief, or, when the relief was employed,
by the use of fewer and larger figures.

<div align="center">NORTHERN GERMANY</div>

The sculpture of Germany at this time may be divided into two
great geographical groups, the northern and the southern. The former
was largely dependent upon the Low Countries. The latter, though
perhaps here and there subject to foreign influence, was thoroughly
German and far more significant.

The most interesting productions of the north were the retables.
What architectural statuary there was, now found its principal place
in the interior of churches. Among the best specimens of stone sculp-
ture are the statues of the four Fathers of the Church, St. Martin, and
St. Victor on the pillars of the choir of St. Victor's, Xanten, embodying
the pictorial and realistic style of JOHANN VON GOCH in the second
half of the fifteenth century. The Stations of the Cross before the
south portal of the same church, dating from about 1525, though trans-
lations of the panels of some Passion-altar into stone and into larger
compass, are correct in proportions and achieve much simple monu-
mental feeling. The greatest centers in the north for the manufacture
of retables were Calcar on the lower Rhine and Lübeck in the Hansea-
tic region. The works of the school of Calcar may be studied also at the
adjoining towns of Xanten and Cleve. The school of Lübeck enjoyed
an enthusiastic market in Denmark and Sweden, so that the churches
and museums of those countries are as rich in examples as Lübeck it-
self. The reason for the Flemish influence was the proximity of the
Low Countries; Jan Borremans had actually exported an altar to
Güstrow in Mecklenburg, and the group of sculptors at Calcar was in
all probability partly a foreign colony. The principal artists living in
the second half of the fifteenth and at the beginning of the sixteenth
century were: at Lübeck, HARMEN RODE, BERNT NOTKE (who
may be the author of the celebrated group of St. George and the
Dragon in the National Museum, Stockholm), HENNING VON DER

HEIDE, and BENEDICTUS DREYER; at Calcar, MASTER AR-
NOLD, MASTER LOEDEWICH, and HEINRICH DOUWERMANN;
and HANS BRÜGGEMANN, who, a Saxon by birth, in his famous
retable in the cathedral of Schleswig, realized the stockier and ruder
German type more than his rivals. Heinrich Douwermann's son,
JOHANN, and especially the Dutchman, ARNOLD VAN TRICHT,
began to introduce the mannered elegance, rhetoric, and ornamenta-
tion of the Renaissance into the altarpieces of Calcar, but poverty and
religious strife, about the middle of the sixteenth century, brought the
artistic productiveness of this region to an end.

SOUTHERN GERMANY

FRANCONIA

THE SCHOOL OF NUREMBERG. In the south, the province of Fran-
conia included the most famous names. It was distinguished from the
other southern provinces by a more passionate intensity and by a more
pronounced love of the dramatic. Of the two great artistic cities,
Nuremberg and Würzburg, the former was the more important. The
heyday of sculpture in Nuremberg began in the second half of the
fifteenth century; but a growing naturalism, continuing the tendency
that we have already found in the fourteenth century at Nuremberg,
is revealed in several monuments before 1450, such as the Deokarus-
altar, with Christ and the twelve Apostles, in the church of St. Law-
rence, a Madonna and Child with angels beside a pillar in the church
of St. Sebaldus, preserving still the original color on the wood, a
colossal St. Christopher on the outside of the east choir of the same
edifice, in which the "tormenting" of the drapery has already begun
and the realism has become detailed, and the Entombment by Hans
Decker (?) in the Wolfgangs-Kapelle of St. Aegidius, executed in 1446.
The characteristics of the fifteenth century, the realistic heads and
the puckered draperies, are already developed in the sculptured sec-
tions of the altarpieces from the workshop of the painter MICHEL
WOLGEMUT (1434–1519) (whether or not he himself did any of the
carving); but his compositions are less agitated than was usual
among his compatriots, very little sincerity seems to underly his
figures, the emotional gestures are perfunctory, and the expressions on
the faces are like those of masks. Typical is the Deposition, the *Schrein*
of the Haller altar in the Chapel of the Holy Cross at Nuremberg.

The *Schrein* of another altarpiece in the church of St. John at Schwa-
bach, ordered from Wolgemut in 1507, was turned over by him to the
sculptor who best incarnated the passionate intensity of the art of
Nuremberg, VEIT STOSS. Not only do the learned pundits disagree

about the date of his birth, which is set even as early as 1431, but the place also is in dispute, since both Poles and Germans claim him as a fellow-countryman. Certain it is that from 1477 to 1496 he was active at Cracow, which since the fourteenth century had given an enthusiastic welcome to German artists, especially those of Nuremberg, and the excitement of his figures has sometimes been traced to his hypothetical Polish blood. He found employment at Nuremberg from 1496 until his death in 1533, though a part of the time he was in disgrace for his flagrant dishonesty; and the main elements in his art seem to have been evolved from precedents at Nuremberg.

His outstanding trait is the dramatic force of his personages. The energy becomes at times almost fierce, as in the marble slabs of the Archbishops Gruszczynski and Oleśnicki in the cathedral of Gnesen, both probably authentic works of the master. Despite the gripping effect of the individual figures in this respect and in harsh realism, the Death and Assumption of the Virgin, the *Schrein* of his first great retable, in St. Mary's at Cracow (Fig. 49), betrays his inability to create a unified dramatic composition or to infuse the restless poses with convincing freedom. The studied postures are often lacking in ease. The perturbation of the forms is carried into the draperies, which are pulled, wound, and broken into the most tumultuous shapes and disorderly arrangements without relation to the bodies whose movements they hide rather than emphasize. The cope of the Virgin in the Annunciation, which is the center of the great Rosary hung above the choir of St. Lawrence at Nuremberg, shows how the fabrics are often tossed up over or beside the body in arbitrary swirls. The same peculiarity may be studied in the lovely wooden Madonna that he did for his own house, now in the Germanic Museum of the same town. He excelled in emotionally realistic Crucifixes, as in that of the church of St. Lawrence. Essentially a wood-carver, he used the deep cuttings of that material in the few instances where he tried his hand at stone, as in the reliefs from the Passion in the choir of St. Sebaldus. The ebullitions of his style subsided somewhat at Nuremberg. The calmer mood is well illustrated by the late altarpiece of 1523 in the Pfarrkirche at Bamberg, in which the slightly more classical drapery, as perhaps in a few other panels by the master, may indicate the only trace of an influence that the Renaissance exerted upon him. His chief merit is found in the powerful personality that underlies all his productions and not seldom lifts his figures even into the sphere of the heroic; but by his pompous groups, mannered gestures, and sweeps of garments, he also realized, more than any of his contemporaries, the best possibilities of the baroque.

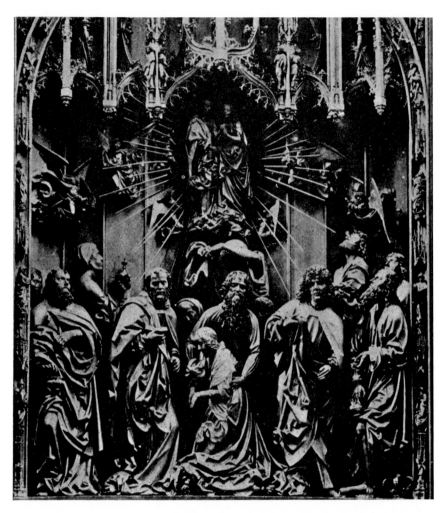

FIG. 49. VEIT STOSS. DEATH AND ASSUMPTION OF THE VIRGIN.
ST. MARY'S, CRACOW

(*Photo. Langewiesche*)

FIG. 50. KRAFFT. THE DEPOSITION. GERMANIC MUSEUM, NUREMBERG

(Plate By E. St ... dam. Berlin)

The stylistic traditions of Veit Stoss were preserved at Cracow by his son, STANISLAUS, for over twenty years, devitalized by his inferior talent and toned down by contact with the Renaissance. After the departure of Veit, indeed, such factors as hatred of German culture and the marriage of Sigismund I to Bona Sforza gradually ousted Teutonic art and enthroned in its stead the new Italianism. The manner of the Stoss workshop, however, had already conquered more territory in Poland and Hungary, even as far as the provinces of Silesia and Transylvania.

ADAM KRAFFT (between 1455 and 1460–1509) differed both in medium and temperament from Veit Stoss. Active only at Nuremberg, he had the almost unique distinction, at this period, of confining himself to the old Gothic material of stone. Trained possibly in the more placid school of Ulm, he refrained from Stoss's emotional extravagances. Although he does not characterize so powerfully, his realism is more sincere. He is less imaginative, but at the same time he does not seek effect through mannerisms. A simple and honest craftsman, he represented what he saw without affectation. He could not disentangle himself completely from the contemporary meshes of drapery, but partially because he felt in stone rather than in wood, his folds are much simpler than those of Stoss and better accommodated to the bodies. The outer edge often forms itself into a lovely undulation of protracted wave-lengths. His modelling is more summary and less scrupulous, the proportions are not always correct, but the postures are likely to possess more naturalistic ease, and the compositions hold together more tightly.

His first great work of 1492, the decoration of the sepulchral grotto of the Schreyer family on the outside of the choir of St. Sebaldus with scenes from the end of Christ's life, is extremely pictorial, because his patrons requested him to reproduce in stone the paintings that had until then adorned the walls of the monument. The background is an elaborately carved landscape, but the planes are not well related to one another. Having imitated the painter in stone, he undertook, in the multiplied and highly wrought details of the ciborium [1] for the church of St. Lawrence (1493–1496), to reproduce the art of the goldsmith. Among the almost countless figures of the tower-like structure, the reliefs are notable for the more consistent treatment of the modified pictorial perspective. The crouching forms used as supports at the base have been taken for the master and two apprentices. By the middle of the fifteenth century the German ciborium had already be-

[1] "Ciborium" is used in this book in the sense of a receptacle for the Sacrament and not of an early Christian *baldacchino* above the altar.

come a pretentious affair. The monument by Krafft set the precedent for many a similar one, and the examples at Kalchreuth and in St. Kilian at Heilbronn may actually be connected with his workshop. The culmination of his career is embodied in the restored seven Stations of the Cross (1505), six of which are now in the Germanic Museum, Nuremberg (Fig. 50, the Deposition), and replaced, on the road to St. John's Cemetery, where they originally stood, by modern copies. The other relief of the seven, the Fourth Station, representing the encounter with St. Veronica, is built into the wall of a house on the Burgschmiet-Strasse. The pictorial method is now definitely supplanted by the truly sculptural. The details are not labored, and there is a nobler realism of the whole body. A more monumental result is obtained by the fewer, larger figures, by the simpler draperies and compositions. Other interesting works of Krafft are the lovely *epitaph* of the Pergenstörffer family in the Frauen-Kirche, representing the Virgin of Mercy, and the humoristic relief of the weighing of merchandise over the gate of the Stadtwage.

THE SCHOOL OF WÜRZBURG. The other great Franconian school of Würzburg, ushered in by a few unimportant works of the earlier part of the century, centers about TILMAN RIEMENSCHNEIDER (1468?– 1531), equally successful both in stone and wood. His magnificent series of sepulchral monuments, most impressive among which is that of Bishop Rudolf von Scherenburg in the cathedral, shows that he had Franconian realism at his disposal; but when not dominated by the necessity of portraiture, in his religious pieces he fell into lyric strains that he may have learned in Swabia. Neither in single figures nor in compositions was he a dramatist, and he was far from an interesting story-teller. The passionate intensity of Veit Stoss was to him a closed book. Only the faces and the hands are used as vehicles of emotion. Living when and where he did, he was bound to treat his faces and forms naturalistically, but they are rather divided into types, masculine and feminine, young and old, and the individuals among the types are not strongly differentiated. The heads, often too large for the bodies, stare bluntly and fixedly at one another or at the spectator. His talent lay in another direction. His countenances are infused with a dreamy, melancholy poetry, strangely inconsistent with his unusually active and practical life in the communal affairs of Würzburg. As far as was possible for a German of the late Gothic period, he had, like the artists of Swabia, a feeling for ideal beauty. In contrast to the more robust forms of Nuremberg, his canon was a slim and graceful body, with disproportionately long legs. For all these reasons his most characteristic figures are feminine, marked by

the sloping shoulders and small breasts of contemporary fashion. Of a large series of Madonnas by the master himself and by his pupils, most notable, from his own hand, is the example in the Städel Art Institute at Frankfort on the Main. The ample hair of the men spreads in a great circle over the shoulders. The draperies, too, though disturbed by the prevalent unrest, fall in longer, more classical folds. In technical facility he excelled Stoss and Krafft. *Mutatis mutandis* he was the Francesco Laurana of Germany. The Renaissance, however, had virtually no effect upon him, introducing some architectural details in only two of his productions, if, indeed, the decoration is by him — the tomb of Lorenz von Bibra in the cathedral of Würzburg and the medallions of the Rosary in the church on the Kirchberg at Volkach.

Besides the works already mentioned, the style of Riemenschneider may be studied at its best in the following monuments: the Adam and Eve from the south portal of the Marien-Kapelle, Würzburg, and now in the collection of the Historical Society of that city (1491–1493); his three great retables, of the Virgin in the Herrgotts-Kirche at Creglingen (1495–1499), of the Crucifixion in the church at Detwang (about 1500), and of the Holy Blood in St. James at Rothenburg (1499–1505) (Fig. 51), all in the valley of the river Tauber; the tomb of Henry II and Kunigunde in the cathedral of Bamberg (1499–1513); and the bust of a youthful saint belonging to the Altman Collection in the Metropolitan Museum, New York.

The later Gothic sculpture of lower Franconia is largely derived from Riemenschneider. The Metropolitan Museum possesses also a half-length Madonna by one of his pupils.

The comparatively unimportant production of Lower Saxony, the Electorate of Saxony, and Hessen during this period owed a considerable debt to Franconia.

SWABIA

The school of Swabia, if less celebrated than that of Franconia, attained as high an artistic level and possessed distinct merits of its own. In contrast to the agitation and drama of its rival, it cultivated restfulness and the expression of deep but not passionate feeling, sometimes through restrained gestures but chiefly only through the countenance. The ordinary arrangement for the *Schrein*, therefore, was simply a row of sacred personages. When reliefs were attempted, the result was hardly ever a compact composition, and the theme was treated more calmly. The forceful and profoundly realistic individualization of Franconia must not be usually expected. In compensation the ampler drapery is not so hard, broken, and contorted, but flows in

fuller folds. In its greater tranquillity the art of Swabia corresponds to the art of the Loire in France, and if its style had spread, a general *détente* might have occurred.

The greatest and most essentially Swabian center was Ulm. The first significant name is that of HANS MULTSCHER (active 1427–1467). His principal extant work in sculpture is the dismantled altarpiece of Sterzing in the Tyrol, the main parts of which are now scattered through the churches and Rathaus of that town. Dreaming heads are set upon drooping bodies, largely hidden by the garments and not defined by any activity. His chief interest is the copious, trailing drapery, which, only slightly changed from the style of the fourteenth century, increases the impression of languor. The naturalistic development has reached the stage represented by the Madonna and the St. Christopher of St. Sebaldus at Nuremberg. The Swabian sensitiveness to ideal beauty may be illustrated by any of the saints and angels of the Sterzing altar. By his poses and sweep of drapery Multscher attained, despite his contemplative style, a certain effect of grandeur.

Multscher's successor was JÖRG SYRLIN (*c.* 1430–1491), who was able to achieve a most happy compromise between the peacefulness of the Swabian school and realistic expression, and who, therefore, was the Adam Krafft of Ulm. The drapery no longer absorbs an inordinate attention but performs its proper function as a part of the general impression. The body emerges as a prime factor and is more correctly rendered, though there is no laboring of detail. The individualization is adequate, but not, as in Veit Stoss, overemphasized. In Jörg Syrlin, the repose of the figures is not felt to be the result of a dispassionate temperament on the part of the artist, but rather of conscious restraint. Of his few documented works, the most important are the choir-stalls of the cathedral of Ulm, like other south German examples, less overladen with ornament and figures than in the Low Countries or northern Germany. Though some would degrade him into a mere carver of ornament, he probably planned the whole series, and executed with his own hand at least the Sages and Sibyls above the ends of the kneeling benches of the stalls and sedilia. Somewhat similar in style but by a more emotional master, perhaps Heinrich Yselin, are the twelve busts from the stalls of the abbey of Weingarten, now in the National Museum at Munich.

Syrlin's son, JÖRG SYRLIN THE YOUNGER (1455–*c.* 1521), reverted partially to Multscher's reveries. His forms are less instinct with life and his draperies less functional; yet at times, in his own way, he was quite his father's equal. The choir-stalls at Blaubeuren, En-

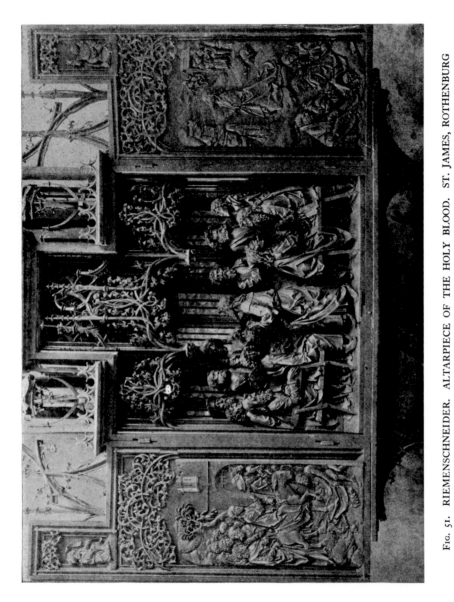

FIG. 51. RIEMENSCHNEIDER. ALTARPIECE OF THE HOLY BLOOD. ST. JAMES, ROTHENBURG

(Photo. Neue Photographische Gesellschaft, Steglitz)

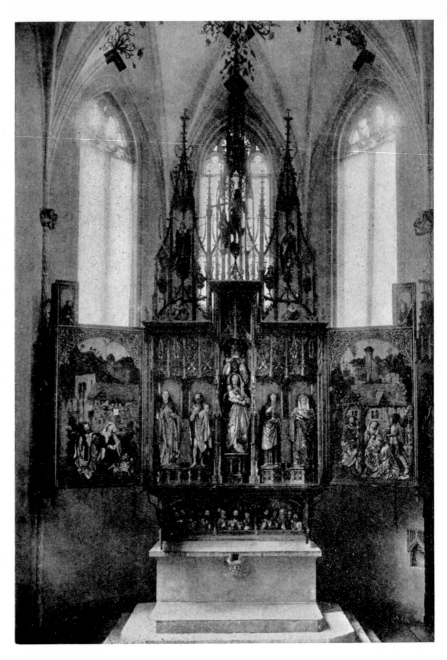

FIG. 52. ALTARPIECE AT BLAUBEUREN

(Photo. Dr. Fr. Stoedtner, Berlin)

netach, and Geislingen were ordered from him and are partly by his hand, the last in a homelier style. Of the retables for which he received the commissions, the pieces from the Ochsenhausen example, now in the church of Bellamont, and the seven *Schreine* from Zwiefalten, now in the Museum of Wurtemberg Antiquities at Stuttgart, were executed in collaboration with his pupils. The figures of the beautiful altarpiece at Bingen near Sigmaringen have also been ascribed to Syrlin the Younger.

The unknown sculptors of two other famous Swabian altars at Tiefenbronn and Blaubeuren (Fig. 52) may be brought into connection with the same local school. The superbly expressive statues of the latter *Schrein*, however, are less phlegmatic than is usual at Ulm.

At the very end of the Gothic period, the production of altarpieces at Ulm became more of a mere industry, unillumined by any great names. The Swabian peace was disturbed by crowds of figures and by a more wanton complication of the drapery. The narrative reliefs obtruded very generally into the *Schrein,* and the craftsman did not shrink even from pictorial backgrounds. Good instances may be seen, near Ulm, at Reutti and at Wettenhausen.

Of the other Swabian cities, Augsburg, during the Gothic period, had little significance as a sculptural center. In wood-carving it was almost sterile. The less celebrated towns of Nördlingen and Heilbronn are more important. The lovely sculptures of the retables in St. George of Nördlingen, St. James of Rothenburg, and at Bopfingen, ordered from FRIEDRICH HERLIN of Nördlingen (*c.* 1435–*c.* 1500) and painted by him, are apparently by a different hand that delights in magnificent sweeps of deep-channeled drapery. It is possible that this is the hand of SIMON LAINBERGER, whom research may eventually prove to have been one of the first great masters of the school of Nuremberg in the fifteenth century. The Calvary behind the church of St. Leonard at Stuttgart seems to be by HANS VON HEILBRONN, to whom also has been ascribed the retable of the high altar of St. Kilian's in Heilbronn itself, one of the masterpieces of Swabian art. Both these monuments are distinguished by an unexpected and penetrating realism. At Hall, by a curious anomaly, the principal altars are like those of northern Germany.

BAVARIA

The features of the other south-German schools do not stand forth so clearly. In Bavaria, the presence of quarries of limestone and red marble gave greater popularity to these materials than to wood. The most striking examples are a number of sepulchral slabs in Munich and the other Bavarian towns, with the usual unsparing German

characterization. The only name of any renown is that of ERASMUS
GRASSER, who signed in 1482 the red marble *epitaph* of Ulrich
Aresinger in St. Peter's church, Munich. To him have been ascribed
the rather elongated Apostles and Prophets of the stalls of the Frauen-
Kirche at Munich (1502), livelier in attitude and more penetrating in
characterization than the similar productions of Swabia. Both these
qualities are purposely carried by him into the realm of caricature in
the ten statuettes of lithe morris-dancers on the corbels of the great
hall of the Old Rathaus (1480). The National Museum possesses sev-
eral Bavarian altars, the reliefs and figures of which are sometimes as
agitated as in northern Germany, sometimes almost as quiet as in
Swabia. The best known wood-carvings of Bavaria, the Christ, Virgin,
and Apostles of the church at Blutenburg near Munich (1496), are
more praiseworthy for their appreciation of ideal beauty and for the
comparative freedom of their majestically conceived draperies from
the ordinary German conventions than for convincing lifelikeness or
skilful modelling.

THE TYROL

The proximity of the Tyrol to Italy spelled Italian influence, but
MICHAEL PACHER of Bruneck, the only important sculptural
personality in this region (*c.* 1435–1498), was also acquainted, in some
way, with Flemish and perhaps Burgundian art. Critics have doubted,
as in the case of Wolgemut, whether Pacher himself did the sculp-
tured parts of his altarpieces, but the affirmative answer is probably
the correct one, and it is rather the paintings that may have been
largely done by other hands. His compositions are pictorial, evi-
dently suggested by Flemish paintings even down to the ubiquitous
little angels. The *Schrein*, however, is not occupied, as in the altars of
the Low Countries, by a crowd of small excited figures, but by truly
monumental compositions of a few large and solemn forms. The
desire for a somewhat more classical beauty may be affected by the
Renaissance, and the draperies, though involved in the customary
meshes, have much of Sluter's wonderful pomp. Nevertheless, de-
spite his superficial foreign importations, Michael Pacher, in types and
in other respects, remained essentially a German. His two principal
works are the altarpieces of Gries near Botzen (carved wings by pupils)
and of St. Wolfgang on the Abersee.

THE UPPER RHINE

In the region of the upper Rhine, perhaps the most interesting figure
is a foreigner, NIKOLAUS OF LEYDEN (d. 1487). Notwithstand-
ing his Dutch birth, he seems to have received his training in the
school where Flemish characteristics were transfigured into a nobler

form, the workshop of Dijon, and it was the style and more lyric real-
ism of Sluter, almost at their best, that he introduced into Strassburg
and other parts of the Teutonic domain. The busts of a Sibyl and
Prophet from a door of the Chancery at Strassburg, though destroyed
in the siege of 1870, may still be seen in casts. Four wooden busts in
the convent of St. Mark are also ascribed to him. Another early work
is the fine Crucifix in the former Cemetery of Baden-Baden (1467).
Nikolaus must have assisted in the education of the anonymous
sculptor who carved the masterful statues of Sts. Anthony, Jerome,
and Augustine for the famous altar of Isenheim, now in the Museum
of Colmar. Still further up the Rhine, at Constance, he and his pupils
were responsible for the wood-carving of the stalls and the west door
of the cathedral. He ended a life of unusually widespread activity in
the employ of the emperor, Frederick III, executing, with the aid of
pupils, the monument of the sovereign himself, now in the cathedral
of Vienna. It is the last word in the profuse elaboration of the
sepulchral type that he had learned from the ducal tombs at Dijon.
The base is of three layers, the highest adorned above with the
escutcheons of the territory acquired by the Hapsburgs, and at its bot-
tom with sitting and kneeling mourners, the next with reliefs of Fred-
erick's pious deeds separated by statues of the princes of the realm,
the lowest with a variety of animal forms. The whole is surrounded
by a balustrade decorated with figures of Christ and the saints. The
larger statues of Apostles on the balustrade perhaps reveal the hand
of a sculptor not directly connected with the tradition of Nikolaus of
Leyden. The marble gravestone of the Empress, Eleanor of Portugal,
in the Neukloster at Wiener-Neustadt is variously dated before or
after the tomb of Frederick III, and is variously ascribed to Nikolaus
of Leyden or an imitator.

THE MIDDLE RHINE

In the district of the Middle Rhine, the most remarkable produc-
tions are a group of upright sepulchral slabs in the cathedral of May-
ence, completing a more distinguished series of Gothic tombs than is
possessed by any other church in the land. The monument of the
Archbishop Konrad von Daun may be taken as the best example of
the earlier fifteenth century, when the heads were infused with a more
forceful individualization than heretofore, but the folds of the abun-
dant draperies were still simply an elaboration of the long, loose waves
of the preceding period. There, as everywhere in Germany, the folds
soon broke up into small and arbitrary fragments, as in the slab of
Bernhard von Breitenbach. At the beginning of the sixteenth century,
the longer, more stately folds again became the fashion, sometimes

falling into parallel lines, but subdivided, always, by the angular con-
tortions developed during the past fifty years. The principal instances
are the archiepiscopal monuments of Berthold von Henneberg, Jacob
von Liebenstein, and Uriel von Gemmingen, the last an imposing
epitaph. All three are probably the work of HANS BACKOFEN, who
is known to have executed the Calvaries by the church of St. Ignatius,
Mayence, and in St. Peter's Cemetery, Frankfort. The heads of
Backofen's sepulchral effigies enshrine, in a superlative degree, the
unsurpassed realistic vigor of his age and country. The Renaissance
has supplied the *putti* and some architectural detail; but the emo-
tional postures and the movement that courses through the draperies
justify once more, as Backofen's critic, Dehio, has suggested, the ap-
plication of the term, baroque, to the so-called late Gothic of Germany.

CHAPTER VIII

GOTHIC SCULPTURE. ENGLAND

1. INTRODUCTION

THE Gothic sculpture of England is not likely, in its present condition, to arouse much enthusiasm in the casual tourist. A considerable amount Puritan bigotry has destroyed completely, and much of the rest it has pitifully mutilated. There is, however, true and noble Gothic beauty in what remains, and the diligent lover of art will be rewarded for ransacking the churches and cathedrals by many lovely surprises in forgotten fragments or small architectural details. But the English were a race less gifted, artistically, than the Latin peoples, and one must not expect to find in the island the life, vigor, and technical skill, the impeccable taste, the poetry, and lofty spirituality of contemporary France. Instead, the sculpture of England maintained itself at a respectable level of high but somewhat prosaic mediocrity, hazarding only occasional flights of inspiration. How much it owed in its origins to France is a problem. It is difficult, at least, to follow insular patriotism so far as to deny to the earlier appearing monumental sculpture of France anything but the influence of example in the creation of the monumental sculpture of England. The stylistic parallelisms are too close. Indigenous characteristics are, of course, to be discerned, some of them inherited from the Romanesque period. A notable difference is found in the place assigned to the carvings. English Gothic developed no great portals upon which to lavish sculpture; only the tympana were sometimes decorated with one or more little reliefs in frames, and rarely a few statues were set at the sides. Some of the great screens that form the peculiar English façades, as at Wells, Lincoln, Lichfield, and Salisbury, were elaborately adorned with superimposed rows of statues and reliefs, suggested, perhaps, by the Romanesque façades of Poitou and Saintonge; but the spandrels of arches and other sections of the interiors furnished, to a larger extent than in the rest of Europe, the principal fields for carvings, which were consequently of smaller proportions. Although the sacred sculpture of England suffered from religious disturbances, her tombs were not subjected to such social upheavals as the French Revolution, and therefore remain in great numbers as the chief objects for the study of English medieval art.

2. THE THIRTEENTH CENTURY

Large detached statues do not seem to have appeared generally in English Gothic until about 1220. The series of rather inferior figures on the façade of Peterborough may have been begun as early as 1200. Far more important examples are found on the façade of Wells, which is the only other English front of the thirteenth century that has not been almost wholly denuded of its treasures (1220–c. 1250); the Apostles and angels at the top must be dated at least as late as the fourteenth century. The iconographical scheme includes the Last Judgment in the gable, a frieze of the Resurrection immediately under the main cornice, and for the whole huge screen the Coronation of the Virgin. The actual Coronation is set over the principal portal as a center; beside and above are grouped in three rows of niches the concourse of attendant saints, the secular predominating at the north and the clerical at the south. From a rather stiff and primitive severity in the earliest statues, the style gains in modelling in the round, in freedom, and in the expression of sober activity and mystic revery (Fig. 53, two statues on the north tower buttresses), until it attains its acme in the figures on the panels between the buttresses in all three rows and in five effigies of deacons. The drapery is rippled in a fashion which was usual in the monumental statues of England during the century and which was more beautifully realized on certain German cathedrals, such as Strassburg. The frequent elongation of the forms may indicate a relation to the antecedent school of the west portal of Chartres; but the erudite and brilliant historians of English sculpture, Prior and Gardner, perceive in the carvings of Wells a greater tenderness and intimacy than in French Gothic, qualities that perhaps may be better understood as a softness of outline consistent with the vaporous atmosphere of the island. The façade of Wells also contains the most remarkable English series of smaller reliefs used for exterior decoration. They are divided among three different tiers, the highest representing the Resurrection of the Dead, the second Biblical episodes, and the lowest half-lengths of angels. The treatment of the drapery remains the same as in the larger statues.

Of the few other extant monumental statues from the thirteenth century, the only ones of high artistic merit are Gabriel and the Virgin on the chapter-doorways of Westminster and the figures about the Judgment Porch at Lincoln, especially the Church and the Synagogue. The relief that gives the Judgment Porch its name, still retaining much of the Romanesque pictorial manner, is the only significant instance, in Gothic England, of a tympanum the whole face of which

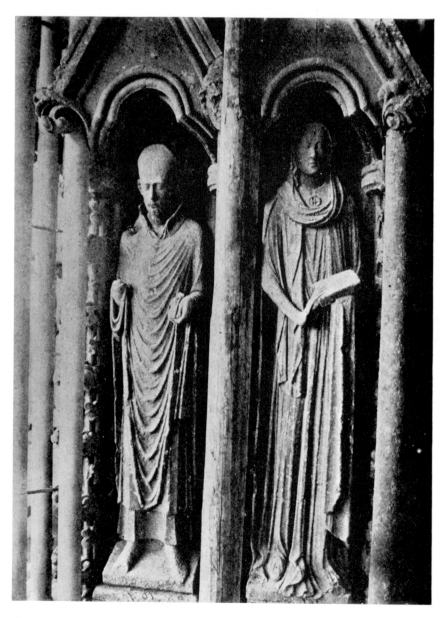

Fig. 53. TWO STATUES ON NORTH TOWER BUTTRESSES, CATHEDRAL, WELLS

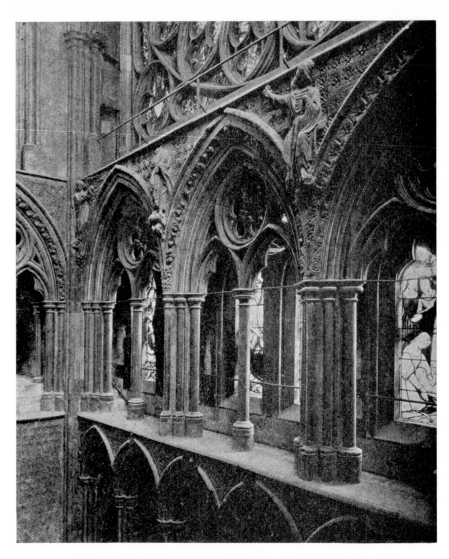

FIG. 54. ANGEL AND TWO OTHER FIGURES, SOUTH TRANSEPT END,
WESTMINSTER ABBEY

(Courtesy of W. A. Mansell and Co.)

is sculptured with a single subject. The arch-moldings, however, are occasionally carved with rows of little figures, either in the continental setting of small niches, as on the doorway of the chapter-house at Salisbury, or after the old English Romanesque fashion, in the interstices of foliage, as on the doorway of the chapter-house at Westminster. Both systems appear on the lovely archivolts of the Judgment Porch.

Apart from Wells, the most notable work in relief is found on the spandrels of interior arches in southern and western England. Best known are the sadly ''restored'' specimens from the Old Testament in the chapter-house of Salisbury. In distinction from narrative reliefs, a popular English theme for the spandrel, as, indeed, for all English sculpture, was the angel, whose outspread wings were peculiarly fitted to fill the given space. The examples include the supreme achievements of English Gothic carving, the four angels above the windows of the triforium level at the two transept ends of Westminster (Fig. 54, south transept end with angel and two other figures). The thirty angels of the triforium arches in the five easternmost bays of the choir at Lincoln are still lovely, though less noble and already somewhat tainted with the coquetry that was to become general in the fourteenth century. Everywhere the churches are full of delicious bits of architectural figure-work, such as the heads from the choir-screen and chapter-house of Salisbury and the medieval *goyescas* on the capitals of Wells.

The forms of English sepulchres do not differ materially from the French. The simple type with the high base seems to have been the most common. Over the heads of ecclesiastics and sometimes of secular personages was carved a recumbent canopy, suggested, it may be, by the importations from Tournai. The representation of the deceased's relatives and friends in an arcade on the chest seems to have occurred first about 1275 on the tomb of Aveline, Countess of Lancaster, at Westminster. The most interesting peculiarity in the effigy itself was the greater agitation of the knights. About the middle of the century, they began to cross their legs. The posture may have originally symbolized the crusader, but later it became a merely stereotyped attitude without any such significance. Possibly, instead, the intent had been to give the impression of movement according to the old precedent of the Romanesque school of Languedoc or to represent a position that the Middle Ages connected with the aristocrat. Familiar instances may be seen in the Temple Church, London. Often, as in a fine example in the Mayor's Chapel, Bristol, the activity was extended to the gesture of drawing the sword. Until about 1280, by all odds the most popular medium was Purbeck marble,

the working of which for tombs was largely the monopoly of London shops. The hardness of the material permitted no delicacy but necessitated a bold and virile technique, in which the countenance was rendered by simple, angular, vigorously hewn planes and the drapery by deep indentations. Even when, as frequently in the southwest, local stones were employed, the style was often affected by the standards of the marblers. A series of early bishops at Wells, however, and a number of knights in the churches of Bristol and the surrounding country show that the sculptors who had done the monumental statues on the cathedral of the former town, or their pupils, executed tombs that avoided the violent methods of Purbeck marble as unsuited to the local stones. Even the marble figures themselves, possibly through continental influence, discarded these asperities in the last years of the century and adopted a broader, smoother fashion. A good example of this style is the tomb of Bishop Inglethorpe in the choir of Rochester.

For the first half of the century, the efforts of the sculptor were directed towards lifting the effigy from the sunken flatness of the slab into existence in the round on top of the base. Having solved this problem, he could devote himself, as in the superb monuments of Bishop Northwold at Ely and of Archbishop Gray at York, to the elaboration of the decorative details in the Gothic frames around the ecclesiastics. He also sought to solve the problem of the lying posture. The pillow was introduced under the head almost at the first, and later was doubled or even tripled; but about 1270, as in the tomb of Bishop de la Wyle at Salisbury, other indications of repose began to appear, especially the incipient fall of the drapery about the body. The first preserved effigies in bronze and wood date from the very end of the century, and reveal the influence of the more usual technique of stone. The Henry III and Queen Eleanor (wife of Edward I) in the Confessor's Chapel, Westminster, begin auspiciously a momentous series of royal bronzes. The oaken figure of Archbishop Peckham in the transept of Canterbury is the finest specimen of the other group.

3. THE FOURTEENTH CENTURY

Of monumental statuary from the fourteenth century, little is left to us, and that rather uninteresting. In greater part, it was apparently based upon the typical style of the period in France. The freer but mannered drapery and other characteristics may already be discerned, by the last decade of the thirteenth century, in the multiplied effigies of Queen Eleanor on the crosses erected in memory of her by her husband at Geddington, Hardingstone (near Northampton),

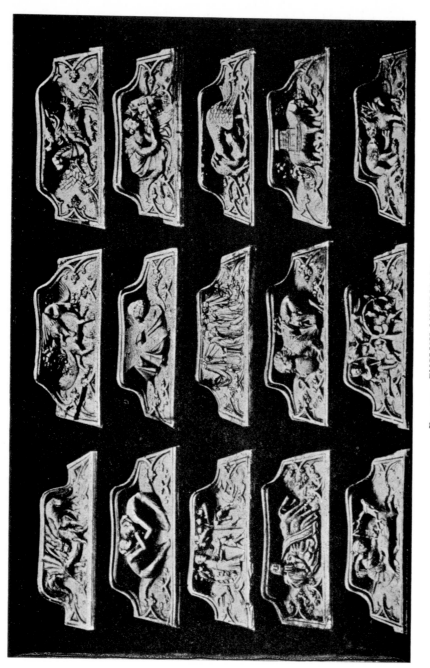

FIG. 55A. ENGLISH MISERICORDS

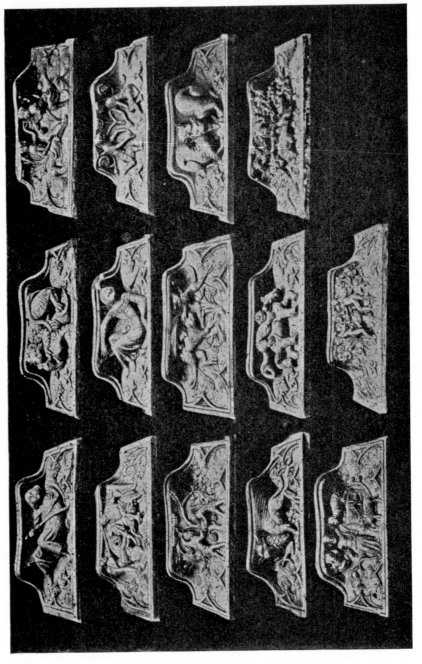

Fig. 55B ENGLISH MISERICORDS

and Waltham (near London). The same qualities may be illustrated by a few other examples, for instance, from the first of the century, the doorway of the chapter-house at Rochester, with the ("restored") Church and Synagogue at either side and the seated Doctors of the Church in the arches, or, from the end of the century, the Virgins over the gateways of Winchester College. Prior and Gardner ascribe considerable influence to the Black Death of 1348 in putting the quietus upon the invention and experimentation that belonged to English sculpture until this time and in reducing the artistic output to the dead level of shop production in which earlier local variations were obliterated and the deterioration was constant. It is possible to trace the change on the façade of Exeter, which alone, from the fourteenth century, has preserved its monumental decoration. The Warriors and Kings that were carved in the lowest row about 1345 exhibit a praiseworthy spirit of initiative in the study of movement and dramatic expression; the Apostles and Prophets in the upper tiers of about 1380 possess, to be sure, more intrinsic beauty, but they are only good, honest pieces of craftsmanship, stolid in proportions and attitudes, destitute of original ideas, and perhaps dependent upon Franco-Flemish art. The rude figures on the gateway of Thornton Abbey, Lincolnshire, may serve as a typical instance of unmistakable degeneration.

Here and there in England in the first half of the fourteenth century there were modifications of the ordinary style of the period. The north country, Durham, York, and the vicinity, which in the preceding century had been virtually sterile, now produced expressive statues in soft and ample draperies which may belong to the tradition embodied earlier in the Angel Choir of Lincoln and which, in many respects, especially in the pronounced bend and physical type, were without doubt influenced by contemporary German work, familiar perhaps to English artists through commerce in figures of wood and metal. The best illustrations are afforded by two angels above the triforium in the choir of Durham, and by two Madonnas at York, one over the doorway in the north aisle (about 1290) and the other at the entrance to the chapter-house. The Abbot and Prior of Bishop Lindsay's gateway at Peterborough and the statues upon the tower of Newark reveal the more sober style with straight draperies that was evolved in the region of the Ancaster quarries south of Lincoln. The figures on the screen of the church at Howden, south of York, effect a compromise between the two extremes.

As elsewhere in Europe, the carvers of capital, corbel, and boss rejected the simplicity of a few architectural lines and sought more

elaborate compositions. Figures intruded more and more upon the foliage, the human head as a *motif* acquired more expression and individuality. The increased fondness for narratives and colloquialisms declared itself, and the grotesques boldly emerged from their hiding-places. Among a multitude of specimens, as typical as any are the capitals beneath the lantern of Ely, the heads of the chapter-house at York, the corbels of the cathedral of Exeter and the church at Cley, Norfolk, and the bosses of the southern, eastern, and western walks of the cloister at Norwich.

Since, after the thirteenth century, English architecture no longer allowed reliefs an important place in covering the spaces of the walls they were restricted more and more to the decoration of interior details, doorways, and ecclesiastical furniture. Their size was diminished, their execution was less careful, their feeling less noble; but in accordance with the general tendency of the fourteenth century, they became more animated, and when narrative was attempted, the scenes were more crowded and often manifested distinct anecdotal ability. The following examples deserve special notice: the arch of the doorway from the cloister into the cathedral of Norwich, the many episodes from the life and miracles of the Virgin on the spandrels of the sedilia in the Lady Chapel at Ely, the figures and groups on the frames of the Easter Sepulchres in the cathedral of Lincoln and at the churches of Navenby, Heckington, and Hawton in the same vicinity, the Percy tomb at Beverly (the detached figures upon which are also among the best that the century produced), and the great reredos at Christchurch, Hants.

The same style is seen in the reliefs of alabaster, which was quarried in south Derbyshire and Staffordshire, and by 1350 was already acquiring the popularity for ecclesiastical furniture that it was to enjoy in England until the end of the Middle Ages. Some lovely detached statuettes of alabaster remain from the period that we are considering, such as the Virgin, St. Peter, and a Bishop from Flawford in the Museum of Nottingham, but the medium found its most characteristic employment in small narrative tablets. During the fourteenth century, these do not yet seem to have been assembled in formal retables; at most, they were hung or set together in groups of three. A large number, coming from later in the century, have curious little embattled canopies. The best examples are the shattered Epiphany, Ascension, and Coronation from Kettlebaston in Suffolk, now in the British Museum.

This century witnessed also the triumph of one of the most charming forms that English sculpture assumed, the figure-carving of the

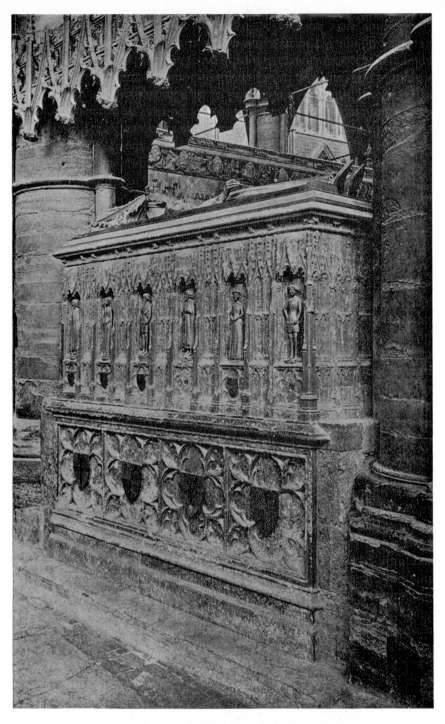

Fig. 56. TOMB OF EDWARD III. WESTMINSTER ABBEY

(Courtesy of W. A. Mansell and Co.)

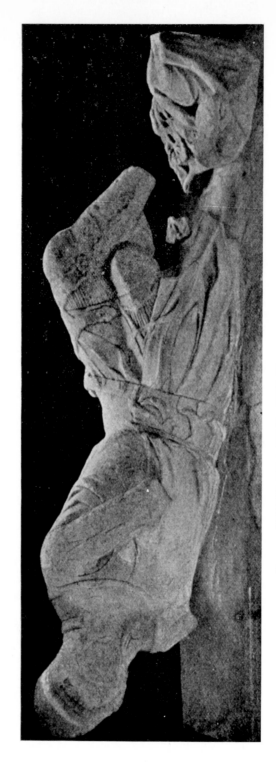

FIG. 57. KNIGHT ON A TOMB, CHURCH AT ALDWORTH NEAR OXFORD

(From "Medieval Figure-Sculpture in England" by Prior and Gardner, with the courteous permission of Mr. Prior)

wooden choir-stalls, as at Winchester, Ely, and Lincoln. The large number of English misericords are peculiarly delightful, comprising an unusually broad range of subjects. They begin in the thirteenth century at Christchurch, Hants, with the representation of foliage, monsters, and only an occasional human figure. At Exeter, where, about 1260, the figure is the chief *motif*, the compositions, often mythological, have the appeal of a winsome simplicity, but the curling decorated end-pieces or *ears* have been added to the seat. The ears themselves were soon made into figure-subjects, and the central theme was elaborated, until by the end of the fourteenth century the whole space beneath the seat was covered. The misericords of Ely, Wells, Chichester, Chester, Gloucester, and Worcester have nothing to fear from a comparison with the finest on the continent. Of the specimens included in the illustrations (Figs. 55A and B), many are from Gloucester: for instance, in the top row of A at the right, the huntsman blowing a horn and perhaps symbolizing the windy month of March; in the fifth row at the center, a fox-hunt; in the top row of B at the right, a game of football; in the third row at the left, the vintage, perhaps standing for October; and in the same row at the center, the Esopic fable of the fox and the lion who feigns sickness. The example at the left of the second row of B representing a tournament is from Worcester.

The forms of tombs remained the same. If the figures around the base were conceived as *weepers*, at least they did not yet, as in France, assume the conventional costume of mourners. Nor did the English achieve, like the French and Germans, any definite portraiture in the effigy. In the ecclesiastics they sometimes approached it, but they came nearer to realizing the individual, as was natural, on the royal sepulchres, for instance, in continuation of the bronze series at Westminster, on the monuments of Edward III (Fig. 56, with bronze *weepers* on base) and of Richard II and his Queen. The more decided portraiture in the Queen Philippa of white marble at Westminster may be due to a foreign importation. At the first of the century, certain knights, such as two examples from a series at Aldworth near Oxford (Fig. 57), show how the histrionic attitude was sometimes increased to an almost painful agitation. On the other hand, the return to tranquillity was more usual, as in the lovely effigies of Crouchback (d. 1296) and of Aymer de Valence (d. 1323) at Westminster. It soon completely won the field, the hands were united in prayer above the chest, and by 1350, as in a superb specimen at Warkworth, Northants, even the crossing of the legs was abandoned. Occasionally the body of the knight turned and lay upon the side. In all types of effigies, the greater freedom and naturalness that had developed at the end of

the thirteenth century, especially in the draperies, became general, perhaps through the influence of the London shops.

Freestone had now supplanted Purbeck marble as the favorite medium, and set the model for work in other materials, but it, in turn, gave way to alabaster about 1360. Wood, also, which had been often used for tombs, succumbed at the same date. Prior and Gardner distinguish three regional styles in the first half of the century, in accordance with the kind of stone employed, allowing, of course, for exportation from one place to another. The thin slabs of oolite in the southwest, where the principal shops were at Bristol, lent themselves to small, delicate, "crisp" detail, but not to depth of modelling. The figure of Chancellor Swinfield in the Lady Chapel of Hereford from the end of the thirteenth century is perhaps the best instance. The sandstone of Exeter created a subdivision in the southwestern group with bolder modelling, as in a knight accompanied by two statuettes of attendants in the north aisle of the choir of the cathedral. The thick blocks of sandstone in a second section of England, the center, induced a "blunter" fashion, with "profuse draperies" and "deeply-cut folds," that is illustrated by the recumbent woman in the south aisle of the Lady Chapel, Worcester. The work of the capital, London, exercised an especially potent influence in the midland districts. Its style, which was a fusion of the three provincial manners, is well represented by the two knightly effigies in Westminster Abbey, already cited, and by a number of ecclesiastics, notably the Bishop Marcia of the south transept at Wells. The knight and lady of the church at Bedale, Yorks, are examples of the third manner, which focused at York and which characterized also the monumental statuary of the north. Here again the analogy to German art is easily recognized. The sweeping involutions of the draperies, permitted by the limestone of Tadcaster, recall vividly the figures on the tombs of Dedo and Henry the Lion. As in Germany, the ladies of Yorkshire hold scrolls with inscriptions, and, in contrast to the ordinary English elevation above the slab, the ecclesiastics are sunk within their frames. The carvers of the north loved to surround the effigy with a luxuriance of accessories, but a little further south the output of the Ancaster quarries was quieter and more severe. By the second half of the century, alabaster had everywhere ousted its rivals, except in the southwest, where freestone divided with it the public favor. Earlier figures of alabaster, such as the Edward II at Gloucester and the John of Eltham at Westminster, had so firmly set the stamp of the capital upon the material that its impress was visible to the end in the one unchanging style that was now adopted throughout the island.

4. THE FIFTEENTH AND SIXTEENTH CENTURIES

The fifteenth and sixteenth centuries may be considered together because the latter betrayed only a decadence of the style of the former. The Renaissance generally influenced merely ornamental detail, and that, by no means universally. The works executed by Torrigiano and a few other Italians were only isolated foreign monuments that did not prevent Gothic from lingering on until the reign of James I. The fifteenth century gave birth to no such great and vital movements in England as in the other countries of Europe. It was a well-nigh unrelieved period of artistic stagnation, continuing with less freedom and correctness the monotonous style that had been evolved throughout the island after 1350. At times it seems as if sculpture had lapsed back into primitive rudeness. A certain amount of Flemish realism was imported, but it was devitalized into a fixed and commonplace dryness. In general, a standard of passable achievement was preserved, as phlegmatic as the Perpendicular architecture that formed its setting.

The niches that English architecture left on the walls afforded an abundant opportunity for monumental statues, but since these were manufactured separately by the shops, they lost their architectural lines. Many façades, gateways, and towers were thus decorated, but the only figures of any artistic significance are found upon such interior structures as the reredos and the chantry, which now became common and pretentious objects in English churches. Of those interior structures that have kept their figures, the choir-screen of Canterbury (about 1400), the chantry of Henry V (about 1420), and the chapel or chantry of Henry VII (1510–1512) at Westminster belong to a style somewhat superior to the ordinary output of the period and therefore of London provenience. Here and there among these figures we get a breath of sincerer realism, as in one of the deacons on Henry V's chantry, who is of an unmistakably English cast of countenance. The assembly of saints in the chapel of Henry VII, despite the frequent stubby proportions and other defects, are rather remarkable for variation of type and posture. The kinship to Flemish sculpture is manifest, and a slight acquaintance with the Renaissance has helped the craftsmen to some realization of ideal beauty and, sporadically, as in the Sts. George, Martin, and Sebastian, to an embryonic attainment of Italian elegance (Fig. 58). A few creditable works were produced outside the London shops, such as the Kings on the choir-screen of York (about 1480).

Smaller architectural carving of figures largely disappeared, except in the case of heraldic symbols, the gargoyles, and the angels on the cornices, all of which now obtained a great vogue. The little scenes of the bosses, especially in the cloisters, as in the north walk of Norwich, were almost all that remained to tell of the wealth of reliefs in the former centuries. Two famous instances of angels arranged in rows to decorate cornices occur in Henry VII's chapel, Westminster, and in St. George's chapel, Windsor. Wooden angels, though often not very fine as separate objects, were used very effectively in long series as accents on or beneath the ceilings, particularly in Norfolk.

Of interior furniture, the stalls and misericords continued without much change in style. Flanders now seems to have had some effect upon the wood-carving, and the misericords grew more complicated, if possible, than in the earlier period. Of these, spirited examples, belonging to the fifteenth and sixteenth centuries, may be seen at Carlisle, Norwich, New College at Oxford, Ripon, Manchester, Beverly Minster, and in Henry VII's Chapel, Westminster (cf. Fig. 55 A, where the misericord in the top row at the left, representing the fight of a wyvern and lion, is from Carlisle). The stone fonts once more fall within the scope of our investigation, because now, after a lapse of two hundred years since the Romanesque period, they again were honored with embellishment by figures and reliefs. A few specimens date from the last sixty years of the fourteenth century, the decoration of which was suggested by the reliefs on tombs and retables. In the fifteenth century, Norwich was a great center for their manufacture, and the fashion of that town was imitated in other parts of the island, especially by the Ancaster quarries. The style did not usually rise above that of mere commercial production. The figures of the earliest fonts were symbolic and heraldic, as at Blakeney in Norfolk; then, scenes of sacred purport took their place, and, as at Walsingham, pretentious bases with other elaborations were added.

The most truly English articles of furniture were the alabaster reliefs, which were now grouped in greater numbers, together with statuettes, as retables of single and, eventually, double tiers. These later and more developed specimens were set in frames of gilded and polychrome wood, and often provided with painted wooden shutters. The central piece (in the upper of the two rows, if there were two) rose somewhat higher than the others. The intricate canopies of pierced tracery were finally carved separately and fitted on the reliefs. In the sixteenth century, especially during the temporary revival of the industry under Queen Mary, the decorative details were sometimes of

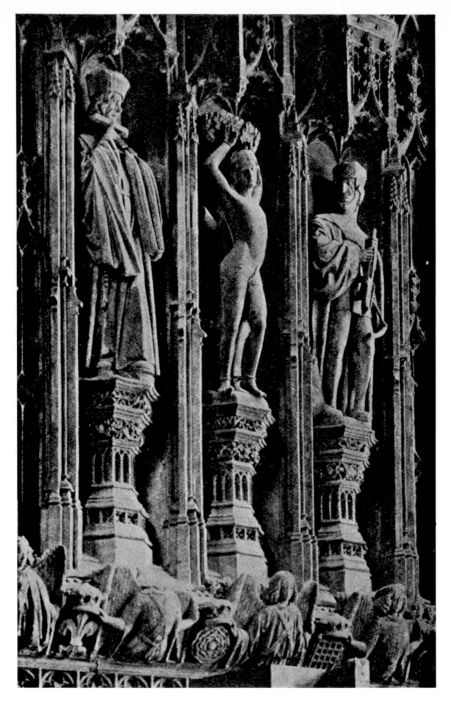

FIG. 58. ST. SEBASTIAN AND TWO EXECUTIONERS, CHAPEL OF HENRY VII,
WESTMINSTER ABBEY

*(From "Medieval Figure-Sculpture in England" by Prior and Gardner, with the courteous
permission of Mr. Prior)*

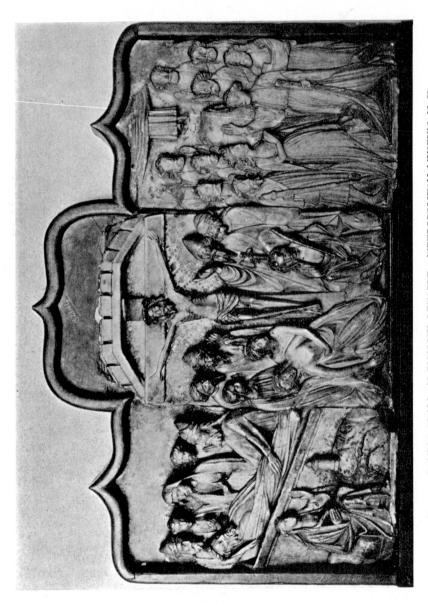

Fig. 59. PANELS FROM AN ENGLISH RETABLE. METROPOLITAN MUSEUM, N. Y.

(Courtesy of the Metropolitan Museum)

the Renaissance. Although the style of the reliefs was doubtless influenced by the Flemish retables and by English painting, the attempt at the pictorial was not carried so far as in Flanders, the story was not told with such a charming spirit of *genre*, and the mannered execution was lamentably inferior. The forms are extravagantly thin and stiff, the anatomy puerile, the hands and feet absurdly long, the poses affected and perfunctory; the craftsmen succeed in reproducing actuality only in the studied contemporary costumes. The most popular subjects for the series of panels, as elsewhere in Europe, were the Passion and the life of the Virgin; certain sets, relating the martyrdoms of saints, are slightly more vigorous than the majority of the others. The cheapness of these *objets de piété*, however, ensured them so enthusiastic a market abroad, particularly in near-lying Normandy, that complete examples may now be seen only on the continent. In England itself, misdirected religious zeal has left nothing but separate panels, and some of these in fragments. Three typical panels are in the Metropolitan Museum (Fig. 59), parts of a retable of the Passion; the retention of the embattled cornice, still preserved in the central compartment, suggests an early date in the fifteenth century. One of the best preserved and most characteristic specimens of the retable at the height of its evolution exists at La Celle in Normandy.

In the types of tombs, an occasional innovation, perhaps appearing first at the end of the fourteenth century, was the opening of the base to reveal the cadaver, as in the monument of Archbishop Chichele at Canterbury, who died in 1443. Over the more pompous tombs were erected ornate canopies instead of the earlier Gothic gables. The sepulchre of Richard Beauchamp in the church of St. Mary at Warwick (about 1450) includes bronze statuettes of relatives in the conventional mourner's costume, as well as smaller figures of angels, which now very commonly were employed also upon the bases, usually as supporters of escutcheons. Interesting uses of angels may be seen in the monument of Ralph Green at Lowick and in the tombs at Swine, Yorks. Heraldry, figures of saints, and sacred scenes appeared as other mortuary *motifs*. Alabaster was the ordinary medium, although bronze was also in demand for the great nobles and freestone for aristocrats in moderate circumstances. The upper middle class contented themselves with the flat engraved brasses. Wood, which had largely been abandoned since the middle of the fourteenth century, returned to favor after 1500, perhaps because the alabaster quarries were beginning to be exhausted. The technique of alabaster had established the norm for the single plastic style which prevailed throughout the country and which may be illustrated by the universal

attitude of "prayerful recumbency" and by the stereotyped dryness in the rendering of the ecclesiastics' vestments. It was still the effigies of prelates and princes that achieved the closest approximation to portraiture. During the sixteenth century, in the last Gothic period, great noblemen were often represented with all the paraphernalia of their exalted positions.

CHAPTER IX

GOTHIC SCULPTURE. SPAIN AND PORTUGAL

1. INTRODUCTION

The French influence dominated sculpture in Spain during the thirteenth and fourteenth centuries as during the Romanesque period. The constant pilgrimages to Santiago de Compostela continued to provide a particular reason for its appearance in the Iberian peninsula. The indigenous impress, however, is to be found, now here and now there, in frequent Moorish elements, in the taste for luxuriant decoration, in a kind of provincialism, in the personal types, in a frequent heaviness of physique, in a tendency to petrify the sacred figures into the solemn rigidity of idols, or, on the other hand, in a more familiar naturalism.

2. THE TRANSITIONAL PERIOD

A transition from Romanesque to Gothic is embodied in the principal portal of Santiago de Compostela, the Pórtico de la Gloria, which, as one of the noblest assemblages of medieval sculpture (Fig. 60), richly deserves its title. St. James, the patron of the church and of Spain, is seated against the central pier on a column carved with the Tree of Jesse. At either side of him, in front of all three openings and likewise upon columns, are ranged the Apostles and Prophets; facing these, at the entrance to the vaulted porch, or narthex, are figures of other sacred personages. The tympanum of the central door and the arches of the flanking doors are consecrated to a magnificent representation of the Last Judgment. The monument has partially preserved its polychromy. Although some details, such as the occasional crossing of the legs and the monsters under the piers, imply a knowledge of southern French Romanesque, it needs only a glance to realize that the Pórtico de la Gloria is an offshoot of the school of Chartres; Bertaux has suggested the south door of Bourges as the closest French parallel. The vigorously differentiated and expressive heads form one of the most striking proofs of the relationship. The statues, however, are less elongated than at Chartres itself, the art is more naturalistic and less schematized, the poses and draperies are freer and more cognizant of grace, the twenty-four Elders on the main archivolt reveal a tenser dramatic sense. The St. James and the trumpeting angels are among the supreme achievements of early Gothic sculpture.

The author of the portal, a Frenchman or Gallicized Spaniard, has broken the usual medieval silence and, as if conscious of his superiority, signed his name on the under side of the main lintel, together with the date of the installation of the sculpture — Master Matthew, 1183.

3. THE THIRTEENTH CENTURY

During the thirteenth century, whole sections of Spain still remained impervious to the new style across the Pyrenees, and continued to work in the rudest Romanesque manner. In other places, as on the main portal of the cathedral of Tudela, the Romanesque has been only touched by the Gothic. French Madonnas in all materials were imported into many towns, or some were carved on the spot by foreigners; but the cathedrals of Burgos and Leon were practically the only important centers of the Gallic fashion, although native artisans imitated the productions of these cities in the surrounding districts. At Burgos, the doors of the two transepts and of the cloister were probably executed by French workmen; the last exhibits the greater freedom of style that came in the second half of the century. In the tympanum of the portal of the north transept, the presence of St. Ferdinand and his Queen among the blessed denotes a tendency to introduce contemporaries into sacred art as in Germany, but without the German desire for realistic portraiture. Likewise, the fine statues in the cloister itself include not only the Adoration of the Magi but also a king and queen with five princes, according to Bertaux, Alfonso the Wise, Violante of Aragon, and their five sons. The style, despite the Spanish costume, suggests, like the equestrian St. George of Bamberg, a derivation from Reims. The carvings at Leon seem to have been executed chiefly at the end of the century. The portal of the south transept, imitated from the corresponding door at Burgos, Lampérez calls the most classically beautiful in Spain. Similar is the portal of the north transept with the Virgin on the dividing pier and the glorified Christ in the tympanum. The principal portal, in three divisions, patterned after the lateral portals of Chartres, is dedicated to the glory of the Virgin, with the Last Judgment in the central archhead. The assembly of the redeemed in the lowest zone of this tympanum is treated with a charming naturalism that bespeaks the Spanish environment. The Virgin on the pillar below, Nuestra Señora la Blanca, is again sculptured in the delightfully familiar fashion of Spain, but the monumental statues under the archivolts, some of them later in date, are generally the work of less skilled, provincial hands.

The Romanesque period had produced few figured tombs. The ordinary Spanish type of the thirteenth century was a niche, usually

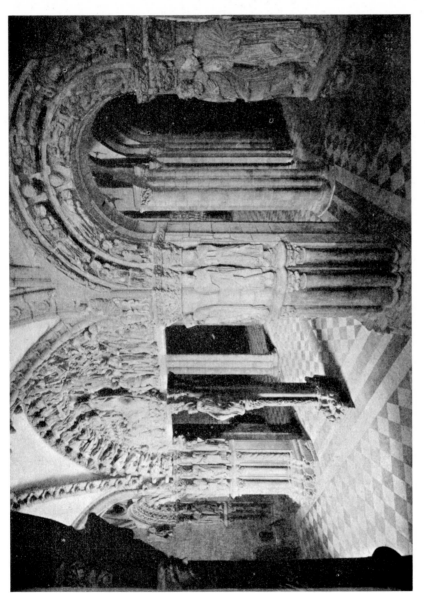

Fig. 60. PÓRTICO DE LA GLORIA, CATHEDRAL, SANTIAGO DE COMPOSTELA

(*Photo. Lacoste*)

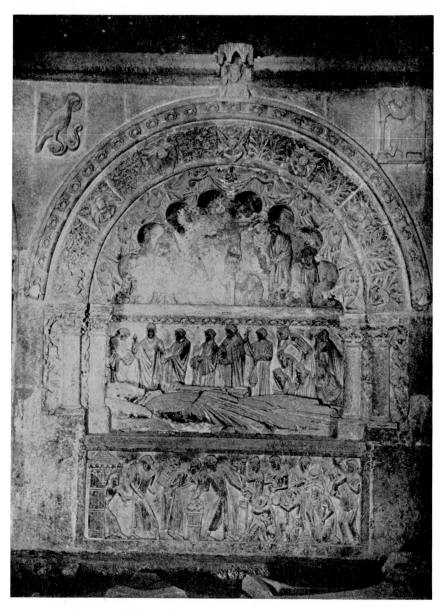

FIG. 61. TOMB OF BISHOP MARTIN. CATHEDRAL, LEON

(Photo. Laurent)

pointed, in the wall of the church or cloister, containing the effigy of the deceased upon a raised base or sarcophagus. Tympanum, base, and arch were decorated with reliefs. Common themes were the funereal ceremony of absolution, the translation of the soul to Paradise, and the lamentation for the dead, the last as old as the middle of the twelfth century in Spain and characterized by a truly southern emotionalism. Religious subjects, especially the Crucifixion, were not infrequent. The monument of Bishop Martin in the cathedral of Leon (Fig. 61) unites the absolution and lamentation immediately behind the effigy, inserts the Crucifixion in the tympanum, uses the translation on the arch, and introduces on the sarcophagus one of the prelate's works of mercy, the distribution of food to the poor and sick, treated already with something of Ribera's and Murillo's delight in squalid naturalism. Spain possesses also a certain number of sepulchral curiosities. In the convent of Las Huelgas near Burgos a series of royal tombs consists of sarcophagi resting upon heraldic beasts and surmounted not by the figure of the deceased but by a simple cover in the shape of a gabled roof. The tops as well as the sides are embellished with heraldry or with figured reliefs. The tomb of the cantor Aparicio in the old cathedral of Salamanca may serve, with its frieze of stalactite vaults, to illustrate another class, in which Moorish decoration was already fused with the Gothic to form a primitive stage of that peculiarly Spanish architectural style called the *mudéjar*.

4. THE FOURTEENTH CENTURY

During the fourteenth century, the French manner, in the form that it then assumed, won its way into all the other important parts of Spain, leaving uninvaded only the sections that were still Moorish or had lately been so and such remote provinces as Galicia and Estremadura. For monumental sculpture the two great fields were now Navarre and the eastern kingdom of Catalonia and Aragon, which had been sterile for the last hundred years. The cloister of the cathedral at Pampeluna, the capital of Navarre, contains much thoroughly Gallic work, the finest example of which is the door called La Preciosa, leading to the old chapter-house. As ordinarily in the fourteenth century, the artist's hand was more successful in the graceful but solemn little scenes of the Virgin's death in the tympanum than in the large figures of the Annunciation below at the sides. Other work in Navarre is more provincial. The best instance is the façade of Sta. María la Real at Olite, where, as on some other churches of the district, the statues are peculiarly disposed under an arcade along the walls beside the portal.

Catalonia reveals a more original adaptation of the French models, as in the Romanesque period, but the originality by no means implies superiority. A palpable difference exists between the Gallicized Virgin and eight Apostles on the main door of the cathedral of Tarragona from the end of the thirteenth century and the rather Spanish Apostles and Prophets around the adjacent buttresses, which, executed towards the end of the fourteenth century, are heavier, less flexible, and more colossal. The acquisition of Sicily by Peter III of Aragon combined with commercial proximity to introduce Italian influence along the eastern littoral. To keep company with the Italian influence upon Catalonian architecture and painting, there was naturally some Italianate sculpture. The most marked example is the reliquary of St. Eulalia in the crypt of the cathedral of Barcelona, a rude counterpart of the shrines of St. Dominic at Bologna and of St. Peter Martyr at Milan, carved in Carrara marble by some inferior pupil of Giovanni Pisano.

Of the three great western cathedrals, Burgos, Leon, and Toledo, the last had waited until now to receive its plastic adornment. But the age of monumentality was passing, and the tympanum of the first portal to be decorated, the Puerta del Reloj, received four zones of many small episodical reliefs. Within the church, however, underneath the arches of the choir-triforium, were placed large statues that recall those of the buttresses at Tarragona.

As in the rest of Europe, the small architectural detail now included elaborate scenes, often drawn from profane literature or from contemporary life. Good examples are afforded by the corbels of the old refectory of the cathedral of Pampeluna and the capitals of the cloisters at Leon and Oviedo; but the student will find most pleasure in the consoles of the old chapter-house, the chapel of Sta. Catalina, at Burgos, almost all of which represent picturesque incidents from the reign of Alfonso XI.

The sculptural decoration of interior ecclesiastical furniture began in this same century. The first specimens of the figured screens that were to become such important objects at the end of the Middle Ages and in the Renaissance may be seen in the cathedral of Toledo. The section of the screen around the ambulatory that was spared by the later modifications is a luxuriant structure with a multitude of saints in niches and finials of angels. According to the peculiar arrangement of Spanish churches, the screen that marked off the large enclosure or *coro* for the clergy in the nave was another prominent article of furniture and is already embellished at Toledo with a long series of Biblical reliefs in the homely manner of the period. In Catalonia, as in other

parts of Europe, in addition to the painted retables there now appeared sculptured examples. Consisting first of a single row of panels, they were soon raised to a greater height, often with a statue in the center.

It is only the more lavish Gothic ornamentation that differentiates the tombs from those of the preceding century. The monument of the Archbishop Lope de Fontecha in the cathedral of Burgos, for instance, adds above the arch of the niche an opulent, pointed gable containing the Coronation of the Virgin. The *weepers* disappeared, for the nonce, from the sepulchres of Castile and Leon, but they are found in other parts of the peninsula, sometimes now in the formal mourning costume, as in a fragment of the Museum at Tarragona from the destroyed royal tombs of the Catalonian monastery of Poblet. The most pretentious and perhaps also the finest monument of the period was done for the Archbishop Lope Fernández de Luna in the Seo of Saragossa (1382). The niche, amplified into a kind of mortuary chapel and covered by a *mudéjar* dome, enshrines a large sarcophagus, which is detached on all but the inner side, and, with its twelve mourning noblemen under an arcade and its three suffragan bishops under projecting canopies, anticipates the tombs at Dijon. Above the sarcophagus is a beautiful effigy of the deceased, and the ceremony of absolution is assigned to an elaborate frieze along the sides of the recess. Mohammedan fancy continued to give a national tone to Spanish art in other sepulchres like those of two knights in the church of S. Esteban at Cuellar near Segovia: the bases, arches, and their frames are embellished with a profusion of Gothic and Moorish *motifs* in flat oriental relief (Fig. 62). Anomalous in another way are the two similar monuments of Pedro III and Jaime II in the Catalonian abbey of Santas Creus. The remains of the former monarch are placed in a porphyry vessel under a sculptured marble cover. The effigies of Jaime II and his queen are set above the sarcophagus on two oblique slabs that meet in a gable. In each case, this eccentric lower part is surmounted by a great Gothic *baldacchino*, the tracery of which is derived from the bays of the cloister.

5. THE FIFTEENTH AND SIXTEENTH CENTURIES

In the fifteenth and sixteenth centuries, until the definite victory of the Renaissance under Charles V, the French influences of the earlier Gothic period were supplanted by other models. Flemish prototypes at first had the cry, but their sway was soon disputed by the related art of Germany. Occasionally, it was the Burgundian modification of the Flemish style that was cultivated. Although Spain did

not quite equal the achievements of France and Germany, the period nevertheless was both fertile and brilliant. The national genius declared itself more emphatically, not so much in single figures as in the ways they were grouped together and in the prodigality with which they were employed as decoration.

Of architectural sculpture in the west may be mentioned the Flemish or Burgundian Prophets on the doorway to the Capilla del Rey Casto in the cathedral of Oviedo, dating from the middle of the century, the German Apostles on the Puerta de los Leones at Toledo of about the same date, and the plenitude of fine figures from about 1500 that adorn the cloister of S. Juan de los Reyes at Toledo. The decoration of the two lateral doors in the façade of the cathedral at Seville is surely due in part, and with great probability as a whole, to PEDRO MILLÁN, a charming master evidently trained in the Burgundian traditions and active in Seville at the beginning of the sixteenth century. Among several other signed works of his in the city, most notable is the St. Michael belonging to the Goyena Collection. The Plateresque façades that were evolved at the end of the Gothic period, such as those of S. Gregorio and S. Pablo at Valladolid, Sta. María at Aranda de Duero, and the west end of the choir-screen at Palencia, employed statues and reliefs as elements in the embroidery of stone, which, resembling the work of a silversmith, gives the style its name. Since in the eastern kingdom the civic life was more vigorous, sculptors were called into service to decorate governmental more often than ecclesiastical buildings. The style of Catalonia and Aragon continued to be more original, and the great commissions were assigned not to foreigners but to native artists, who, though schooled in the Flemish manner, yet impressed local qualities upon their work. Among the best examples, dating from the first half and middle of the fifteenth century, are the archangel over the door in the old façade of the Casa Consistorial at Barcelona,[1] a medallion of St. George and a frieze of realistic heads over the entrance to the Casa de la Diputación, and at Palma on the island of Majorca, the numerous figures on the Exchange or Lonja, by GUILLEM SAGRERA, who also did a St. Peter, well characterized in the *bourgeois* manner of the Flemings, for the great portal of the cathedral in the same town.

The architectural sculpture, however, was neither so typical nor so important as the decoration of ecclesiastical furniture and the tombs. The *retablos* rapidly increased in number and in size. No longer confined to subordinate chapels, they began to tower over the high altars

[1] Mr. W. W. Cook, who has just returned from Spain, kindly informs me that documentary proof has come to light showing that the sculptured decoration of the Casa Consistorial is the work of Pere Johan de Vallfogona and his *bottega*.

FIG. 62. TOMBS, S. ESTEBAN, CUELLAR

(From a photograph that belonged to the late Mr. Hervey Wetzel)

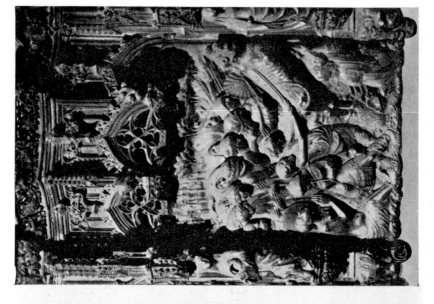

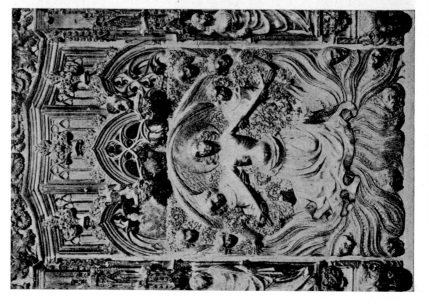

Fig. 63. PERE JOHAN DE VALLFOGONA. TWO PANELS FROM RETABLE OF CATHEDRAL, TARRAGONA

as impressive and distinctive objects in Spanish churches. Huge structures of stone or wood, larger than the retables of the rest of Europe, they were not transportable but were fixed immovably in their places. They were higher than they were broad, and were not provided with folding wings. The material in the east was alabaster. The finest specimens were done by PERE JOHAN DE VALLFOGONA and his workshop, one for the cathedral of Tarragona, begun in 1426 (Fig. 63, two scenes from the martyrdom of St. Thecla), another for the Seo at Saragossa, begun in 1445 (finished by a German in 1480), and a third of the same period, including merely a *predella*, for the archbishop's chapel at Saragossa, now in the Metropolitan Museum, New York. Though treated naturalistically with a moderate Flemish picturesqueness, the reliefs at times, as most notably the St. Thecla in the flames at Tarragona, reveal an almost oriental sensibility to design and conventionalization. In the west, the retables originally consisted of paintings, but during the reign of Ferdinand and Isabella, they became colossal screens of sculptured wood, sumptuously colored and overladen with a truly pagan magnificence. The high altars of Seville and Toledo are surmounted by the two most remarkable examples, the former by the Flemish master Dancart, with side-pieces and a crown of slightly later date, the other partly by the Dutchman Copin, although certain sections belong to the Renaissance.

The choir-stalls now received a care and an elaboration that make them equal, if not superior, to any others in Europe. At first the decoration consisted only of Gothic and Moorish design, with few or no figures, but by the second half of the fifteenth century a multitude of reliefs and statuettes had intruded themselves. Typical are: the series at Leon, the last sections of which were carved in 1481, with powerful Teutonic naturalism, by the German Theodoric; the series at Seville largely by Dancart; and the lower range at Toledo, with scenes from the siege of Granada, by another German, Roderic.

The sepulchral type of the niche in the wall remained the same, but, according to the taste of the epoch, it was more highly adorned. The whole chapel in the new cathedral of Salamanca that contains the niche of the archdeacon Palenzuela (d. 1530) is so richly embellished that it has received the name of the Capilla Dorada; but amidst the other figures, from a rectangular opening in the wall, appears, as in the Dance of Death, the gruesome personification of our mortality. In Catalonia and Navarre, as at least once in southern France, to the art of which the production of the eastern Spanish kingdom was always related, the decorative enhancement sometimes took the eccentric form of an arrangement of the material in bands. On the tomb

of the Bishop Bernard de Pau in the cathedral of Gerona, for instance, lowest are the angels with the escutcheons, then the prelate kneeling before the Virgin and accompanied by his heavenly patrons, next the effigy, and finally, behind it, the mourners. Similar vertical arrangements of at least two or three bands, especially the setting of one effigy above the other in double tombs and the position of the effigy on its side parallel to the wall, are found in other parts of Spain, notably at Sigüenza and Cuenca. In addition to the sepulchral niche, there appeared for the first time in Spain the completely detached base, sculptured with the mourners, the ecclesiastics of the obsequies, or with religious subjects. Charles the Noble had made his kingdom of Navarre a center of artistic enterprise at the end of the fourteenth and beginning of the fifteenth century. As early as 1416, his fine monument, now in a hall adjoining the cathedral of Pampeluna, was executed by a Fleming, JANIN or JAUM LOMME of Tournai, with an approximation to the Burgundian tomb of Philip the Bold that it seems difficult to follow Bertaux in explaining by similar artistic antecedents rather than by actual acquaintance. To the class with detached base belong also the tomb of the great bishop of Burgos, Alonso de Cartagena, set in the chapel of the Visitation in the cathedral and executed in the German style that he patronized, and the twin sepulchres of Alvaro de Luna and his wife in the cathedral of Toledo, each of them amplified by four praying figures at the corners, Knights of Santiago on the monument of the Constable, Franciscan friars on that of the Duchess. A superb wall-tomb which provides in the first half of the century one of the most signal instances of Burgundian influence is that of the Cardinal de San Eustaquio in the cathedral of Sigüenza.

The Gothic tradition produced in Spain at the end of the fifteenth century a sculptor of distinct individuality, GIL DE SILOÉ. Trained among the Teutonic masters who had been working at Burgos in this century, he retained their influence in his complicated draperies, but he sought, especially in his countenances, an ideal beauty that constituted a partial *détente* and made him the Michel Colombe of Spain. His peculiar style already appears with a kind of youthful purity in the utterly captivating feminine figures of an early work, a small retable for a lateral altar in the Chapel of the Constable in the cathedral of Burgos. His most pretentious achievements are found in the sanctuary of the Carthusian church of Miraflores near Burgos: the unusually opulent retable (in collaboration with Diego de la Cruz); in front of the altar the joint tomb of Isabella's royal parents; and against one wall the monument of her brother, the Infante Alfonso. The shape

of an eight-pointed star for the base upholding the effigies of John II and his queen and the geometric patterns of the retable are of Moorish derivation and assist in creating the Spanish atmosphere. The richness of the altarpiece is paralleled by the sumptuous costumes of the deceased and by the wealth of Gothic decoration on the royal sepulchre. Most interesting amidst this decoration are the statuettes of the Virtues, who had already shown themselves on one or two earlier tombs in the peninsula. The embellishment runs even greater riot on the niche of the monument of Alfonso, who is represented as kneeling in prayer. Gil de Siloé always rose to the occasion of carving the heavy stuffs and jewelled embossings of the draperies in which he delighted. The most superb example is perhaps to be seen in the tomb of Isabella's favorite page, Juan de Padilla, now in the Museum of Burgos (Fig. 64), a chaster counterpart to Alfonso's monument and the sculptor's masterpiece.

A similar tendency to what may be termed a *détente* may be discerned in a sculptural school that centered at Sigüenza at the end of the century and was employed chiefly upon tombs. Although the effigies are likely to assume a graceful reclining posture of reading, the Burgundian ebullition has been stilled, and the sepulchres are pervaded by a quiet, vague, and almost mystic melancholy, embodied particularly in diminutive pages or other attendants that now sit at the feet of the deceased in place of the symbolic animals of the earlier Middle Ages. The technical skill, especially in the rendition of the human form, is above the average of Spanish Gothic in the fifteenth century. Here again, as in France, an explanation of these qualities has sometimes been sought in the supposition of an early influence of the Italian Renaissance, but there is nothing to show that the development was not indigenous. Good examples are the sepulchres executed towards the end of the century for the Count of Tendilla (son of the famous man of letters, the Marquis of Santillana) and for his wife in the church of S. Ginés at Guadalajara; but the masterpiece of the school is the tomb of the young Knight of Santiago, Don Martín Vásquez de Arce, erected about 1490 in the cathedral of Sigüenza.

6. PORTUGAL

The Lusitanian kingdom achieved no such distinction in sculpture as in architecture and painting. During the earlier Gothic period, which, as in Spain, was dependent upon France, the rare figured portals, such as that of Evora, are provincial and unimportant. Certain tombs alone have any significance. The loveliest are in the abbey of Alcobaça, two similar monuments of the fourteenth century, devoted

to the memory of Pedro I and his beloved but ill-starred wife, Ignez de Castro. The completely detached sarcophagi — the king's resting upon lions, that of Ignez upon sphinxes (?) — are adorned with an exotic incrustation of Gothic *motifs*, statuettes of saints and mourners, and reliefs, the lace-like delicacy and almost Indian luxuriance of which constitute a characteristic note of Portuguese art even before the days of oriental exploration. Kneeling angels fitly guard the beautiful effigies. Shortly after 1500 the Spanish influence produced several notable monuments of ecclesiastical furniture: the retable of the old cathedral at Coimbra by Hispanicized Flemings; the choir-stalls of the church of Santa Cruz in the same town, surmounted by a quaint frieze of reliefs celebrating the maritime enterprise of Portugal; and the Prophets and saints of wood in the Templar Church at Thomar. Monumental sculpture, at the very beginning of the sixteenth century, was virtually non-existent, for the great contemporary architectural style, the Manuelian, until at the end of Manuel's reign it was contaminated with the Renaissance, did not regularly admit the figure to its rich display of botanical, nautical, and geometric decoration.

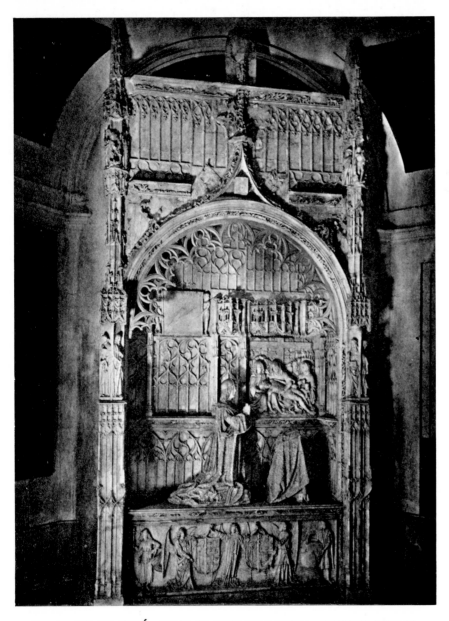

FIG. 64. GIL DE SILOÉ. TOMB OF JUAN DE PADILLA. MUSEUM, BURGOS

(Photo. Laurent)

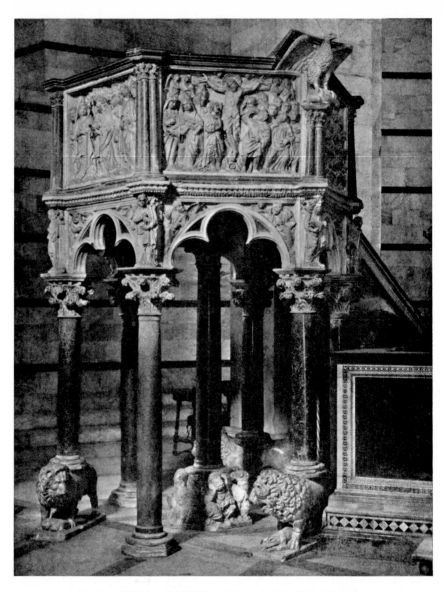

FIG. 65. NICOLA D'APULIA. PULPIT. BAPTISTERY, PISA

(Photo. Fratelli Alinari)

CHAPTER X

GOTHIC SCULPTURE. ITALY

1. INTRODUCTION

By a rather arbitrary but convenient nomenclature, the chronological limits of the Gothic period in Italian sculpture are usually defined as including the plastic production that began with Nicola d'Apulia about the middle of the thirteenth, and continued, largely in dependence upon him and his son, Giovanni Pisano, until the end of the fourteenth century. It was as different from the Gothic of the rest of Europe as had been the sculpture of Romanesque Italy, and for identical reasons. The development of more distinct personality in Italian artists aided in this differentiation, and the rapid conquest of the whole peninsula by the models of Nicola d'Apulia and Giovanni Pisano created a greater unity of style than was to be found across the Alps. One must beware, however, of overemphasizing the divergent life of Italian sculpture. Many parallelisms to French, and in Venice, to German, prototypes reveal the term Gothic as no misnomer.

2. NICOLA D'APULIA AND GIOVANNI PISANO

NICOLA D'APULIA was the first great master of pronounced individuality, not only in Italy, but in all Europe, since the days of classical art. As the second part of his name implies, his family was southern; the title, Nicola Pisano, by which until recently he has been known, was derived from his residence and probable citizenship in Pisa.[1] Whether or not he was actually born in Apulia, he certainly acquired his training in the south. The determinative motive of his technique, the imitation of the antique, he learned from the revival of classicism under Frederick II in the Campanian and Sicilian schools. The Byzantine compositions that he sometimes employed had had a special vogue in the southern kingdom. The elements of French Gothic architecture that appear in his pulpits he probably studied in the Castel del Monte erected by Frederick II. The polygonal form of pulpit, with an interposition of arches between the box and the supporting columns, had already been evolved in Apulia. The greater

[1] In a book of these dimensions there is no space for the recapitulation of the evidence that may now be regarded as having definitely proved Nicola's southern origin.

progress of Romanesque sculpture in the south makes the advance of Nicola less surprising than if he had been educated elsewhere. He was not impervious, however, to his later Tuscan environment. Though he did not use the rectangular shape of the Romanesque pulpits of central Italy, he took from them the complete investiture of the panels with sacred narrative and substituted it for the southern restriction to a few symbolical scenes. Some knowledge of French architecture he might have obtained also from the Burgundian abbey of San Galgano near Siena. But the most significant influence of Tuscany upon Nicola was spiritual. The vigorous communal life of the central Italian towns, especially of Pisa, which in the thirteenth century reached the zenith of her commercial and political power, was more propitious to the development of a great genius than southern cultural conditions, which stagnated after the death of Frederick II. With Nicola d'Apulia, Tuscany entered upon that glorious heritage that she was to enjoy as the artistic focus of the peninsula for more than two centuries.

Both Nicola and his son Giovanni did their most typical work at a rather advanced age. The former, born probably in the early years of the century, seems to have labored as an architect and as an architectural carver until he received the commission for his first great monument, the pulpit of the Pisan Baptistery, which he completed in 1260 (Fig. 65). Five sides of the hexagonal box contain episodes from the life of Christ, the sixth opens to the staircase. Beneath, the spandrels of the arches and the dividing angles are decorated with figures of Old Testament worthies, Sibyls, and Evangelists. The method by which Nicola accomplished the resuscitation of sculpture is obvious: he reverted directly to the Graeco-Roman sarcophagi. The classical derivation is evident in the heroic Roman types, in the crowding of the reliefs, and in the use of two planes in contrast to the single plane of Lombard and Tuscan Romanesque. Even Vasari recognized that Nicola copied some of his figures from antiques that used to stand before the cathedral but have now been relegated to the Campo Santo. The Roman matron, for instance, into whom the Virgin of the Epiphany has been transformed, was suggested by the Phaedra of the famous sarcophagus depicting the story of Hippolytus; the Herculean Samson dividing two of the arches below reproduces Hippolytus himself; the High Priest of the Presentation and his attendant are a Christian translation from a marble vase representing Bacchus supported by a boy. The general idealism of the thirteenth century is here very close indeed to the idealism of ancient art.

But Nicola was more than a mere imitator. His originality did not

stop when he had fused harmoniously his dominating antiquarianism with the Tuscan method of religious narrative and a French architectural setting. He possessed a fine sense of composition, and he imported into his rendition of the sacred drama a keen observation of actual life. The Virgin, who in Byzantine representations of the Crucifixion stood erect, he ideated more naturally as swooning in the arms of the Holy Women. He revivified the listless forms of the classic decline by electrifying them with the energetic youthfulness of the Middle Ages and the new Italian culture.

Having mastered his technique through a study of ancient sculpture, he was able to give freer rein to his originality in the second of his two principal works, the pulpit of the Sienese cathedral, begun with the aid of several pupils in 1265 or 1266. An elaboration of the earlier monument, it is an octagon, substituting statuettes for the small grouped columns that had separated the reliefs and eight Virtues for the holy personages that had separated the arches. About the base of the central supporting column are gathered the seven Liberal Arts and Philosophy, the idea and iconography of which he may have acquired from some itinerant French artist. The Olympic majesty of the Pisan pulpit was partly sacrificed to the crowding of the panels with smaller figures and to a greater realism, as in Fig. 66, where in the same frame with the Presentation have been added the deliberation of Herod, the vision of St. Joseph, and the Flight into Egypt. The Virgin in the reliefs is approximated to the ordinary woman; in the Nativity, instead of dominating the scene like a recumbent empress, she turns and seems to look sadly down the vale of the coming years. The haggard St. Elizabeth of the Visitation is almost painfully realistic. The crucified Saviour no longer reigns from the tree, as on the Pisan pulpit, but hangs in the wasted likeness of our flesh, His mouth gaping with agony. The two extra panels afforded additional opportunity for themes demanding realism and movement. Nicola expanded the Last Judgment into two panels, exerting his dramatic *verve* upon that representing the punishments of the damned; into the remaining section of the octagon he introduced the Massacre of the Innocents, and created in some of the suffering women histrionic types that persisted in the later Italian iconography of the subject.

In the reliefs of the Sienese pulpit he advanced further towards realism than the characteristic contemporary sculptors of other countries, except Germany. One sometimes wonders, indeed, whether his son Giovanni, who was his apprentice, did not have a larger hand in these reliefs than has usually been allotted to him. In the statuettes of the corners, Nicola gave the highest expression to his sense of ideal

beauty, but it was now an idealism based as much upon a study of nature as upon classical art. All of these statuettes exhibit a feeling for gentle grace that was not to be expected in the man who carved the robust and stately forms of the Pisan pulpit. The loveliest perhaps is the Virgin and Child, the first erect and separate representation of the subject in the round in Italy, probably suggested by a French ivory and establishing the main outlines for the many later recurrences of the type in the peninsula.

By the time that Nicola d'Apulia had set to work upon the Sienese pulpit, he realized the crux that so often presented itself to Italian artists, the impossibility of completely adapting the repose of classical sculpture to the emotional quality of Christian iconography. Having learned all that he could from his archaism, he therefore partially abandoned it, and struck a skilful balance between archaism and naturalism. His son, GIOVANNI, accentuated the agitation and realism of the Christian subjects, and so moved further away from an imitation of the antique. The works of Giovanni, like the later works of Nicola, in their forms, if not in their spirit, resemble more the Gothic sculpture of the rest of Europe.

Until his father's death, which occurred probably in 1278 when he was engaged upon a fountain at Perugia, Giovanni, who was born about 1250, acted as his assistant. Having devoted himself chiefly to architecture at Pisa and Siena until he was fifty years old, like his father he expressed himself most characteristically in two pulpits. The first, executed 1298–1301 for the church of S. Andrea at Pistoia, is like Nicola's Pisan pulpit in construction, except that it employs statuettes for the dividing angles above and substitutes a range of Sibyls between the arches below. An increased naturalism is evident at every point. In contrast to the sturdy forms that his father retained, though on a reduced scale, even at Siena, those of Giovanni are slighter and more human, so that the spaces are less crowded. The Virgin of the Annunciation is a shrinking peasant maid, Gabriel is merely a child rejoicing in his news. Fainting in the Crucifixion, the Mother casts a last agonized look at her Son, whom, as a Babe, she had tenderly lifted the covering to look upon; the suffering rather than the majesty of the outstretched Saviour is embodied in the protruding bones and muscles of the emaciated figure. The individualization is greater: the best instance is the cleric framing the Nativity on the left, a veritable portrait. But the most pronounced trait of Giovanni Pisano is his emotionalism. This declared itself at times in the tender and pathetic attitude towards the religious themes bred by Franciscanism, as in some of the figures mentioned above. Or it took the

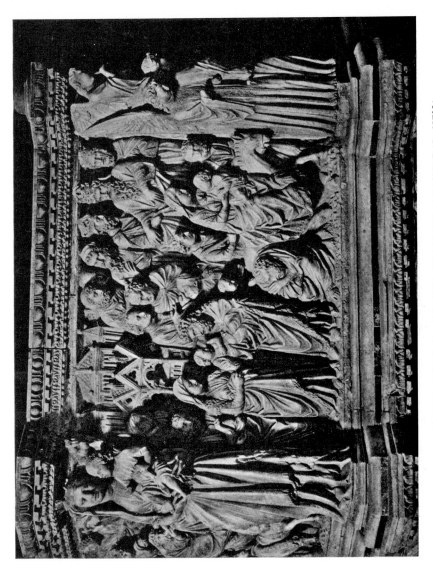

Fig. 66. NICOLA D'APULIA. SECTION OF PULPIT. CATHEDRAL, SIENA

(Photo. Fratelli Alinari)

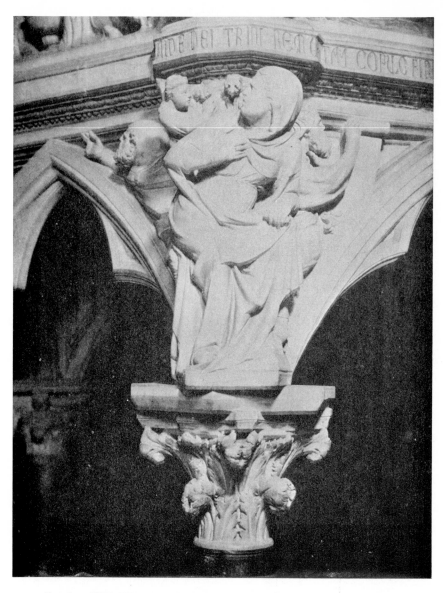

Fig. 67. GIOVANNI PISANO. SIBYL ON PULPIT. S. ANDREA, PISTOIA

(Photo. Fratelli Alinari)

shape of a nervous and in places an almost tragic intensity, revealed in the expression of the countenance, in distortion of the body, and in violence of single and grouped action. In the striking effigies of the Sibyls he appears as the direct precursor of Michael Angelo. He winds and twists them into instruments of expression for the turbulent passions that harassed his own soul (Fig. 67). This divine fervor he instilled even into such supreme examples of a quieter and more ideal beauty as the corner-piece of St. Matthew's angel.

The most elaborate pulpit in the series was built by Giovanni Pisano between 1302 and 1310 for the cathedral of Pisa. It was injured by fire at the end of the sixteenth century, but its principal parts are preserved in the cathedral and the Museum and in the Kaiser Friedrich Museum at Berlin. Its most distinctive architectural feature was the frequent use of grouped allegorical, theological, and sacred statues as caryatides instead of the supporting columns; the lady Pisa, herself surrounded by the four cardinal Virtues, shows that in Italy the civic life was exalted to an equal eminence with the religious. The peculiarities of the Pistoiese monument are exaggerated. The emotionalism has become feverish, the movement wild. In one panel, the new theme of Christ's torments before the Crucifixion is added for its emotional possibilities. The relief everywhere is higher so that the figures may sway, not only to the side, but backward and forward. The aged Giovanni Pisano defiantly indulges in incorrect proportions, in order to divert the observer's attention from accurate representation to the impression of passion. The torsos, especially, are often too long for the legs, and the forms are marked by a neurotic, pathological emaciation. In examining the late work of Giovanni Pisano, one inevitably recalls the painting of El Greco.

The serener manner of the angel at Pistoia is embodied also in a series of separate devotional statues of the Madonna and Child, which he was the first in Italy to carve in the large. His small ivory treatment of the subject in the sacristy of the Pisan cathedral gives the clue to the chief source of his inspiration: he caught his suggestions as much from French Gothic as from the corner-piece on his father's pulpit. The French bend to the side is only less decided in the more monumental Virgins than in the ivory statuette. As was to be expected, Giovanni humanized the theme more than Nicola. His tragic outlook on life led him to choose as models the sorrowing rather than the smiling Virgins of the French fourteenth century, and to emphasize still further the sadness of the Mother to whom had been foretold the woes that she as well as her Son must suffer. The loveliest example in the series was sent about 1305 to the Arena Chapel at Padua,

which Giotto was decorating or had just decorated with frescoes, so that the styles of the sculptor and painter who set the fashion for Italy of the fourteenth century may be seen side by side.

3. THE FOLLOWERS OF NICOLA D'APULIA

The two principal pupils of Nicola d'Apulia, besides his son, were the Dominican FRA GUGLIELMO of Pisa and Arnolfo di Cambio. If the former was indeed responsible about 1260 for the pulpit of the cathedral of Cagliari in Sardinia, he began in the old Romanesque style of Tuscany, and later became an uninspired imitator of Nicola, copying his forms but unable to reproduce their strength, dignity, or life. Shining by the light reflected from his master, yet always a clumsy provincial, he was not seldom slovenly in detail and monotonous in composition. His two typical monuments are the shrine of St. Dominic in S. Domenico at Bologna, the designs for which were made by Nicola himself (1265), and the pulpit of S. Giovanni Fuorcivitas at Pistoia, in which he still retained the old Tuscan rectangle.

Frey's differentiation of ARNOLFO DI CAMBIO (d. 1301 or 1302) into two persons, one an architect and the other a sculptor, may be rejected. An assistant of Nicola at Siena and Perugia, he is important for the creation of two artistic types in Italy, the Gothic *ciborium* or *baldacchino* and the Gothic tomb. Of the *baldacchino*, he executed two examples at Rome, in S. Paolo fuori le Mura (finished in 1285) (Fig. 68), and in S. Cecilia in Trastevere (1293). The canopy consists of cusped arches surmounted by crocketed gables and of corner niches surmounted by pinnacles. The whole monument is adorned with *opus tessellatum* or *Cosmati-work*, a decorative combination, in geometric designs, of colored marbles inset with porphyry and glass mosaic, taking its name from the fact that it was the stock in trade of the Roman guild of artisans who were known as the Cosmati and were extensively employed in the region for sepulchres and ecclesiastical furniture. For the explanation of the Gothic elements in the canopy as for the explanation of his later Gothic architecture at Florence, it is not necessary to assume an interval of study in France. He might have learned much from travelling Frenchmen; or in the service of Charles of Anjou (for whom he may have done the portrait statue now in the Palazzo dei Conservatori, Rome) he might have acquired some rudiments of the French Gothic architecture which was flourishing in that monarch's kingdom of southern Italy. Like Nicola d'Apulia, he superimposed upon the Gothic architecture of his *baldacchini* figures suggested by the antique. In the earlier of the two monuments, for instance, St. Paul (in the niche at the right of the illustration) has the

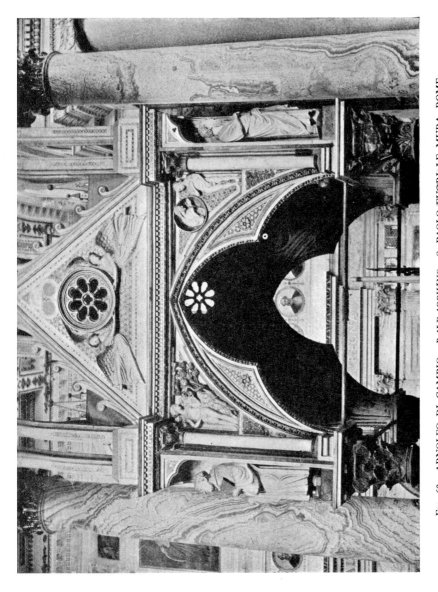

Fig. 68. ARNOLFO DI CAMBIO. *BALDACCHINO.* S. PAOLO FUORI LE MURA, ROME

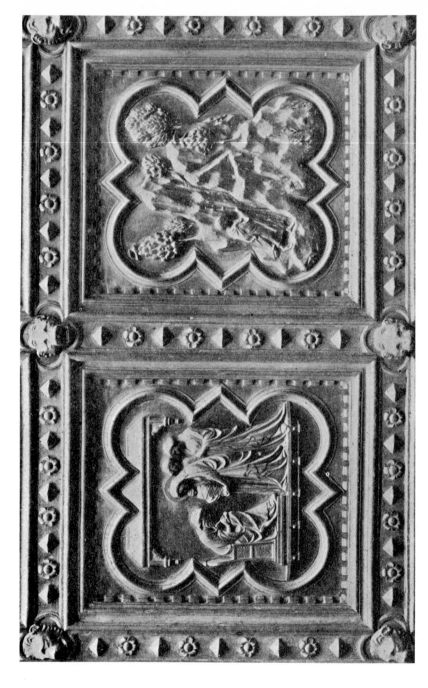

Fig. 69. ANDREA PISANO. PANELS FROM BRONZE DOORS OF BAPTISTERY, FLORENCE, REPRESENTING THE NAMING OF ST. JOHN BAPTIST AND THE YOUNG ST. JOHN GOING FORTH INTO THE DESERT

costume and pose of an ancient orator, and Eve recalls the character-
istic Venus of late classic sculpture. Arnolfo's types, however, are
stubbier, more naturalistic, and more popular than those of his
master. His canopies were imitated at Rome in S. Maria in Cosmedin
and in S. Giovanni in Laterano.

Hitherto interment had taken place in a mere sarcophagus without
the effigy of the deceased, but about 1282, with the sepulchre of the
Cardinal de Braye in S. Domenico, Orvieto, Arnolfo began the tradi-
tion of the more elaborate Italian medieval tomb. The recumbent
figure is set in a kind of mortuary recess, the curtains of which are
drawn aside by two deacons; and above at the left the prelate appears
again, kneeling before the enthroned Virgin, to whom he is presented
on his own side by St. Paul and on the other by St. Dominic. The
mortuary recess is elevated on two tiers of architectural decoration in
Cosmati-work, and the same sort of ornamentation frames the upper
group. The Virgin has all the Roman majesty of Nicola d'Apulia's
early style, but St. Dominic and the two portraits are in Arnolfo's
more naturalistic vein. Arnolfo, indeed, began here the attempt at
portraiture in sepulchral statues that became general in Italy during
the period. The immediate imitations of this tomb in the churches of
Rome and Viterbo suppressed the upper section but spread above the
prostrate effigy a Gothic canopy, similar in outline to Arnolfo's
baldacchini.

4. THE PISAN STYLE AT FLORENCE

The greater part of the sculpture of the fourteenth century, or, as the
Italians call it, the Trecento, belongs to the school of Giovanni Pisano.
His temperamental idiosyncrasies defied imitation, but the outer sem-
blance of his work — the compositions, the types, the full classic
draperies, flowing in undulations of Gothic line and often hiding the
action of the body beneath — largely supplanted the Romanesque
models throughout the peninsula.

The movement achieved its highest distinction at Florence, which
now became the cultural center of Italy. Its first great Florentine ex-
ponent was Andrea di Ugolino, who was born, however, at Pontedera
in the territory of Pisa and was called ANDREA PISANO (*c.* 1270?–
1348). He was certainly well advanced in years when in 1330 he re-
ceived the most important commission of his life, the first bronze doors
of the Baptistery at Florence. The delicacy of his workmanship and
the statement on his epitaph make it likely that hitherto he had de-
voted himself principally to the profession of the goldsmith, in which
so many of the great Florentine artists began their careers. The doors

consist of twenty-eight rectangular panels, in which are inscribed Gothic frames of a shape paralleled on the portals of Rouen and Lyons (Fig. 69). In the upper twenty of these frames is related the story of St. John Baptist, the patron of Florence, in the lower eight are allegorical Virtues. The reliefs, curiously enough, are the work of a man whose nature was diametrically opposed to that of Giovanni Pisano. The distinctive notes are simplicity, repose, grace, and gentleness. In contrast to the high frenzy of the earlier master, each narrative compartment contains only the figures necessary to tell the tale, and their postures aim at quiet elegance rather than emotional violence. The desire for gracefulness in the inclination of the body, especially through the lowering of one hip, and in the manipulation of the draperies is a definitive trait of European sculpture in the fourteenth century; but here the draperies are amplified, they flow in longer, smoother, more unbroken curves, and they avoid angularity.

In his simplicity of composition, Andrea Pisano was influenced by Giotto, whose dominating personality made itself felt even in sculpture, and he actually accommodated to the smaller scope of his panels sections of the painter's monumental frescoes in the Peruzzi chapel of S. Croce. It was perhaps the study of painting that led him to employ a certain amount of landscape setting, although he wisely did not attempt the pictorial perspective which later was to violate the boundaries of sculpture. The iconography of the Virtues recalls Giotto's epoch-making representations at Padua, but the painter's stalwart women have become gentle ladies, lacking the powerful characterization of the Arena Chapel. The emphasis upon formal grace rather than upon Florentine strength and solidity denotes in Andrea Pisano an influence of Sienese art, which was the most truly Gothic in Italy, and which was already beginning to affect some of Giotto's Florentine followers in painting.

Andrea's admiration for Giotto rendered it fitting that he should undertake the sculptural adornment of the Campanile which that versatile artist had begun to build in 1334. Of the two zones of reliefs, the lower, including twenty-six panels, represents the Creation, the institution of labor by Adam and his descendants, and its different manifestations in the manual, representative, and intellectual arts. The upper zone, with twenty-eight panels, comprises the allegorical figures of the seven Liberal Arts (in contrast to their actual exercise below), followed by the seven Virtues, the seven Planets, and the seven Sacraments. GIOTTO seems to have conceived the whole iconographical scheme, drawing from Nicola d'Apulia and France in the upper tier and showing more originality in the lower, although the

writings of Brunetto Latini, Dante's master, may have given him certain ideas. Whether he himself did some little carving or at least made any designs for the reliefs, it is impossible to determine. With the exception of the five panels done by Luca della Robbia in the Renaissance, the lower zone wholly or in very large part is apparently the actual handiwork of Andrea Pisano, who, in certain reliefs that exhibit an energy unusual for him, such as the representation of Agriculture, may have used models left by Giotto. The art of weaving is in Andrea's gentlest and most graceful manner. The upper but less successful zone was carved by later Florentine hands, perhaps under the direction of FRANCESCO TALENTI, Andrea's successor on the Campanile; the seven Planets may be the work of Talenti himself.

Of Andrea's two sons, NINO and TOMMASO, both of whom took up their father's craft, the former and more significant is remembered in the history of art for his more human treatment of the Madonna and Child. He tended to abandon the hieratic more than his predecessors and to stress the tender, earthly side of the relationship (Fig. 70). In the church of S. Maria della Spina, Pisa, he introduced into Italian sculpture the Virgin nursing the Infant, the *Madonna del Latte*, and for the first time in Italy reduced the sculptured Virgin to a half-length. Although Nino Pisano's manipulation of the drapery betrays a more intimate knowledge of French models than he could have obtained from Giovanni and Andrea Pisano, and although he imbued the subject with much sweetness, neither he nor any other Italian admitted the "smiling coquetry" in which the lighter nature of the French found satisfaction. The vestige of Giovanni Pisano's sorrowful yearning remained in an underlying expression of pensive wistfulness. The Metropolitan Museum possesses a good example of a Virgin in Nino's manner, probably to be assigned to one of his pupils (accession no. 09.141.5). It was also the tradition of the French minor arts that helped him to imagine large detached statues of Gabriel and the Virgin Annunciate.

ANDREA ORCAGNA, one of Giotto's most original followers in painting, naturally revealed in his sculpture a more vital Giottesque influence than Andrea Pisano. His one great monument in this phase of art is the opulent canopy over the miraculous Madonna of Or San Michele, Florence, completed in 1359 after the precedent set by Arnolfo at Rome. The base is decorated with reliefs of the Virgin's life and the three theological Virtues, the back with the Death and Assumption of the Virgin, and the other parts with figures of angels, prophets, patriarchs, saints, and additional Virtues. He retained not only the sturdy strength of Giotto's forms but also his wonderful

spirit of religious gravity. He even gave to the masculine types a degree of vigor and asperity not achieved by Giotto. In his homely and familiar treatment of the sacred themes, he patterned after his master, but he himself introduced such lifelike details as St. Anne's caress of her new-born child or the feminine spectator leaning on the parapet in the Presentation of the Virgin. More than Giotto, he occasionally sought a Gothic and Sienese grace, especially in the draperies.

The late fourteenth century at Florence witnessed the rise of the goldsmith's art to greater importance, its elevation to the realm of true sculpture, and its absorption into the tradition of the Pisani. The chief monument, the silver altar of the Florentine Baptistery, now in the Opera del Duomo, adorned with scenes from the life of the Baptist, was begun in 1366 by LEONARDO DI SER GIOVANNI, and continued by his pupils, but the last compartments were not added until the Renaissance was well advanced. The principal interest of the reliefs belonging to the Trecento is that, though based upon the compositions of Andrea Pisano's doors, they develop still further the backgrounds of landscape and architecture and thus constitute a transition to the pictorial method of Ghiberti. Leonardo was also one in the long line of artists, who, since the end of the thirteenth century, were working upon the similar monument of Gothic craftsmanship, the silver altar of St. James in the cathedral of Pistoia.

The most significant marble sculpture done in Florence at the end of the Trecento was the decoration of the two lateral doors of the cathedral, the Porta dei Canonici and the artistically superior Porta della Mandorla, which were not finished until the beginning of the next century. In the moldings, the profusion of figures and *motifs* copied from the antique leads directly into the Renaissance.

5. THE PISAN STYLE AT SIENA AND NAPLES

The hedonistic and rather languid attitude towards life at Siena, the admiration for the mannered French Gothic models of the fourteenth century, bred in her artists a predilection for graceful elegance and sweet sentiment. These qualities are better exemplified by the great school of Sienese painters, but they may be discerned in the sculpture. They were early transplanted to Florence, and were given a higher expression than at Siena itself when merged with the nobler and more talented sculptural personalities of that city. In the sculptors of Siena, elegance and sentiment were weaker and more unrelieved, and were often marred by incorrectness of proportions and modelling, as well as by a defective sense of beauty.

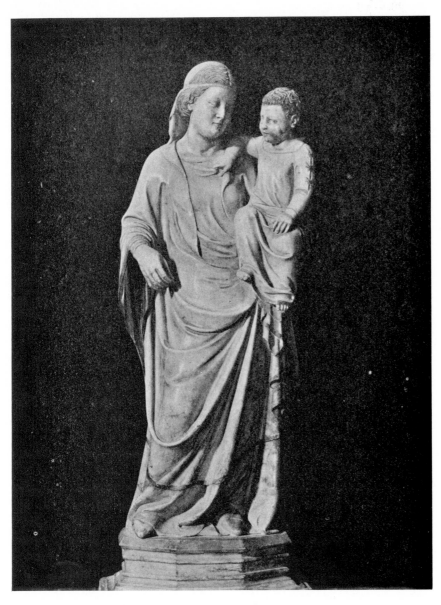

FIG. 70. NINO PISANO. MADONNA AND CHILD. MUSEUM, ORVIETO

(Photo. Fratelli Alinari)

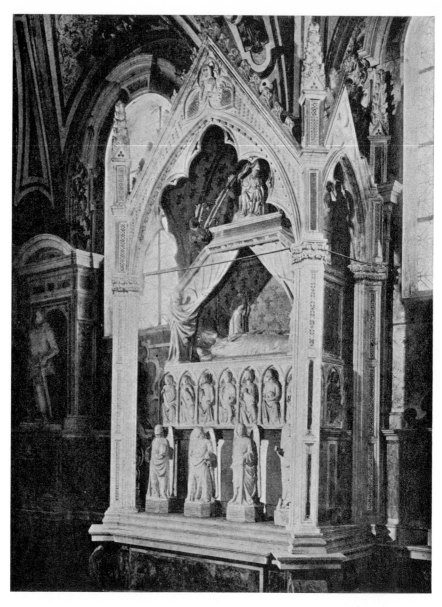

Fig. 71. TINO DI CAMAINO. TOMB OF MARY OF HUNGARY.
S. MARIA DONNA REGINA, NAPLES

(Photo. Fratelli Alinari)

The best known names are TINO DI CAMAINO and LORENZO
MAITANI. The former owes his fame to the development that he gave
to the Italian type of Gothic sepulchre. The most complete examples
were done for the cultured Angevin court at Naples, which under King
Robert had also given an enthusiastic reception to Sienese painting.
The mortuary chamber, the curtains of which are lifted by angels, and,
at a higher level, the presentation of the deceased to the Virgin, were
inherited from Arnolfo; the Gothic canopy had already been used in
tombs of Arnolfo's type at Rome and Viterbo. Tino added: the Vir-
tues as caryatides; the decoration of the sarcophagus with the effigy
of the deceased as living, surrounded by members of the royal family
or of the court; and clerics performing the funeral rites within the
mortuary chamber. Typical is the first monument that he con-
structed in 1325, the tomb of Robert's mother, Mary of Hungary,
in the church of S. Maria Donna Regina (Fig. 71). The subsequent
Neapolitan tombs even until the beginning of the Quattrocento and
certain Roman tombs by PAOLO ROMANO[1] in the first quarter of
that century followed, with some variations, the norm set by Tino.
For Robert himself, in 1343, GIOVANNI and PACIO OF FLORENCE
erected in S. Chiara a very elaborate example, in which they covered
the piers with statuettes, introduced between the mortuary chamber
and the glorified Virgin another compartment containing a statue of
the enthroned monarch, and substituted for the funeral rites the
figures of the seven Liberal Arts.

If LORENZO MAITANI himself carved certain sections on the
lower façade of the cathedral at Orvieto, such as the scenes from
Genesis, he would constitute an exception to the strictures that have
been made upon Sienese sculpture. He undoubtedly was master of
works upon the church from 1310 to the year of his death, 1330, in all
probability planned this loveliest of Italian Gothic façades, and,
through French suggestion, devised the iconographic scheme for the
plastic decoration of the four broad pilasters at the bottom. Begin-
ning at the left, the first contains the early episodes from Genesis, the
second a Tree of Jesse combined with figures of the Prophets, the
third the life of Christ, and the fourth the Last Judgment. The diffi-
cult problem of attribution is the same as for Giotto's participation in
the Florentine Campanile. Did Maitani make any more exact designs
for the reliefs, and did he do any of the work himself? The general
unity of style would imply that he superintended the carving and
that after his death the Sienese and Florentines who succeeded him

[1] To be distinguished from another Paolo Romano active in the second half of the Quat-
trocento.

used his models. Some would see his own chisel especially in the first scenes from Genesis, which represent the highest achievement on the façade (Fig. 72). In any case, the pilasters as a whole must be reckoned among the masterpieces of Gothic sculpture. The sinuous charm of Siena is ennobled, the nude is treated with enthusiasm and with unexpected knowledge, and the Italian feeling for the body itself rather than the drapery as a plastic vehicle is evident in the effort to outline the forms beneath garments that are narrower and more clinging than was usual in the Pisan tradition. The partial technical emancipation of the reliefs at Orvieto is one of the paths of transition to the Renaissance; the embryonic but well defined pictorial perspective in several places, as, for instance, in the Creation of the Birds and Beasts, unites with Gothic grace to clear the way for the accomplishments of Ghiberti.

6. THE PISAN STYLE IN LOMBARDY

The purveyor of the Pisan mode in Lombardy and the adjacent districts was GIOVANNI DI BALDUCCIO of Pisa. His great monument for the Dominican St. Peter Martyr in S. Eustorgio, Milan (1339), was suggested by the shrine of St. Dominic at Bologna. The best section is the row of Virtues as caryatides, which are already distinguished by that sensibility to feminine beauty that was always peculiarly characteristic of Milanese art. Other parts are inferior, especially the reliefs from the life of the saint, and probably were largely the production of pupils. Of the many works in the north executed by followers of Balduccio, most remarkable is the shrine of St. Augustine in S. Pietro in Ciel d'Oro at Pavia. Amidst the multiplicity of detail, certain figures are marked by a distorted elongation and emotionalism prophetic of the eccentric style that in the Lombard Renaissance is ascribed to the Mantegazza brothers.

At the end of the Trecento and the beginning of the Quattrocento, a host of French and German architects and sculptors were employed upon the cathedral of Milan, and their style was imitated by local masters, some of them possessing considerable distinction. Reminiscences of Balduccio were combined with the old Lombard-Romanesque tradition, or with foreign borrowings, by a family of sculptors coming from Campione on Lake Lugano and enjoying wide northern patronage even as late as the first part of the fifteenth century. The most important works connected with their names are the group of tombs for the Scaliger family in the little cemetery adjoining the church of S. Maria Antica at Verona; but the collaboration of the Venetian exponents of the Pisan peculiarities, the *bottega* of the Santi family, is now very generally admitted. The only monument of cer-

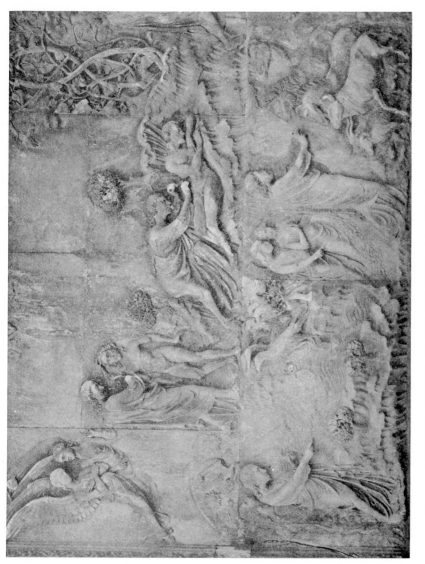

Fig. 72. MAITANI? RELIEFS OF THE CREATION. FAÇADE OF CATHEDRAL, ORVIETO

(Photo. Fratelli Alinari)

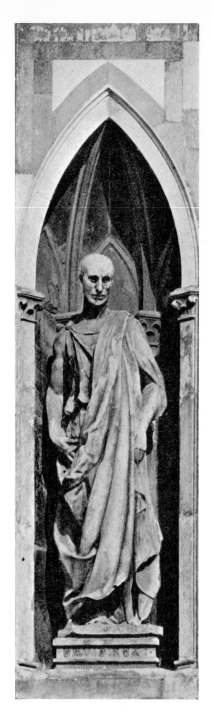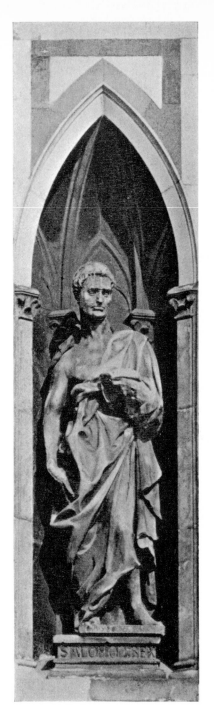

FIG. 73. DONATELLO. "LO ZUCCONE" AND JEREMIAH.
CAMPANILE, FLORENCE

(Photo. Fratelli Alinari)

tain attribution was finished for Can Signorio in 1374 by BONINO DA CAMPIONE. The sepulchre of Can Grande, Dante's patron, who died in 1324, is variously ascribed to the Campionesi or the Santi. On the mausoleum of Mastino II, dating from about 1350, the majority of critics are willing to discern Venetian hands at least in certain sections. The series of monuments presents an ever increasing elaboration of the ordinary sort of Veronese tomb, the sarcophagus of which either rests upon consoles against an outer wall or is elevated as a separate exterior monument, in both cases surmounted by a Gothic superstructure. On these three tombs of the Scaligers, above the canopy rises a kind of spire, on the apex of which is a vigorous equestrian statue of the deceased, a *motif* fairly common in the sepulchral art of northern Italy at this period.[1] Can Grande's sepulchre is set against the wall, the two others are detached. It is some of the reliefs on the sarcophagi and some of the figures of angels and Virtues that recall Balduccio. The type of round feminine head, with the hair bound close about the top and bursting in a thick circle of heavy curls over the shoulder, is a trade-mark of the CAMPIONESI. A fourth tomb of the family in the same cemetery, that of Giovanni Scaliger, slightly earlier than the monument of Mastino II, is so similar to the sepulchres of the Carrara family in the church of the Eremitani at Padua that the attribution to Andriolo Santi almost imposes itself. The Gothic canopy is very simple, and the only distinctly Veronese feature is the position on an outer rather than an inner wall.

7. THE PISAN STYLE AT VENICE

The Pisan models penetrated even the Byzantine barriers of conservative Venice. They seem to have had only a slight effect upon the opulent decoration of the capitals and corners of the Ducal Palace with the usual profane repertoire of allegories, arts, sages, and the like, interspersed with a few sacred themes; these continued to be carved chiefly in a style that was sometimes still Lombard-Romanesque, sometimes half French or German, until the first quarter of the fifteenth century. The Pisan influence manifested itself particularly in the richly sculptured tombs, which resemble those of Verona, except that they were usually placed on the interior wall of the church, and the great crowning Gothic arch was likely to be in the most luxuriant Venetian taste. Sometimes a reredos was substituted for the arch. The sarcophagus was embellished with statuettes or reliefs of sacred purport. The first great representatives of the Pisan style

[1] The original equestrian figure of Can Grande, the best of the three, has now been removed to the Museo Civico, Verona, and a copy substituted.

at Venice, in the middle and third quarter of the fourteenth century, were a family named SANTI (or Di Sanctis) and their workshop, the leading master in which was ANDRIOLO SANTI. Apparently they devoted themselves chiefly to sepulchres of the approved Venetian norm. Andriolo's attainments may be studied at Padua in the tombs of Jacopo and Ubertino da Carrara in the church of the Eremitani and in the sculptured decoration and mausoleums of the chapel of S. Felice in the church of S. Antonio. The trend of modern criticism is to ascribe to this Venetian artist the celebrated tomb of Enrico Scrovegno in the Arena Chapel, Padua, hitherto often deemed the work of Giovanni Pisano himself, who at the beginning of the century had executed the Madonna on the altar of the little church.

Late in the Trecento a very definite German influence joined itself to the Pisan in the persons of JACOBELLO and PIER PAOLO DALLE MASEGNE, an earnest of the Germanization of Venetian painting that was to occur at the beginning of the Quattrocento. The forceful realism of their Teutonic types is best illustrated by the Apostles on the iconostasis of St. Mark's. Followers of the Masegne during the first years of the next century enjoyed a wide vogue not only at Venice but also in the Venetian territory of Dalmatia.

8. CONCLUSION

The second half of the Trecento throughout Italy was in general a period of less brilliant artistic production. The great medieval painters and sculptors had already done their work, and it was only sporadically that masters of secondary talent instilled any life into the enervated repetitions of Giottesque or Pisan forms. The very listlessness of the decline made more natural the reaction of the Renaissance.

PART III

THE RENAISSANCE

CHAPTER XI

THE RENAISSANCE. INTRODUCTION

According to the established chronology, the Renaissance began in Italy in the fifteenth century, reached its fruition in the sixteenth, and at that time, a hundred years after its inception, spread to the rest of Europe. It should be acknowledged at once, however, that the world of artistic criticism is coming more and more to realize a close similarity between Italian painting and sculpture of the fifteenth century or Quattrocento and the contemporary Gothic output of other European countries. The question therefore arises, whether the distinctive Italian quality of imitation of the antique attained enough determinative importance before the sixteenth century or Cinquecento to justify the application of the name, Renaissance, to painting and sculpture. The break with the Gothic tradition was from the first more decisive in architecture, and partly for this reason, partly for the sake of convenience and clarity, the writer has deemed it wise to retain the usual system of dating.

"Renaissance" is, in any case, a misnomer, if with the old classicists we understand it as meaning a "Rebirth" from the Middle Ages considered as a period of darkness and barbarism. The Quattrocento and Cinquecento constituted a revival only in the sense that they resurrected antiquity, learning, and science. Both the Middle Ages and the Renaissance possessed their own great and peculiar qualities, and both expressed them with beauty, force, and brilliancy. The diversity between the two ages manifested itself in two principal channels — in humanism, the more eager and intelligent comprehension of antiquity, and in individualism, the greater emphasis upon personality.

The classical current had never been absolutely interrupted in Italy by the Dark and Middle Ages. It had continued to flow, here in less, and there in greater volume, but it now poured forth in full stream. Earlier imitations of ancient art had been limited and somewhat casual; they now became more general and more studied. A similar development took place in the field of literary pursuits. Virgil and certain others among the classical authors who enjoyed popularity in the Middle Ages had been largely misunderstood and had been interpreted, not in the light of their own civilization, but as if they had

written of medieval characters in medieval times. Liberating themselves from this distorted opinion, the pioneers of the Renaissance, the humanists, examined ancient culture and literature from the historical and scientific standpoints and revealed to themselves and their contemporaries a whole new civilization, different from their own, the existence of which the Middle Ages had only adumbrated. Like the artists, they imitated much more extensively and exactly than their predecessors the writings of Greece and Rome. A long line of eminent scholars stretches through the two centuries of the Renaissance. Many of them held important governmental and ecclesiastical positions, they gave the characteristic tone to their age, and created a seething ferment of archaeological enthusiasm.

The racial inheritance of the Italians made all this humanism much more largely Latin than Hellenic. Greek ideals, however, began to have some influence during the second half of the century. Their most significant effect for art was the foundation of a Platonic Academy at Florence by Cosimo dei Medici and the dissemination of Neoplatonic doctrines by such famous members as Marsilio Ficino and Pico della Mirandola. Under the spell of this philosophy many a sculptor and painter sought to bestow upon his figures the appearance of an ecstatic and mystic contemplation. The spiritual love advocated by the cult evoked in the art of the Quattrocento the most ethereal feminine types.

The concomitant phenomenon of individualism was partly bred by the desire to emulate that realization of the individual's fullest capabilities which the Renaissance discovered in the well-rounded gentleman of Athens or Rome. In the Middle Ages, the individual was somewhat submerged in the common life of the feudal system or the free commune. In the Renaissance, he extricated himself from the society in which he lived and began to realize and cultivate his own personality. From a study of self he was led to an interest in other human beings and finally to an investigation of his and their environment, the natural world. Almost all branches of intellectual activity received a powerful new impetus. Study with the preconceived notions of the Middle Ages was abandoned, and empirical research gained the day. In every phase of activity men longed to stretch forth and increase the treasure of human achievement. The spirit of the age was revealed in art by the effort after a more truthful representation of actuality; and this tendency grew and grew until in the sixteenth century almost all primitive eccentricities were repudiated, and an exact, but as we shall see, a superficial, faithfulness to nature was the great desideratum. In the fifteenth century, the struggle

for a more accurate reproduction of nature fell into line with the ubiquitous contemporary European emphasis upon realism. With this realistic consummation in view, many Italians devoted themselves, in the scientific temper of the day, to the solution of the technical problems of art, such as anatomy, perspective, and the rendering of movement. Other influences of individualism upon art will be considered in the discussion of the sculpture of the Quattrocento. One of the most interesting manifestations of the phenomenon was the evolution of universally talented geniuses such as Alberti, Leonardo da Vinci, and Michael Angelo, who sought to realize to the fullest every possibility of man's personality. If humanism was the motive principle, individualism was the motive power of the Italian Renaissance. Helped by a passionate longing to vie with the ancients, it supplied the force for a period which, in artistic and intellectual achievement of every sort, can be paralleled only by the Periclean Age. On every side was a deep and sincere culture. Splendid costumes, rich rugs, stately furniture, magnificent processions and dramatic spectacles — all must be brought within the realm of art. The whole Italian people had become a nation united, if not politically, at least by the craving for the beautiful in everything.

The Renaissance attained its apogee in the first quarter of the Cinquecento, and the rest of the century in some respects betrayed a decadence. Humanism lost something of its youthful fire. Artists became the slaves rather than the students of the antique, and this archaeological servility cooperated with the complete loss of political liberty and other reasons that will be mentioned in their proper place to precipitate a general esthetic decline. By an excess of individualism, self-development was debased into self-gratification. The result of an extreme license and of an abnormal enthusiasm for ancient ways of thought and life was a certain degree of paganism which began in the fifteenth century but assumed alarming proportions only in the sixteenth. The paganism of the Renaissance has been exaggerated by writers who base their conclusions upon the short stories of the period and upon colored Protestant accounts, but on the other hand there can be no doubt that the standard of morals was much relaxed. The standard of faith was also impaired. The robust religion of the Middle Ages, though it had still been able to inspire the creations of the Quattrocento, was now so far shattered as to constitute, together with the ethical collapse, a reason for the degeneration of art. The freedom of thought stimulated by the Renaissance, the proclivity towards an individualistic interpretation of the Christian tradition, the worldliness of the Church and papal court, were not least among the forces

that occasioned the Reformation in northern Europe. Conditions within the Church itself and among the adherents that remained faithful were much ameliorated in the second half of the Cinquecento by the Counter Reformation or Catholic Reaction, led by the recently founded order of Jesuits, confirmed by the Council of Trent (1545–1563), and intended partly as a means for combating Protestantism; but Jesuitism and the new Catholicism had not yet acquired enough power to stem the decline and became effective as a stimulus to art only in the baroque of the next century.

It was not until the Cinquecento that the Renaissance, in any significant degree, found its way to the rest of Europe. The transplantation of humanism and individualism, though it produced many great scholars, especially Erasmus, did not result, broadly speaking, in quite such brilliant manifestations as in Italy. One of the reasons was that the other countries adopted rather the somewhat enervated and less inspired culture of the second century of the Renaissance. The art, particularly, was inferior, not only to that of Italy, but also to the earlier and more essentially indigenous achievements of the different nations in the Gothic period. Whereas in Italy the Renaissance was a natural development and an outgrowth from the long established esthetic tendencies of the peninsula, in other lands it was, to some extent, a foreign excrescence and therefore not so suitable a medium for the expression of racial ideals. Except in England, however, the old artistic traditions of the several countries partially impressed themselves upon the Italian importations and gave to them, in each case, a certain national tone.

CHAPTER XII

THE RENAISSANCE IN ITALY. FLORENTINE SCULPTURE OF THE FIFTEENTH CENTURY

1. INTRODUCTION

THE Italian Renaissance may be divided into two periods, the Quattrocento, when the influence of the antique was only a contributing factor to the art, and the Cinquecento, when it had become a dominant factor.

The analogy between Italian and other European art of the fifteenth century has already been stressed. Realism and dramatic passion were common, international property during these hundred years; Donatello and Verrocchio had no more of a monopoly upon them than Claus Sluter in Burgundy or Veit Stoss in Germany. In the first half of the century, the forms of Italian sculpture, as in Ghiberti and Jacopo della Quercia, often still remained largely Gothic; but even when, as particularly in the second half of the century, the forms became different from those of the rest of Europe, the spirit was the same. Ghiberti, in his *Commentaries*, mentions a sculptor of Cologne who influenced the young Florentines. Venturi supposes here a confused reference to Claus Sluter; but probably, in general, although there was some artistic communication between Italy and the other countries, the analogies are due to parallel evolution throughout Europe. The tranquillizing effect of the antique may be called into service to explain the frequent moderation of realism and passion, although this phenomenon may also be viewed as the same kind of spontaneous reaction that is represented by the French *détente*. The similarity of Italian to other European art is also indicated by certain technical characteristics, such as the still widely prevalent practice of polychromy and the method, followed by Donatello and at least a large number of other Italians in the Quattrocento, of hewing the stone without constructing a full-size model.

What difference existed was created by the Italian devotion to the antique, generated by the rise of humanism. But the study of Greek and Roman sculpture had not yet assumed large enough proportions to constitute an absolutely determinative factor. The artists of the Quattrocento adapted suggestions from the antique to their own pur-

poses instead of merely copying the antique like their successors of the Cinquecento. Details of modelling, poses, costume, and setting were often derived from classical prototypes, but the basic conception and execution remained original. Not many large pieces of ancient statuary were yet known, and the sculptors caught their ideas chiefly from such examples of the minor arts as coins, cameos, and small reliefs. How little the wonderful production of the Quattrocento was conditioned by the ancient models is evident in the fact that the objects of inspiration did not belong to the best classical period. Despite the inferiority of these objects, the humanism of the day cast over them its glamour, and the most important results of the increased admiration for the achievements of Greece and Rome were a general exaltation of the esthetic ideal and a stimulation to equally high, though not similar, attainment.

Realism, individualization, and the innate characteristics of all Christian art, qualities that Italy shared with the rest of Europe, served to distinguish the sculpture of the Quattrocento from the ancient art that it imitated. The existence of these qualities was also fostered in Italy by the unprecedented development of the phenomenon of individualism. Since they had manifested themselves to a certain degree in some later Greek and Roman sculpture, the distinction may be brought into clearer light by a more extended comparison with the production of the other supreme period in the world's history, the Periclean Age, but, broadly speaking, the distinctions hold for classical sculpture in general.

Whereas ancient statuary was *idealistic,* tending to exclude the ugly and to enhance what was already lovely, the sculpture of the early Renaissance was *realistic,* seeking, in the fresh impetus of research, a more exact reproduction of nature and not shrinking from the disagreeable, when required by such subjects as an emaciated St. John Baptist or a Magdalene disfigured by austerities. Again, the Greek artist studied the different sections of the anatomy in many models and fused together what he had learned in one typical figure, i.e., he *generalized;* the point of departure for an Italian of the fifteenth century was a specific person, i.e., he *individualized.* Thirdly, the classical master stressed the beauty of the *body,* viewing the head only as a part of the whole physique; his successor in the Renaissance, through an individualistic concern with the inner life and meaning of things, stressed the underlying *thought* and *passion.* As the contemporary man of letters delineated the psychology of his characters, so the artist endeavored to represent spiritual experiences through their outward manifestations in the body and particularly the countenance.

The poignant sentiment and emotionalism of Christianity added passion to the mental qualities that sought external expression. A fourth contrast was thus created: Christian drama and agitation took the place of Periclean repose.[1]

On the technical side, one of the most important factors that distinguished the Quattrocento from the greater part of antiquity was the development of that highly pictorial relief with a deep perspective of landscape which never afterward lost its vogue except in cases where the admiration for Graeco-Roman art was very potent, as in the Neoclassic epoch. The reason was partially a question of processes. When the ancients followed their ordinary practice of cutting their reliefs out of stone, they naturally did not wish to remove any more material than was necessary and worked from without inward, so that they did not tend to evolve a deep background. Reliefs of clay they stamped from molds, and these molds they could not recess deeply if they wanted them to be effective in stamping. Their bronze reliefs they usually made by beating a sheet of metal and so found it difficult to give to the foremost figures the height of projection that was essential if there were to be a large number of other planes behind. In the Renaissance, the norm was set by bronze reliefs, not beaten but cast from clay models. The starting-point for such models was the background, from which, by adding piece upon piece, the relief was gradually built up. A deep perspective was the natural result. Marble reliefs were influenced by the fashion established in the commoner bronze examples.

The results produced by individualism and humanism partially differentiated the sculpture of the Quattrocento from that of the Middle Ages. It is possible, however, to exaggerate the change. Christian art, by its very nature, had always tended to express spiritual rather than physical characteristics, and the idealism of the thirteenth century had sought serene beauty in the head rather than in the body. Realism and individualization had been slowly unfolding in the fourteenth century, but they now became in Italy more general and more definite. In the case of Giovanni Pisano, Christian emotionalism had been more than prophesied. So also with humanism, the difference was not so much qualitative as quantitative. The antique had been one of the sources of medieval sculpture, and in Italy had exercised a vital influence throughout the Middle Ages. Indeed, the Renaissance might have begun a century and a half earlier with Nicola d'Apulia, if his son had continued to set the example of a

[1] Some of these distinctions have been suggested by Marcel Reymond in the excellent introduction to the second volume of *La sculpture florentine*.

fervid antiquarianism. Yet in general, the sculptors of the Renais-
sance imitated ancient art with more zest and accuracy. Of special
interest was the addition of mythological and classical themes to the
repertoire of art, which hitherto had been so largely religious. The

Other signs of a new age were not wanting. A growing appreciation
for the esthetic significance of the nude was due, not only to the pat-
tern of the ancients, but also to the prevalent enthusiasm for investi-
gation, which would not rest until it had reached what in the sphere of
art is closest to the essence of things, the undraped human body. The
individual artist, conscious of his high profession, took the place of the
medieval craftsman, who was one of a corporation, and iconography
depended more on individual invention. The builder began to be more
sharply differentiated from the carver, although the now often noted
parallelism of Italy to the rest of Europe and the versatility of Italian
genius still frequently combined the two professions. The develop-
ment of individualism instilled into art a fresh and unique spirit of
energy, enterprise, and experimentation, sharply contrasted with the
rather lifeless imitation of Pisan models in the later fourteenth cen-
tury and declaring itself even in such minor matters as the more care-
ful valuation of paintings and sculptures by groups of experts and the
award of important commissions only after competitions.

2. THE THREE GREAT INAUGURATORS OF THE QUATTROCENTO

The most vigorous, beautiful, and characteristic sculpture of the
Quattrocento was produced at Florence, which was then the center of
Italian civilization. The most illustrious figure in the new movement
and the father of all Renaissance art was Donato di Niccolò di Betto
dei Bardi, called DONATELLO (c. 1385–1466). His life, through a
large part of which he enjoyed the patronage of Cosimo dei Medici,
may be divided into four periods. In the first, which may be extended
to 1432, the year of his journey to Rome with his partner, the architect
and sculptor, Michelozzo Michelozzi, he acquired his training, partly
under Ghiberti; he cleared away the lingering encumbrances of the
decayed Pisan tradition; he blazed the path for the Renaissance by
embodying in his works its typical traits of realism, dramatic passion,
intellectualism, and antiquarianism; and at the end of the period he
reached the fullness of his powers. A previous visit of the young Dona-
tello to Rome in company with Brunelleschi about 1400 or a few years
later is accepted as a fact by the majority of critics. The most impor-
tant products of his partnership with Michelozzo from 1425 to 1436
were two sepulchres, one for the pope John XXIII in the Baptistery of

Florence, and the other for the cardinal Brancacci in S. Angelo a Nilo, Naples, based, with some modifications, upon the medieval type of Tino di Camaino but substituting for the Gothic details the ornamentation of the Renaissance. Michelozzo was a man of too meagre talent in sculpture to have had any essential influence upon the brilliant innovator in this phase of art, and although he was a distinguished architect, it is even doubtful whether he or Donatello designed the tombs. The second period, covering the decade from 1433 to 1443, and confined chiefly to the sculptural adornment of architectural monuments, was affected by his second (?) short sojourn in the eternal city. He adopted more suggestions from the antiques that he had seen; he introduced into his exterior pulpit at Prato and into his singing-galleries at Florence the Cosmati-work of the medieval Roman monuments; and by employing as the principal *motif* on the pulpit at Prato and the singing-gallery of the Florentine cathedral the *putto* or nude child, suggested by the pagan Cupids or funereal genii, he definitely established one of the loveliest elements in the art of the Renaissance. The third period and the culmination of his career, including the next decade, was passed at Padua in the creation of the great equestrian statue of the Venetian *condottiere*, Erasmo da Narni, nicknamed Gattamelata,[1] and the bronzes composing the high altar of the church of S. Antonio. About 1450, by travel and labors in the cities around Padua, he spread his style and helped to cause the Renaissance in all northern Italy. In his old age, from 1454 to 1466, following the usual course of evolution, he exaggerated the salutary qualities of his prime.

Donatello's outstanding characteristic was his realism. Its early phase is exemplified by a group of Prophets and Patriarchs begun about 1412 for the cathedral and campanile of Florence and belonging to a large series of monumental statues that were executed at this time by Donatello and others for these edifices and for the exterior niches of Or San Michele. Of Donatello's works in this series, a certain number (all or the majority of them slightly earlier than the worthies of the Old Testament), such as the St. Peter and the St. Mark for Or San Michele, are only ameliorations of the Pisan style; but the group of Prophets and Patriarchs, with, perhaps, one or two exceptions, break violently with the medieval tradition. They are highly individualized portraits of withered old men, to the delineation of whom Donatello gladly turned because the pronounced features, the wrinkles, the protruding bones, muscles, and veins, gave him an opportunity to

[1] Literally in Italian, "honeyed cat," with very much the same connotation as our word, *sly-boots*.

show that he was not afraid of a realism as unsparing as in the strikingly similar Burgundian Prophets by Sluter. The Florentines, whose nimble minds so readily coin nicknames, have called one the Zuccone, or pumpkin-head, by reason of his bald pate. It probably represents Job or Habakkuk, not David, as the inscription states, and does not seem to have been executed until 1435–1436 (Fig. 73, the Zuccone, and also by Donatello, the Jeremiah of 1427). Donatello abandoned the Pisan conventions of drapery, and purposely complicated the folds peculiarly in order to exhibit his new found skill in the extraordinary phases of actuality.

Realism in Donatello took partly the form of emaciation, by which also the structure of the body was laid bare. The Prophets and Patriarchs are good illustrations; a better is the young St. John Baptist, done about this time for the home of the Martelli and now in the museum of the Bargello, Florence (Fig. 74). But there was a more deepseated reason for this emaciation. It has sometimes been felt in the world's history as an esthetic ideal, appearing, for instance, in the Florentine standard of femininity as contrasted with the Venetian, in certain painters of the sixteenth century, such as Parmigianino and El Greco, in fashions for the feminine shape and dress of a decade ago, and, with the exaggeration that marks the school, in some of the Post-Impressionists. Donatello liked it for itself especially in the masculine figure, and throughout his career he found in it a kind of esoteric beauty, symbolic of the wiry energy, the unceasing activity, the purity, and the asceticism that for him constituted the highest ideals of life. The miserably wasted body of St. John calls up the image of a sufferer from Indian famine, but it is permeated by that charm of composition and that nameless grace which relieve even the most brutal pieces of Donatello's realism.

The increased influence of the antique through his journey to Rome in 1432 helped to temper the extravagance that had marked his more youthful realistic experimentation.[1] His proclivities manifested themselves more attractively in the *putti* of the pulpit at Prato and the choir-loft at Florence, direct studies of lusty, romping urchins in every posture of excited activity, whose appeal lies in the animation and high spirits of childhood. The ultimate examples of a moderated realism are the Paduan masterpieces, the Crucifix and saints of the altar and the head of the Gattamelata (Fig. 75). As an old man, he abandoned this moderation, and in the Magdalene of wood in the Florentine

[1] If the Zuccone was done in 1435–1436, it would reveal Donatello working, by exception, in an extremely realistic style even immediately after the journey to Rome, inspired perhaps by the precedent of his earlier Prophets of the same group.

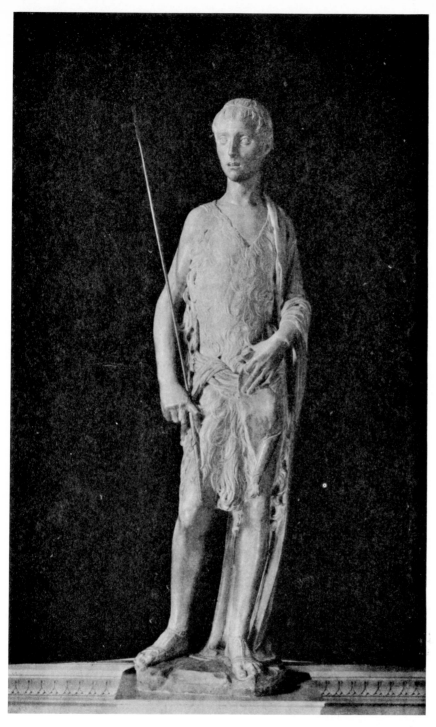

Fig. 74. DONATELLO. ST. JOHN BAPTIST. BARGELLO, FLORENCE

(Photo. Fratelli Alinari)

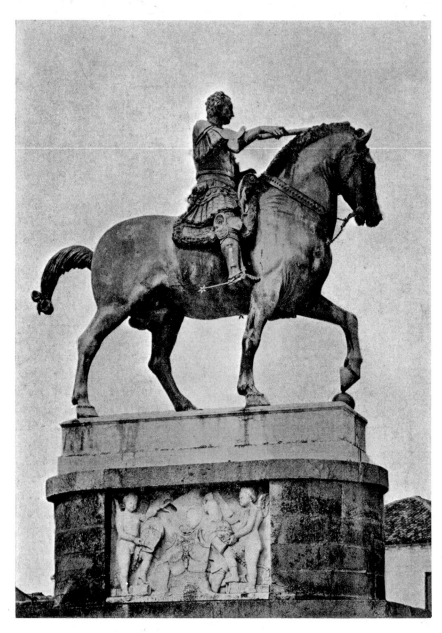

FIG. 75. DONATELLO. GATTAMELATA. PADUA

(Photo. Fratelli Alinari)

Baptistery and the bronze Baptist of the Sienese Cathedral, like certain modern men of letters, he felt that he could prove himself realistic only by turning to the sordid ugliness of life.

The quality that sublimated Donatello's realism was the infusion of his figures with thought. The outer form, the countenance and the posture, were with him a means of expressing the inner mental experiences of the person represented. Beyond mere accidents of subject and costume, what most essentially distinguishes his famous early work for Or San Michele, the St. George (now in the Bargello), from the statue of a classical hero is the impregnation of the head with a chivalrous nobility that makes him a typical representative of Christian knighthood. Other examples of the interest in the underlying spiritual nature may be chosen almost at random: the participants in Herod's Banquet on the bronze relief for the Sienese font (Fig. 76); in the second period, the pairs of saints in the compartments of the bronze door for the sacristy of S. Lorenzo, Florence, where new significance is given to this old medieval *motif* for decoration of doors, not only by variety of action, but also by conceiving the holy personages as sunk beneath weighty meditations; at Padua, the enthroned Virgin of the altar, who is no longer a simple peasant maid, and the Gattamelata, who again is distinguished from the Roman equestrian statue that gave Donatello some suggestions, the Marcus Aurelius of the Capitoline, by the intellectual trait which speaks through the lineaments of the face, that nobler craftiness of the military strategist betokened by his nickname.

Donatello also sought expression for his own emotional nature. His personages are highstrung and nervous. The angels in the relief of the Assumption on the Neapolitan tomb soar in an impassioned flight. In the Florentine singing-gallery, the architectural members that had divided the agitated children of the Prato pulpit are set forward so that behind them there may be one uninterrupted rush of frenzied movement across the whole frieze. For the theme of the Madonna and Child, the Pisani had already stressed the human side of the relationship. In the few reliefs of the subject surely by Donatello's own hand and in the large number done by his immediate school, the Virgin often seems almost to consume her Son with caresses, and the yearning maternal love becomes so intense as to be almost painful. The terracotta example of the Metropolitan Museum (Fig. 77) is one of a group of closely similar panels, none of which are certainly by the master himself. His representations of the theme were so gripping that he popularized its treatment in half-length reliefs, of which there had hitherto been very few. In the subjects of the Pietà and Deposition,

as on the marble tabernacle of St. Peter's, made during his sojourn at Rome from 1432 to 1433, and as in the bronzes of the Paduan altar, he never failed to take advantage of the highly emotional possibilities. The climax was reached in the principal works of his old age, the two bronze pulpits for S. Lorenzo, Florence, one representing scenes from the Passion, the other, the episodes from the Descent into Hell to the Ascension and the martyrdom of St. Lawrence, both of them carried out very largely by pupils, chiefly Bartolommeo Bellano and Bertoldo, on Donatello's designs.[1] The flood-gates of feeling have been thrown open. The spaces are filled with surging throngs, whose figures, bowed beneath grief, terror, amazement, or adoration, are even crowded out behind or in front of the architectural divisions. The scenes from the Passion are like one great vibrating sob. In the second pulpit he even chose as decorative *motifs* for the upper frieze straining nudes holding fiery horses. Now at the end of his life, in the extreme realism of his Magdalene and Baptist, in his violation of the boundaries of the compartments, in his unrestrained vehemence, he cast aside, like Beethoven, the canons that he himself had created. He now sought to seize and crystallize momentary impressions, and he had come to prefer bronze because it preserved the freshness of the clay model and permitted more rapid execution.

Amidst these eminently modern characteristics little place was left for any very vital influence of the antique, except in so far as it softened his realism and curbed his nervous energy. Sometimes it suggested poses, passages of modelling and drapery, or invested his works with borrowed finery. The early marble David for the cathedral (now in the Bargello) wears a Bacchic wreath of ivy; the head at his feet was cut rather from a centaur than from Goliath. The Zuccone is garbed like such a classical orator as the Vatican Demosthenes. Donatello's antiquarianism increased after the journey to Rome in 1432. The terracotta medallions of Evangelists in the ceiling of the sacristy of S. Lorenzo are full of archaeological accessories. The Gattamelata, the first large bronze equestrian statue since classical times, despite the contemporary armor, dominates the piazza at Padua like a Roman general in triumph. The Mourning Germania in the Loggia dei Lanzi was the source of the Judith, now in the same place. Where, as often, he employed classical buildings for the backgrounds of his reliefs, he forestalled Mantegna in an original and romantic reconstruction of the antique that finds a certain analogy in the architecture of the early Renaissance and is curiously paralleled in the paintings of Alma Tad-

[1] The pulpits were not completed until the sixteenth century, when the few remaining spaces were filled out in sculptured wood colored to represent bronze.

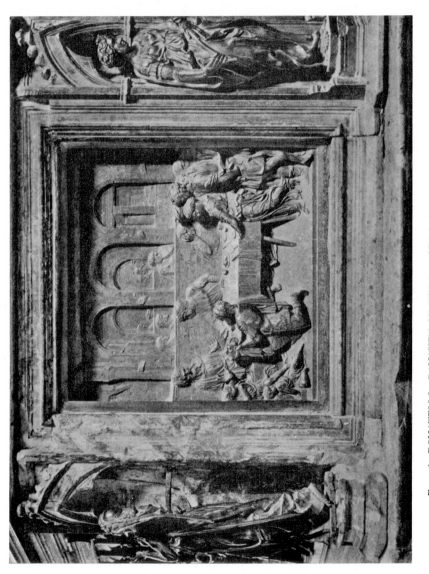

Fig. 76. DONATELLO. BANQUET OF HEROD AND (*at left*) STATUETTE OF HOPE. FONT, BAPTISTERY, SIENA

(*Photo. Fratelli Alinari*)

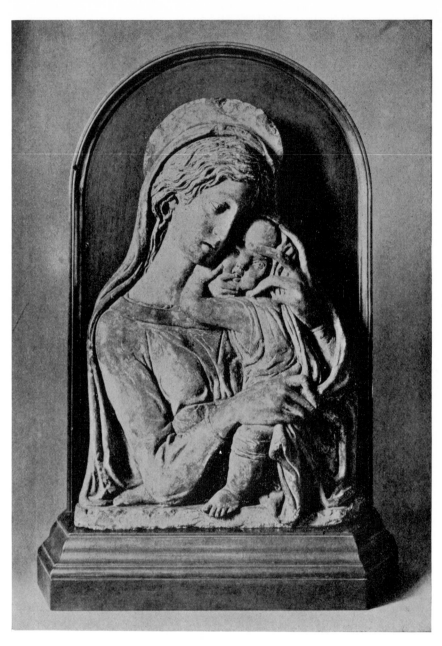

Fɪɢ. 77. DONATELLO OR PUPIL. MADONNA. METROPOLITAN MUSEUM, N. Y.

(Courtesy of Metropolitan Museum)

ema. Indeed, Donatello was so original that when he actually essayed the profession of architecture in the frames for such pieces of sculpture as the tabernacle of St. Peter's or the Annunciation of S. Croce, Florence, he evolved modifications and combinations of Roman *motifs* more fantastic than was usual even among the architects of the early Renaissance. Perhaps the conscious emulation of Roman portrait busts joined with other reasons to produce his realistic treatment of the head. Above all, the precedent of the antique turned Donatello towards the nude. He began in his early works by laying many parts of the body bare of the Pisan wrappings. In the bronze David, done at the end of his first period or the beginning of the second for the courtyard of the Medici palace (now in the Bargello), of his own volition he stripped the Hebrew hero of all drapery, thus overriding medieval prejudice and again making an epoch with the first detached nude since the decay of classical art. Although the velleity for emaciation resulted in a sparer form, the unevenly distributed weight, the curves of the body, and the cast of countenance were derived from Graeco-Roman prototypes. His archaeological enthusiasm carried him so far that, neglecting realism and individualization, he here for once strove to reproduce the idealized and generalized beauty of antiquity.

It has already become evident that Donatello possessed the temperament of a bold innovator, impatient of every convention. Several other spheres in which he experimented deserve mention. He instituted the very low kind of relief described by the Italians as *schiacciato* (or *stiacciato*); and in such mystic subjects as the Assumption of the Neapolitan tomb, the Delivery of the Keys to St. Peter in the Victoria and Albert Museum, London, and the Madonna on the Clouds in the Quincy Shaw Collection in the Boston Museum, he used its depressed and shadowy outlines, often merging into the background, to gain the unearthly effect required by the themes. The delicacy of *rilievo schiacciato* ensured its popularity among Florentine artists, who always retained much of the goldsmith's sensitiveness. At the same time as Ghiberti, in the loggia and landscape of the lovely *predella* to the St. George, representing the fight with the dragon, he tried his hand at the pictorial treatment of relief, applying the laws of perspective evolved by his friend Brunelleschi; but henceforth he usually employed only architecture for the backgrounds in perspective, feeling that landscape was less suited to the mediums of bronze and stone. Donatello separated his planes more distinctly than Ghiberti. In the Sienese panel and in the medallions from the life of St. John in the sacristy of S. Lorenzo, he achieved this purpose through architectural partitions. He again anticipated the painters Mantegna and Me-

lozzo in experiments in spatial composition. Seeking to create the illusion in two of the episodes from the life of St. John that the space of the relief is a continuation of the space of the room in which it is placed, he represented the lower bodies of the foremost figures as cut out from view and, in the Translation of St. John, the lines of perspective as assuming the downward slant appropriate to objects above the level of vision. The effect is of scenes observed through round windows in the ceiling. Similar bits of invention occur even in the works of his old age, the pulpits of the same church. Especially in the second, instead of formal pilasters, the very architecture of the reliefs is utilized to divide them from one another, and the impression of realism is further augmented in the panel of the Marys at the Sepulchre by actually carrying the piers of the loggia around in front of the figures.

Donatello's nimble mind was so fertile in invention that he chafed under the bonds of traditional iconography. He liked to create new compositions of his own, fraught with intense dramatic interest. The brilliantly varied actions of the powerfully characterized participants in the Banquet of Herod upon the Sienese font are all focused upon the object of greatest interest, the head of the Baptist. The same subject is given an utterly different but equally dramatic arrangement in a marble relief of the Museum at Lille. In the Assumption at Naples the usual earthly actors are omitted in order to increase the feeling of a heavenly mystery. Donatello's dramatic imagination may also be studied in the Martyrdom and Translation of St. John in the sacristy of S. Lorenzo, Florence.

Even a casual review of Donatello's career demonstrates the breadth of his genius. When he desired, the statuettes of Faith and Hope on the Sienese font (cf. Fig. 76) and the Annunciation in S. Croce show that he could be as graceful as Ghiberti, and that without affectation; but he did not so far restrict himself to one kind of style that his personality can be defined by such phrases as the grace of Ghiberti or the robust vigor of Jacopo della Quercia. Attraction by mannerism, charm of mere prettiness he usually avoided. His whole production leaves the impression of a chastity and a virility which harmonized with the clean-cut outlines of his individual works and which are illustrated by the anecdote about his refusal to wear Cosimo dei Medici's gift of a handsome costume "because it seemed to him to be effeminate (*delicato*)."

Donatello was one of a great triad who ushered in the sculpture of the Renaissance. The other two were LORENZO GHIBERTI and Jacopo della Quercia, who, though a Sienese by birth and not active

at Florence, must be considered here simply because he was a member of this triad.

The former (1378–1455) is known chiefly as the author of the second and third bronze portals of the Florentine Baptistery. The commission for the second portal he received in 1403 by winning a competition from which, if it were not absurd in the case of artistic movements, we could date the beginning of Renaissance sculpture, since Brunelleschi, Jacopo della Quercia, and Ghiberti all entered the lists with their virgin attempts. The subject for the contest was the Sacrifice of Isaac, and the panels of Ghiberti and Brunelleschi may still be seen in the Bargello. The second doors, upon which he labored until 1424, are obviously based upon the prototype of Andrea Pisano. They are divided into the same number of twenty-eight compartments, the upper twenty containing the life of Christ and the lower eight the Evangelists and Latin Fathers; the compartments are enclosed in Gothic frames of the same shape as Andrea's. Although the complication is greater than in the medieval portal, the scenes still consist of comparatively few figures, and the accessories of setting are simple. For Andrea's decorative border with accents of lions' heads is substituted a delicate *motif* of ivy with accents of human heads which are imitated from antiques or studied from actuality. The outer jambs and lintel are adorned with a chain composed of garlands of richly varied foliage, flowers, and fruits, filled, like the inner border, with all manner of things creeping and flying. All these details are of Gothic derivation, but they sacrifice the partial conventionalization that the best Gothic artists deemed suitable to the rigidity of architecture for botanical and zoological accuracy bred by the revival of scientific interest. In the third portal (1425–1452), the "Gates of Paradise," as they were called by a sculptor of a diametrically opposite nature, Michael Angelo, Ghiberti broke with the medieval precedent and used for the episodes from the Old Testament ten much larger rectangular panels in order to have better opportunity for the pictorial perspective that he here brought to its apogee (Fig. 78). In accordance with the general tendency to elaboration manifested in the third doors, the inner border now includes, besides the heads, statuettes of Hebrew worthies and of Sibyls, and the continuous wreath of the outer frame is more luxuriant.

Although in some respects Ghiberti was in sympathy with his times and owed much to humanism, he may be called the last great Gothic sculptor of Italy. Both his style and compositions were somewhat affected by Don Lorenzo Monaco, who still maintained in the Quattrocento the Gothic tradition of painting. In lines of body and

drapery, he achieved the most exquisite Gothic grace. He often gave to his figures the decided Gothic bend to the side, and the Virgin, Child, and prostrate Wise Man of the earlier portal illustrate how he might continue one extended line of undulation through the contours of a whole group. He repeated again and again with infinite variations an elegant convention of drapery, by which the folds are gathered first over the shoulders, then caught by one arm, swathed about the waist, and allowed to fall upon one foot in long and lovely curves, the edge of which is like the blade of a simitar. In sitting figures, a projecting point like the knee is sometimes taken as a peg upon which to hang a congeries of concave folds. As early as in his relief for the competition he had already abjured the realism and emotionalism that characterize Brunelleschi's version of the theme. He returned to the serener Gothic idealism, but he curiously fused with it the idealism of antiquity. His forms differ from the earlier Gothic in that upon them is superimposed a desire for classical beauty. The contemplation of even inferior Graeco-Roman works inspired him with an esthetic sense that in some ways was almost Hellenic. It taught him classic restraint and prevented him from indulging in violence of attitudes or expression through the countenance. Sometimes, as in the statuettes of the border to the third door, he consciously imitated ancient models. With Ghiberti the body acquires more prominence than in ordinary Gothic sculpture; excellent nudes are introduced whenever there is any justification; in other places parts of the anatomy are exposed; and often, even when the garments have the ordinary Gothic amplitude, the form is clearly outlined beneath them. His nudes do not exhibit, like those of so many of his contemporaries and successors in the Renaissance, an interest in the anatomical study of violently contracted muscles, they avoid the robust strength of Roman sculpture, and are marked by the almost feminine grace that permeates his whole production. How impossible it was for him to render majesty is evident from his different representations of the Christ and in his few monumental statues for Or San Michele, especially the St. John Baptist, where the struggle for majesty has ended in a grotesque vacuity. His delicate hand, indeed, was not so successful in large figures, which, by magnifying the scale of his mannerisms, made them too obvious.

Although he was not so thoroughly an exponent of the times as Donatello, the tendencies of the Renaissance were bound to color his productions. If the heads of the participants in the scenes belong to types rather than individuals, the characterization by posture and movement is adequate, so that, in contrast to the work of Andrea

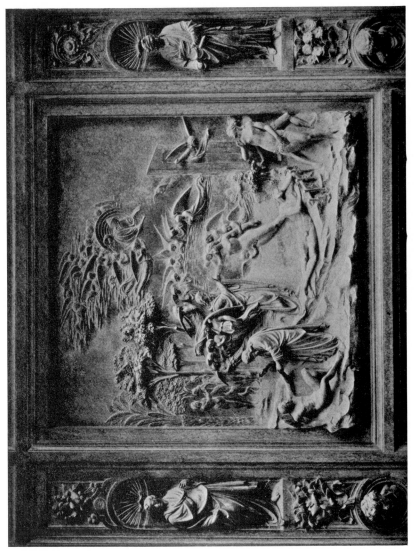

Fig. 78. GHIBERTI. PANEL REPRESENTING STORY OF ADAM AND EVE,
EAST DOORS OF BAPTISTERY, FLORENCE

(Photo. Fratelli Alinari)

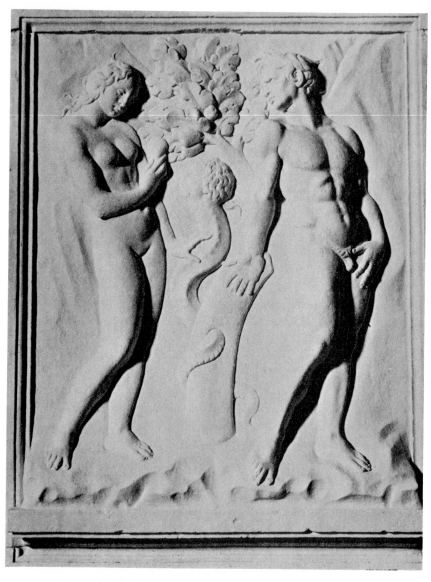

Fig. 79. JACOPO DELLA QUERCIA. SIN OF ADAM AND EVE.
PORTAL OF S. PETRONIO, BOLOGNA

Pisano, a single figure, if taken by itself, would transmit the intended impression without the assistance of the whole composition. In general the movement is greater and more varied than in Andrea, and the members of groups and the decorative heads are differentiated.

But the sphere of Ghiberti's most daring experimentation was the pictorial treatment of relief. In this transformation of its nature, he was influenced by his keener admiration for painting, evinced in his *Commentaries*, a kind of artist's autobiography, and by his own youthful exercise of that profession. Suggestions for the pictorial method he found in the Trecento, he developed it further in the second door, especially in the later episodes from the life of Christ, and finally in the third employed it in its most extreme form. The setting becomes an elaborate landscape of rocks and foliage or a grandiose expanse of architecture. For the effect of a deep perspective, Ghiberti uses a series of many planes, gradually diminishing in height of relief until they vanish into the background and so merging into one another that they create rather the illusion of one continuously receding plane. In order that there may be a multiplicity of planes, the foremost figures have to be given such high relief that they are virtually detached in the round; and in order to preserve the impression of one continuous plane, Deity is encircled with a flight of angels whose forms, encroaching upon one another, grow slowly less and less distinct until they seem a single disappearing mass. The profundity of the relief makes it possible to separate more clearly the episodes that, in the third door, after the old custom, are brought together in one frame. Purists in esthetics have objected to the pictorial treatment because it confuses the aims of painting and sculpture and because perspective of landscape cannot be so convincingly rendered in the mediums of sculpture as in the gradated colors of painting. In any case, Ghiberti's achievement in this method was so transcendent that ever since his example has been often followed.

Jacopo della Quercia, who was born at Siena probably about 1375 and died in 1438, also retained much Gothic feeling, and yet a genius more different from Ghiberti could not be imagined. His personality is best expressed in the Virgin, Virtues, and scenes from the Old Testament, originally forming the Fonte Gaia at Siena (1409–1419) but now removed to the Palazzo Pubblico for the safer keeping of the battered fragments that remain, and in the culminating and most typical works of his life, the statues of the Virgin and saints and the reliefs from Genesis and the infancy of Christ (Fig. 79) that he began in 1425 for the main portal of S. Petronio at Bologna. He here appeared as the truest precursor of Michael Angelo. He chose full,

powerful figures as of a race of supermen, and breathed into them passionate strength. Giovanni Pisano had prophesied Michael Angelo by the contortions of his bodies; Jacopo della Quercia did not usually indulge to such an extent in this emotional device, but by transforming the Gothic slouch into a violent backward and sideward thrust he made it serve his constant purpose of imbuing his forms with a mighty energy. The Virtues at Siena, however, and the one bronze relief executed by him on the font that he himself designed in the Sienese Baptistery show how he could coerce broad, magnificent sweeps of drapery into performing an emotional office. He had an ardent fondness for the nude, but unlike Ghiberti was interested in its force rather than its grace. The rehabilitation of the nude in him as in others was partly occasioned by the prevalent enthusiasm for ancient art, and a direct dependence upon classical models can sometimes be traced, as in the Adam of the illustration, who is a metamorphosed Hercules. Unlike both Ghiberti and Donatello, he admitted only a few large figures to his reliefs, and reducing the details of setting to their lowest terms, scorned nearly altogether the pictorial treatment.

Whence could he have acquired this monumental and heroic style? Surely not from the last languid and inferior representatives of the medieval sculptural tradition in his native town. Jacopo's Gothic qualities seem German, Flemish, or Burgundian rather than Italian, especially the frequent complication and involution of the drapery, which reach the extreme in the reredos and tombstones of the Trenta family in S. Frediano, Lucca, and in the statues of the lunette at Bologna. The object at Siena that excited his youthful admiration was the old pulpit by Nicola d'Apulia, and perhaps from this he was led to study Nicola's earlier pulpit at Pisa, which more closely resembles his own work and the Epiphany of which he remembered in his own version of the subject on the lintel of S. Petronio. Jacopo was attracted by Nicola's antiquarianism and by his filling of the panels with a few robust figures. In the case of both artists, however, the predilection for the massive may be induced by the old tradition of central Italy, which is recognizable in ancient Etruscan art, in the Romanesque pulpits, and in such painters as Piero dei Franceschi, Luca Signorelli, and Melozzo da Forlì.

In marked contrast with Jacopo's usual agitated style is the tomb of Ilaria del Carretto in the cathedral of Lucca, one of the supreme works of the Renaissance and his earliest known effort. The loveliness of the sleep of death has never been rendered with more classic tranquillity. The noble beauty of Ilaria's form, the simple yet impressive drapery, are quite beyond the power of language to describe. On

the base, bearing funereal wreaths, are the first important nude *putti* of the period. The French type of monument, the foreign costume, above all the wide departure from Jacopo's ordinary manner, have lately led Professor Marquand of Princeton to doubt the justness of the ascription.

3. THE LESSER SCULPTORS OF THE FIRST HALF OF THE QUATTROCENTO

The limited scope of this book excludes a discussion of the sculpture of BRUNELLESCHI and MICHELOZZO, which was so much less significant than their architecture. It is thought by some critics that the most significant rôle of Michelozzo in his partnerships with Donatello, Ghiberti, and Luca della Robbia was as a caster of bronze. Had we the space, it would be instructive to linger over the fripperies of another architect, ANTONIO AVERLINO called IL FILARETE, in the bronze doors of St. Peter's at Rome, for his very clumsiness in proportion and modelling brings out by contrast the excellencies of his greater contemporaries, and he affords perhaps the most extreme example of the undigested erudition of the epoch and of the incongruous fusion of pagan and Christian culture. We may be allowed at least to name, among the lesser personalities of the early fifteenth century, three men who worked together with Donatello and who helped to bridge the transition from the Trecento to the Quattrocento — the severely dignified BERNARDO CIUFFAGNI, NANNI DI BARTOLO, called IL ROSSO, who was one of those to spread the Florentine style into the eastern peninsula, and NANNI DI BANCO, who showed such promise that, if he had not died young, he might have surpassed Donatello. Nanni di Banco ordinarily imbued his figures with a sober and haughty Roman strength; but in the tympanum of the Porta della Mandorla on the Florentine cathedral, the best among the few Italian Gothic tympana that were decorated with figures, he adopted, perhaps from the many figured examples of France, a violent and florid agitation.

4. TWO INNOVATORS OF THE FIRST HALF OF THE QUATTROCENTO

There remain two other sculptors of prime importance who, though younger than Donatello, Ghiberti, and Jacopo della Quercia, yet belong chiefly to the first half of the century — BERNARDO ROSSELLINO and Luca della Robbia. The former (1409–1464), the oldest of five brothers, all of whom devoted themselves to the profession of art, was chiefly an architect, and his significance for us lies in the fact that he has usually been considered the author of the tomb of the great human-

ist, Leonardo Bruni, in S. Croce (Fig. 80), which established a sepulchral type that was to be popular in the Quattrocento, and to endure, with certain modifications, in the Cinquecento. A recent hypothesis, however, without any definite proof, ascribes to the architect Alberti the design of the monument and leaves to Rossellino only the execution. In an arched rectangular recess in the wall, soberly adorned with the architectural detail of the early Renaissance, the deceased lies upon a solemnly draped bier above the sarcophagus, which in turn is slightly raised upon the base. The head, as in Donatello's tomb of John XXIII, is turned to the spectator as if in sleep. Three slabs of porphyry, admirably proportioned to the rest of the mausoleum, constitute most dignified decoration for the space behind the catafalque. The sarcophagus is embellished with two flying angels upholding the inscription, the tympanum with a medallion of the Virgin and Child adored by two angels, and the top of the arch by two *putti* supporting the escutcheon in a wreath, the ends of which fall on either side. The tombs by Donatello and Michelozzo had been merely medieval forms adorned with *motifs* of the Renaissance repertoire. The sepulchre of Leonardo Bruni, though it borrowed certain elements from Donatello and Michelozzo, was, taken as a whole, a new invention, of such stately beauty that it henceforth imposed itself upon the Italian Renaissance. The severity and architectural monumentality of the tomb are paralleled in the few other and less successful sculptural works of Bernardo Rossellino.

LUCA DELLA ROBBIA (1400–1482) demands our attention, not only, like Bernardo Rossellino, because of his innovation, but also because of his high artistic merit. His innovation was his method of glazing terracotta with shining enamel of different colors. Although he did not invent this method but probably adopted it from its earlier use for pottery in Italy, he applied it to sculpture, developed it, and employed it with such distinction that it remained the precious possession of his family's workshop for a hundred years and enjoyed a phenomenal popularity.[1] It commended itself also to less affluent and more numerous patrons by its cheapness and by its delightful effects, which rivalled those of the more expensive marble. Luca della Robbia began in the more usual mediums and continued to employ them throughout his life, thus preserving more true sculptural feeling than his successors who worked in nothing but glazed terracotta. Although he had perhaps experimented in this method before, his first certain and timid use of it was in the tabernacle now in the church at Peretola near

[1] It now seems to be established that at least one other *bottega*, that of the Buglioni family, produced works in glazed terracotta at the end of the fifteenth and in the sixteenth century.

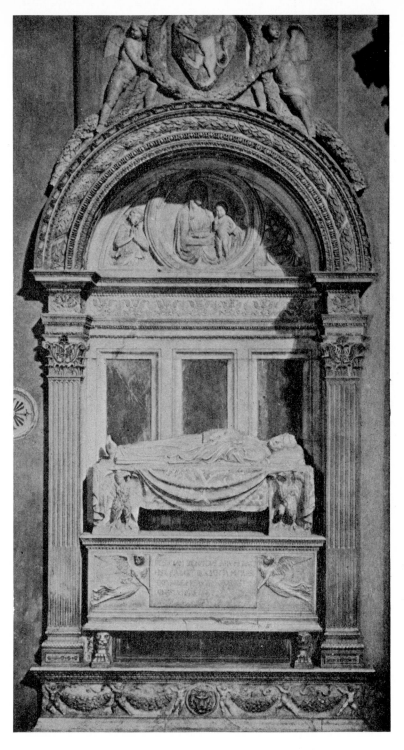

FIG. 80. BERNARDO ROSSELLINO. TOMB OF LEONARDO BRUNI.
S. CROCE, FLORENCE

(Photo. Fratelli Alinari)

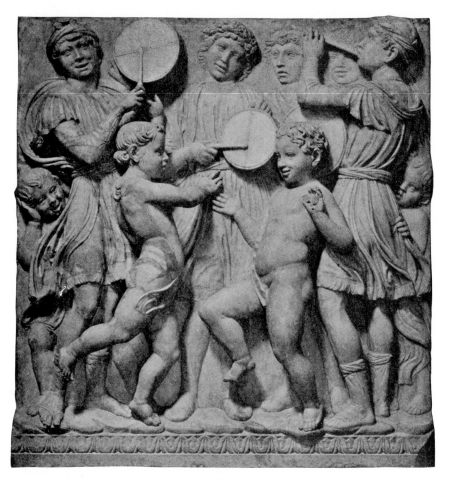

FIG. 81. LUCA DELLA ROBBIA. PANEL OF SINGING GALLERY.
OPERA DEL DUOMO, FLORENCE

(Photo. Fratelli Alinari)

Florence (1441–1443). Luca's color-scheme was always simple and re-strained. The figures are white set against a blue background. The iris of the eyes is sometimes touched with blue, and the hair, garments, and wings are here and there accented with gold. His color was more varied and comprehensive only in decorative detail, such as the en-circling wreaths of flowers and fruit, or in the heraldry of escutcheons. For the red glaze that it was impossible to obtain, violets, purples, and brown were substituted, and later real red was merely painted in. Since the death of Luca's last artistic descendant in the sixteenth cen-tury, a similar durable glaze has never been recovered.

His style was as simple as his color. Though he was influenced by Donatello and especially Ghiberti, he was not distraught by the thought and passion of the one or the estheticism of the other, nor did he groan beneath the sturdy emotion of Jacopo della Quercia. He has little intellectuality or reminiscence of the antique. It might almost be said that he would have been the same, even if he had not lived in the Renaissance. He was faithful to nature, as far as he went, but he did not, like Donatello, seek to probe its more abstruse aspects. He was satisfied to reproduce its lovelier and more smiling appearances. His achievement, as Venturi has intimated, was that of the ordinary craftsman raised to the *nth* power; but this honesty of the workman was penetrated and illumined by the light of an acute artistic sense. He possessed that wonderful combination of robust nobility and true gentleness which is so often encountered in the unspoiled Italian peasant. A peculiar purity of character expressed itself in all his crea-tions. He came of a farming family, and he always delighted in the flowers and fruits of the fields. Above all, he had the countryman's sincere, wholesome, and happy religion, and he was able to invest his sacred figures with a simple majesty that without affectation gives the effect of divinity. Better than anyone else in history, he was able to express intense and tender devotion, while his nobility kept him from passing into the region of the sentimental.

There is no monument of art in the world that has been honored with such widespread popularity as Luca's earliest work, the singing-gallery of the Florentine cathedral, now reconstructed, to a slight extent wrongly, in the Opera del Duomo (Fig. 81). The passionate rush of Donatello's companion piece is softened down into groups of children, arranged in separate panels and illustrating the verses of the CL psalm, in which humanity is called upon to praise God in different kinds of music. In reality it is the apotheosis of joyous, vigorous Tuscan child-hood, in the delineation of which Luca particularly excelled. Concrete instances of his simple manner are the symmetrical composition in sev-

eral of the panels and the avoidance of pictorial perspective. His simplicity well fitted him to continue the medieval series on the Campanile with five reliefs symbolizing certain of the Liberal Arts. His tomb of Bishop Benozzo Federighi, now in the church of the Trinità, is less pretentious than the usual sepulchral types, and the frame, which is a flat mosaic of very small pieces of glazed terracotta, represents a garland of rustic vegetation. Two other productions in marble, reliefs from the life of St. Peter now in the Bargello, are important because they betray Luca's expected inadequacy in the dramatic. In bronze, he received, together with Michelozzo, the commission for the doors of one of the sacristies in the cathedral, constructed of panels, each containing the Virgin, the Baptist, or one of the Evangelists or Fathers, between two angels. Although Venturi discerns the more intricate design of Michelozzo in the four lower panels of the Fathers, all the figures at least are in Luca's most inspired religious style.

In glazed terracotta, his most beloved works are his numerous representations of the Madonna and Child, occasionally accompanied by angels. Sometimes they are more austere and hieratic, like the Madonna Frescobaldi in the Kaiser Friedrich Museum, Berlin; sometimes they are more human and familiar, like the half-length group of the illustration, also in the same Museum at Berlin (Fig. 82). Certain examples in unglazed terracotta, one of which is in the Metropolitan Museum, are more or less hypothetically ascribed to Luca. He also employed the medium very successfully for architectural decoration, as in the medallions of the cardinal Virtues in the ceiling of the sepulchral chapel for the young Cardinal of Portugal in S. Miniato, Florence. A more notable instance is found in the medallions of Apostles on the walls and of St. Andrew over the entrance to the Pazzi Chapel; the more realistic and garishly colored Evangelists on the spandrels of the dome were probably at least designed by Brunelleschi or some other. How beautifully he used glazed terracotta in purely architectural detail may be seen in two tabernacles for the church at Impruneta near Florence. He also applied it effectively to coats of arms and their surrounding wreaths, as in the escutcheons of the Pazzi and Serristori in the Palazzo Serristori and in that of the Council of Merchants on Or San Michele. In one of the most appealing works of the Quattrocento, the Visitation of glazed terracotta in S. Giovanni Fuorcivitas at Pistoia, he anticipated somewhat the intense sentiment of his nephew, Andrea della Robbia.

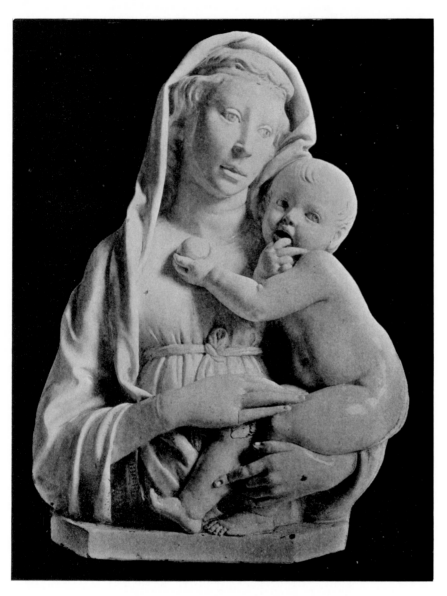

FIG. 82. LUCA DELLA ROBBIA. MADONNA AND CHILD.
KAISER FRIEDRICH MUSEUM, BERLIN

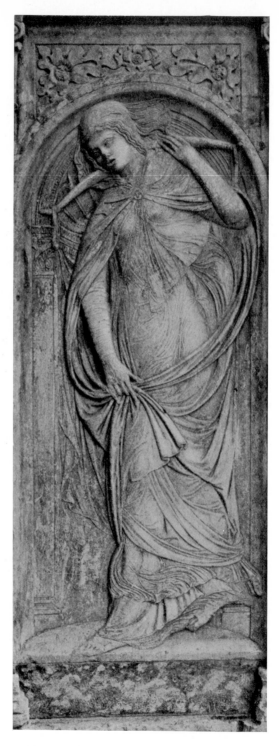

FIG. 83. AGOSTINO DI DUCCIO. PATIENCE.
S. BERNARDINO, PERUGIA

(Photo. Fratelli Alinari)

5. THE SECOND HALF OF THE QUATTROCENTO.
THE PUPILS OF DONATELLO

During the second half of the fifteenth century, artistic conditions at Florence were so complicated that a division of the sculptors into groups with clearly differentiated tendencies is difficult. We may first dismiss two masters who were pupils of Donatello and who do not fall naturally into the other groups — BERTOLDO DI GIOVANNI and Agostino di Duccio. The former (1410–1491) has a double interest: he was the most faithful disciple of Donatello and a perpetuator of his principles, and he turned in a more decided fashion than any of his rivals to the closer imitation of the antique that was to be one of the determinative traits of the Cinquecento. He had, indeed, the distinction of teaching Andrea Sansovino and Michael Angelo. He labored much throughout Italy and at Florence under the Medici. He was made the curator of Lorenzo the Magnificent's collection of antiquities in the Medici gardens and the professor of this Renaissance *École des Beaux Arts*, where studied so many artists of the next century. The undoubtedly authentic productions of his own hand are few and all in bronze; but many other works are attributed to him on stylistic grounds. The bronze plaque of a mythological battle in the Bargello exhibits the dependence upon Donatello in the emaciation of the forms and in the passionate rush and confusion of the scene. The painfully anatomical treatment betokens a new influence, that of Antonio Pollaiuolo. The elevation of one plane above the other instead of any real perspective, the crowding, and the emphasis on the body rather than the mind, demonstrate his admiration for ancient sarcophagi. The composition indeed seems to have been derived from a definite example in the Campo Santo of Pisa. The bronze relief of the Crucifixion with Sts. Francis and Jerome in the Bargello has something of Donatello's dramatic power, and reveals Bertoldo's mannerisms of allowing the hair to fly and of binding the draperies in folds like cords.

He is now perhaps more renowned for his small bronzes, such as the Bellerophon of the Hofmuseum, Vienna, and the Arion or Orpheus of the Bargello. They are suggested by the antique, but are so emaciated that the bones and muscles seem actually to chafe against the skin. Unlike Donatello, Bertoldo is here occasionally somewhat awkward in his poses. Even in the Hercules, now in the collection of Mr. H. C. Frick, where, if anywhere, we should expect burliness, he employs his usual model of the spare, curly-headed youth. As a medallist, he was less expert, adopting too low a relief and insufficiently defined modelling.

AGOSTINO DI DUCCIO (1418–1481) was of quite a different temperament. He was essentially a decorator. From Donatello he derived his *rilievo schiacciato,* and from a study of Neo-Attic remains his disposition of transparent drapery in minute plaits and great swirls. This style he utilized for the adornment of architecture, always willing to subordinate realistic correctness, for which he had no talent, to his love of decorative undulating line and to the effective filling of the spaces. In his sacrifice of representation to calligraphic design he was a lesser Botticelli; and he went almost far enough along this road to please a Post-Impressionist. His ethereal and languishing feminine types also recall the figures of Botticelli. His two great undertakings were the embellishment of the interior of S. Francesco at Rimini and the façade of S. Bernardino at Perugia. In the former instance, following the ornamental scheme planned by the medallist Matteo dei Pasti, Agostino di Duccio carved: in the chapel of S. Gaudenzio eighteen Muses and personifications of the Liberal Arts; in the chapel of S. Lorenzo the Planets and Signs of the Zodiac, summoned, according to a Latin poem of Sigismondo Malatesta, the despot of Rimini, to appeal in the prince's favor to his famous mistress, Isotta degli Atti; on the cenotaph of Sigismondo's forebearers, two reliefs, one, showing these ancestors in the temple of Minerva, and the other, the despot's triumphal advance in a chariot; and in other places, angels and musical *putti.*[1] Like Botticelli and other artists of the fifteenth century, in representing the Planets Matteo and Agostino caught their ideas of the classical deities not so much from looking at ancient effigies of them as from reading about them, and they therefore imagined them in shapes like those of their saints, distinguishing them by attributes. The naïve effect of mythological scenes in the art of the Quattrocento may be traced to this masquerading of its peculiar forms in the guise of ancient personages. In a fine relief from a monastery near Rimini and now in the Archaeological Museum, Milan, depicting the encounter of Augustus with the Sibyl or of St. Louis of France with an angel, not only do the garments undulate, but the whole landscape heaves and curls — the trees, the ground, the water, the fishes, even the horse's tail.[2]

The culmination of Agostino di Duccio's career is embodied in the façade of S. Bernardino, Perugia. On the jambs of the door are musical angels and four Franciscan Virtues (Fig. 83, Patience); on the lintel, episodes from the life of the titular saint; in the tympanum, an

[1] The execution of the reliefs in the chapel of S. Lorenzo and of the musical angels has been recently but not very convincingly ascribed to the actual hand of Matteo dei Pasti.

[2] This relief has also been attributed by some critics to Matteo rather than to Agostino.

apotheosis of the saint; in the gable, Christ in glory; in niches at the sides, the Annunciation and two saints detached in the round. The situation in the open air required a higher relief than at Rimini. The frieze of S. Bernardino's miracles is the most striking instance of a sacrifice of representation to the decorative purpose, since here especially one would expect a more naturalistic treatment. The statues in niches show how far he was out of his element as soon as he abandoned relief. It is interesting to remember that Agostino di Duccio, perhaps because he did not feel his graceful chisel suited to a colossal subject, desisted from working upon the block of marble, out of which Michael Angelo was to hew his David.

6. THE SECOND HALF OF THE QUATTROCENTO.
THE SENTIMENTALISTS

The other prominent Florentine sculptors of the later Quattrocento may be divided into three groups: those who sought to infuse their creations with the gentleness and wistfulness of deeprooted human affections, who therefore stood in close relation to the current of Florentine painting that had its source in Fra Filippo Lippi, and who may be called, in no derogatory sense, the Sentimentalists — Andrea della Robbia, Desiderio da Settignano, and Mino da Fiesole; the extreme Realists, Antonio Pollaiuolo and Andrea del Verrocchio; and those whose style lay midway between these two tendencies — Antonio Rossellino, Benedetto da Maiano, and Matteo Civitali.

ANDREA DELLA ROBBIA (1435–1525) continued the *bottega* of his uncle Luca in all its *éclat*, confining himself to glazed terracotta. Because in most respects he clung so faithfully to Luca's principles, the diversities are the more apparent. Most significantly, he introduced sentiment into Luca's themes. There is already a suspicion of it in his early commission, the medallions of infants for the loggia of the Hospital of the Innocenti at Florence. They incline to be winsome, and their heads are infused with more thought and definite character. The same contrast may be seen between Luca's *tondo* of a youthful bust at Berlin and Andrea's in the Metropolitan Museum. But it is in Andrea's representations of the Madonna and Child that the new tendency is best illustrated. The Virgin (Fig. 84, Madonna of the Architects, Bargello) has a wistful and melancholy mysticism, which may very well have been affected by the contemporary cult of Neoplatonism. The Child has become "cute" and cuddles to the Mother, putting a finger in his mouth or toying with her wimple. Andrea's religion is more conscious than Luca's and more divorced from the interests of ordinary life. With a Neoplatonic yearning towards the

skies, he gives the subject a more distinctly spiritual and heavenly tone by employing haloes, by flecking the background with clouds and surrounding the Holy Pair with flights of angels. Luca does not introduce angels in such numbers, and usually he merely stands them beside the sacred personages; but by the simple majesty that he is able to impart to his figures, he achieves a truer religious impression than does his nephew with all his accessories. Andrea manipulates other themes in the same ethereal way as his Madonnas, for instance, the Adoration of the Child in the principal church at La Verna.

The tendency to complication that has been noticed in the elaboration of the setting increased in all aspects of Andrea's work as he grew older. He now extended the use of glazed terracotta to whole altarpieces. Under the influence of the extreme Realists, his draperies were more involved. He sought pictorial effects of landscape in the medium, he was less chaste in his color and indulged in more gilding. Ornamentation became excessive, workmanship less fine. As the orders multiplied upon him, like Perugino, he merely repeated former compositions, and in the case of both men there was a consequent degeneration. He resorted to artificial stamps for his floral borders, so that we miss the fond personal touch which the lover of nature, Luca, impresses upon foliage, flowers, and fruit. A characteristic production of his last period is the Adoration of the Magi in the Victoria and Albert Museum. Lingering on far into the sixteenth century, he even adopted, as in a lunette over the entrance to S. Maria della Quercia near Viterbo, the more robust forms that were then introduced through a more servile imitation of Roman sculpture; and together with other artists of the time he finally renounced that expressiveness to which the Quattrocento had gladly subordinated exact representation. Although Andrea della Robbia lived too long, it is not the writer's intention to detract from his just due. He was a great master, and even if he suffers slightly by comparison with his uncle, one would not willingly refashion him in Luca's mold and thus lose his appealing sentiment.

DESIDERIO DA SETTIGNANO (1428–1464) was the most exquisite sculptor of the Quattrocento. He was Donatello's greatest pupil, but he did not inherit all the sides of his master's universal personality. When his charming production was cut short by his untimely death, he had left behind him no memory of scenes from the Passion or dramatic incidents from the lives of saints. What he had inherited was Donatello's supreme technical skill, and within his chosen sphere, which was restricted to the sweet and pleasant aspects of existence, he was without a peer. He clothed his skill in aristocratic elegance,

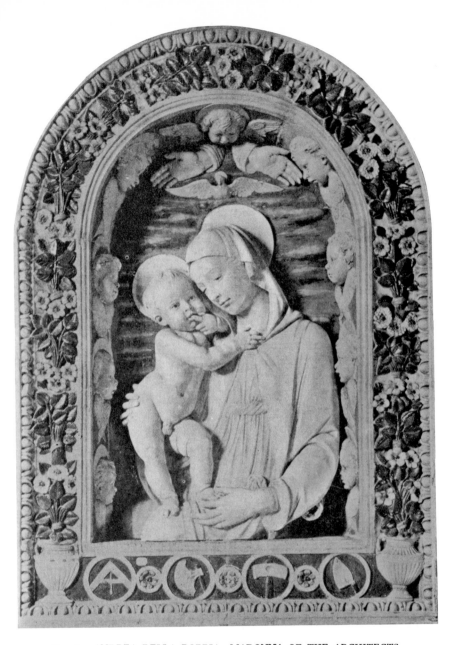

FIG. 84. ANDREA DELLA ROBBIA. MADONNA OF THE ARCHITECTS.
BARGELLO, FLORENCE

(Photo. Fratelli Alinari)

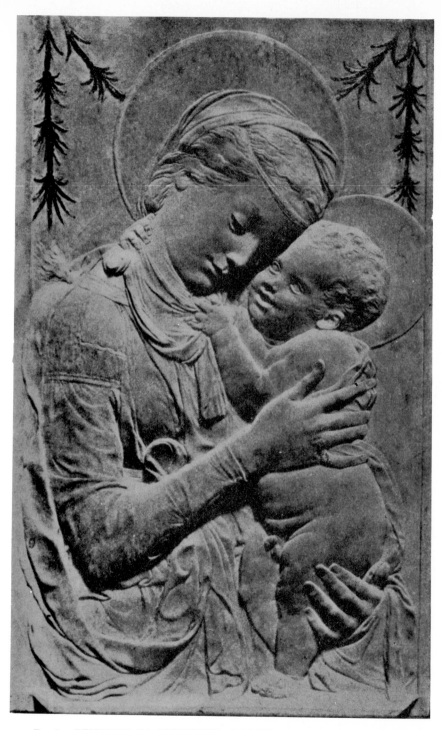

FIG. 85. DESIDERIO DA SETTIGNANO. MADONNA. PINACOTECA, TURIN

and he applied it to the expression of a light and happy temperament. His sensitive nature spontaneously fell into Donatello's *rilievo schiacciato*.

In his most monumental work, the tomb of another humanist, Carlo Marsuppini, in S. Croce, opposite Bruni's mausoleum of a decade earlier, upon which it is modelled, he revealed his character by rendering Bernardo Rossellino's sepulchral type less solemn and more graceful. Instead of the gloomy sarcophagus he used a *cassone* embellished with ornate foliage, and beneath it he placed the delicate decorative detail of a shell flanked by wings, the symbols of immortality. To avoid still further the impression of death, he accentuated the inclination of the body towards the spectator. In the background he substituted four slender slabs of marble for the three of Rossellino. He removed from the arch the heavy weight of escutcheon and *putti* and set at the apex an elegant flaming lamp, from which garlands fall to be supported by two youthful figures upon the cornice at either side, full of energy and singing with joy. In lieu of Rossellino's sober little genii at the top, he diminished the gravity of the tomb by placing on the base two merry urchins supporting the armorial bearings of the deceased. The Madonna of the tympanum is an embodiment of all Desiderio's virtues. His other marble representations of the Virgin and Child, such as the example in the Pinacoteca at Turin (Fig. 85), became so popular that copies in colored stucco were sold broadcast. The same lovely children and infants appear on his other great monument, the tabernacle in S. Lorenzo, Florence, the original arrangement of which has been disturbed. The treatment of the central panel in perspective as if it were a chapel leading to an inner shrine, even if anticipated by Bernardo Rossellino, was so beautiful that it established an important precedent in the Renaissance.

Desiderio introduced children wherever it was possible. He was not interested, like Donatello, in their rapid movements or their unrestrained expression of emotion; nor, like Luca della Robbia, in their robust innocence. His elegant temperament found delight in the delicate lines of their young forms, the gentleness of their natures, the readiness of their smiles. It was especially upon the exquisite modelling of the skin's texture that he exerted himself. He was the sculptor of many juvenile busts, which often passed nominally as effigies of the young Christ or the young St. John Baptist but which in reality were studies of the children with whom he must have loved to play. Among the examples may be mentioned the St. John recently added to the Widener Collection, Philadelphia, the laughing *putto* in the Benda Collection, Vienna, and the little Redeemer in the chapel of the Van-

chetoni, Florence. They are not at all the sturdy peasants of Luca but the refined offspring of the most aristocratic families in Florence. The soft outlines of highly cultured ladies also offered an opportunity to Desiderio's sensitive chisel. Superb specimens are a bust in the Bargello and another, called the Princess of Urbino, in the Kaiser Friedrich Museum, Berlin.

MINO DA FIESOLE (1430 or 1431–1484), who was Desiderio's most eminent pupil, or at least was influenced by him, by a curious freak of criticism has gained a reputation of which he was unworthy. His name has become a talisman for that delicate charm of Florentine sculpture at its height which was actually represented by Desiderio. As a matter of fact, Mino was not a great artist. The popular misconception of him is due to two causes, the false ascription to him of works by other masters and the ingenuous sweetness which, breathing through his whole production, wheedles us into forgetting his defects. He possessed also certain minor alleviating traits, such as the exquisiteness with which he carved architectural detail and the cleverness with which he imitated various fabrics. But in the nobler qualities of sculpture he was lamentably inadequate. He was inferior to Desiderio in two essential ways. First, he lacked his consummate technical knowledge. His modelling is sometimes even puerile. In an age permeated with realistic study, he was ignorant of anatomy. He had no respect for the laws of equilibrium. Many artists of the period gave their drapery decorative mannerisms, but Mino's folds are too stiff and too far removed from actuality. His mannerism was the disposition of the drapery in straight lines, repeated at short intervals, becoming oblique, and forming sharp angles, so that one gets the impression of an opening fan. Bad enough in single figures, he was worse in the relative proportions of several objects and in the representation of pictorial background when it came to the complicated problems of perspective in scenes from sacred history. Unlike Desiderio, he had the temerity to attempt these, but he lacked a dramatic imagination. Occasionally he belittled such scenes by a sportive mood unsuited to the solemnity of the religious themes. Secondly, like most disciples he exaggerated the chief quality of the man whom he imitated: where Desiderio was delicate, Mino was dainty. This tendency combined with his defective modelling to deprive his figures of that asset which even Florentine painting possessed, "tactile values," i.e., solidity, existence in three dimensions, and to bestow upon them the semblance of paper-dolls or of fragile manikins.

Characteristic examples of his work are the two altars in the cathedral of Fiesole and in the Badia of Florence. His tombs of Bernardo

Giugni and of the Count Hugo von Andersburg in the Badia are modifications of Desiderio's sepulchral type. The latter (Fig. 86) is perhaps his masterpiece. The relief of Charity, substituted for one of the dark panels in the background, reveals his peculiar *finesse* at its best. A comparison of the armorial *putti* with Desiderio's affords a striking illustration of the difference between delicacy and daintiness. The bust of the deceased for the simpler tomb of the Bishop Salutati in the cathedral of Fiesole is, for Mino, a penetrating characterization, and shows how even the poorer sculptors of the Renaissance treated such subjects with the utmost realism of which they were capable. Many less excellent busts, usually in ancient costume, are ascribed, whether wrongly or rightly, to Mino. The flat modelling and the sharp outlines of a profile relief of a feminine bust in the Bargello justify the attribution of the work to him. The Dance of Salome, one of three panels that he did for the indoor pulpit of the principal church at Prato, is a shocking instance of his faults in episodical relief and of his lack of religious seriousness.

He was very popular at Rome, especially from about 1473 to 1480. Here he usually collaborated on altars and tombs with the Dalmatian GIOVANNI DA TRAÙ (also called Giovanni Dalmata) or with Andrea Bregno. Even the former, trained at Venice and in Lombardy and influenced at Rome by Mino, if not so seductive, was, in the essentials of his art, a better master than his partner. The tombs belonged to the types then brought into favor at Rome by Bregno. Of Mino's alliance with Bregno, the loveliest result is his Madonna of the tympanum of Bregno's mausoleum for the cardinal Cristoforo della Rovere in S. Maria del Popolo. Of the association with Giovanni da Traù, the greatest product has usually been considered the pretentious elaboration of Bregno's sepulchral type, in which all of Bregno's elements were doubled, for the tomb of the pope Paul II, the fragments of which are preserved in the Grotte Vaticane; but it has lately been proposed, in accordance with a tradition known to Vasari, to identify the Dalmatian's partner here, not with Mino da Fiesole, but with Mino's Neapolitan pupil, MINO DEL REAME, whose works have been confused with those of his more famous Florentine master but who was certainly a more earnest seeker after truth.

7. THE SECOND HALF OF THE QUATTROCENTO. THE INTERMEDIATE GROUP

Of the group whose style was half sentimental, half realistic, ANTONIO ROSSELLINO (1427-1478), Bernardo's youngest brother and pupil, was the most distinguished. Similar in nature to Desiderio,

he did not have his advantage of education under Donatello, but he compensated for lesser technical delicacy by a wider range of subject and was successful in episodical and dramatic reliefs. His figures are more solid and real than Desiderio's, and he preserved Bernardo Rossellino's religious sobriety in facial expression; but his forms were often more animated than those of either of the two sculptors to whom he was most closely related.

Antonio Rossellino also achieved renown by a great mausoleum, that of the young Cardinal of Portugal in the Florentine church of S. Miniato. He deepened the recess into a kind of mortuary chamber, carving two folded curtains upon the architectural frame, and adorning the under surface of the broad arch with a series of rosettes in squares. The sarcophagus is copied from an ancient porphyry specimen in the Lateran Museum, Rome. The two *putti* no longer bear escutcheons but sit upon the sarcophagus toying with its drapery. The youths bearing festoons have become two angels bringing to the prelate the palm and crown of the elect. As was to be expected from the livelier Antonio Rossellino, the angels around the medallion of the Virgin are represented as dashing through the air. He established the vogue of a double border for the medallion, one of foliage and the other of cherubs' heads. The decoration of the base is enriched to include male nudes, unicorns, two reliefs of man's triumph, and — a curiosity in the Renaissance, which liked to hide the grimness of the grave in symbols of joy — a death's head. Very similar is his tomb of Maria of Aragon in the church of Monte Oliveto at Naples, the upper sections of which were finished by Benedetto da Maiano. The lovely relief of the Nativity in the same chapel of the Neapolitan church applies to marble Ghiberti's pictorial perspective. The Metropolitan Museum contains, by Rossellino, a very beautiful Nativity of separate figures in the round. It is one of those devotional groups that are exhibited in Catholic churches at Christmas. Few, if any, examples exist from an earlier period, and not many by great artists are extant. The inferior animals may be the work of another hand.

Of Antonio's other achievements, the three reliefs on the pulpit at Prato only bring more obloquy upon Mino's companion pieces. The little St. John in the Bargello is a striking contrast to Desiderio's hothouse products. The bust of the philosopher, Matteo Palmieri, in the Bargello exhibits the unsparing realistic power of this group of sculptors when they undertook portraits. At the end of his life, Antonio Rossellino joined the vanguard that abandoned the emaciated bodies which the Realists liked to study and the over-delicate forms in which the Sentimentalists delighted, and he began to show a predilection for

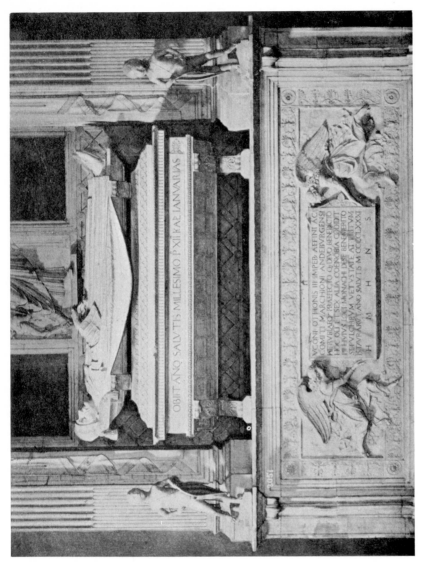

Fig. 86. MINO DA FIESOLE. TOMB OF COUNT HUGO. BADIA, FLORENCE

(Photo. Fratelli Alinari)

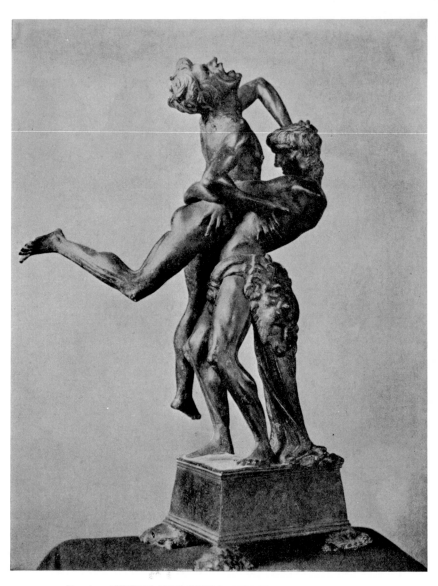

FIG. 87. ANTONIO POLLAIUOLO. HERCULES AND ANTAEUS.
BARGELLO, FLORENCE

(Photo. Fratelli Alinari)

the robust figures of ancient Roman art. He had already evinced the tendency at the beginning of his career in the St. Sebastian of the Pieve at Empoli, which also renounces the individualization of the Quattrocento for the generalization of antiquity and is the most ideally beautiful masculine nude of the Renaissance prior to Michael Angelo.

His follower, BENEDETTO DA MAIANO (1442–1497), since he had not come directly into contact with Desiderio's sentiment, was more realistic. He amplified the forms still farther, especially in his late works, accentuating the tendency by swathing the lower parts of the body in yards of drapery.

His indebtedness to his master is illustrated by his adaptation of the arrangement and figures of Antonio's tombs to the altars of S. Fina in the Collegiate Church and of S. Bartolo in S. Agostino at San Gimignano. His most celebrated work is the pulpit of S. Croce, Florence, with reliefs from the story of St. Francis. It is marked by the greater richness of architectural decoration which is one of Benedetto's traits, signalizing the less chaste spirit of the later Quattrocento. Another typical monument was a door in the Palazzo Vecchio, adorned with figures of Justice, St. John Baptist, and *putti;* the writer does not know whether all the parts have been restored from the Bargello to their original position. In distinction from Benedetto's usual style, religious tradition has preserved an ascetic thinness in the St. John, which is now *in situ.* In the works of his last days, such as the altar of the Annunciation in the church of Monte Oliveto, Naples, and the Madonna and the St. Sebastian of the Misericordia, Florence, under increased classical influence he partly lost, like Andrea della Robbia, the freshness of the Quattrocento and became rather dry and empty. The Baptist of the Neapolitan altar has even somewhat of the rhetorical gesticulation of the Cinquecento. His busts — for instance, those of his patrons Filippo Strozzi and Pietro Mellini, in the Louvre and Bargello respectively — are among the best of the period.

MATTEO CIVITALI of Lucca (1436–1501), another follower of Antonio Rossellino, was a kind of provincial Benedetto da Maiano, without quite so keen an esthetic sense as those who dwelt constantly in the artistically strenuous atmosphere of Florence. His forms, however, are not always so robust as Benedetto's. The St. Sebastian of the cathedral at Lucca was inspired by his master's at Empoli. The tomb of Pietro Noceto in the same church was suggested by the type of Bernardo Rossellino and Desiderio, but the sarcophagus was derived from Antonio Rossellino. The portrait head on the fragment of another tomb in the Victoria and Albert Museum is a demonstration

of Matteo's realistic power, which is here so brutal that we wonder how the patron could have been satisfied.　By a strange unevenness of style, which perhaps indicates in Civitali the provincial, his attempt at narrative relief on the *predella* of his great altar of St. Regulus in the cathedral is not much better than Mino's.　In the relief of the Annunciation in the Museum of Lucca, the provincial is tangibly betrayed by the poor right hand of the Virgin and her stolidity in contrast to the intellectual enlightenment of the Florentine women.　The decoration has the opulence of Benedetto da Maiano.　The Madonna of the Cough, invoked against croup, in the chapel of the Trinity, Lucca, is a mere nurse with a greedy and bewitchingly naturalistic child.　On the other hand, a whole series of works, such as the Faith of the Bargello, the Ecce Homo of the Museum at Lucca, the terracotta angel of the Metropolitan, and the adoring Virgin of Fenway Court, Boston, reveal one of Civitali's distinctions, the ability to infuse his personages with a profound but not disagreeably sentimental religious feeling.　Just before he died, in the statues of Adam, Eve, Habakkuk, and Elizabeth for the chapel of St. John Baptist in the cathedral of Genoa, he passed completely into the amplitude, dryness, and grandiloquence of the Cinquecento, losing his charm in the process.

8. THE SECOND HALF OF THE QUATTROCENTO. THE EXTREME REALISTS

All these luminaries of the later Quattrocento, however brilliant, were outshone by the extreme Realists, Antonio Pollaiuolo and Andrea del Verrocchio, both of whom were great painters as well. They were the culmination of a long line of Florentine masters who had devoted themselves to the study of the technical problems of art, such as perspective, color, and the representation of landscape and who occasionally were so carried off their feet by scientific enthusiasm that they then worked rather as experimenters than as true artists. POLLAIUOLO (1432–1498), like the rest of them, owed much to the father of the Renaissance, Donatello.　His training in the goldsmith's profession, even more than was usually the case with other Florentines, inculcated a wonderful precision and delicacy.　He excelled particularly in the modelling of hands and feet.　Both he and Verrocchio preferred the medium of bronze for the same reasons as Donatello in his last period and because it allowed more accuracy in detail.　He chose as his provinces of investigation the nude and violent action, usually combining the two.　His small bronzes are typical, especially the struggle of Hercules and Antaeus in the Bargello (Fig. 87).　As Maud Cruttwell has said, Giotto had realized the solidity of the body,

Donatello its superficial appearance, and now Pollaiuolo studied scientifically the underlying structure of bone and muscle. The forms of Hercules and Antaeus resemble the figures of an anatomical lecturer, but all this painstaking effort was an indispensable preliminary upon which later artists, such as Michael Angelo, could build and attain perfection. Yet by some magic of genius Pollaiuolo was able to change his most unequivocal studies into works of art. A part of their appeal consists in the tremendous energy with which he endowed the physiques until the spectator himself feels that he is participating in the muscular strain. It is not Donatello's force of thought; it is force of body.

His two greatest commissions in sculpture were executed at the end of his career, the bronze tombs of Sixtus IV and Innocent VIII in St. Peter's, Rome. They differ widely from the usual sepulchres of the Quattrocento. A superb portrait statue of Sixtus IV, who had thrown all Italy into turmoil, lies calm and majestic upon an elevated base of sloping sides. On its horizontal upper face, around the Pope, are the seven Virtues, no one of which he had exemplified; along the sides Pollaiuolo gladly attacked the problem of representing on concave surfaces the Liberal Arts, increased from seven to ten by the addition of Theology, Philosophy, and as we might expect, Perspective. In the lightly clad Virtues and Arts, Pollaiuolo now extended his investigation to the feminine nude. These figures exhibit in every way the zeal of the scientific artist. The difficulty of the concave surface was great enough, but he contorted the bodies in order to satisfy his craving to solve the most abstruse problems. Not content with the ordinary phases of reality, he used those eccentric feminine types with long legs and short waists which he transmitted to Botticelli. Another reason for the appearance of these types was that the scientists in general scorned any of the more common appeals to the public, such as mere prettiness. It is the same experimental state of mind that arranges the drapery in complicated patterns. The style in the tomb of Innocent VIII is similar, but the form of the monument, the original disposition of which has been somewhat disturbed, is different. Against the wall the Pope is represented as sitting and giving his benediction, surrounded by the four cardinal Virtues and surmounted, in a lunette, by the three theological Virtues. Beneath, the effigy is repeated prostrate upon a sarcophagus projecting from the wall. Of the busts attributed to Pollaiuolo, that of a young warrior in the Bargello is the most authentic. It is instinct with the master's marvellous vigor, and his proclivities betray themselves even in the embellishment of the cuirass with mythological nudes in violent movement.

ANDREA DEL VERROCCHIO (1435–1488), who took his name from his teacher, the goldsmith Giuliano dei Verrocchi, was one of those versatile prodigies in whom the Italian Renaissance was so rich. In addition to his greatness as a goldsmith and sculptor, he was a painter, an architect, a mathematician, a musician, and especially a marvellous teacher, numbering among his deeply indebted pupils such men as Perugino and Leonardo da Vinci. Donatello, under whom he may have served an apprenticeship, was the innovator in realism; but Verrocchio, in a series of famous works, brought to its apogee the tendency that Donatello had championed and was an even more unswerving student of nature. Like Pollaiuolo, he was affected only very superficially by the antique, for instance in details of costume and architecture. His art might easily have existed outside the revival of antiquity, and, except for his superior Italian esthetic sensibility, recalls vividly the realistic German sculpture of his time.

Donatello in his David for the moment had forgotten a little his passion for realism in a desire to reduplicate the success of the ancients in the treatment of the nude. Verrocchio in his bronze David, now also in the Bargello, has reproduced with unsparing truth the wiry young athlete of the fields, he has endowed the body with more movement, and in order to heighten the impression of actuality he has caused to flit across the countenance the beginning of that quizzical smile which was to be developed by Leonardo. The sleeping youth of terracotta in the Kaiser Friedrich Museum at Berlin, attributed to Verrocchio, has the same uncompromising realism. A still more impressive opportunity for comparison with Donatello is afforded by the last work of his life and his masterpiece, the equestrian statue of the *condottiere*, Bartolommeo Colleoni, in the square in front of the church of SS. Giovanni e Paolo at Venice (Fig. 88). Verrocchio died before he had quite finished the model from which the casting was done, and the group was in the end completed and cast by the Venetian sculptor Alessandro Leopardi. The extent of Leopardi's participation is a moot question, but at least in all essentials the work is a product of Verrocchio's genius. He has not, like Donatello, clothed his captain in the personality of a Roman general; he has boldly presented him, as he might actually have appeared, compelling his troops by his iron will and eagle's glance. He has also given to horse and rider alike one of those vigorous poses in which Pollaiuolo excelled and in which there seems to be stored up all the powerful energy of the young Renaissance. Few critics would dispute the justice of calling Verrocchio's achievement the greatest equestrian group in the world.

His realism is as apparent in a work of a totally different sort, the

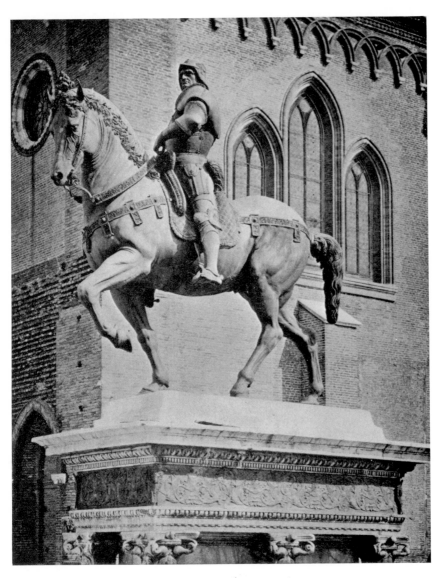

FIG. 88. VERROCCHIO. COLLEONI. VENICE

(Photo. Fratelli Alinari)

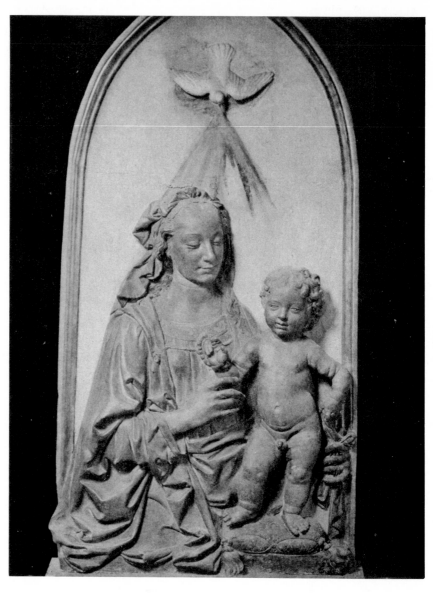

FIG. 89. VERROCCHIO. MADONNA AND CHILD. BARGELLO, FLORENCE

(*Photo. Fratelli Alinari*)

boy with a dolphin now over a fountain in the court of the Palazzo Vecchio, Florence. A comparison with Desiderio's ethereal children is all that is necessary to prove the point. Verrocchio's *putto* is a real boy, and in its wonderful movement is again an intrusion upon one of Pollaiuolo's specialties. The marble group of Christ and the doubting Thomas in the niche on Or San Michele which had held Donatello's St. Louis is interesting, because it has fallen victim to the general European disease of the fifteenth century, the involution and indentation of the drapery for the sake of chiaroscuro. Here and in other instances the similarity of the folds to those of Veit Stoss is one of the most palpable examples of a parallelism to German sculpture. But we forget details in the solemn majesty of the postures, which becomes more tangible by a comparison with the figures of the Sentimentalists or even of Benedetto da Maiano.

The breadth of Verrocchio's range must already have impressed the reader. With equal success he tried his hand at realism, at Pollaiuolo's energy and movement, at religious dignity, and when he would, he could even be as exquisite as Desiderio, though not perhaps as spiritual. Of his two certainly authentic Madonnas, both in the Bargello, one in terracotta and the other, less attractive, in marble, the former (Fig. 89) has united to Desiderio's aristocratic elegance greater amplitude of form. On the softer feminine and infant faces, the smile of the David has approached more closely that of Mona Lisa. In his one unquestionably genuine portrait bust, the marble lady of the Bargello, he surpassed the delicacy of Desiderio in the modelling of the hands and the dexterity of Mino in the counterfeiting of fabrics. Both in the Madonnas and the portrait, all these qualities have a greater effect upon the spectator because they are only auxiliaries to the general impression and are bestowed upon figures that possess more reality.

CHAPTER XIII

THE RENAISSANCE IN ITALY. THE SCULPTURE OF THE FIFTEENTH CENTURY OUTSIDE OF FLORENCE

1. SIENA

THE new style of the Renaissance was disseminated throughout the rest of Italy very largely by Florentine masters, especially Donatello.

Florence's rival in Tuscany, Siena, had never achieved any distinction in sculpture, and her output in this phase of art during the Quattrocento was comparatively unimportant. Her one boast, Jacopo della Quercia, was not Sienese in temperament, and it has been found convenient to consider him in the preceding chapter. He exercised only a limited influence in his native town. It was Donatello who was the great model, and a good deal of respectable Donatellesque sculpture was produced. The chief name was LORENZO VECCHIETTA (c. 1412–1480), a good realist, who was most successful in bronze. The natural expression of Siena was painting. Vecchietta also used the brush, and his two principal successors in sculpture, NEROCCIO DI LANDI (1447–1500) and FRANCESCO DI GIORGIO (1439–1502), are better known as painters.

2. LOMBARDY

During the first half and middle of the Quattrocento the field of sculpture in Lombardy was occupied by Gothic craftsmen from northern Europe working upon the cathedral of Milan, by importations of Flemish and German wood-carving, by Florentines such as Michelozzo and Filarete, and by indigenous masters working in a combination of the Gothic and Florentine manners. It was only in the second half of the century that Lombard sculpture rose to real importance and, as in the Romanesque period, once more sent to many other parts of Italy its representatives, who still were often more like master stone-cutters than artists of highly developed personalities. Milan and Pavia now both became great humanistic centers. The style that was evolved was based upon the Florentine, but with it were amalgamated Teutonic elements. It was distinguished by the luxuriance of its architectural setting, the details of which, even to a greater extent than elsewhere, were copied from the

goldsmith's art. This meticulous opulence was facilitated by the extraordinary popularity of the pliable medium of terracotta for decoration, and even when terracotta was not employed, its ornamental effects were imitated in the marble. The greatest Lombard sculptor was Amadeo, but a necessary preliminary to a discussion of his achievement is a consideration of the problem connected with the two brothers, CRISTOFORO and ANTONIO MANTEGAZZA, who may have influenced him.

Although it is impossible to attribute with certainty any one piece of sculpture to the brothers, it has become customary to ascribe to them a peculiar style that appeared in northern Italy in the latter part of the century. How far we are justified in this conjecture is a question. The style is exemplified in some parts of the façade of the Certosa near Pavia, the principal Lombard edifice adorned by the sculptors of the period, and we know that both of the Mantegazza labored here with Amadeo. But since the peculiarities are only exaggerations of elements in Amadeo's ordinary style, it may be that Amadeo himself produced these parts of the façade and other pieces of sculpture of the same sort, in the extravagant moments to which he was only too susceptible, or that his pupils are responsible, accentuating eccentricities that they found in their master's works. Whatever be the truth, the term, "the style of the Mantegazza," has found a place in the vocabulary of historians of art and has a perfectly definite meaning.

It is well exemplified by the St. James in the second row of decoration from the bottom on the façade (Fig. 90) and by the "restored" Deposition in the Victoria and Albert Museum, London. The bodies are often emaciated and elongated to the last degree, and yet even these impossible forms, especially the countenances, are rendered with a harsh and excessive realism. The neurotic figures and heads are infused with a painful intensity of emotional expression. The eyes are cavernous, and the mouths are usually opened for outcries. But the most pronounced eccentricity is the treatment of the drapery, which is a translation into stone of the mannerisms used by the north Italian painter Mantegna and his followers. The garments have a distinctly metallic quality, as if beaten out of brass, or to use another simile, the bodies look as if they were involved in a mesh of great cords. The critic, Malaguzzi Valeri, has aptly said that they seem to have emerged from an involuntary bath, and indeed we know that the Lombard painter Bramantino moistened cloths and papers and arranged them in this artificial fashion. The drapery is broken into a large number of minute, protuberating, and sharp-edged folds. Verrocchio also indulged in too many folds, but each fold was in itself natural; with

these Lombards each fold is mannered. The style of the Mantegazza brothers may have been affected by the similar peculiarities of Flemish painting or of the German prints that were already relished by the Italians.

The normal manner of GIOVANNI ANTONIO AMADEO (or Omodeo) of Pavia (1447–1522) is a type of the kind of sculpture produced in Lombardy, much of which is dependent upon him; and even when he is extravagant he is representative of an abnormal strain that occasionally crops out in the art of the region. Within the mortuary chapel of Bartolommeo Colleoni that he built as an annex to S. Maria Maggiore at Bergamo, his elaboration, for the *condottiere's* own tomb, of the sepulchral form employed in the shrine of St. Peter Martyr at Milan shows that no more than in Tuscany was there any sudden break with the medieval tradition. His figures, moreover, are plainly reminiscent of the Gothic sculptors from Campione. The women, especially, have the same long, cylindrical necks and the same treatment of the head and hair. A certain Teutonism may perhaps be traced in the characteristics that he shares with the works ascribed to the Mantegazza, an obtuseness to physical beauty, a frequent elongation of the members of the body, and a leaning towards passionate intensity. All of his qualities, through the influence of Florence, are given the tone of the Renaissance, and are framed in ornament of the Renaissance. Proud of his new-found treasure, he paraded his humanism wherever he could — in architectural decoration and in the backgrounds of his reliefs. His numerous *putti* recall Michelozzo, though they are more lively and imaginative. With their short, fat legs and podgy bodies, they lack Donatello's anatomical correctness as well as the wonderful nervous energy that the great Florentine breathed into the infant forms; but no one has ever realized with more variety and appreciation than Amadeo the charm of childhood — its joy, thoughtlessness, vivacity, and mischief.

His incorrectness is not confined to the *putti*. His mistakes are those of a man who did not have the benefit of living in such a critical atmosphere as that of Florence. He enthusiastically attempted difficult foreshortenings but seldom with success. The perspective of his reliefs may be faulty. The anatomical defects into which he sometimes falls in adult figures are perhaps intentional, as in the case of certain other Lombard artists, for the sake of exotic effects in which the Lombard temperament seems occasionally to have revelled. The curious and often impossible bend of the back in his nudes may be due to this same tendency. His structural deficiencies are extended to the architecture of his tombs and to his architecture in general. A true

FIG. 90. STYLE OF THE MANTEGAZZA. ST. JAMES.
FAÇADE OF THE CERTOSA, PAVIA

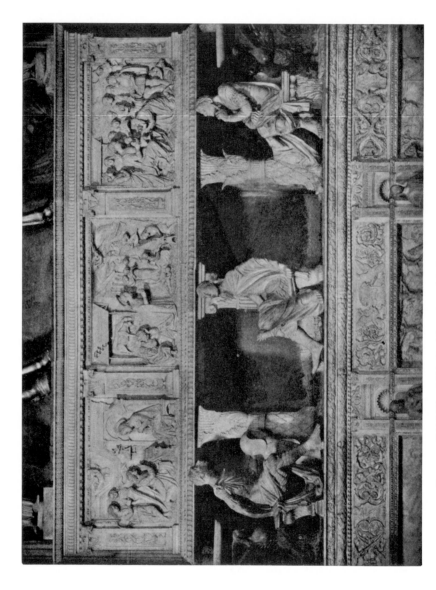

FIG. 91. AMADEO. DETAIL OF TOMB OF COLLEONI. COLLEONI CHAPEL,
S. MARIA MAGGIORE, BERGAMO

(*Photo. Fratelli Alinari*)

Lombard, he was more concerned with the decorative richness of his surfaces than with the logical organism of his buildings. He was more at home and better in reliefs than in separate statues. He often resorted to a peculiar method of relief that was very popular in northern Italy during the Quattrocento and was occasionally essayed, sometimes in a less pronounced form, in other parts of the peninsula. The figures in the foreground, though themselves kept in low relief, are undercut and almost detached so as to cast shadows and create an effect of chiaroscuro. Since Amadeo had a predilection for sharp outlines and therefore very commonly chose the profile position, the forms often look as if they had been stuck upon the background. The writer has observed the usual practice of ascribing to pupils and to other sculptors the more decided instances of the Mantegazza eccentricities that appear in monuments connected with Amadeo's name, but in view of the complexity of the whole question it should never be forgotten that possibly Amadeo himself was often guilty of these aberrations.

The most authentic example of Amadeo in his maturity is the sepulchral chapel at Bergamo, though here, as usual, he was assisted by others, some of them perhaps trained under the Mantegazza. On Colleoni's tomb the miserable equestrian figure of wood at the top was done later in 1501 by two German artisans. The reliefs from the infancy of Christ on the upper of the two rectangular boxes of the tomb (Fig. 91) and the two reliefs of the Flagellation and Resurrection at the ends of the lower box are characteristic works by Amadeo himself. The type used for the Virgin is much the same as appears in the contemporary Lombard painting of Foppa and his school. The three other reliefs from the Passion on the lower box are marked by a more feverish emotion that probably betrays the hand of an assistant; the clumsy statuettes of Virtues that divide them are certainly not by the master. His humanistic leanings are exhibited: by the three seated and meditating Roman heroes between the two boxes; by the medallions of emperors, which are so frequent an element in the Lombard decorative repertoire and which may be seen in the spandrels at the top, in the lowest frieze, and in the architectural background of the Flagellation; and by such a detail, in the setting of the Flagellation, as the representation of the Roman equestrian statue called *il Regisole*, then still extant at Pavia. The three heroes are the most tangible indications of a Teutonic strain. On the lower frieze of the lower box Amadeo has introduced some of his most delightful *putti*. The tomb of Colleoni's daughter, Medea, in the same chapel follows more closely the Florentine sepulchral norm; the effigy of the deceased has

the long, cylindrical neck that Amadeo preserved from the Middle Ages.

There was a constant interchange of influences between Lombardy and Venice in the Renaissance, Lombardy exercising the dominant rôle. The façade and, to a lesser extent, the whole edifice at Bergamo reveal, especially in the designs of colored marbles, a certain dependence upon Venetian architecture, which was perhaps desired by the Venetian *condottiere* himself. The exquisitely carved architectural details are those common to the exuberant Lombard repertoire: the candelabrum shafts, the vases, the medallions of heads, the *motifs* of every kind of foliage, the *putti*, fauns, mounted cavaliers, the lions, birds, and dolphins, all combined and interwoven with the most unflagging and fantastic invention. How much of this or of the other figured ornamentation was carved by Amadeo's own hand is hard to say.

The difficulty of attribution is even greater in the Certosa of Pavia where he was extensively employed from 1466 to 1499. He perhaps designed two sides of the opulent embellishment of the Minor Cloister, executing some of the lovely little angels above the capitals himself. Apparently he worked also upon the door, with the tympanum of the Virgin, leading to this cloister. The design of the whole Major Cloister may be his. On the façade, of which he had a model accepted in 1490 and of which he was made general director in 1491, it is usual to ascribe to him, in the second row of reliefs, the Raising of Lazarus, the Christ among the Doctors, the Nativity, and the Epiphany. In the rest of the lower façade, the greatest confusion exists in regard to ascriptions to Amadeo, his pupils, and the Mantegazza. Some of the carving may very well have been done in the sixteenth or even seventeenth century. Did Amadeo himself execute any of the parts in which are embodied the more extravagant phases of the Mantegazza's mannerisms? He certainly has adopted them in a less pronounced form in the Epiphany, which is generally admitted to be his. The lowest windows, at least designed by Amadeo, are the spots where the wealth of Lombard ornament reaches its acme. In addition to the *motifs* already mentioned, there are shields, ribbons, eagles, and monsters. Loveliest are the little angels, kneeling or standing, often singing from rolls of music, with their draperies flying in the wind. The upper section of the façade belongs to the Cinquecento. Amadeo also labored upon the interior doors of the church and upon the great central portal, but it is hard to define his exact participation. The great portal is mainly due to his companion and successor at the Certosa, BENEDETTO BRIOSCO.

In works assigned to Amadeo at Cremona, the spell that the Mantegazza cast over him (if spell there was) operated more fatally. The style approaches so dangerously near to caricature in the reliefs from a reliquary of Persian martyrs built into the pulpits of the cathedral that, despite doubtful signatures of Amadeo, Venturi attributes them to another Lombard, PIETRO DA RHO or Rondo, then active at Cremona. The contortions of the bodies, the conventionalization of clouds and trees, are neurotic and absurd enough to gibe with the theories of the most extreme modernist. The collaboration of Pietro da Rho in these reliefs is all the more likely in view of the fact that Amadeo assumed a commission that had been given originally to him, a reliquary for St. Himerius, one panel of which is extant in the north wall of the cathedral. Less exaggerated than the reliefs of the Persian martyrs, it nevertheless betrays a progressive decadence of Amadeo into the peculiarities of the Mantegazza.

During the latter part of his life Amadeo confined himself almost wholly to architecture. If we may follow the common but perilous process of ascribing to him only the less extravagant pieces, then in his last great sculptural commission of 1498, the shrine of Lanfranc in the church of the same name near Pavia, his own hand is to be discerned in such panels as the saint blessing and the saint's vision of the Virgin. The exclusion of the more eccentric reliefs on this shrine from the canon of Amadeo would justify the conclusion that he now returned somewhat to the earlier and simpler manner of Bergamo. In our final estimate of the master and of Lombard sculptors, whose chief representative he was, we must acknowledge that if they lacked the good taste and accuracy of the Florentines, they partially atoned by their brilliant invention and originality.

The rest of Milanese sculpture that falls within our scope and in some instances carries us over into the Cinquecento we may connect with three tombs. The first is that of Gian Galeazzo Visconti who was not given a final sepulchre in the Certosa until 1493, almost a century after his death. The monument recalls the royal French tombs of the early Renaissance in St. Denis and may have inspired them. Above the effigy, which lies on a high base, is an arched canopy, surmounted by a second story with reliefs, small figures, and a statue of the Virgin. In the Lombard spirit of the goldsmith's delicacy, the canopy was decorated with a rich embroidery of ornament and figured medallions by a distinguished master, GIAN CRISTOFORO ROMANO (c. 1465–1512), the son of another sculptor, Isaia da Pisa. Though Gian Cristoforo was a Roman, the Roman school itself was under large indebtedness to Lombardy, and it was therefore natural

that he should work in the temper of that province. He was the official sculptor of Isabella d'Este and was popular throughout Italy, having left a few productions in other places. Another well-known work is the bust of the young Beatrice d'Este in the Louvre, in which he has wonderfully expressed girlhood as distinguished from womanhood and in the costume and head-dress of which he once again indulged his goldsmith's taste. Gian Cristoforo was also a prominent humanist and musician, and he figures as an interlocutor among the great exponents of Renaissance culture in Castiglione's *Courtier*.

His collaborators on the tomb were Benedetto Briosco, who did the statue of the Virgin on the canopy, and CRISTOFORO SOLARI, who executed the effigy. The latter's style is easier to see in the two recumbent portraits of Ludovico Sforza and Beatrice d'Este that have been preserved in the Certosa from the mausoleum raised by the Duke to his spouse (1497). The draperies cling to the old artifices of the Mantegazza. The heads, especially that of Beatrice, have been somewhat accommodated to the personal type that Leonardo da Vinci introduced into all later Milanese art. They resemble particularly the heads of Leonardo's Milanese pupil, the painter Boltraffio. But in the more robust forms and the fuller garments, it is plain that Lombard sculpture was now passing into the mode of the Cinquecento. Upon this pompous, empty, and colossal manner Solari entered completely in several statues in and on the cathedral, notably the Eve, upon whose face there lingers something of Mona Lisa's smile. Even in this less attractive phase, he lacked the academic anatomical correctness of the Florentines. He had a predilection in his latter days for the subject of Hercules and Cacus, which was a favorite with the sixteenth century because it permitted contortions of the nude.

The third in the series of tombs and the most important was ordered by Francis I for the French general in the Italian wars, Gaston de Foix. Its author was a pupil of Amadeo, AGOSTINO BUSTI, called IL BAMBAIA (1480?–1548). Generally speaking, he represented the mannered grace of the Cinquecento, but in the recumbent portrait he outdid himself, shook off his environment, and reverted to the noble simplicity of the early Quattrocento, to the dignified and idealized repose of the Ilaria. The monument, begun in 1515 on a pretentious scale, was never completed, and after the expulsion of the French it was dismantled. Its fragments are dispersed through several European museums. The injured effigy, together with a few other pieces, is now in the Archaeological Museum, Milan. With the exception of this effigy, the tomb was carried out in the style which, so far as it was capable of excellence, was best manipulated by Benvenuto Cellini and

Giovanni Bologna. Unchecked by the better taste of Florence and Rome, Bambaia fell into the worst rhetorical affectation. In the panels he unsuccessfully essayed the pictorial, and created curious artistic hybrids by attempting, without any proper transition, a cross between relief and separate statuettes in the round. The majority of his other works, chiefly tombs, in Milan and the vicinity, are in the same decadent manner. Bambaia closed the book of great Milanese sculpture by executing its masterpiece and, strangely enough, by also ushering in the decline.

3. VENICE

If it fell within our purpose to examine the art of the medallist, it would be pleasant here to discuss the achievement of a man who was born at or near Verona in what was afterwards Venetian territory, ANTONIO[1] PISANO, called PISANELLO (1397 or 1398–1455). The first real medallist in the world's history and at the same time the greatest, he might with the more propriety be included in our study, because through his boldness of relief, his aversion to the trivial, his powerful characterizations, and his poetic symbolism and allegory, he elevated his art to the plane of truly monumental sculpture.

Venetian sculpture was much less significant than Venetian painting, which better embodied the taste of the city for color and display. In all phases of art and culture, Venice freed herself from medievalism less quickly than Florence. The new fashion in sculpture was introduced by secondary Florentine masters, who worked chiefly on the large figured capitals and corner-pieces of the Ducal Palace. The Gothic style, however, largely persisted during the first half of the century, and the greatest native sculptors of this period, GIOVANNI BUON and his son, BARTOLOMMEO, evolved a manner that belonged half to the Middle Ages and half to the Renaissance. It is especially noteworthy that their figures were still ensconced in the midst of Gothic architectural decoration. In the second half of the century, when the Renaissance was more definitely established at Venice, a potent Lombard influence took the place of the Florentine. The Lombard sculptors and craftsmen were much more numerous than the indigenous masters, but they adapted themselves more or less to the city's atmosphere.

The typical Venetian sculptor of the Quattrocento was ANTONIO RIZZO (d. 1499 or 1500), a Veronese by birth, probably identical, as far as present knowledge goes, with the person who was sometimes called Antonio Bregno and Antonio Dentone. He is first mentioned at Venice in 1464, and he was active at the Certosa of Pavia in 1466.

[1] His Christian name is now known to have been Antonio, not Vittore.

Even Rizzo, especially in his first commissions, partly retained the forms of the Gothic past. His figures are, to a certain extent, inherited from the Campionesi, but they are less meticulous and nobler than those of Amadeo. The drapery takes grander sweeps, has deeper indentations, and is not tainted by the Mantegazza peculiarities.

The series of ducal tombs contains excellent specimens of the style of the period. With two of these Rizzo's name is connected. For the monument of Francesco Foscari in the church of the Frari, which is usually ascribed to him at an early stage of his career, the old Venetian sepulchral type was preserved but decorated here and there with details of the Renaissance, especially in the lower section, which was perhaps suggested by Donatello's tomb of John XXIII. Two warriors, holding the heraldic shields, instead of the traditional angels, now draw aside the curtains hung over the sarcophagus, and warriors or pages henceforth were commonly substituted at Venice for the Florentine *putti* as bearers of escutcheons. These two warriors and the Virtues standing around the bier and carved upon the sarcophagus are characteristic examples of Rizzo's manner. On the later tomb of the Doge Niccolò Tron in the same church, which, if Antonio Rizzo did not plan, he at least helped to decorate, the ornament is wholly of the Renaissance. In the center of a huge structure against the wall, the sarcophagus still projects upon consoles in the medieval fashion; but the general architectural design is incoherent, and the sarcophagus is isolated and lost in its piecemeal surroundings. Rizzo apparently executed only the two Virtues beside the erect statue of the Doge at the bottom, the statuettes of Virtues on the sarcophagus, and the two jaunty pages. The rest would seem to have been largely done by Lombards. Two pages in the Arconati-Visconti Collection at Paris, from a dismantled tomb and probably by Rizzo, resemble the long-haired Venetian youths of Carpaccio's paintings.

The loveliest figure on the Tron tomb is the Virtue at the Doge's right, who possesses a voluptuous feminine form bursting through diaphanous garments. This phase of Rizzo's personality is better illustrated by his masterpiece, the nude Eve (Fig. 92), one of the statues that he did for the Arco Foscari in the Ducal Palace, begun under the Buon. He here embodied adequately for the first and last time in sculpture the Venetian conception of feminine beauty, which in its luxuriance varied essentially from the chaster, more emaciated and delicate Florentine type. Different from the nobler and more idealized Hellenic type, it was to become as lovely in the magic hands of the painters Giorgione and Titian. The narrow, sloping shoulders, the emphasis upon the abdomen, the cast of countenance, and the

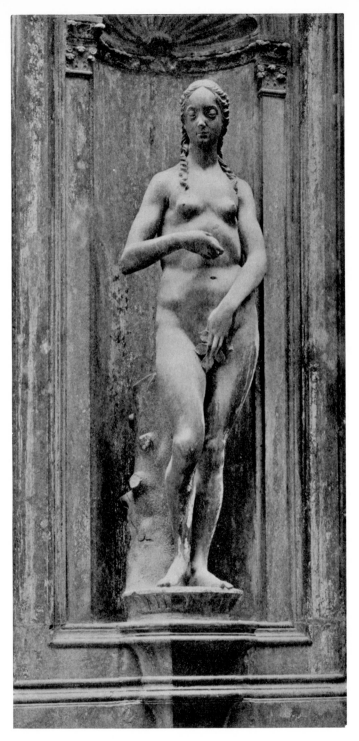

FIG. 92. ANTONIO RIZZO. EVE. DUCAL PALACE, VENICE

(Photo. Fratelli Alinari)

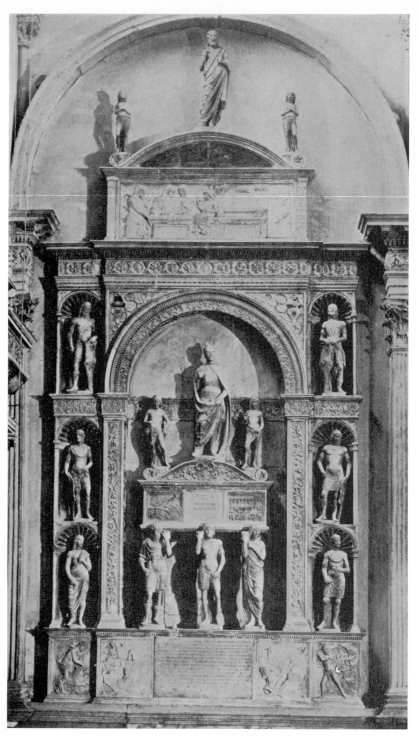

Fig. 93. PIETRO LOMBARDO. TOMB OF PIETRO MOCENIGO.
SS. GIOVANNI E PAOLO, VENICE

(Photo. Fratelli Alinari)

greater naturalism in comparison with the feminine nudes of Florence, denote, as in Lombardy, a Teutonic influence, whether German or Flemish, living on, at Venice, from the late Middle Ages. The companion statue of the Adam is also too robust for the average Florentine taste. It incarnates an intensity of sadness which is apt to appear in Antonio Rizzo's production and is largely concentrated in the expression of the mouth and deep-sunken eyes.

Of the Lombard invasion, the chief representative was PIETRO LOMBARDO, active at Venice at least as early as 1462. His style is less vigorous, less individual, and more monotonous than Amadeo's. His figures possess a pleasant gravity, but the vice of this virtue is a tendency towards a rigidity which binds the arms to the body and would make it possible to inscribe the whole form in a rectangle. Here and there are traces of the Mantegazza drapery. His first great work at Venice was the tomb of the Doge Malipiero in SS. Giovanni e Paolo, remotely derived from the Florentine prototypes but elevated on the wall in the Venetian fashion and disfigured by the traditional Venetian canopy outspread over the bier.

In his productions from the last quarter of the century he approximated the grander, more Roman manner of the Cinquecento. In the tomb of the Doge Niccolò Marcello in the same church he had in mind the triumphal arch, even before Andrea Sansovino established its vogue in sepulchres. How incapable he was of rendering anything but recumbent and dignifiedly erect postures is betrayed by the Virgin, Child, and kneeling figures of the tympanum. A third ducal mausoleum for Pietro Mocenigo, also in SS. Giovanni e Paolo (Fig. 93), is an impressive example of Venetian pride in its transmutation of the central section beneath the great arch into a triumphal procession. The sarcophagus, embellished with reliefs of the deceased's victories, is represented as borne along on supporting figures, two of them stalwart warriors, and upon it the Doge stands superbly, accompanied by the two customary pages. The two reliefs of the deeds of Hercules on the base are weak counterparts of themes employed by Amadeo and his assistants. The greatest architectural and sculptural undertaking of Pietro Lombardo, his sons Antonio and Tullio, and his *bottega* was the gem-like church of S. Maria dei Miracoli, a fitting witness to the Venetian love of splendor. Its walls, without and within, are completely covered by a rich incrustation of marbles, and the plastic decoration runs the whole Lombard gamut.

ANTONIO (d. 1516) and TULLIO LOMBARDO (d. 1532), since they lived on through the beginning of the Cinquecento, became more classical when they worked apart from their father. The former is

most definitely known by his marble panel of a child exonerating its mother in the series of reliefs from the life of St. Anthony that were now begun in the chapel of the Saint in S. Antonio, Padua. It is a cold and lifeless work, but Antonio has at least succeeded in emerging completely into the Romanizing style of the sixteenth century. Tullio's two reliefs, on the other hand, though more animated, attempt an unpleasant fusion of the Venetian manner of the Quattrocento with the fashions of the Cinquecento. If we had no further acquaintance with the two brothers, we should have a very poor opinion of them. But together they labored, in SS. Giovanni e Paolo, upon the tomb of the Doge Andrea Vendramin, which was possibly designed by Alessandro Leopardi. The sepulchral type is derived from the monuments of Niccolò Marcello and Pietro Mocenigo, but the approximation to the triumphal arch is still closer, especially in the substitution of columns for pilasters, and the panelling of Florentine mausoleums is used behind the sarcophagus. For the two nude pages bearing escutcheons, now in the Museum of Berlin, there have been substituted two portly feminine forms (by an assistant of the Lombardi, Lorenzo Bregno), described variously as two Muses or as Sts. Catherine and Mary Magdalene. The many decorative figures, in contrast to the Paduan reliefs, belong to the best tradition of Pietro Lombardo's *bottega*, with little or no addiction to classicism. The ascription of the different parts to Antonio and Tullio and the question whether Leopardi cooperated in the actual execution constitute a vexed problem; perhaps the loveliest forms, those of the Virtues on the sarcophagus, which are in a more graceful and exquisite style than the other sections, were carved by Antonio Lombardo.

ALESSANDRO LEOPARDI (d. 1522) was a dominant personality in Venetian sculpture at the end of the fifteenth and beginning of the sixteenth century. He was chiefly famed as a worker in bronze, and we have already seen his connection with Verrocchio's Colleoni. He collaborated with Antonio Lombardo on another monument, the bronze tomb for the Bishop Zeno in the chapel belonging to the prelate in St. Mark's. The sepulchral type is the simple old medieval base surmounted by the effigy. Around the base are statuettes of Virtues that anticipate the mannered elegance achieved in bronze by Jacopo Sansovino and Giovanni Bologna. Leopardi's most interesting accomplishments in this medium are the bases for the flag staffs in the Piazza San Marco.

Another master of bronze, a contemporary of Leopardi and active in Venetian territory, was ANDREA BRIOSCO, called RICCIO, of Padua (1470–1532). Trained by Donatello's pupil, Bellano, he ac-

quired much of the great Florentine's technical skill in bronze, and now and then he reveals traces of Donatello's style, especially a fondness for rapid movement; but in general he cast his lot with the antiquarianism of the Cinquecento. His most celebrated work, the highly ornate and elaborate Paschal Candlestick in S. Antonio, Padua, might bettĕr serve for pagan rites. Many of the reliefs and decorative figures are classical in theme, and even the Christian subjects are so disguised that they would not have offended the religious scruples of an ancient Greek or Roman. In the reliefs, however, he retained the pictorial perspective of the Quattrocento, as also in the two crowded bronze panels of David dancing and of Judith and Holofernes for the series begun in the choir of S. Antonio by Bellano. The most eccentric instance of his archaeological hobby may be seen in the bronze reliefs from the tomb of Girolamo and Marcantonio della Torre, now in the Louvre. Copies have been substituted on the original monument in S. Fermo, Verona, a curious structure in which the sarcophagus, like a reliquary, is raised on the backs of bronze sphinxes over a kind of altar. The reliefs from the life and death of Girolamo della Torre could easily be mistaken for the story of some classical worthy; Riccio even introduces Charon, the Styx, and the Elysian Fields. He was also one of the principal manufacturers of small bronzes.

4. EMILIA

Partly because marble was not plentiful and painted clay and terracotta were the ordinary mediums, no great indigenous school was developed. The only distinguished sculptor of the Quattrocento, Guido Mazzoni, usually adopted a manner differing widely from the styles practised in the rest of the peninsula, and although a number of minor works were produced by native artists earlier in the century, his chief predecessor came from the south, NICCOLÒ DA BARI.

The personality of the eccentric Niccolò (d. 1494) is so varied and elusive as to defy explanation. In the embellishment of the upper part of St. Dominic's reliquary at Bologna with saints, *putti*, and a Pietà, and of the altar with a kneeling angel bearing a candlestick, he reveals familiarity with Florentine sculpture; but several of the statuettes, such as the St. Florian, are so curiously similar to the productions of the Burgundian school of Sluter as to imply that he had at some period sojourned in Dijon. The draperies of the candle-beari ɽ angel are Burgundian, the lineaments of the face are Burgundian, Flemish, or German, but the refining influence of Florence has softened the northern elements until it has made the figure his masterpiece. From the beauty of the reliquary he received the nickname of Nicholas of the Shrine, Niccolò dell' Arca.

He perplexes us still further by the different style of his first work at Bologna, the Pietà of painted clay in S. Maria della Vita (1463), consisting of large detached figures treated with the utmost naturalism so as to give the illusion of breathing persons. It is the Italian counterpart of the Gothic Holy Sepulchres common to the rest of Europe in the fifteenth century. Had Niccolò been in Burgundy and seen the specimens there? He might have found at least one previous example in Italy itself, in the church of S. Anastasia, Verona, and henceforth such Sepulchres were frequently made in Emilia and given the title of *Mortorii* (singular, *Mortorio*). Niccolò da Bari, with his naturalistic bent, uses more pronounced peasant types than any that we have hitherto studied in the Renaissance, and he gives them gestures that are baldly colloquial. The naturalism manifests itself also in an absolutely unrestrained expression of grief that he might have observed in the funerals of his southern birthplace. The St. John and the more stolid Joseph of Arimathaea are again Burgundian or German in appearance.

Guido Mazzoni of Modena (1450–1518), probably a pupil of Niccolò da Bari, continued the manufacture of *Mortorii* in painted clay. He is extremely realistic, introducing contemporary costume more often than Niccolò, and excelling in the rendition of the epidermis; but he is less frantic in his expression of grief and frequently sacrifices both realism and emotion to a feeling for beauty of form, countenance, and pose. The Holy Sepulchre now in S. Giovanni della Buona Morte, Modena, is characteristic (Fig. 94). His realism is illustrated by the Nicodemus and especially by the Joseph of Arimathaea, in whose face he has represented marvellously the attempt to restrain an outburst of weeping. The St. John and the woman at his right, however, are beautiful ideal figures. The same methods Mazzoni employed for the group of statues representing the Nativity, now in the crypt of the cathedral at Modena. The sense of beauty is more developed, especially in the lovely Madonna and Child, but with Mazzoni's ordinary stylistic dualism, the St. Joseph is very realistic, and the maid-servant cooling the broth is purposely carried into the region of ugly vulgarity. During the last thirty years of his life Mazzoni took his craft from place to place, laboring for the Aragonese dynasty at Naples and finally emigrating to France under Charles VIII, where he helped to spread Italianism and where he executed several important but non-extant works,[1] not in the manner of his *Mortorii*, but in the more normal style of the Renaissance.

The technique of clay in Emilia was adapted to the style of the

[1] Two or three extant works are hypothetically attributed to him.

Cinquecento by ALFONSO LOMBARDI and ANTONIO BEGARELLI. They continued to do sets of separate figures arranged in dramatic compositions, sometimes *Mortorii*, sometimes other subjects. Alfonso Lombardi (1497–1537) belonged to a family of Lucca that had emigrated to Ferrara. In a characteristic production, the large group of the Death of the Virgin in the Oratory of S. Maria della Vita, Bologna, he has really created, in a style that suggests Raphael, an aggregation of ancient philosophers disputing round about Our Lady's bier. He also worked in marble, for example, in the reliefs from the life of St. Dominic on the *predella* of the shrine in S. Domenico, where he perhaps reveals the influence of the classic manner of the Florentine Tribolo, who had been recently employed in Bologna.

Begarelli, who was born in Modena at the end of the Quattrocento and who died in 1565, is a better known personality. His training is a subject of conjecture. Some would make him a pupil of Guido Mazzoni or of Alfonso Lombardi. He seems to have been one of those many sculptors and painters who were influenced by the forms which the powerful personality of Raphael had popularized and which Begarelli may have learned from the engravings of Marcantonio. Now and then one discerns in his works details suggested by Correggio. Though his medium and themes are the same, his style, dependent upon the Roman art of the Cinquecento, is very different from that of Mazzoni. The uncompromising realism of his predecessor has largely, though not wholly, given way to an idealism that cultivates Raphael's translation of ancient forms and costumes. His most celebrated and pretentious composition is the group of the Deposition from the Cross in S. Francesco, Modena. By adapting here to statuary a subject usually confined to painting or to relief, he reveals a pictorial proclivity that is evident everywhere in his production. Among Begarelli's other numerous works may be mentioned: the simpler Pietà in S. Pietro, Modena; the Raphaelesque Madonna, Child, and infant John in the Museo Civico; and again in S. Pietro, the Madonna in glory amidst clouds and angels with four saints below, an absolute transcription of the kind of painting done by Raphael and his pupils, in which Begarelli was assisted, as often, by his nephew Ludovico.

5. ROME

Artistic conditions in Rome during the Quattrocento prevented the formation of any essentially Roman school either in sculpture or in painting. Masters from other Italian cities considered it the crown of their reputation to be allowed to labor in the capital of Christendom, and the constant change in pontiffs rendered precarious the continu-

ous employment of any indigenous school, for each new pope was likely to summon his favorite artists from the places in which he had hitherto been interested. Several sculptors active at Rome have already been mentioned, and there now remain for discussion one or two men who, though of foreign origin, left their most significant productions in the eternal city.

Donatello's pupil, ISAIA DA PISA, to whose work the atmosphere of Rome gave a more pronounced antique tone, is connected with two important tombs which began the tradition of a Roman sepulchral type, although the extent of Isaia's own participation in the monuments and of others' cooperation is an unsolved problem. In the tomb of the Cardinal Chiaves, which was made shortly after 1447 and the dismantled fragments of which are in S. Giovanni in Laterano, the use of the architrave over the rectangular niche instead of the arch employed by the Florentines, the insertion of little niches with statuettes in the framing pilasters, and the decoration of the lower section with a broad inscription flanked by *putti* were elements that were to appear in the fully developed Roman mausoleums by Andrea Bregno and his followers. In the tomb of Eugene IV, erected before 1455 in St. Peter's, later in the century transferred to the church of S. Salvatore in Lauro, and then remodelled, the same elements are present, except that escutcheons are substituted on the base for the *putti;* but it is difficult to decide how far the still closer approximation to Bregno's monuments is due to the subsequent reconstruction.

ANDREA BREGNO (1421–1501) was the chief personality in mortuary commissions at Rome, often collaborating with his followers and with other masters, such as Mino da Fiesole and Giovanni da Traù. He was a really great sculptor, whose high merits have not yet been properly appreciated. A Lombard by birth and training, through the classic influence of Rome he evolved a much soberer, less fantastic, and less mannered style than his compatriots Amadeo and the Mantegazza. Here and there one discerns a slight reminiscence of the peculiar Lombard drapery, but the figures have none of the Mantegazza's elongation and are free from nervous agitation. The proportions of the bodies are excellent; they lie halfway between the thinness of Florentine fashion and the amplitude of Roman work of the Cinquecento. The Roman environment assisted him in obtaining an enviable nobility and repose suited to his sepulchral purpose. One feels the Lombard vigor in his forms, but it is controlled. He introduced the plenitude of the Lombard decorative repertoire into his tombs, but he used the repertoire with a chastity and restraint that cannot be paralleled in its home in the north. Living at Rome, he borrowed more

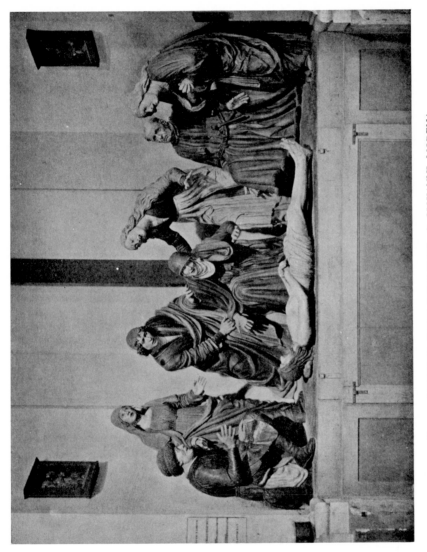

FIG. 94. MAZZONI. HOLY SEPULCHRE. S. GIOVANNI, MODENA

(Photo. Anderson)

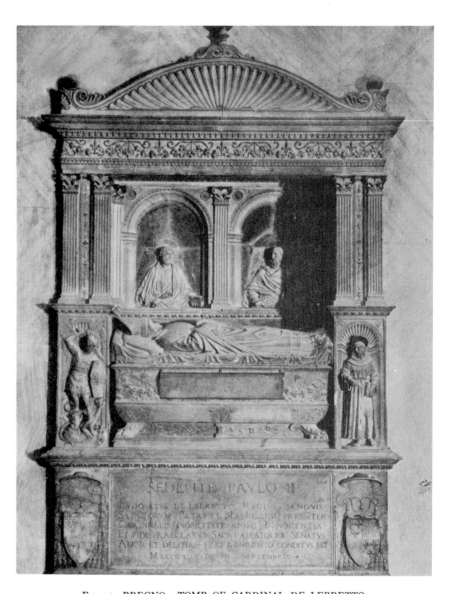

FIG. 95. BREGNO. TOMB OF CARDINAL DE LEBRETTO.
S. MARIA IN ARACOELI, ROME

widely and directly from antiquity than the majority of his contemporaries. Details of figures and ornamentation he carved with a most exquisite and unexpected precision, and he bestowed upon each work a most beautiful finish. Some of his monuments are among the masterpieces of the Renaissance.

From the precedents of Florence and of Isaia da Pisa he created three types of tombs that were often imitated, with slight modifications, by others, and he established the sepulchral standards for Rome in the second half of the century. The first type is embodied in the mausoleum of the cardinal d'Albret or De Lebretto in S. Maria in Aracoeli (Fig. 95). The rectangular compartment is elevated upon a high base adorned with a grandiose inscription and coats of arms at either side. The compartment is framed, not by single pilasters, but on each side by two slimmer, fluted pilasters, resting upon somewhat heavy pedestals out of each of which is hollowed a small niche for the statuette of a saint. Between the two pilasters there runs a delicate *motif* of vases and flowers. The compartment is covered, not by the arch, but more classically by an entablature, and the crown is simpler than at Florence, omitting figures and consisting only of volutes and small ornamental detail. Within the compartment the effigy of the deceased lies upon a lovely sarcophagus suggested by a *cassone* and embellished with a long tablet, which here lacks the appropriate legend that is usual in these sepulchres. Behind and above the deceased, the Florentine slabs of marble are replaced by two blind arches, which are framed by pilasters continuing the order of the outer pilasters and contain, against a background of dark blue marble, half-lengths of Sts. Peter and Paul. The beautiful decoration illustrates Bregno's customary manipulation of the Lombard *motifs*. His most magnificent monument of this class is that of the cardinal Pietro Riario in the church of the SS. Apostoli. In certain sections he reverted to the norm of Isaia da Pisa, adopting a broader single pilaster with saints in niches instead of the coupled pilasters and setting the escutcheons on the base in the hands of weeping *putti*. The elevation of the effigy upon a bier above the lid of a sarcophagus adorned with a *motif* of scales is evidently copied from Desiderio. The relief, in the background, of Sts. Peter and Paul presenting Riario and his brother to the Virgin is one of Bregno's best achievements. The occasional suggestions of Mino da Fiesole's style probably do not indicate the Florentine's collaboration; the greater solidity of the forms and their similarity to the Lombard's other figures reveal rather the hand of Bregno himself, though under the influence of Mino. The sphinxes that support the sarcophagus, the masks of Medusa and Abundance, and

the dance of *putti* on its face are all directly imitated from the antique. His monument for the cardinal Coca in S. Maria sopra Minerva is a partial simplification of the type that he had used for the tomb of De Lebretto. The contraction of the pedestals and the consequent lengthening of the pilasters result in better proportion.

The trouble with this class of tombs was that the architrave cast so heavy a shadow that the figures in the background could not be clearly seen. Bregno, who was always improving on his former models, therefore devised two new types, modifying the old in such a way as to obviate the difficulty. First, as in the sepulchre of Raffaello della Rovere in the SS. Apostoli, he simply left out the figures altogether and thus made the compartment into a low cell. The weeping genii with the escutcheons he now set within the cell at the foot and head of the effigy. Another way to avoid the difficulty was to substitute the Florentine arch for the entablature, and this he did on the tomb of the cardinal Cristoforo della Rovere in S. Maria del Popolo, filling it, as at Florence, with the Madonna (executed by Mino) and adoring angels. The lower section of the monument, from the effigy to the bottom, remains much the same, but it is now completely enclosed by the single pilasters supporting the arch and extending to the ground, and the sarcophagus and deceased receive proper emphasis by projecting on a base supported on consoles. He also now uses the Florentine slabs of marble in the background, not, however, dark in color, but white and adorned with a cross and candelabra. This type is Bregno's best solution of the sepulchral problem.

He also produced a series of splendid altars, suggested by the triumphal arch, with a great opening in the center, smaller niches at either side for statuettes of saints, and a crown of some sort above. Examples are the altars of Roderigo Borgia in S. Maria del Popolo, Rome, of Francesco Piccolomini in the cathedral of Siena, and of the church of S. Maria della Quercia near Viterbo. The Piccolomini altar is enclosed in a kind of little apse, the architectural forms of which are Bregno's but the sculpture of which was executed in great part by Michael Angelo and others. The angels with candelabra and those in the spandrels with the heraldic half-moons of the Piccolomini are probably by Bregno himself and reveal him archaizing in the Neo-Attic style. For the altar within the apse he was more largely responsible.

6. SOUTHERN ITALY

No important indigenous schools of sculpture were formed in the kingdoms of Naples and Sicily, and what commissions there were had to be carried out by masters from other regions. Two of the principal

sculptors employed in the south were DOMENICO GAGINI of Genoa and, much more significant, the Dalmatian, Francesco Laurana. Both of them, throughout a large part of their lives, were either united in the same enterprises or were active in the same places. The former (d. 1492) belonged to a large family of Lombard sculptors, who came from Bissone near Lugano but were chiefly active at Genoa, bridging over the transition from the Gothic to the Renaissance, in the ranks of which Domenico, a pupil of Brunelleschi, definitely aligned himself. At Genoa he was principally occupied on the façade of the chapel of St. John Baptist in the cathedral, but there is no agreement among doctors upon the questions whether he or Laurana made the design and as to the share which he, Laurana, and others, such as Domenico's nephew, Elia, had in the execution of the lavish sculpture. The problem of ascription of the several parts becomes so much more complicated in the greatest sculptural monument of Naples in the Quattrocento, the Triumphal Arch, conceived at least as early as 1452 by King Alfonso I to stand before the Castel Nuovo as a commemoration of his victorious occupation of the city, that we cannot linger over the different issues involved. Francesco Laurana is now generally conceded to have been the designer of the monument, using, it may be, a sketch of Pisanello's. It is marked by his fantastic architectural invention, by his richness of ornament, and by his lack of organic feeling, although the structural difficulties were perhaps surmounted as well as they could be, considering the narrowness and height of the space to be filled. A large number of other sculptors, chiefly from Rome and Lombardy, joined with Laurana and Domenico Gagini in the execution of the figures and reliefs, but there is no consensus of opinion upon the division of the labor. As early as 1463 Gagini anticipated Laurana in finding occupation in Sicily, but when a few years later Laurana arrived, the Dalmatian's style became dominant in the island. Gagini himself was influenced by his rival, so that, although he doubtless accomplished a good deal of work, it is very difficult to make definitive attributions. In the Cinquecento, however, Domenico's son, Antonello, reconquered Sicily for the style of the Gagini family, and with his children and followers, completely tyrannized over the sculpture of the island throughout the century.

FRANCESCO LAURANA of Zara (c. 1425–c. 1502), possibly a relative of Frederick of Urbino's architect, Luciano Laurana, was the most important of several sculptors from Dalmatia, which, as a Venetian province, was a center of considerable artistic activity in the Renaissance. As in the Romanesque period, its art still depended upon Italy. Since we know nothing certain about Francesco Laurana's

training, there is room for the widest theorizing. Venturi makes him a
pupil of Agostino di Duccio. He certainly was conversant with
Lombard sculpture, and many critics think that he collaborated with
Domenico Gagini on the chapel of St. John Baptist at Genoa. There
is some reason to believe that with Gagini he studied under Brunel-
leschi at Florence, and some works of his would indicate an acquaint-
ance with Donatello. Now and then he was affected by the Gothic
of France, where he sojourned so much. W. Rolfs [1] describes as
Slavic his softness of spirit, his susceptibility to the influences of
others, and his sentiment, but these qualities were also possessed by
some of the contemporary Italians. Those, indeed, who believe Veit
Stoss to have been a Slav find the racial characteristics to be exactly
the opposite.

Among the sculptors of the Quattrocento, Laurana was the linealist.
He models his surfaces very slightly, and obtains his effects through
lovely lines and their contrasts. The lines themselves are reduced to
the lowest number possible. His famous feminine busts are geometri-
cally constructed of fine arrangements of a few verticals, horizontals,
and curves. Since he cares for lines rather than modelling in the
round, he employs in his reliefs the flattest planes. Botticelli has
demonstrated that, by a curious but not inexplicable psychological
phenomenon, the desire for expressiveness seems to go with the temper-
ament of the linealist. So it is that Laurana excels in rendering the
mysterious subtleties of the feminine soul. The persons whom he
represents belong to a race so aristocratic that they are unconscious of
any other kind of existence but their own. With half-closed eyes, as
if lost in day-dreams, they muse away their lives, not in lethargy, but
in the languor of the upper classes. His delicacy and sentiment sug-
gest an analogy to Desiderio, but the Florentine by birth and environ-
ment was naturally more concerned with realistic modelling, more
vigorous, and, in his feminine busts, not content with such simple
means. From a sculptor with an endowment like Laurana's we must
not expect dramatic scenes or ability to group figures; when he at-
tempts these things, he is likely to make a fiasco. We must not cavil
if he does not connect properly the persons in the foreground with the
background or if the proportions of his forms are not always im-
peccable.

There is no certain knowledge of Laurana until the reference to his
presence at Naples in 1458. In the midst of the chaos that surrounds
the attributions on the Arch of Alfonso, Laurana's actual hand may
perhaps be discerned in the timid and dreaming youths, if not in the

[1] W. Rolfs, *Franz Laurana.*

other figures, of the relief on the inner side of one of the lower piers, representing a Neapolitan sovereign surrounded by his court. Probably he also worked in other sections. Having labored for the usurping Aragonese sovereign of Naples, he, strangely enough, betook himself in 1461 to the court of the exiled legitimate monarch, René of Anjou, in southern France. From this visit there are preserved only a series of badly cast medals in as near an approximation to Pisanello's manner as Laurana's temperament permitted. His next period of activity, which began as early as the end of 1467, was in Sicily, where he labored in several towns. His important monumental commission was the façade of the Mastrantonio chapel in S. Francesco, Palermo, very similar to the façade of the Baptist's chapel at Genoa. The panels of the Evangelists in the upper section may have been influenced by Donatello's reliefs in the sacristy of S. Lorenzo. The *bottega* of Gagini perhaps helped in the enterprise, and Laurana himself had already become a great enough personality to have a number of assistants, chief among whom here was PIETRO DI BONTATE of Bergamo. The master executed only the relief of Sts. Jerome and Gregory at the bottom, and one, if not both, of the languid *putti* at the base. He also made several lovely statues of the standing Madonna and Child, in which is embodied the same haunting feminine type that appears in his busts. The drapery is arranged with simple beauty and variety, the rhythm of plaits at the right contrasting pleasantly with the broad, smooth expanse at the left. Some have discerned in these figures the influence of Catalan and French examples; but it is doubtful whether any sculptured Catalan Madonnas were imported into Sicily before Laurana's arrival, and Rolfs has pointed out that Laurana's conception may have been evolved from the precedent of Nino Pisano. The most charming example is in the Church of the Crucifixion at Noto, signed and dated 1471. Domenico Gagini seems to have imitated Laurana's type, and their pupils repeated it again and again until there is scarcely an important Sicilian church without one of these Virgins.

The most characteristic expression of Laurana's genius is his series of feminine busts. Since with a certain idealization he conforms the features to his own standard of womanly beauty and to his geometric treatment of the countenance, all the busts, excepting that of Battista Sforza, look very much alike, and Rolfs considers them all idealized portraits of Beatrice, the second daughter of Ferdinand of Aragon, multiplied by Laurana as decorative objects for private palaces. Others distinguish among them, in addition to Beatrice, Eleanora, the eldest daughter, or another Sicilian Eleanora of Aragon, or a Florentine

lady of the Bardi family, but it is all guesswork. The finest specimens are in the Museum of Palermo (Fig. 96), the Kaiser Friedrich Museum at Berlin (evidently a nuptial bust), the Hofmuseum, Vienna, and (more youthful) the Dreyfus Collection, Paris. The Renaissance has produced no other feminine busts so exquisite. The technical delicacy is indescribable. They are alive, but they live an ethereal and rarefied life, remote from any ordinary existence. The esoteric beauty of the type is accentuated by the slight obliquity of the eyes, the straightness and sharpness of the nose, the fullness of the lips, and the parting of the flatly laid hair in the middle. Directly in connection with the "Beatrice busts" should be mentioned a considerable number of marble masks of the same feminine type, without ears or the upper part of the head, perhaps not made by Laurana until his last sojourn in France. Their purpose is enigmatical. They are not death masks. Were these idealized faces intended to be inserted in sepulchral effigies of cheaper material? Were they merely samples of his art sent to prospective purchasers? One from the series may be seen in the Metropolitan Museum (accession no. 13.9). Two other busts must be included in our survey: that of a youth, possibly Nicola Antonio Speciale, in the Museum of Palermo, probably by Laurana and in the same gentle manner as his feminine portraits; and, certainly by the master, the effigy of Frederick of Urbino's wife, Battista Sforza, in the Bargello. A comparison of the latter with the realistic portrait of the same lady by the painter Piero dei Franceschi, who, of all Italian artists, is most objective, shows how the Dalmatian sculptor interprets his subject in terms of his own personality. The bust of the Sicilian lad's father, the magnanimous Pietro Speciale, in the palace of the family at Palermo, is more doubtfully attributed to Laurana.

From 1472 to 1476 Laurana was in Naples and probably in other Italian cities. The remainder of his life he spent in France. Of the monuments upon which he was employed, most important is the tabernacle of St. Lazarus in the Old Cathedral of Marseilles, where he was assisted by others, especially a sculptor of some merit, TOMMASO MALVITO of Como. The architecture again recalls the Baptist chapel at Genoa. The arrangement of the statuettes seems to have been disturbed, and the extent of Laurana's actual execution is again much debated. The Magdalene, even if by a pupil, retains something of his old charm in feminine figures. It is unfortunate that his last work, the relief of the Via Dolorosa in St. Didier, Avignon, part of a larger monument ordered by René of Anjou, should have been a failure. His one attempt at a complicated dramatic theme, it betrays his inadequacy in this phase of sculpture. Rolfs exonerates him, as usual, by

admitting his participation only in a few parts, but surely the general conception and design are his. The defects that have already been indicated are here present. The composition is painfully symmetrical and crowded; there is little movement, and when he tries it, he is unconvincing. Obviously he has been very much influenced by Franco-Flemish sculpture, especially in the bald realism of the masculine heads, which often assume ugly grimaces. Since he was not at home in this style, he could impart no life to the realism, and created only a set of tragic masks, too large or too small for the bodies. Some of the feminine faces dream softly, as of yore, but they are out of place in their environment. Francesco Laurana, however, was great enough to realize his limitations, and, like Desiderio, he confined himself ordinarily to themes suited to his genius. Within this restricted field, he made himself one of the world's most beloved artists.

CHAPTER XIV

THE RENAISSANCE IN ITALY
THE SIXTEENTH CENTURY

1. INTRODUCTION

One of the factors that operated most powerfully to differentiate the art of the Cinquecento from that of the Quattrocento was the much augmented devotion to the antique, traceable partly to natural development and partly to the excavation of ancient statues. It now definitely disassociated Italian art from the Gothic tradition. The Quattrocento had simply chosen certain elements from the antique and adapted them to its own purposes and civilization; the Cinquecento tended rather to imitate and reproduce the antique. Hitherto the importations from Greece and Rome had not hampered originality; now the desire to be like the ancients crushed the expression of the Italians' own ideas. Sculpture was more vitally affected by antiquarianism than painting, and the esthetic principles of the Quattrocento were abandoned for a return to those of the classic past.

For the realism and individualization of the fifteenth century were partially substituted idealization and generalization. The consequence was one of the most fatal things that can befall art, the desertion of nature as a mistress. The Greeks had always studied nature as a starting-point; the mature Renaissance, desiring an idealized beauty and believing that the Greeks and Romans had here attained the summit of human possibility, was largely content merely to reproduce their achievements. An additional impediment was the fact that the Renaissance was not familiar with the best that they had created but, for the most part, only with the commonplace sculpture of Rome and with copies of Greek sculpture in its decline. Nevertheless, although the men of the sixteenth century were less faithful to nature than those of the fifteenth, they required that their figures should have a closer superficial resemblance to actuality, and they would not brook those eccentricities which we connect with the "primitives." The eccentricities occurred because the Quattrocento was ready to sacrifice the literal fact to other higher purposes, such as expressiveness, the emaciation of asceticism, decoration, the feeling of solidity, and beautiful lines. Although in the greater part of a statue and in the general effect

these earlier masters were sincerer students of nature, they did not shrink, in order to intensify an impression, from emphasizing the furrows of age, the sweetness of a smile, the strain of a muscle, the distortion of an agonized face, above what their models actually revealed to them. Often they consciously neglected careful definition of some details for the sake of concentrating the spectator's attention upon this desired impression. It is this attitude that largely constitutes the "charm of the primitives," and it was because the Cinquecento repudiated it and sought a greater but a false literalness that it ceased to be "primitive." The literalness of the Cinquecento was false because the intervention of Greek and Roman models prejudiced the study of nature. Partly owing to the fact that the ancient works which they imitated had lost their polychromy, the custom became general and, except in isolated instances, has prevailed to the present day, of leaving sculpture uncolored.

The underlying thought, which since the beginnings of Christianity had been the chief concern of the artist, was now largely sacrificed to the cult of the body. One corollary of this change was the increased predilection for the nude, often imbued with a sensuality which had been absent from the Quattrocento and which was now bred by the resuscitated paganism. Another was the choice of the more robust forms of Rome, the artistic remains of which were much more plentiful than those of Greece. Thus a discrepancy between art and actuality was created, for these forms were different from the slighter and more delicate physiques of contemporary Italians. The classical forms had been evolved as suitable to the themes represented by the ancients, but they had little relation to the content of Christianity. They were used more congruously in the mythological and other classical subjects, which now entered upon a prodigious popularity. In such subjects, the forms employed in sacred art were no longer, as in the Quattrocento, naïvely decked out with the attributes of pagan deities, but the ancient forms were revived, and, with the development of a more accurate archaeology, the ancient themes were treated more in the ancient way. The extreme vogue of these themes in a modern civilization involved a certain element of artificiality. A third corollary was a reversion to the classical attitude which exalted the human figure above all other artistic *motifs*. Relief lost the great favor that it had enjoyed, and separate statues in the round gained accordingly. The human figure even became a common decorative element. In general, the exuberant decorative repertoire of the Quattrocento gave way to the plainer and severer details of antiquity. The medieval heritage of foliage, flowers, and fruit was renounced; the arabesque

triumphed, but no longer admitting any play of fantasy, it was frozen into stiffness and formality.

Not only did the artist give up expressing in the features the mentality of the person represented, but he did not infuse his productions, to such a degree, with his own individuality. Hence the frequency with which we must apply the adjectives "cold" and "empty" to the sculpture of this period. The individualism of the Renaissance was now somewhat spent and partially submerged beneath the concurrent phenomenon of humanism.

The simplicity and directness of the Quattrocento succumbed to the grandiose and pompous. There was a bombastic rhetoric of art, as of literature, in the Cinquecento. Through the hard effort of the Quattrocento, art had now attained the full realization of its possibilities and more and more began to be ostentatious of them. The output of Italy grew more and more academic, concerned, not with the expression of ideas or feelings, but with mere technical dexterity. The subject of a piece of sculpture was less important than the execution. It was art for art's sake, with a vengeance, and the result was the loss of "primitive sincerity," that is, the loss of the attitude which sets the intellectual content above the form that clothes it. For the sake of greater accuracy, there began that habit of employing a full-size clay or plaster model in making a stone or marble statue, which has continued in favor ever since. Since artists were now masters of the technical problems that their predecessors had solved, they were obliged to find some further field in which to exert themselves. Neither they nor their patrons were any longer satisfied with mere truth of representation; they craved sensational truth, and the result was that the artists exerted themselves in affected and melodramatic postures. The renunciation of expression through the countenance and the cultivation of ancient impassivity may have helped to induce exaggerated expression through the body, since the sculptor had to find some way to impart his effects. For the altered attitude, the transplantation of the artistic center from Florence to Rome was also responsible. The environment of classical remains stimulated an exaggerated interest in antiquity; and the show and pomp of the papal court, the real capital of the western world, was reflected in taste, both literary and artistic. Such was the temper and such were the characteristics of the new century; and although great masters now and then rose superior to their *milieu*, the period betrayed an unmistakable decadence from the supreme achievements of the Quattrocento. The great local schools of the fifteenth century gradually died out, and the needs of the whole peninsula were principally supplied by sculptors who, though they

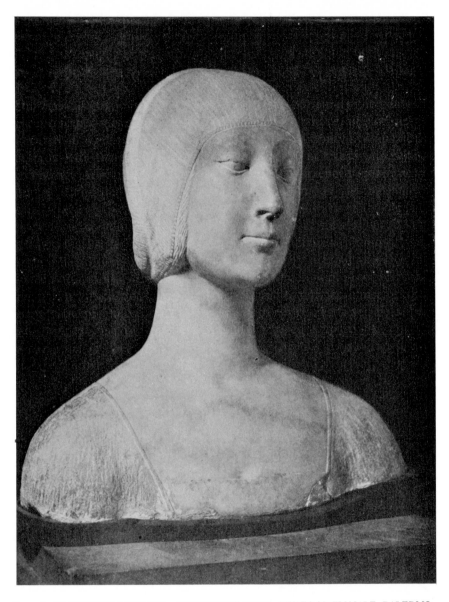

Fig. 96. FRANCESCO LAURANA. "BEATRICE" BUST. MUSEO NAZIONALE, PALERMO

(Photo. Fratelli Alinari)

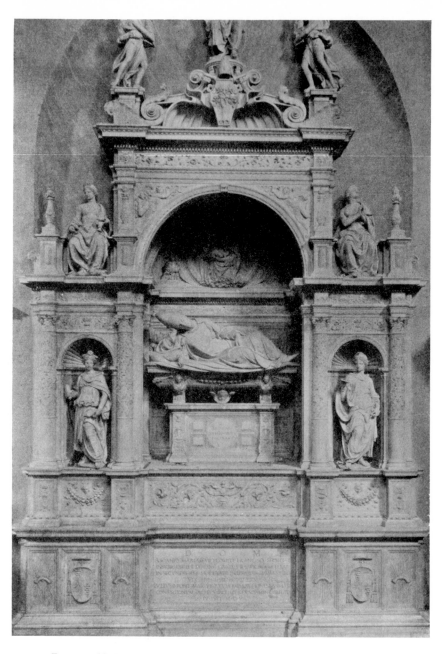

FIG. 97. ANDREA SANSOVINO. TOMB OF ASCANIO MARIA SFORZA.
S. MARIA DEL POPOLO, ROME

were not usually Roman by birth and though they cannot be said to have constituted a Roman school, yet had been trained at Rome and were permeated by the Roman atmosphere.

The neoclassicism of the late eighteenth century reproduced many of the traits of the Cinquecento, such as the inordinate imitation of the antique, the impassivity and vacuity, the devotion to the nude, and the turning to Rome; but it cultivated them in an even more pronounced form and worked them into a much more inflexible system. The Cinquecento, with all its failings, still preserved much of the vitality of the Renaissance and could not be so superciliously oblivious to nature as a Thorvaldsen.

2. THE TRANSITION

The sculptor who perhaps embodied best the transition from one century to the other was Andrea Contucci, called ANDREA SANSOVINO from his little Tuscan birthplace, Monte San Sovino (1460–1529). His early altars in his native town and at Florence contain reminiscences of the style of the fifteenth century, but even here his figures have the more heroic bodies, the cold and expressionless heads, the broader draperies of ancient Roman statues. He unequivocally led the way into the new manner with his two principal monuments, the almost identical tombs of the cardinals Girolamo Basso della Rovere and Ascanio Maria Sforza (Fig. 97) in S. Maria del Popolo, Rome. The sepulchral type established a precedent for the Cinquecento. It is a direct imitation of the triumphal arch. It was probably suggested, especially in its high base, by the Roman tombs of the Quattrocento, which often used lateral niches beside the great central arch. The closest prototype was perhaps the monument of Paul II. But now, with two larger niches, one at each side of the central compartment, and with the dividing columns instead of pilasters, the dependence upon the triumphal arch is more absolute. The Florentine Madonna is still retained in the main tympanum, and the upper section of the edifice is loaded with statues. The restlessness of the Cinquecento, not content, in the effigy of the deceased, with the dignified repose of earlier days, wakes him to a half-reclining posture, derived from some ancient funereal relief, and crosses his legs. With more or less reason the objection has been brought against this class of mausoleum that the prominent lateral niches detract from the interest which should be concentrated upon the central compartment with the dead man's portrait. Of Andrea Sansovino's other works, the Christ of the group of the Baptism over the Gates of Paradise on the Baptistery of Florence is already a classically beautiful nude; the

St. John Baptist, which, with the Virgin, he executed to complete Civitali's series of statues in the chapel of the Genoese cathedral, is marked by the pomposity of the epoch. As a last commission, he planned the decoration of the screen around the Holy House at Loreto, upon which so many Florentines were to labor, and he himself made the relief of the Annunciation and probably that of the Nativity. The former is full of rhetorical agitation.

Another transitional master was GIOVANNI DELLA ROBBIA (1469–1529 or 1530), one of five from Andrea's seven sons to follow the paternal profession. He began, as in his earliest dated work, a Lavabo in S. Maria Novella, Florence, by superimposing a few traits of the Cinquecento upon a close imitation of his father, whom, indeed, he survived by only four or five years. It was the influence of his epoch that made his figures slightly drier and more robust than Andrea's, and led him at times to indulge in somewhat melodramatic gesticulation. He did not model so carefully, and he overloaded his monuments with cumbersome ornament. Most significant, he was less original, not always inventing his own compositions but copying in glazed terracotta those of former masters, especially Verrocchio and, as on the Lavabo, Desiderio. The vogue of the Della Robbia ware had now grown to enormous proportions, but even in the case of Andrea this vogue was synchronous with degeneration, because it encouraged repetition and the artificial production of borders. In order to hasten the manufacture, Giovanni followed his father's bad example of representing large parts of the background by painting instead of modelling, and he thus confused sculpture and painting more than Ghiberti. Even modelled figures or sections of figures he often painted rather than glazed, especially in passages requiring red, which the *bottega* could not obtain in enamel. Since the spirit of the day inculcated the desire for a greater approximation to actuality, he was particularly prone to leave the nude parts unglazed that they might benefit by the more naturalistic tones of painting. He expanded the gamut of colors in glazed terracotta, especially to include dark tones which are not very agreeable in that medium, and he came dangerously near to being garish. He carried the medium into the field of episodic reliefs, for which, because of its simple character, it was not suited. In his maturity, as in the great Assumption of the Campo Santo, Pisa, he evolved a more or less original style, in which the types were to a certain extent distinguished from his father's and the religious feeling was very sincere. A masterpiece that has been connected with his name is the decoration of the portico of the Ospedale del Ceppo at Pistoia. It now seems to be definitely established that he himself

executed at least the five medallions and the four half-medallions containing a series of heraldic escutcheons and three scenes from the life of the Virgin. Six of the reliefs of the frieze representing the Seven Works of Mercy have been attributed to him, but they are more probably the work of another producer of glazed terracotta, Santi Buglioni, who possibly used the design of Niccolò Tribolo. By some critics they have been ascribed to Giovanni's brother, Girolamo, and by others two separate hands have been discerned. The reliefs are very effectively treated as scenes from Italian life, but the naturalism is not developed too far for the medium. There is monumentality in the simple compositions and in the omission of pictorial backgrounds. If the manipulators of the medium had always maintained themselves at this height, their art would not so soon have lapsed back into the industry of which it was only a glorified form. The seventh relief representing the ministration to the thirsty, not in glazed terracotta like the others, but in painted stucco, was added about 1585 apparently by Filippo Paladini.

A third master of the early Cinquecento, BENEDETTO DA ROVEZZANO, born at Pistoia and active at Florence (1474–1556), owed very little to his times and was rather a belated *Quattrocentista*. His production was predominantly decorative. What figures he did are to be found in small reliefs for his highly embellished monuments or in occasional human forms as elements in his decorative repertoire. His St. John for the cathedral of Florence, in the most cramped style of the early fifteenth century but with an empty face of the sixteenth, proves how inadequate he was when he did attempt statuary. His smaller figures, in reliefs or decoration, are rather carelessly modelled relics of the Quattrocento, recalling especially Mino da Fiesole with all his faults. His tombs of Pietro Soderini in the church of the Carmine, Florence, and of Oddo Altoviti in the church of the Apostles employ the sepulchral architecture of the Quattrocento, omitting the figures, except here and there in the ornamentation, and allowing only a sarcophagus without the effigy of the deceased. Fragments of the great reliquary of S. Giovanni Gualberto, which was broken to pieces in 1530 before it was finished, are now in the Bargello. The reliefs are typical of Benedetto's manner. The decorative pieces show how he established an important precedent by increasing his already lavish repertoire with details related to the themes of his monuments, in this instance, objects for ecclesiastical functions. An altar in the chapel of St. Nicholas in the church of the Trinity was perhaps constructed from other fragments of the reliquary. The human forms here used as ornament, like his usual richness of embellishment, suggest a

knowledge of Lombard art and of Amadeo. Benedetto da Rovezzano also did secular decoration, such as the chimney of the Borgherini Palace, now in the Bargello, with a relief of an allegorical subject. The two nude male genii above are much more beautiful bits of modelling than he ordinarily took the pains to achieve. In 1524 he went to work in England, and after his return was prevented by blindness from further production.

3. MICHAEL ANGELO

The greatest sculptor of Europe in the sixteenth century was MICHAEL ANGELO BUONARROTI (1475–1564). His influence was paramount during the epoch, and has continued to be a vital factor in art down to our own day. Although he manifested supreme genius also in poetry, painting, and architecture, he was, by nature, essentially a sculptor, and he conceived and executed his paintings from the sculptor's standpoint. He embodied the characteristics that are observed in the other sculpture of the period, but he transcended them. A passionate enthusiast for the antique, he caught suggestions from classical statues more often than has been surmised, but he absorbed these borrowings and made them a part of his own highly original style. Though he derived his love of the nude from the antique, he did not acquire his anatomy from Greek and Roman figures but from life. His countenances are more impassive than those of the Quattrocento, and in accordance with the tendency of his century he sought expression rather through the body, with the result that his figures are not so strongly individualized as those of the earlier Florentines; but, in distinction from his contemporaries, his own personality was so powerful that it permeated all his productions, and saved them from the prevalent danger of vacuity. It bestowed upon every one of them his own high and peculiar sense of beauty, so that nothing is more unmistakable than a work of Michael Angelo's.

A consideration of his training involves a catalogue of his qualities. Born at the small Tuscan town of Caprese, while his Florentine father was Podestà in the region, he was apprenticed by him, at the age of thirteen, to the painter Ghirlandaio, and his real education as a sculptor did not begin until about three years later, when he entered upon a course of study in the Medici collection of antiques. Under the impetus of the antique he lent his authority to the reaction against the medium of bronze, and turned to the broader and more monumental manner of marble. Nevertheless, through Donatello's most faithful pupil, Bertoldo, the director of this Medici museum, there were perhaps transmitted to Michael Angelo some of Donatello's principles, especially another factor in which he differed from his rivals of the

Cinquecento, the infusion of each piece of sculpture with profound thought or strong passion. It is thus possible to trace a relationship between the two great representatives of their respective centuries. But the master of the early Quattrocento who most influenced him was Jacopo della Quercia, whose works he had opportunity to examine in his sojourns at Bologna. In him he found already his own force of character, the more robust forms, the enthusiasm for the nude, and the resort to contortions for the embodiment of powerful emotion. The dissection of corpses was an important element in his study of the nude, but he did not, like Pollaiuolo, investigate the human body as an end in itself. He learned to know it better than anyone else of his time only for the sake of utilizing its esthetic possibilities and molding it into an instrument for the utterance of his own ideas. Another artist who had the honor of building up his style was the painter of central Italy, Signorelli, who was an innovator in the employment of the nude as a vehicle of expression.

The most vital intellectual influences that played upon him were the contemporary cult of Neoplatonism, the writings of Dante, and the personality of Savonarola. Through Neoplatonism, which is the dominant note of his poems, he justified his devotion to physical beauty as a reflection of divine loveliness, and he learned to infuse his figures with spiritual aspirations. Always an ardent admirer of Dante, whose ship-wrecked life was so similar to his own, he crystallized in marble and fresco the same Prometheus-like rebellion against his own lot and the corruption of his day that Dante consigned to his rough-hewn, sculptural verse. Michael Angelo is the only other Italian upon whom one would dare to say that the mantle of the sovereign poet had fallen. Savonarola's gloomy Philistinism and his outcries against the evils of Italy also found a ready echo in the young man's soul, and later in life Michael Angelo took up and continued the message of this modern Jeremiah.

His career may be divided into five periods. The first may be extended to the date of his employment by Julius II, 1505. His early works not only reflect his education but reveal in embryo the qualities of his maturity. The unfinished relief of a Battle of Centaurs in the Casa Buonarroti, Florence, has the technique of the late classical sarcophagi and was doubtless suggested by Bertoldo's bronze Battle, but it is already impregnated with Michael Angelo's highly individual type of beauty, and the nudes are studied from life. The kneeling angel bearing a candlestick, one of two or three pieces of sculpture that he did about 1495 for the reliquary of St. Dominic at Bologna, is probably inspired by an ancient Victory with a torch, but the bor-

rowings, as usual, have been transformed in the crucible of his imagi-
nation. A comparison with the companion piece by Niccolò da Bari
supplies a concrete instance of the differences between the Quattro-
cento and the Cinquecento.

A significant date in his life was his arrival in 1496 at the city of the
antique, Rome, in connection with a piece of chicanery by which one
of his works was passed off as a genuine old statue and in which he
himself, in all probability, was at least somewhat implicated. In this
environment it was natural that he should first do two mythological
subjects, a Bacchus and a Cupid. The former, in the Bargello, is as
realistic as the Cinquecento ever became. Michael Angelo still so far
belonged to the Quattrocento that he caught his idea of Bacchus, not
from Graeco-Roman statues, which had shown him rather as the god
of life, but from reading about him; and he therefore represented him
as the deity of drunkenness, modelling with unflinching faithfulness
and with supreme but disagreeable skill a besotted youth and giving
him the unsaintly attributes of grapes and a bowl of wine. He had now
evolved his favorite posture in order to rid his bodies of stiffness and
to make them seem livelier. One of the legs is thrown forward, the
shoulders backward, and the head again forward, so that the whole
form inscribes the curve of an S. Regularity is further avoided by
drawing back one side of the body and pushing the other forward.
The attitude betrays a preliminary stage of Michael Angelo's contor-
tions. Some consider the Cupid to be the kneeling Eros in the Vic-
toria and Albert Museum, one of Michael Angelo's rare failures; others
believe it to have been lost and date the example in London at a later
period. In any case further elaborations upon the posture of the
Bacchus have made the attitude of the extant Eros into a definite
contortion. One half of the body is now, in addition, raised high
above the other, and the head is bent violently to the side. We have
here, indeed, a phase of that attitude which was frequently used by
him, which was to become a mania with the sixteenth century after
him, and which is described in Italian by the term *contrapposto* — the
turning of one part of the body in a different direction from another.
The same involution of style — contortion, if you will — may be
discerned in his verse. By a strange anomaly for the Renaissance,
Michael Angelo has represented the god of love, not as an infant, but,
according to Hellenic iconography, as a youth, and he seems to have
taken the position from ancient gems.

An achievement of quite a different sort was the Pietà, begun while
he was at work on the Bacchus and now wretchedly and dishonorably
housed in the first chapel at the right of the entrance of St. Peter's,

Rome. It is perhaps the most marked example of the antique operating in Michael Angelo to smother emotional expression, but his personality and sense of beauty were so keen that the result has not been the emptiness characteristic of the period. The grief has simply been rendered ineffably solemn and noble. The wonderful impression of laxity derived from Christ's body shows the value of the nude as a mode of expression and what it means to obtain one's effects better with the undraped than with the draped form.

He returned to Florence in 1501 to undertake the David which he was commissioned to hew from the block of marble upon which Agostino di Duccio had made some beginnings in 1464. The peculiar shape thus given to the block may have helped to occasion such small defects in proportion as the inordinate size of the right hand and head, although the latter fault is not infrequent with Michael Angelo. But one forgets carping criticism in the general impression, since for the first time he has transferred to a statue the Titanic force of his own nature. It is not its size alone that gives it the right to the epithet of the Giant. Once more Michael Angelo went to ancient art for ideas — in this instance to the two Horse-tamers on the Quirinal. Compared to Verrocchio's or even Donatello's David, Michael Angelo's is classic and generalized; but compared to the sculpture of his own day, it is individualized and possesses something of the profound thought of Donatello's St. George. The face has the tragic intensity which appears in almost all of his works and for the imparting of which he later resorted also to contortions. The statue is now in the Academy of Florence, where several of his productions have been gathered. From the end of the first period come also four Madonnas. Two of them, reliefs, the Madonna of the Steps in the Casa Buonarroti (Fig. 98) and the example of the London Academy, hark back to the Quattrocento, the former in the use of Donatello's *rilievo schiacciato*, the latter in a playfulness like Desiderio's; and yet the forms are already in the characteristic heroic manner of the Sistine ceiling. In the lovely *tondo* of the Bargello, the tendency towards the powerful and majestic is extended to the broad and simple sweeps of drapery, and the group in Notre Dame at Bruges is merely a translation of this style into detached figures in the round.

The second period (1505–1512) was chiefly occupied by the painting of the Sistine ceiling, but the so-called Tragedy of the Tomb of Julius II then began, and continued until the latter part of his life. The third period, the pontificate of Leo X (1513–1521), was a time of disappointment for Michael Angelo, because the Medicean pope could not, like the military Julius II, appreciate his strength, and preferred

the grace of Raphael. During these years the master devoted himself principally to the papal tomb. When Julius first planned the monument as one of the wonders of the world, Michael Angelo's great mind conceived the superhuman scheme of a separate temple in the midst of St. Peter's, but Julius soon desisted from the enterprise and thus contributed to the embitterment of the artist's life. In 1513, after the pontiff's death, Michael Angelo was allowed to ideate a second, less pretentious plan, a three-sided structure against the wall, adorned with forty statues. The sepulchral type was derived from the triumphal arch, but the central compartment was to be elevated to give it the prominence that is lacking in Andrea Sansovino's mausoleums. Around the base were to be a series of bound and writhing captives, symbolizing the Neoplatonic concept of the imprisonment of man's soul in an earthly body or the fettering of the arts by the death of Julius, but also referring, for the master himself, to the fate that ought to descend upon the foreigners, the *barbari*, who were then seeking to subjugate the peninsula. In the niches were to be angels or Victories crushing barbarians under their feet. Above in the central arch, angels were to lift the effigy from the sarcophagus at the feet of the Virgin and Child. At the sides, in this second stage, were to be seated Moses and Paul, typifying respectively the Pope's military and intellectual abilities, and Rachel and Leah, typifying respectively the contemplative and active aspects of his life. Many things conspired, however, to thwart the realization of this plan, the scope of the monument was constantly reduced, and the work dragged on for thirty years more until the tragedy, in its last sordid act, produced in S. Pietro in Vincoli, Rome, a mere shadow of what Michael Angelo had intended, only the lower part of which recalls in any way the ideas of 1513.

On the tomb as it now stands, the Moses alone is wholly by the master himself, a statue which he has so infused with his own strong will and fierceness that it is one of the most terrifying pieces of sculpture in the world. Michael Angelo was not embodying here, as on the Sistine ceiling, his own anguish but rather his own righteous wrath. He obtained his effect of terror partly by the tense moment that he chose, representing Moses as about to rise from his seat and wreak his stern indignation upon his followers. Several other statues, originally meant for the tomb, are scattered in different places, and, like the Moses, reveal Michael Angelo's style in its full development. Two Captives are in the Louvre. In both of them the contortions are employed, as in all of his works henceforth, to express his three-fold sorrow at the political degradation of Italy, at the corruption of religion, and at the disillusionments of his own life. The straining

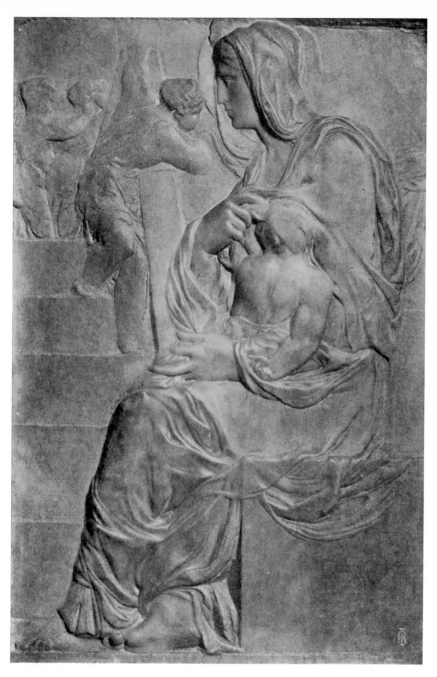

Fig. 98. MICHAEL ANGELO. MADONNA OF THE STEPS.
CASA BUONARROTI, FLORENCE

(Photo. Fratelli Alinari)

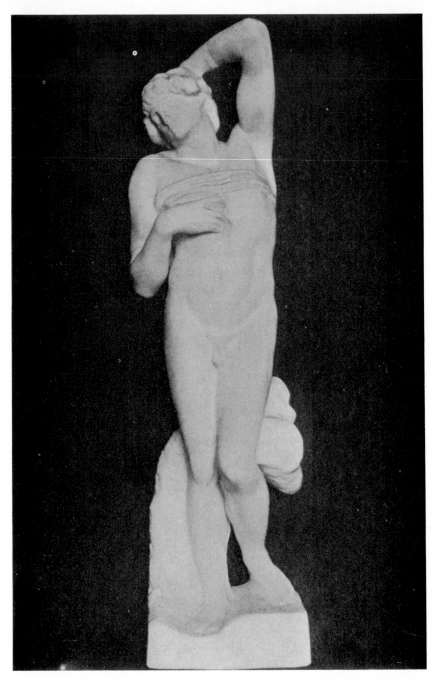

FIG. 99. MICHAEL ANGELO. SLEEPING CAPTIVE. LOUVRE, PARIS

forms bespeak also the constant struggle within himself between his fervent Christianity and his pagan love of physical beauty, which, with all his Neoplatonism, he could not quite delude himself into pardoning. The contortions had now received the approval of the antique by the discovery of the Laocoon, which he was the first to see after its excavation in 1506 and parts of which he often used for suggestions. The Sleeping Captive (Fig. 99) belongs to the same glorious race as the *Ignudi* of the Sistine Chapel. The Heroic Captive, perhaps more than any other creation of his, errs in that excessive muscularity that was to become a disease among his imitators. Four other Captives, only just begun, are now in the Florentine Academy. The group of Victory overpowering an old man, in the Bargello, was probably a part of the sepulchre, but a masculine conqueror was substituted for the feminine. Both the Victory and the Heroic Captive are excellent instances of *contrapposto*.

His fourth period was the pontificate of another Medicean pope, Clement VII (1523–1534), when the awful misfortunes of Italy, culminating in the sack of Rome and the extinction of Florentine freedom, found expression in the tombs of the Medici at S. Lorenzo, Florence. The enterprise had been conceived at the end of Leo X's reign, it had lapsed under the reactionary Hadrian VI, and was now resumed. Michael Angelo was to build a second sacristy to the church to contain the monuments of several members of the family. He again first ideated the commission on a most magnificent scale, but in the end he was obliged to satisfy himself with the decoration of the sacristy in the form of a chapel, including the tombs only of Leo's brother, Giuliano, Duke of Nemours, and his nephew, Lorenzo, Duke of Urbino. The monuments of the Dukes were placed at the sides, an altar at the front, and a Madonna between Sts. Cosmas and Damian[1] at the back. The new type of sepulchre represented by the two similar tombs, was to have a long history in the sixteenth and seventeenth centuries. The idealized portrait statue sits in an architectural façade; beneath is the sarcophagus surmounted by two reclining allegorical figures, for Giuliano, Day and Night, for Lorenzo, Dawn and Sunset (Fig. 100). Below were to be recumbent river-gods, imitated from the statues of the Nile and Tiber that had recently come to light, and although they were never executed, the posture of the allegorical figures may be influenced by these antiques. Michael Angelo may have taken the bare idea of the allegories from classical pediments, in which the rising sun and setting moon were sometimes introduced, lying at the angles. The problem of their significance has given rise to many

[1] The statues of the two saints were executed by pupils.

theories. Are they merely the four parts of the day, which, together with the rivers of the earth, are invoked in a hymn by St. Ambrose for the feast of the titular saint, Lawrence? Do they symbolize the universe, embodied in its different hours, mourning for the deceased? Less concretely, do the contrasting Day and Night represent the frank but melancholy nature of Giuliano, and the dim, uncertain periods of the day the treacherous character of Lorenzo? In any case, their gloom-sunken and agonized forms incarnate, more emphatically than ever before, the religious, patriotic, and personal depression of the master. He has definitely told us, in a quatrain, that this is at least one of the meanings of the Night. In addition to expression through the bodies, he has set upon the features of Dawn an unspeakable woe. He has utilized *contrapposto* even in the figure of the Child with the Madonna at the back of the chapel.

The fact that the tombs were never quite completed raises the question as to why Michael Angelo left so many of his works unfinished. Some have believed that such was his definite purpose and that he sought thereby to gain a mystical effect. The device has been adopted by certain modern sculptors, notably Rodin, and it has provoked a superfluity of such subjects as primitive man emerging from the rock, *etc*. With the great Italian, however, it was probably not conscious, for his troubled career accounts sufficiently for the abandonment of many of his commissions, once begun, and he was of a restless temperament that was always pressing on to vast new undertakings. As Symonds has well observed, some of his most celebrated creations are highly finished. Yet perhaps he was not always sorry to be forced to leave some of them in an inchoate condition, since with his Neoplatonic proclivities he must have valued the impression of mysticism.

During his fifth and last period (1534–1564), when Christendom was ruled by the popes of the Catholic Reaction, he devoted himself chiefly to architecture. The characteristic sculptural production of this time is the unfinished Pietà, intended for his own tomb but now behind the high altar in the cathedral of Florence. Michael Angelo broke it to pieces, but his apprentice, Calcagni, gathered the fragments and himself did the Magdalene. In contrast to the simplicity and freshness of his earlier rendition of the theme, the exhausted forms are bowed and bent under the weight of grief and suffering, embodying the old man's settled melancholy. The group has the fervid religious sentiment of the Counter Reformation, which Michael Angelo's virile nature here saved from degenerating into its usual hysteria.

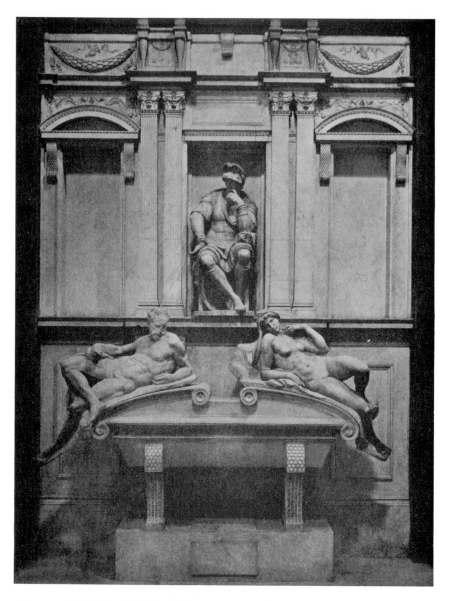

FIG. 100. **MICHAEL ANGELO. TOMB OF DUKE OF URBINO. SECOND SACRISTY,**
S. LORENZO, FLORENCE

(Photo. Fratelli Alinari)

Fig. 101. MONTORSOLI. FOUNTAIN. PIAZZA DEL DUOMO, MESSINA

(Photo, Fratelli Alinari)

4. THE COLOSSAL TENDENCY

In the rest of the vast sculptural output of Italy during the sixteenth century, two fairly well defined tendencies may be discerned: that which, preserving the outer shell but not the spiritual content of Michael Angelo, cultivated the massive and muscular, and usually chose the medium of marble; and that which retained more of the old Florentine feeling for grace and delicacy, and naturally preferred bronze. The majority of masters produced in both styles, but it is ordinarily possible to distinguish a more pronounced leaning in one direction or the other. The exponents of the former were likely to exaggerate it into a colossal vacuity, while the others transformed grace into mannered elegance. It still continued to be true that the greatest sculptors were Florentines, either by birth or artistic adoption.

Of the colossal tendency, one of the most distinguished representatives was Michael Angelo's best pupil in sculpture, the Servite monk, Giovanni Angelo Montorsoli (1507–1563). The great master's peculiarities, especially his contortions, are everywhere evident in Montorsoli's production, but they are not developed to that degree of extravagance which is customary among Buonarroti's imitators. The St. Cosmas that he did to accompany Michael Angelo's Madonna at the back of the Medici Sacristy is a very creditable piece of work. He is chiefly remembered for his two fountains at Messina (both slightly injured by the earthquake), in which he followed the precedent established for the fountains of the Cinquecento by the Florentine sculptor and landscape architect, Niccolò Tribolo (1485–1550). The example on the littoral consists of a colossal Neptune on a pedestal, surrounded at a lower level, in the basin, by marine deities and *motifs*. The second fountain (Fig. 101), in the square in front of the cathedral, is far more elaborate, constructed, in the manner of Tribolo, of three basins, one above the other, and lavishly decorated with aquatic and mythological figures and reliefs. The central Christ of an altar that he did at the end of his life in S. Maria dei Servi, Bologna, is a definitive instance of the massive and muscular style applied to a religious subject.

The worst personification of the colossal tendency was Baccio Bandinelli (1493–1560), who seems to have been as ugly in character as he was in his art, making enemies of practically every other artist of his day, especially Michael Angelo and Benvenuto Cellini. Like so many objects of art and literature, his works, though possessing little intrinsic value, are important because the traits of the

period are exhibited by them in an exaggerated form and thus may
be more readily studied than in better productions. Bandinelli's
style may be summed up in the adjective, "academic." He did not
have, like Michael Angelo, any great concepts to embody, he lacked
even the sensuality of Jacopo Sansovino. He was not interested in the
end but in the technical means. The devotion to the antique and the
cult of the colossal were tolerable in Michael Angelo because infused
with his Titanic thoughts; in Bandinelli they are impossible because
unrelieved. His final condemnation, however, is that he did not
possess the technical skill on which he prided himself.

A comparison of his first important statue, a St. Peter for the cathe-
dral of Florence, with the series of Prophets and Apostles by Dona-
tello and others in the early Quattrocento, which it imitates, pain-
fully illustrates the loss of vigor and individualization. The sculptor
is no longer able to breathe any of his own personality into the work.
The most notorious example of all his vices is the group of Hercules
and Cacus at a corner of the Palazzo Vecchio. In a famous passage
of the *Autobiography* Benvenuto Cellini flays its technical defects so
unmercifully that he leaves nothing further to be said. Bandinelli's
bust of Cosimo I in the Bargello, however, is simpler, nobler, and less
forced than Cellini's, and his portrait of himself in relief in the same
Museum is perhaps his masterpiece. In the similar tombs of the Med-
ici popes, Leo X and Clement VII, in S. Maria sopra Minerva at Rome,
he carried still farther the archaizing tendency that Andrea Sansovino
introduced into the sepulchral type. Having abandoned altogether
any reminiscence of the early Florentine mausoleums, he reproduced
exactly the triumphal arch, and abjured the luxuriance of the deco-
rative repertoire of the Quattrocento, which Sansovino had retained.
The seated effigy, in both instances executed by another sculptor, is
placed under the central arch, and the statue of a saint is set in each
of the lateral niches. The attic contains reliefs from the lives of the
pope and saints represented below. His last labors were again in the
cathedral of Florence. The reliefs of Prophets and Apostles for the
choir-screen are the most frankly academic works of his career, being
little more than studies of various postures and various dispositions of
the drapery. They resemble drawings from a sketch-book, and con-
sidered as such, are rather good, indeed so good that they are very
generally thought to have been principally executed by his pupil,
Giovanni dell' Opera. One can easily sympathize with the authorities
who in 1722, because of the nudities, decreed the dismantlement of his
sculptures upon the high altar, now dispersed in several places at
Florence. The Adam and Eve, in the Bargello, are, indeed, rather ex-

treme for a church, being treated, without sensuality, to be sure, but yet once more in the perfectly unblushing manner of academic studies. Bandinelli's misfortune was that he belonged too completely to his times and that these times happened to be decadent. Had he lived in a better period, he might have left as distinguished a memory as Benedetto da Maiano or Matteo Civitali.

5. THE TENDENCY TO ELEGANCE

The first great representative of the other tendency to a mannered grace was the Florentine architect and sculptor, Jacopo Tatti (1486–1570), called JACOPO SANSOVINO from his master Andrea. Marcel Reymond has contrasted his style with that of Michael Angelo, describing the former as feminine and the latter as masculine. Much the same difference, indeed, exists between these two exponents of the Cinquecento as between Ghiberti and Jacopo della Quercia at the beginning of the Quattrocento. Lacking Michael Angelo's powerful personality, Jacopo Sansovino is emptier and imitates the antique in a more servile fashion, preferring naturally the Praxitelean standard of slim elegance to the sturdiness of old Rome. He has much of Ghiberti's exquisite grace, but he is likely to exaggerate it into affectation. He has much of Ghiberti's technical supremacy, but he is likely to bestow upon it the tone of a cold, academic perfection. He does not transfigure his grace, like Ghiberti and the Quattrocento, with nobility of thought. Under the spell of the antique, his interest is almost solely in the elegant bodies, and upon these he is prone to impress the sensuality of the epoch.

All these characteristics and his divergence from Michael Angelo are illustrated by a comparison of the most renowned work of his early period at Florence, the Bacchus of the Bargello, with Buonarroti's treatment of the same theme. Sansovino conforms his conception more to ancient standards. Even though Michael Angelo thought that the subject of the patron of wine required emphasis upon the softness of indulgence, he gave his figure a force and a muscularity far greater than Sansovino's, whose apparent aim, nevertheless, was to represent Bacchus as the god of life.

Having found some employment at Rome, chiefly architectural, after 1527 he definitely settled at Venice for the rest of his life. The sensuality of his art well fitted him to be the principal sculptural exponent of the paganish culture that was more gloriously embodied in paint by his friend, Titian. His most notable plastic achievement in this new environment was the embellishment of one façade of the Loggetta that he had constructed around the base of the Campanile

with four mythological bronze statues, emblematic of the civic virtues of the Republic. The Apollo (Fig. 102) is obviously derived from the statue of the Belvedere. For the interior of the Loggetta he also did in terracotta one of his Madonnas. In the groups of the Virgin and Child, he had to encounter the insoluble dilemma of combining tender loveliness, towards which his temperament inclined him, with the cold stateliness imposed upon him by the antique. The most that one can say is that the results are better than could have been hoped. The tenderest part in the group of the Loggetta, the head of the little St. John, was lost in the collapse of the Campanile. Despite his technical perfection and despite his beauty of decorative *motifs*, which again recall Ghiberti, his cult of the graceful instead of the real and his theatricality caused him to fail in dramatic scenes such as the episodes from the life of Christ on the bronze door of the sacristy of St. Mark's, or worse still, the six miracles of the Evangelist on the iconostasis. When he used marble for the dramatic in the relief representing St. Anthony's resuscitation of a drowned woman in the chapel of St. Anthony in S. Antonio, Padua, the medium did not provoke mannered elegance so much as imitation of the antique. The young men are Roman athletes, the women Roman matrons. In the one figure where he seeks to any degree expression through the features, the kneeling mother (?), the effect is too forced and obvious. The bodies, however, whether nude or revealed by the draperies, have great beauty, and one cannot help admiring in the whole panel a cold and truly "statuesque" loveliness that Jacopo Sansovino not seldom attained.

In this instance, as in some others, he turned rather to the style of his rival, whom he disliked, Michael Angelo. He was guilty of two pitifully futile efforts in the colossal, the Mars and Neptune at the top of the stairway in the court of the Ducal Palace. A much more successful monumental work, free from his usual mannerisms, is the noble bronze memorial to Thomas of Ravenna over the portal of S. Giuliano, Venice. To the same style, the severe impressiveness of which is one of the compensations for the inordinate devotion to Roman antiquity, belongs the tomb of the Doge Francesco Venier in S. Salvatore. It was evolved upon the precedent set in the monument of Andrea Vendramin, but constitutes a more strictly archaeological reproduction of the triumphal arch than either this or Andrea Sansovino's sepulchres.

Among the pupils of Sansovino at Venice, the most notable was ALESSANDRO VITTORIA of Trent (1524 or 1525–1608). His religious and mythological statues are excellent technical performances with the mannered twists and gestures of his master, but with a

fondness for more movement that makes his sculpture transitional to the baroque. He has a particular addiction to *contrapposto*. His mediums were usually marble or stucco, and his forms are likely to be somewhat more robust than Sansovino's. Typical are: the altar of Sts. Anthony, Roch, and Sebastian in S. Francesco della Vigna, Venice; the St. Jerome in the church of the Frari, already baroque in its naturalistic treatment of the aged nude; the stucco figures in the vaulting over the stairway in Sansovino's Library, and over the Scala d'Oro in the Ducal Palace; the Fame at the apex and the two supporting Slaves at the left on the tomb of Alessandro Contarini in S. Antonio, Padua; and the four effigies of the Seasons in the Palazzo Pisani at Montagnana. But Alessandro Vittoria had another, better style. He created in marble, terracotta, and bronze a splendid series of unaffected, realistic busts that, recalling the best tradition of the Quattrocento, are happily free from the vacuity and pompousness of his time and again prophesy the baroque faithfulness to nature in such themes: witness the portraits of Pietro Zeno and Apollonio Massa in the library of the Seminario at Venice, of Domenico and Francesco Duodo in the Accademia, of Lorenzo Cappello in the Museum of Trent, and of Ottaviano Grimani in the Kaiser Friedrich Museum, Berlin.

The Veronese GIROLAMO CAMPAGNA (1549 or 1550–1623 ?), a pupil of another of Sansovino's followers, Danese Cattaneo, maintained the Florentine master's tradition at Venice, unimpaired, to a still later date. Characteristic specimens of his work are: a Pietà in S. Giuliano; the high altarpiece of S. Giorgio Maggiore, consisting of a bronze group of the Evangelists supporting the globe upon which stands God the Father and in front of which are the Crucifix and the dove of the Holy Spirit; and in the chapel of the Saint in S. Antonio, Padua, the relief of the resurrection of a youth.

The persistence of the old Florentine tradition of delicacy in BENVENUTO CELLINI (1500–1572) is apparent in the fact that he began as a goldsmith and in essence always so remained. Sculpture in the large he did not take up until the age of forty in France. He executed few great plastic works, and were it not for his persuasive boastfulness and for the charm with which he invests them by his descriptions in the *Autobiography*, as a monumental sculptor he would be comparatively unimportant. When he kept within the limits of the goldsmith's trade, he was a distinguished master, though affected by the bad taste of his day. He could preserve the proportions and model delightfully in small figures, whereas in large statues he failed. Benvenuto made his name so famous by his literary achievement that

directors of museums and owners of private collections have been freer than usual in the ascription to him of articles in their possession; as a matter of fact, very few are of unquestionable authenticity.

The salt-cellar of Francis I, now in the Imperial Treasury, Vienna, is the only absolutely authentic piece of the goldsmith's art. Neptune and Venus sit opposite each other in difficult postures, a small triumphal arch affords the aperture for the emission of the salt, and the base of the salt-cellar and the top of the arch are covered with nudes. It is an epitome of Benvenuto's style. First, it is highly ornate. Second, it prefers the nude human figure as a decorative *motif*. Third, the triumphal arch and the frigidity of the figures embody the increased enthusiasm for the antique.

Of several pieces of sculpture that he states to have been done in France, only one is extant, the bronze recumbent Nymph destined for the tympanum of a portal at Fontainebleau and now in the Louvre. The nude is too much attenuated, though this is a pleasant vice as a relief from the swollen forms in which the exponents of the colossal revelled. As usual in Benvenuto's larger figures, there are anatomical defects, such as the masculine chest, to which breasts have been attached, and the awkward bend of the body. The breasts themselves, the abdomen, the arms, and the hands, however, exhibit the goldsmith's dexterity in details. The skilful and charming animals continue the tradition of the great bronze-workers of the previous century, such as Ghiberti and Pisanello. In the same fine manner is the bronze plaque of a hound in the Bargello, vibrant with life and reflecting a keen love and knowledge of dogs.

His most celebrated statue is the Perseus, begun in 1545 on his return to Florence from France, the interest in which is piqued by his wonderful account of its no less than miraculous casting. In the first rough little sketch of wax in the Bargello, by a supreme effort of genius he succeeded in shuffling off the ponderous forms and pompous poses of his contemporaries, and he returned to the forceful simplicity of the Quattrocento. The body, almost slight enough to have pleased Donatello, is instinct with vigor and the very spirit of youth. He has caught in the legs that paradoxical union of grace and awkwardness so often observed in adolescence. If he had completed the statue in this guise, it alone would have sufficed to have preserved for him the prerogative of a great sculptor. Another sketch in the Bargello, a bronze statuette, is not so graceful, but it is better than the finished work in the Loggia dei Lanzi. In this he unfortunately abandoned his first ideas and created one of the popular Herculean forms, frittering away his energy upon a study of muscles. Again, there are anatomi-

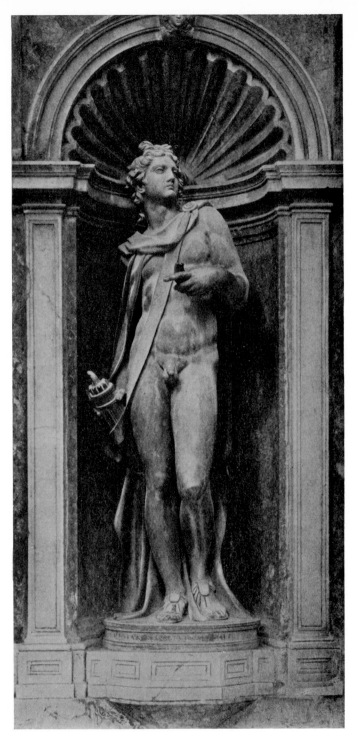

FIG. 102. JACOPO SANSOVINO. APOLLO. LOGGETTA OF
CAMPANILE, VENICE

(Photo. Fratelli Alinari)

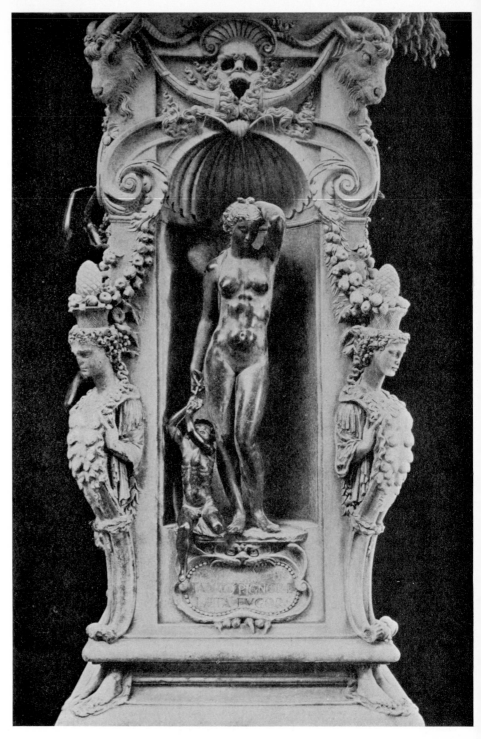

FIG. 103. BENVENUTO CELLINI. DANAE, ON THE BASE OF THE STATUE OF PERSEUS, LOGGIA DEI LANZI, FLORENCE

(Photo. Fratelli Alinari)

cal shortcomings, and the final result is cold enough to leave us un-
moved. One of Benvenuto's chief ambitions in the Perseus was to
refute Bandinelli's accusation that he could not work in the large, but
in point of fact the statuettes on the ornate base are far superior. The
Danae (Fig. 103) is one of the loveliest feminine forms of all art. The
curious Jupiter alone has the more mannered elegance that we have
faulted in Jacopo Sansovino. The relief of Andromeda's deliverance,
now transported from the base to the Bargello, is full of every kind
of *tour de force*, indicative of the technical ostentation that marks the
age and especially Benvenuto. The postures, particularly in the group
at the right, are not the natural expressions of emotion in the persons
concerned, but are perfunctorily and melodramatically devised by the
master himself.

He was not a great portraitist. Of his two authentic bronze busts,
that of Cosimo I in the Bargello, though evidently a very faithful
superficial likeness, illustrates painfully the change for the worse that
had taken place in a century. The powerful individuality that almost
seems to speak in a bust of the Quattrocento is gone. The goldsmith's
elaboration of the armor is pleasantly absent from the less theatrical
portrait of the merchant-connoisseur, Bindo Altoviti, at Fenway
Court, Boston. Benvenuto's medals are inferior, partly because the
new process of striking from a die was not yet well understood.

Two sculptors of the Cinquecento, Ammanati and Giovanni Bo-
logna, combined in themselves both the colossal and graceful phenom-
ena, but each inclined to the latter. The Florentine, BARTOLOMMEO
AMMANATI (1511-1592), perhaps derived his two manners from his
study under Jacopo Sansovino at Venice. He has left some early
works at Padua, but his most celebrated monument is the foun-
tain in the Piazza della Signoria, Florence, the commission for which
he obtained only after winning a contest that created the greatest
stir. It unites both manners. The huge marble Neptune at the
center, accompanied by three smaller Tritons and drawn through the
water by four bronze horses, though well modelled, is vapid, and the
unfortunate turn of the head creates the disagreeable affectation of
Giovanni Bologna's *colossi*. The four marine deities elevated at the
corners of the basin and the pairs of satyrs that sit at the sides of each
on the edge of the basin, all in bronze, are slimmer and more elegant.
The desire for elegance has provoked in the two marine goddesses and
in the youthful god excessively long necks and small heads, and the
imitation of the antique has resulted in a hopelessly vacant stare. The
satyrs, however, are masterpieces, animated with as much expression
as the sixteenth century ever allowed and brilliantly varied in contor-

tions that make them the lesser counterparts of the Nudes on the
Sistine ceiling. Ammanati also executed the congenial subject of
Hercules and Antaeus for the top of Tribolo's fountain in the Villa di
Castello near Florence.

The last great sculptor of the Italian Renaissance proper was a
Fleming of Douai, Jean de Boulogne, translated by the Italians,
GIOVANNI BOLOGNA (between 1525 and 1529–1608). He was one
of many distinguished Flemish sculptors who became naturalized
Italians at the end of the sixteenth and in the seventeenth centuries,
and he signalized the preëminence that Flemish sculpture was to en-
joy for a time during the late Renaissance. By his Belgian master,
Jacques du Broeucq, he was inspired to study at Rome, probably in
1551. Both in his native land and at Rome he acquired the character-
istic style of the Cinquecento. Like all others he was influenced by
Michael Angelo, especially in contortions of the nude, but he derived
from him the less excellent manner of Buonarroti's old age. Later in
life, as a companion piece to Michael Angelo's Victory in the Bargello,
he did the Virtue overcoming Vice now also in the same Museum; but
he exaggerated the writhings, failed to imbue them with meaning, and
proved himself so far ignorant of the heroic possibilities which the
Greeks, Michael Angelo, and Tintoret realized in the feminine form
that the Virtue is little more than a mountain of flesh. Passing
through Florence on his way home after two years of study, he found
it to his advantage to remain, and henceforth was, to all intents and
purposes, an Italian master.

He was more in sympathy with the graceful tendency; and when
he attempted colossal figures, he endowed them with a factitious ele-
gance which is utterly incongruous to the huge stature and creates
the same unfortunate impression as when we see in real life effeminacy
united to a large body. He was able, however, to model a massive
form with more correctness than Bandinelli or others usually at-
tained. The most curious instance is the crouching colossus, about
seventy feet high, of Jupiter Pluvialis or the personification of the
Apennines, set up beside a pond in the Villa Pratolino near Florence.
In general he possessed a high degree of technical skill, most brilliantly
illustrated by his best known work, the bronze of the flying Mercury
in the Bargello. A miracle of anatomy and movement, it interests the
spectator less than the achievements of the Middle Ages or Quattro-
cento, because it is empty and enshrines no great spiritual conception.

The sixteenth century was an age of fountains, and Giovanni Bo-
logna, having attracted attention by his model in the contest for the
fountain of the Piazza della Signoria, Florence, began his career in this

phase of production and labored in the course of his life upon several notable specimens. The earliest (1563–1567), erected in the central square of Bologna, comprises a base, surrounded by *putti* with dolphins and Nereids pressing the water from their breasts, and surmounted by a statue of Neptune. It belongs to the master's colossal manner, as does also the fountain of the Isolotto in the Boboli Gardens, Florence, where, as often, Giovanni Bologna carried out Tribolo's designs. Here Oceanus stands at the top; beneath on consoles are the three personifications of the rivers Ganges, Nile, and Euphrates; and the pedestal is adorned with appropriate mythological reliefs. Giovanni Bologna also did more work in the Boboli Gardens. The Venus of a fountain in the Grotto Buontalenti of these Gardens and a similar Venus over a fountain in the gardens of the Villa della Petraia belong to his other style in which, with exquisite grace but with some affectation, he maintained, like Cellini, the old Florentine tradition. The rest of the latter fountain was executed by Tribolo; according to the bizarre exits that the sixteenth century chose for such purposes, the water issues from the end of the lock of hair that Venus wrings. Another of Giovanni Bologna's many feminine nudes, which partakes of both his manners, is the figure of Architecture in the Bargello. It has a double interest. The artificial head-dress and the addition of a necklace create an unpleasant effect of nakedness which is consistent with the sensuality often betrayed by the master but which could have been avoided if the nude had been left in its native simplicity. Secondly, it is an ill-omened work, for it initiates that succession of nude allegorical females, representing Industry, Liberty, or the like, which has ended so ignominiously in our own day with what may be stigmatized as "Exposition Art." Personifications of the Virtues and Sciences had, of course, existed before, but they had been infused with the sculptor's personality. This is perhaps the first of those pieces of vapidity that find their most congenial habitat in World's Fairs but alas! are also allowed to disfigure our public buildings.

The most avowedly academic productions of Giovanni Bologna are the Rape of the Sabine Woman (Fig. 104) and the Hercules and Nessus, both in the Loggia dei Lanzi. Viewed as merely academic, the former is one of the greatest feats of all sculpture. It is planned to give three kinds of nudes, the feminine, the youthful masculine, and the more mature masculine, in as widely varied contortions as possible. The gracefully undulating lines by which one body is made to rise out of the other without any perceptible interruption creates a feeling of coursing movement, and the group may be inspected from any point with equal effectiveness. The relief beneath has groups as clever, and

is a *tour de force* in perspective. The struggle of Hercules and Nessus is an academic experiment in a different line — in the forceful and brutal. The more skilful such things are, the more intolerable; and the highest praise that one can bestow upon this work is to say that it is most intolerable. A concrete instance may be seen in the cruelly real and muscular arms of the Nessus, and there are many such ghastly tricks as the imbedding of the centaur's bestial hand in the flesh of his opponent's chest.

Some of Giovanni Bologna's sacred productions, such as the Risen Christ of an altar in the cathedral of Lucca, have the theatrical piety of the Counter Reformation; but many of them reveal an unexpectedly sincere and virile religious sense, only slightly affected by mawkish sentiment, mannered elegance, and other epidemic vices. The best examples are the reliefs from the Passion, the Virtues, and the angels done in bronze for the Cappella Grimaldi at Genoa and now in the University of that town. The reliefs from the Passion do not possess the Gothic subtlety with which Ghiberti treated these subjects nor the wild emotion of Donatello's pulpits; but Giovanni Bologna here attained a strange beauty all his own, derived largely from the classic veil that he cast over the sacred story. He succeeded, where so many failed, in accommodating classic principles, without any great incongruity, to the Christian themes. Like Raphael he caught and crystallized a happy, evanescent moment when the two civilizations almost blended. He followed Raphael also in sometimes employing severe and impressive architectural backgrounds to increase the solemnity of the scenes. The panel of the Flagellation is perhaps the best. Of the Virtues, the Hope and Charity are astonishingly sober and restrained. Both they and the *putti*, in recalling distantly Donatello, again demonstrate the persistent vitality of the old bronze tradition of Florence.

As his religious subjects are his best works, so his portraits are his worst. He received commissions for equestrian statues of Cosimo I and Ferdinand I of Florence, Henry IV of France, and Philip III of Spain; but he finished only the first in the Piazza della Signoria and merely began the three others. The statue of the Duke Cosimo himself would be less acceptable, if the horse were not even more characterless. The anatomy of the animal is not studied from nature but from the monument of Marcus Aurelius. Together with the steeds of his pupils, it set the precedent for the fat and stocky horses of the baroque. No better proof of the decline into which the sculpture of the Renaissance had lapsed could be desired than that afforded by a comparison of this lifeless and frigid group with the Colleoni.

One of Giovanni Bologna's chief activities was the manufacture of small bronzes. Some of these, according to the common practice, were merely copies from the antique. Of his original creations, a part are executed in his coldly classical style. Others, and these the more attractive, belong to his gracefully mannered phase, especially an exquisite series of bathing women.

6. THE TRANSITION TO THE BAROQUE

Of Giovanni Bologna's three principal pupils, who spread his art to other districts of Europe, Pietro Tacca, Pierre Franqueville, and Adriaen de Vries, the last two were active in France and Germany respectively, and will be considered in the discussion of those countries' sculpture. Both Franqueville and Tacca completed commissions that had been assigned to Giovanni Bologna. PIETRO TACCA (1577–1650), for instance, finished the equestrian statues of Ferdinand I in the Piazza dell' Annunziata, Florence, of Philip III in the Plaza Mayor at Madrid, and of Henry IV at Paris (destroyed in the Revolution). The two extant specimens are uninspired in comparison with Tacca's original equestrian statue, the Philip IV in the Plaza de Oriente at Madrid, perhaps the first work of this sort in which the horse rears upon his hind legs. The idea may have come from some engraving or lingering tradition of Leonardo da Vinci's destroyed equestrian figure of Francesco Sforza at Milan, or from a painting of Rubens, which, together with a bust by the Spanish sculptor, Montañés, familiarized Tacca with the features of the monarch, whom he had not seen. Among several other productions, the four chained Slaves around the base of Giovanni dell' Opera's statue of Ferdinand I at Leghorn are the most significant. He might have found the conception already in some of Leonardo's drawings for equestrian monuments, but he probably took it from Giovanni Bologna's scheme for the monument of Henry IV. The figures are treated with a powerful and unexpected naturalism, which shows that Tacca had lived on into the days of the baroque.

He did one of the reliefs, the Epiphany, for the three pairs of bronze doors in the façade of the cathedral at Pisa. These doors, from the beginning of the seventeenth century, form one of the principal monuments of the waning Renaissance and were the work of a group of sculptors, chief among whom were Franqueville and Caccini. Consciously modelled upon the supreme prototypes of Ghiberti, they are decorated, in opposition to the usual practice of the Cinquecento, with borders consisting largely of the earlier repertoire of vegetation and animals. Much of the ornamentation, which is the most interest-

ing part, is the work of GIOVANNI BATTISTA CACCINI, who also executed the simplest, most monumental, and most delightfully narrated scenes, comprised in the four lower panels on the principal door. All the reliefs employ Ghiberti's elaborate pictorial method. Caccini (1556–1612 or 1613) was one of those sculptors, who, much influenced by Giovanni Bologna, prepared the way for the baroque. It has often been pointed out that his *baldacchino* over the high altar of S. Spirito, Florence, resplendent with marble polychromy, saints, and angels, established a precedent for Bernini's achievement in St. Peter's, Rome.

Two sepulchres of the later sixteenth century are significant as providing a transition from the type used by Michael Angelo in the Medici tombs to the baroque type of Bernini. The monument of Paul III in St. Peter's by the Milanese GUGLIELMO DELLA PORTA (d. 1577) once consisted of a fine seated portrait of bronze on a pedestal, accompanied below by four reclining allegorical females. Two of these have been removed to the Palazzo Farnese, Rome, and the two in place have been disfigured by the subsequent addition of zinc draperies. The mausoleum of Michael Angelo in S. Croce, Florence, designed by Vasari, repeats the kind of sarcophagus which the great master himself had employed in the sacristy of S. Lorenzo and which Bernini was to copy for Urban VIII. Upon it, according to a common practice of the time, was set merely the bust of the deceased. The three personifications of Architecture (by Giovanni dell' Opera), Sculpture, and Painting that sit upon the base, in their mourning for the dead forestall Bernini's unification of the tomb; and above the monument there is even introduced the essentially baroque *motif* of a marble curtain.

The close of the Cinquecento and the opening of the Secento witnessed at Rome the development of an art which, under the spell of the Counter Reformation, led directly into the baroque. The paganisms and nudities of the Renaissance were largely repudiated, a more truly Christian spirit was instilled into the monuments, the peculiarities of the mannerists were partly avoided, and a revival of naturalism was at least adumbrated. The sculptors in vogue were not the Florentines, among whom still lingered the principles of the Renaissance, but a large coterie of minor personalities from Lombardy, Flanders, and France. The most characteristic achievements of this movement were the similar tombs, in S. Maria Maggiore, of four popes, Pius V, Sixtus V, Clement VIII, and Paul V. These consist of an architectural structure of colored marbles against the wall with a partial resemblance to the triumphal arch; the upper entablature is supported by carya-

tides in the attic. A sitting or kneeling effigy of the pontiff is en-
sconced under the central arch, and the other spaces are merely filled
with reliefs from his life. As Reymond has suggested, the portrait
statues, in comparison with the usual pompous frigidities of the six-
teenth century, denote a distinct advance in naturalism.

Among the numerous transitional sculptors at Rome, two deserve
special mention. STEFANO MADERNO (*c.* 1566–1636), one of the
Lombard colony, appears as no more than a mediocre artist in the
majority of his few works, such as the St. Ephraem on the exterior of
the Cappella Paolina in S. Maria Maggiore, the chief result of his
collaboration on this monument, or the two angels beside the high
altar of the church of S. Maria di Loreto in Rome. But he outdid,
not only others, but himself, when in 1599–1600 he made the lovely
prostrate effigy of St. Cecilia for a shrine beneath the altar of her
church across the Tiber. Although it is distinguished by an exquisite
simplicity, it obviously belongs already to the mode of the seven-
teenth century. The beautiful draperies have abandoned manner-
ism for naturalism. The posture is said to have been suggested by
that in which the actual body was found, but the Cinquecento would
never have thought of reproducing an attitude so realistically
dramatic.

PIETRO BERNINI (1562–1629), the father of the great Gian
Lorenzo, was born at Sesto near Florence and trained under the man-
nerists. He studied the antique at Rome, but the first period of his
production was at Naples, where he settled in 1584. The Neapolitan
sculpture of the Cinquecento, the fountain-head of which was Giovanni
Merliano da Nola, was not much affected by the artistic develop-
ments of the century in the great centers, but continued in a rather
cramped and provincial imitation of the style that had been estab-
lished in the city by the masters of the Quattrocento who had there
found employment. Pietro Bernini, largely forgetting his education
among the mannerists of Florence, and much influenced by another
Florentine sculptor who lived at Naples, Naccarini, adopted this Nea-
politan mode, which is well illustrated, among a number of examples,
by his Baptist in S. Maria la Nova and by his Sts. Simon and Bartholo-
mew in S. Filippo dei Gerolomini. In one of the later works of this
period, however, the charming Madonna in the Museum of S. Mar-
tino, he shows that he is moving towards the baroque in his pictorial
treatment of the drapery and in his use of the bending pose that
Michael Angelo had chosen for his Virgin in the Medici sacristy.

This alteration in style was only accentuated by his removal to
Rome about 1607 and his resulting contact with the above-mentioned

sculptural tendency of the Roman Counter Reformation. It was fitting, therefore, that he should be chiefly employed in the church of S. Maria Maggiore, the seat of this school's principal labors. He actually did the caryatides and the relief of the pontiff's Coronation on the tomb of Clement VIII. The caryatides incarnate a fresh type of girlish beauty that betokens a passage from the deadness and formality of the late Renaissance to the originality of another age. The Coronation contains several naturalistic portraits. The relief of the Assumption, now in the chapel of the Baptistery in the same church, shows how Pietro Bernini has progressed from the static attitudes of his Neapolitan phase to the agitated postures of the Secento. Here we may plainly see the earmarks of the baroque — its pictorial clouds and garments, its passion, and its strained expressiveness. The father, who had completed these commissions by 1614, could lead his son, with whom later he kept a *bottega* in common, so far over the new road that he left him but a short space to travel by himself.

CHAPTER XV

THE RENAISSANCE OUTSIDE OF ITALY

1. FRANCE

The Renaissance did not penetrate from Italy into the rest of Europe until about the beginning of the sixteenth century, and then, at first, only in architectural detail. For the figures and often even for the ornament, the Gothic style persisted at the first of the century, and, in places, beside the new Italian manner, well on into the century. It was the Italian style of the Cinquecento rather than that of the Quattrocento that was adopted in France and other countries.

In France it is possible to distinguish three stages in the introduction of the Renaissance. The Italians, such as Francesco Laurana, who worked for René of Anjou in the third quarter of the fifteenth century, and the medallist Giovanni di Candida, who labored for Louis XI and at the commencement of his reign for Charles VIII, had little or no effect upon native endeavor, and merely blazed the trail for their fellow-countrymen who were to succeed them. In his later sojourn at the end of his life, Laurana was too far isolated in southern France to constitute a center of influence. A second stage, which began to establish Italianism in France but still had little importance for indigenous production, was inaugurated by the Italian expedition of Charles VIII, who brought back with him many Italian artists, notably Guido Mazzoni. Benedetto da Rovezzano may be mentioned among the Italians who found employment under Charles VIII's successor, Louis XII. A significant factor in the penetration of the Renaissance was the importation of marbles from the great *botteghe* of Carrara and Genoa, the brilliant whiteness of which struck the fancy of the French noblemen in contrast to the duller gray stones of their own quarries. These marbles consisted chiefly of pieces of architectural ornament, designed for tombs, fonts, holy-water stoups, and the like, and were executed, not by distinguished artists, but by master stone-cutters, who soon themselves began to follow the pathway of popularity which their works had travelled into France. They did not, however, reveal to Frenchmen the figure-sculpture of the Italians.

It was not until the third period, the reign of Francis I, a passionate admirer of Italy and a magnanimous patron of art, that the Renais-

sance was actually ingrafted and produced French sculpture of the new fashion. French buildings were henceforth lavishly embellished with imitations of Italian *motifs*, both figured and purely ornamental; the sepulchral repertoire of Italy gradually intruded itself upon French tombs. Andrea della Robbia's son, Girolamo, Benvenuto Cellini, and a legion of other Italian sculptors were honored with patronage and taught the native artists. The Giusti family at Tours, Primaticcio at Fontainebleau, and Domeniço Fiorentino in Champagne may be chosen for special mention. The GIUSTI—chiefly Giovanni I—made the tomb of Louis XII and Anne of Brittany in St. Denis at the command of Francis I. It established a precedent for royal sepulchres in the French Renaissance. The sarcophagus with the cadavers rests upon a base carved with reliefs of the sovereign's deeds in Italy and surmounted by a rectangular canopy of the Renaissance consisting of a series of arches. Above the canopy kneel the two effigies; at the four corners of the base sit the Virtues and under each of the arches one of the twelve Apostles. The two portraits and probably the cadavers were done by the school of Michel Colombe; the rest is largely the production of Giovanni di Giusto, respectable work of the early Cinquecento.

FRANCESCO PRIMATICCIO (*c.* 1504–1570), who belonged to the Raphaelesque tradition and was also a painter, became the general director of Francis I's artistic enterprises, especially in the decoration of the palace at Fontainebleau. An important event for the history of French sculpture was Primaticcio's journey to Italy in 1542 to get bronze replicas of the famous ancient statues that had recently been excavated. These antiques and the Italian sculpture that was being produced at Fontainebleau made the palace a school in which many French sculptors were trained. Typical of Primaticcio are the caryatides of stucco adorning the chamber formerly assigned to the King's mistress, Madame d'Étampes. Disassociated from the degeneration into which sculpture in Italy was falling, he retains much of the exquisite charm of the Quattrocento, he models slighter and more delicate forms, and he is better than in his painting. Moreover, he is imbued with the French spirit. The bodies are elongated into architectural lines, according to that architectural feeling in sculpture which the French continued to exhibit occasionally even after the Middle Ages, and they are alive with that delight in femininity which from first to last has impressed itself upon every aspect of French civilization.

Domenico of Florence, called by the French DOMINIQUE FLORENTIN, appears first in 1537 as one of the Italian colony at Fon-

tainebleau. A respectable and typical sculptor of the Cinquecento, much influenced by Michael Angelo but softer and sweeter in temperament, he was active in Champagne from 1540 to 1550, especially at Troyes. The most important remains of his activity are the Faith, Charity, and reliefs of the life of St. Stephen from the choir-screen of St. Étienne, Troyes; the two statues are now in the church of St. Pantaléon, Troyes, and the reliefs are in the church of St. Étienne at Bar-sur-Seine. The Renaissance had already penetrated Champagne through the indigenous artists who had studied at Fontainebleau but who retained a certain degree of the wonderful style assumed by the *détente* in their native province. Among these transitional masters, most significant was JACQUES JULIOT, whose capital works are the much injured reliefs from the reredos of the abbey of Larrivour, now in the Museum of Troyes. But the presence of Dominique Florentin in Champagne spelt the definite triumph of Italianism, and the large amount of sculpture that was then executed in the province was, to a great extent, an exaggerated imitation of his mannerisms. In comparison to the superb achievements of the *détente*, this Italianate production betrayed an obvious decadence, and even the persisting artistic fecundity of Champagne was soon stunted by the religious wars of the later sixteenth century.

The sensitiveness to architectural function and to the charm of femininity that has been remarked in Primaticcio distinguished the French from the Italian Renaissance. French artists were also saved from falling into such utter coldness as we often find in Italy of the Cinquecento by a certain persistence of the old Gallic naturalism of the Gothic period. Although French sculpture of the Renaissance was derived from the Italian style of the Cinquecento, it was permeated by a kind of freshness that may be paralleled in the Italian Quattrocento. Although it came a century later, it had about it something of the youth of a new movement that Italy had lost.

There is less of Gothic naturalism and more of Italianism in the greatest French sculptor of the sixteenth century, JEAN GOUJON (d. before 1568), than in any other prominent French sculptor of the period, and yet his achievement is by no means so frigid as the contemporary Italian output. Probably a Norman, he emerges into history first at Rouen in 1540. What was his training? He does not seem to have learned from the Florentine or Milanese craftsmen employed at the château of Gaillon near Rouen, for his style is a reflection rather of the severer Roman Renaissance. Had he actually studied at Rome? His drawings for the first French edition of Vitruvius almost impose the conclusion that he had examined and measured ancient

ruins, but it is just possible that he could have acquired all his knowl-
edge from the antiques and the Italians at Fontainebleau. A close
analogy certainly exists between Primaticcio's caryatides and Goujon's
delightful feminine figures. Though he is remembered as a sculptor,
he apparently considered himself primarily an architect. He elongated
his forms for monumental effect, and he was always as ready to sacri-
fice correct anatomy to the exigencies of an architectural design as to
his love of undulating outlines. He gave his figures the high relief re-
quired for distinctness in the midst of their architectural setting. All
his important work was done for the decoration of architectural monu-
ments, and he was less successful in his separate statue of Diana for
a fountain, the chief fragment remaining from his labor in the château
of Anet, built by Henry II for his mistress Diane de Poitiers. Although
the figure, now in the Louvre, is superior in proportions, statuesque
nobility, grace of pose, and feminine charm to Cellini's Nymph, by
which it was suggested, it has more of the coldness and dryness of
the sixteenth century than Goujon usually admitted. It demon-
strates also that his absolute nudes are less attractive than those in
which he suggests the body through clinging and undulating gar-
ments. A true Frenchman, he expressed himself most characteristi-
cally in sinuous feminine forms emerging from sinuous drapery. They
are elegant but not so mannered as most sculpture of the sixteenth
century. His masculine forms, likewise, tend towards a studied grace,
but they also adopt, to a certain degree, the prevalent cult of the
colossal, which French naturalism saves from becoming as empty as
usual. His drapery is Neo-Attic in its great swirls and in the minute-
ness of its plaits. It is particularly in this drapery that his peculiarly
French nicety of execution manifests itself.

Leaving out of account hypothetical ascriptions at Rouen, we find
many features of his style already developed in the reliefs of the Depo-
sition and the four Evangelists for the choir-screen of St. Germain-
l'Auxerrois at Paris, now in the Louvre. The masculine figures,
especially, are characteristic, the Evangelists being obviously influ-
enced by Michael Angelo's paintings on the Sistine ceiling. The
Deposition has the cold beauty of Jacopo Sansovino, inevitably some-
what rhetorical, but it possesses the additional attraction of the quali-
ties that the French superimposed upon the Renaissance. The nude
of Christ's body is an academic triumph. From his next commission
in the Constable Anne de Montmorency's château of Écouen, the
most important relic is the altar now at Chantilly. In the Virtues
he was slowly approximating his ideal of the feminine figure. He came
still nearer to it in the allegorical forms above the outside and inside

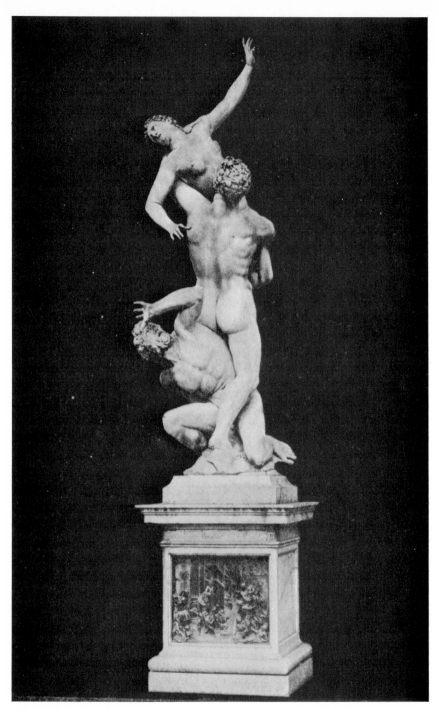

FIG. 104. GIOVANNI BOLOGNA. RAPE OF THE SABINE WOMAN.
LOGGIA DEI LANZI, FLORENCE

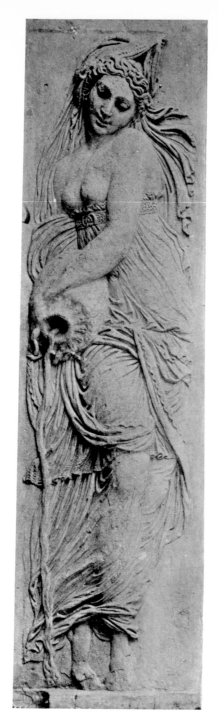 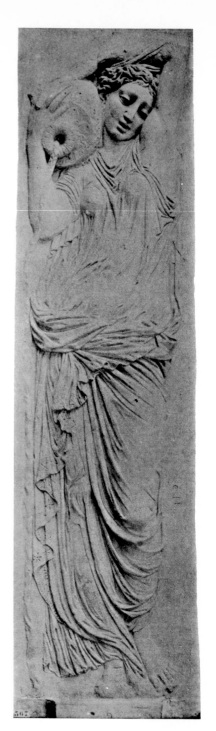

Fig. 105. GOUJON. TWO NYMPHS FROM FOUNTAIN, SQUARE OF THE INNOCENTS, PARIS

(*Photo. Giraudon*)

of the main portal to the edifice at Paris now known as the Hôtel Carnavalet. The Seasons on one façade of the courtyard, perhaps the work of pupils, have more of the popular amplitude, especially the masculine Autumn.

He finally achieved the ideal after which he was striving in his masterpiece, the Fountain of the Nymphs, now in the Square of the Innocents, Paris. In its present condition it is a four-sided, rectangular structure. Between the pilasters framing the arched openings are the Nymphs, and in the frieze above, reliefs. At the remodelling towards the end of the eighteenth century, a Nymph comprised in Goujon's plan was added, and his original three sides were completed by a fourth; the greater part of the plastic accretion was done by Pajou, who succeeded wonderfully in reproducing his predecessor's manner. Three reliefs of marine deities and monsters that Goujon had introduced on the base, being imperilled by the flow of water, were removed in 1812 and are now in the Louvre. The Nymphs (Fig. 105) belong to the world's greatest sculpture. It is high enough praise to state that they may be compared with the Victories of the balustrade for the temple of Athena Nike, now in the Acropolis Museum, Athens. Not since Greek days had any sculptor realized so well that happy mean between voluptuousness and noble restraint in the treatment of the feminine form. The undulation in body, posture, and drapery, which Goujon always cultivated, is here more truly justified by the function of the Nymphs and reliefs as decorations of an aquatic monument. By the same token the artifice of dampening the garments to reveal the forms beneath, in this instance, becomes natural.

The culmination of Goujon's career, from the standpoint of renown, was his employment on the royal palace of the Louvre. About 1550 he executed three pairs of allegorical women to frame the round windows above the doors on Pierre Lescot's façade. The style is that of the Nymphs, impaired by the greater classical dryness that marks his last period. Between 1555 and 1562, with much aid from assistants, he adorned two attics on this façade; the War and Peace and the bowed and crouching Captives are definite reminiscences of Michael Angelo. His most surprising achievement is within the palace, the four caryatides supporting a balcony in the antechamber of Catherine dei Medici. He and others had drawn reconstructions of caryatides from the description of Vitruvius, and caryatides appear on the tomb of Louis de Brézé in the cathedral of Rouen, which has been attributed to Goujon. But those of the Louvre have a difference and a superiority that are hard to explain. They are less beautiful sisters of the greatest of all caryatides on the porch of the Erechtheum, but it is much even to be

sisters. Goujon could not have known the Greek masterpieces, but by brilliant artistic intuition he reflected their glory in the monumental nobility of his impassive forms and in an architectural restraint of drapery, which is contrasted with the license that he ordinarily permitted himself in this phase of his art.

The two other great court-sculptors of the French sixteenth century were less Italian and more closely related to the old Gothic tradition. PIERRE BONTEMPS, a still shadowy personality (active 1536–1562), received his initiation into the Renaissance at Fontainebleau. He and the architect Philibert de l'Orme were chiefly responsible for the tomb of Francis I at St. Denis, a pompous elaboration upon the precedent set by the monument of Louis XII, made more strictly classical, especially by the substitution of columns for pilasters, and accommodated to the triumphal arch by the addition of arched lateral projections. Bontemps executed the cadavers of the King and Queen and, above, their kneeling portraits, together, probably, with that of their little daughter, Charlotte. In these effigies surviving French naturalism has vitalized the coldness of the Renaissance. The panels around the base, representing the King's military enterprises, were also done by Bontemps in a naturalistic style with contemporary costumes. The reliefs symbolizing the arts and representing the activities of artists on the lovely urn and pedestal for the heart of Francis I, now in St. Denis, are products of Bontemps's study under Primaticcio and the antiquarians of Fontainebleau. The sitting mortuary statue of Charles de Maigny in the Louvre loses by comparison with another sepulchral effigy that has been attributed to Bontemps, the Admiral Chabot, also in the Louvre. In the superb portrait of Chabot, as in the other works of Bontemps, the Renaissance has done little else but lend dignity and solemnity to the tradition of Gothic naturalism. Originally it was part of one of those few French tombs which in the sixteenth century emulated the pagan magnificence of Italian mausoleums.

The Parisian GERMAIN PILON (1535–1590), whether or not an actual pupil of Bontemps, carried his style to the end of the century and developed its highest artistic possibilities. The influence of Goujon may also be discerned in his production. In the monument for the heart of Henry II, possibly designed by Primaticcio and now to be seen in the Louvre, the three Graces of marble made by Pilon to support the urn are more naturalistic translations of Goujon's feminine ideal. Their wonderful litheness and movement are brought into relief by a comparison with the similar but purposely more sedate Virtues, also in the Louvre, that he later executed to uphold the reli-

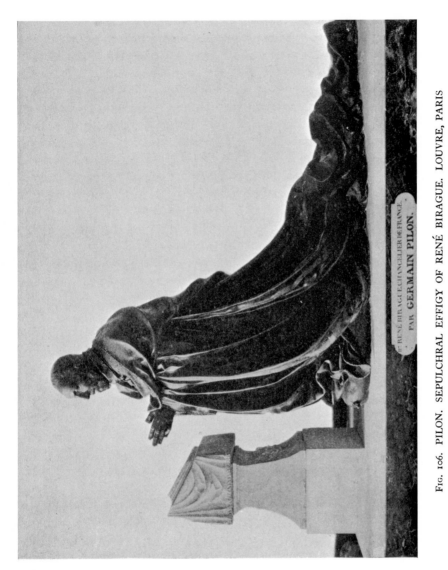

FIG. 106. PILON. SEPULCHRAL EFFIGY OF RENÉ BIRAGUE. LOUVRE, PARIS

(Photo. Giraudon)

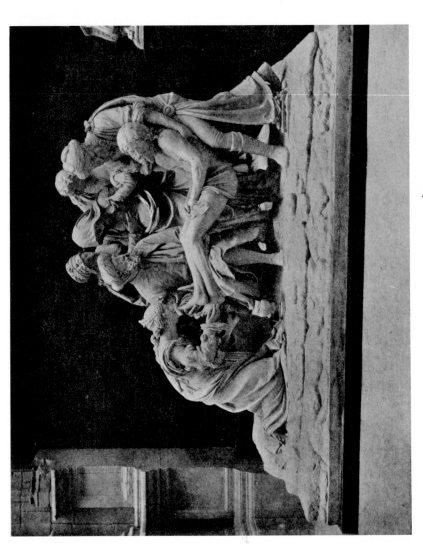

FIG. 107. LIGIER RICHIER. HOLY SEPULCHRE. ST. ÉTIENNE, ST. MIHIEL

(Photo Buller)

quary of St. Geneviève. Here, however, the material of wood has made Goujon's undulating folds more angular, and in general Pilon attempted less delicate and minute plaits than his predecessor.

As in the case of Bontemps, the most conspicuous employment of Pilon was upon a royal mausoleum, that of Henry II in St. Denis, designed by Primaticcio with a miniature temple above the cadavers instead of the triumphal arch. Primaticcio also probably executed the bronze Virtues at the corners of the edifice in a more voluptuous style than his caryatides at Fontainebleau. The kneeling bronze portraits and the marble cadavers of Henry and his queen Catherine dei Medici are by Pilon. The former are in his best naturalistic vein. In the latter, he has made the disagreeable *motif* as palatable as possible by a harmonious union of naturalism and of a moderate idealization that veils the repulsive.

As he grew older, he emancipated himself further from the mannerisms of the late Renaissance and cultivated a more uncompromising realism, often retaining medieval polychromy. Typical examples are afforded by the reliefs from the pulpit of the church of the Grands-Augustins and the Agony in the Garden, all now in the Louvre. The St. Francis, now in the church of St. Jean-St. François, Paris, is Spanish in its naturalistic presentation of religious ecstasy. His classical training, however, helped him to maintain a proper repose and monumentality in his busts and sepulchral effigies. His greatest triumph of vigorous and penetrating portraiture is the kneeling bronze of the Chancellor de Birague in the Louvre (Fig. 106). The resuscitation of realism is apparent especially in the modelling of the head and hands. By the end of the century, the old medieval tomb with the effigy upon a detached, elevated base had been completely abandoned for an edifice against the wall, partially suggested by Italian examples but with the important difference of the kneeling attitude for the deceased. Pilon's ennobled realism is also illustrated by his great medals, which, in opposition to the general practice of the time, he was wise enough to make by casting rather than by striking from a die. Yet, despite the reassertion of the national tradition in Bontemps and Pilon, the revival of the antique in France was an assured fact, and the foundations of French classicism were laid.

Throughout the sixteenth century the provinces were centers of considerable activity in religious sculpture somewhat apart from the artistic evolution at the court. The old subjects and compositions, such as the retables and the Holy Sepulchres, were still repeated again and again, but the figures themselves were gradually Italianized. Agitated postures became more general; the gestures affected a man-

nered elegance; the drapery fluttered hither and thither; the coun-
tenances lost their individualization and adopted the cold and general-
ized idealism of the Renaissance. The sculpture that in Champagne
was influenced by Dominique Florentin has already been mentioned.
The greatest of these provincial masters was LIGIER RICHIER of St.
Mihiel in Lorraine (c. 1500–1567), who, like Jacques Juliot of Cham-
pagne, retained many of the old medieval characteristics in the midst
of his Italianism. For the sacred personages he frequently employed
the contemporary costumes of the *détente*, and he revealed, in a pro-
nounced form, the notes of pathos and passion that mark so much late
Gothic art. Typical early works are the two similar representations of
the Pietà in the churches at Étain and Clermont-en-Argonne. The
Virgin swooning in the arms of St. John, a group of wood, originally
part of a Crucifixion, in the church of St. Michel at St. Mihiel, pre-
serves much of the lovely feeling of the *détente*. His religious master-
piece is the Holy Sepulchre in St. Étienne of the same town (Fig. 107).
The original disposition of the figures has been disturbed, and some of
them are not by Ligier Richier's own hand. Nancy possesses his ex-
tant recumbent mortuary effigies: René de Beauveau with his wife in
the Musée Lorrain, executed in a style that would not dishonor Michel
Colombe; and the aged widow and nun, Philippe de Gueldres, in the
Franciscan Church, treated with a vigorous but kindly realism. In the
upright cadaver of René de Châlons in St. Pierre at Bar-le-Duc, he
gave to the common medieval *motif* one of its most repellent expres-
sions, but even this skeleton covered with putrifying flesh he ennobled
in a certain way by the exaltation of the gesture with which the de-
ceased offers his heart to God.

2. THE LOW COUNTRIES

The Flemish adopted the Renaissance enthusiastically and gradu-
ally impregnated it with their indigenous characteristics. As in the
flamboyant period they had treated the Gothic forms with the great-
est license and fantasy, so now they played with the Italian forms,
sometimes giving the human body capricious proportions, delighting
in agitation, molding the ornamental detail into whimsical shapes,
and creating curious architectural compositions. Sculpture was con-
ceived to have a decorative rather than an intrinsic value; the beauty
of an individual figure was not deemed so important as its general
effect in the whole monument. As they had overladen their Gothic
style with figures and decoration, so now they produced opulently
adorned architecture and pieces of ecclesiastical furniture. The sculp-
ture of the Flemish Renaissance was indeed a premature aspect of the

baroque. No great colonies of Italians were imported into the country as into France and Spain, but the Renaissance was introduced by native masters who went to study in the southern peninsula. Here and there, perhaps, may be discerned an influence of the French Renaissance. At the end of the sixteenth and beginning of the seventeenth century several sculptors, such as Giovanni Bologna and François Duquesnoy, became such Italianates that they remained in the country where they had been educated and were leaders in the artistic developments of that land. Italianism, as elsewhere, appeared first in the architectural detail of such medieval types as retables, tabernacles, and choir-screens, and then began to affect the figures and draperies themselves. The retable of 1533 in the church of St. Martin at Hal by the distinguished sculptor, J E A N M O N E, is more thoroughly in accord with the new movement than the works of Jacques Juliot or Ligier Richier in France. The several kinds of medieval monuments, indeed, continued to exist throughout the sixteenth century and even later, but their figured and architectural decoration was completely Italianized. At the end of the century, the Renaissance style of the Low Countries obtained, in many parts of Europe, especially England and Germany, a popularity which, though unwarranted, was as great as that which had been enjoyed by Flemish art of the late Gothic epoch; and in these regions it largely superseded the direct importation from Italy. The production of Holland during the period was not essentially distinguished from that of Belgium, except that it was less copious and less brilliant; the principal centers were Breda, Dordrecht, and Utrecht.

The chief purveyor of the Renaissance in sculpture, through study at Rome, was J A C Q U E S D U B R O E U C Q, who was born at Mons or St. Omer between 1500 and 1510 and died in 1584, and who also distinguished himself as an architect, especially under the patronage of Charles V. He brought back from Italy the forms and characteristics of the Cinquecento, but he never acquired the knowledge of anatomy or the accuracy of modelling possessed by the Italians, and he usually made elongated bodies that sway hither and thither and seem to have no back bones. He is full of the restlessness that marks the art of his country, and he has a disagreeable habit of opening the mouths into emotional grimaces. His capital production was the choir-screen of Ste. Waudru, Mons, the majority of the fragments from which may still be seen in the church. The three round reliefs of the Creation, Last Judgment, and Triumph of Religion are curious and lackadaisical attempts to repeat the pictorial manner of Ghiberti and to superimpose upon it the rhetoric of the Cinquecento. The rectangular reliefs

from the Passion are in the regular Romanizing style of Andrea San-
sovino. The Scourging, based upon a drawing of Michael Angelo, is
disfigured by all of Du Broeucq's faults; the Last Supper is the best
of the series. His masterpieces are the Virtues from the screen, espe-
cially the Theological. They are somewhat vitiated by the usual cold
classicism; but they are not so weak as the figures of his reliefs, and
they have a real beauty that is accentuated by the aureoles of hair
with which he frames the heads. Although he has denied himself
individualization and expression through the countenance, he skil-
fully suggests the conceptions of the Virtues through posture and
through drapery that distantly recalls the sinuous and diaphanous
grace of Goujon. The sentimentality of the statues of Hope and the
Saviour betray how the Flemish Renaissance prepared the way for the
baroque. The Magdalene that he himself executed for an altar which
he designed in this church belongs to the same stylistic group as the
Virtues. Of his extant sculpture, the other important examples are
the cadaver and the nobly idealized kneeling effigy from the dis-
mantled tomb of Eustache de Croy, bishop of Arras, in Notre Dame
at St. Omer. The original disposition of the monument was perhaps
suggested by the lower section of Louis de Brézé's mausoleum at
Rouen — the cadaver at the center upon a bier, at one end the kneel-
ing prelate with his patron St. Eustace, and at the other Faith over-
coming Heresy.

Other sculptors and sculpture were more national. A series of pre-
tentious fireplaces, together with the specimens from the Middle
Ages, constitute one of the greatest peculiarly Flemish contributions
to the history of art. The example now in the Burgomaster's Room of
the Hôtel de Ville, Antwerp, by the painter Peeter Coecke of
Alost (1502–1550), combines Italianism with Flemish decorative elab-
oration and employs the supporting human figures that were usual
in these mantelpieces and were much affected in other kinds of monu-
ments during this epoch in Flanders. The somewhat more classical
fireplace in the Stadhuis of Kampen, Holland, by Jacob Colyns
de Nole, is embellished with figures of Virtues and reliefs from Bib-
lical and Roman history illustrating these Virtues. The most mag-
nificent example was executed in the Council Chamber of the Palais
de Justice, Bruges, by Guyot de Beaugrand, Herman Glo-
sencamp, and others on the designs of the painter Lancelot Blondeel
(Fig. 108). In the upper and principal section, which reverts to the
Flemish material of wood, the statues of Charles V and his ancestors
still possess much of the old Gothic realism.

Of carved wooden choir-stalls, for which the Low Countries had

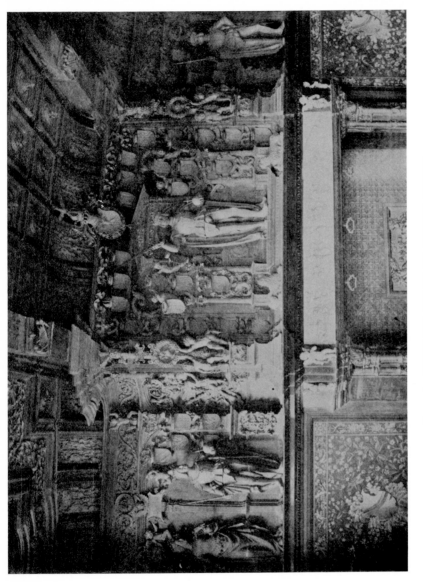

FIG. 108. FIREPLACE, PALAIS DE JUSTICE, BRUGES

(*Courtesy of Secretary of Société Archéologique, Bruges*)

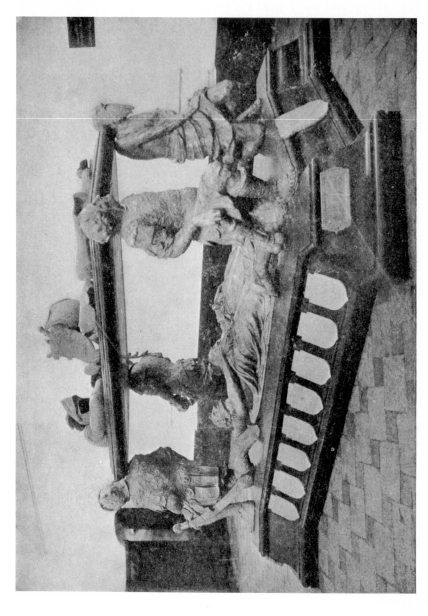

FIG. 109. TOMB OF ENGELBERT II OF NASSAU AND HIS WIFE. PROTESTANT CHURCH, BREDA

(Courtesy of Dr. Jan Kalf)

always been famous, the Renaissance produced several fine series. The most notable examples, in a chaster and severer taste than was common in Belgium or Holland, are those by JAN AERTS VAN TERWEN in the Groote Kerk at Dordrecht, representing the Triumphs of Christ, of the Eucharist, and of Charles V, and episodes from the Bible and Roman history.

One of the great exponents of the more indigenous adaptation of the Renaissance and one of the first Belgians to spread this style in other parts of Europe was the architect and sculptor, CORNELIS FLORIS DE VRIENDT of Antwerp (1514 or 1518–1575). Though thoroughly Italianate, he gave to his forms and draperies more of the "fussiness" of Flanders, he cultivated a kind of French gracefulness, and he helped to evolve the sportive Flemish modifications of Renaissance detail. His tabernacle or ciborium in the church of St. Léonard, Léau, with its heaping and laboring of detail, is an absolute translation into Italian of similar medieval structures. In certain sections he uses human figures as supports. The tabernacle of Suerbempde near Diest, which likewise introduces caryatides, is more monumental in its fewer and larger architectural divisions and decorative figures. In the great choir-screen of the cathedral at Tournai, he is also distinctly classical, although like Du Broeucq he resorts in places to Ghiberti's pictorial treatment. The figures in the spandrels, however, are given a Flemish decorative effect, and in the ornament he is developing the Flemish grotesques. It was chiefly by his tombs in Denmark, Sweden, and Germany that he disseminated the fashions of his native land. A characteristic example is the mural monument of Albert I of Prussia in the cathedral at Königsberg.

The sepulchres of the sixteenth century, such as that of the Count Antoine de Lalaing and his wife in the church of St. Catherine, Hoogstraeten, often continued the medieval type with high base and with honestly realistic effigies. In other instances, as for Jean III de Mérode and his wife in the church of St. Dympna, Gheel, they consisted of a table supported by the popular human figures. The mausoleum of Engelbert II of Nassau and his countess in the Protestant Church, Breda (Fig. 109), is constructed of a low slab sustaining the effigies in their shrouds, surmounted by a table which is upheld by four kneeling classical heroes and displays the armor of the deceased. These supporting figures embody a not very successful attempt at Italian *contrapposto*. The tomb of Reinoud van Brederode and his wife in the church at Vianen already has the canopy so characteristic of Dutch mausoleums in the seventeenth century. *Epitaphs*, in the typical florid manner of the Flemish Renaissance, persisted as

a frequent mode of commemoration. They usually took the form of
a small arch elevated upon the wall, under which the deceased kneels
before a sacred subject; or else, with more pretension, they became
great altars with the whole family kneeling at the base.

Several masters of the Low Countries, whom the havoc created by
the Spanish governors in the second half of the century perhaps dis-
couraged from laboring at home, are discussed, in this book, under the
headings of the foreign countries in which they were chiefly active.

3. GERMANY AND RELATED COUNTRIES

The late Gothic of Germany had reached the acme of its develop-
ment at the beginning of the sixteenth century, so that the Renais-
sance at first received a rather niggardly reception and appeared only
here and there as an isolated phenomenon. Even where it obtained
entrance it had to effect a compromise with much of the old Gothic
spirit and even with the medieval forms. Commercial and cultural
relations with the nearest great Italian center, Venice, caused the art
of that city to exert the preponderant influence in the formation of the
first stage of the German Renaissance, and the sculptors were also very
much indebted to contemporary German painters and engravers,
especially Dürer. Very little important monumental sculpture was
produced at this time in the style of the Renaissance, but the German
masters excelled in small objects, such as statuettes, mythological
plaques, and pieces of the minor arts.

By a strange paradox, when the Renaissance had definitely tri-
umphed in the middle of the century, German sculpture had fallen
into decadence. The chief cause was the devastation wrought by the
religious wars. The development of Protestantism also tended to re-
strict sacred art to the Catholic south, and left little scope to northern
sculptors, except in sepulchres. Almost all the important commis-
sions, especially towards the end of the century, were assigned to
sculptors from the Low Countries. Much work was produced through-
out the country by native Germans, but none of these were artists of
distinction or of great individuality. They often merely took the
medieval types for choir-screens, stalls, altars, pulpits, tabernacles,
tombs, and *epitaphs*, and gave them an Italian dressing. The pulpits
sometimes developed a human figure as a support, such as the St.
Paul beneath the example in the cathedral of Magdeburg. The
epitaphs, laden with ornamentation and suggested by Flemish pro-
totypes, were frequently heaped up in several stories with a number of
sacred episodes and with the deceased and his whole family kneeling
below. The Germans had also a passion for ranging lines of ancestors

beside a tomb or along the sides of a mortuary chapel. Occasionally, the sepulchral monuments, such as those of the Archbishops Adolf and Anton von Schauenburg in the cathedral of Cologne, were more Italian in their structure. As in Belgium, the sculptors liked to spend their energy in decorating the façades of houses and public buildings with details and reliefs in the style of the Renaissance.

An early focus of the Renaissance was Nuremberg, where for a considerable time it existed beside the medieval manner of such men as Adam Krafft and Veit Stoss. Nuremberg had long been in contact with Italy, especially with the northern part of the peninsula, and the Venetian painter and engraver, Jacopo dei Barbari, now played an important rôle in the introduction of the new Italian fashions.

The greatest sculptor of the German Renaissance, PETER VISCHER of Nuremberg (1460–1529), died before Stoss and was himself, like his contemporary in painting, Dürer, half Gothic. His personality involves a difficult problem. He and his workshop preferred and excelled in the medium of bronze, and some writers would debase him into a mere caster of the designs and models furnished him by others. Although in a number of instances he certainly used such suggestions, the trend of modern criticism is to consider him, in general, an original artist of lofty invention, and he may indeed have refashioned what he borrowed according to his own ideas.

In a series of sepulchral monuments, it is interesting to trace step by step the intrusion of the Renaissance into his Gothic style. The tomb, with high base, of the Archbishop Ernst in the cathedral of Magdeburg (1495), in its rich multiplication and elaboration of meticulous ornamental detail, recalls the manner of Adam Krafft, and could be reckoned still completely Gothic, were it not for the statuettes of Apostles around the base, which reveal in the heads an effort for a calmer and more ideal beauty and in the drapery less angularity and a predilection for more unbroken and broadly flowing lines. It is always possible, however, that, in the early stage of Vischer's career, these qualities were due, not to Italy, but to the tendency towards a *détente* which was most pronounced in the Swabian school. The vigorous bronze slab of the Bishop Veit I in the cathedral of Bamberg (1503), the design for which was provided by the painter Katzheimer, is absolutely medieval, except, perhaps, for the greater simplicity of the drapery; but a series of slabs at Cracow reveal the gradual adoption of the ornament of the Renaissance. The slab of Peter Kmita (1505) in the cathedral admits only a molding of laurel for the arch above the head, but that of an unknown Cardinal, also in the cathedral, whether the attribution to Vischer is correct or not, substitutes a

complete niche of the Renaissance for the Gothic background. In the Stadt-Kirche at Römhild, the lovely raised tomb of the Count Hermann of Henneburg and his wife exhibits in the highly relieved effigies a greater classicism than any of the monuments hitherto mentioned. The persistence of Gothic ornament, however, would perhaps suggest a *détente* rather than a dependence upon Italy.

The indebtedness to the Renaissance is unmistakable in Vischer's masterpiece, the bronze shrine or canopy (1507–1519) covering the old reliquary of St. Sebaldus in his titular church at Nuremberg (Fig. 110). Some have ascribed the Italian elements to Hermann Vischer or Peter Vischer the Younger, two sons who had studied in Italy; but although there is no evidence that the father himself made the *italienische Reise*, it is likely that all parts of the monument were conceived and very largely executed by him and that he acquired his knowledge of the Renaissance from those elements of it that had already sifted into his native city, as well as from Dürer, from Jacopo dei Barbari, and from his sons. The shrine is a hybrid of the Gothic and Renaissance: its general form is perhaps remotely derived from the canopied papal tombs of the fourteenth century at Avignon and Villeneuve-lès-Avignon. It consists of three terraced domes, heavy with Gothic ornament and supported on eight piers, upon which, beneath small *baldacchini*, are the twelve Apostles. Between the piers are candelabrum shafts, and these, as well as every other available part of the monument, are covered with a fusion of medieval and Renaissance decoration, especially *putti* which make up for what they lack of Italian correctness by a certain Teutonic lustiness and sportiveness. At the center of each side of the base is one of the cardinal Virtues, and at the four corners of the base are Hercules, Samson, Perseus, and Nimrod, symbolizing the victory of man over nature and embodying an interest in the nude, which here, in Germany, is given a realistic handling that is strikingly similar to the work of Antonio Pollaiuolo. The foundation upon which the reliquary rests is embellished with reliefs of the saint's miracles, all in the more severely classical style of the late Renaissance, restricting the number of figures and eschewing the pictorial. The bodies emerge from the graceful draperies, and some of the lovely feminine forms are derived from Jacopo dei Barbari's engravings. The Apostles represent the summit of Vischer's attainment and the perfection of those qualities which he had adumbrated in the similar statuettes at Magdeburg. Through the influence of Italy they have lost German stockiness and have become more *svelte* and elegant. The heads are beautifully idealized, but the idealism starts with German types and is not carried so far as to destroy all

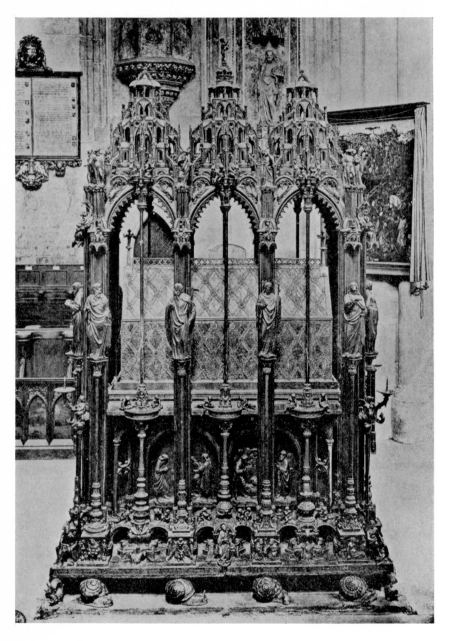

FIG. 110. PETER VISCHER. RELIQUARY OF ST. SEBALDUS.
ST. SEBALDUS, NUREMBERG

(From Dehio and Von Bezold, "Die Denkmäler der deutschen Bildhauerkunst")

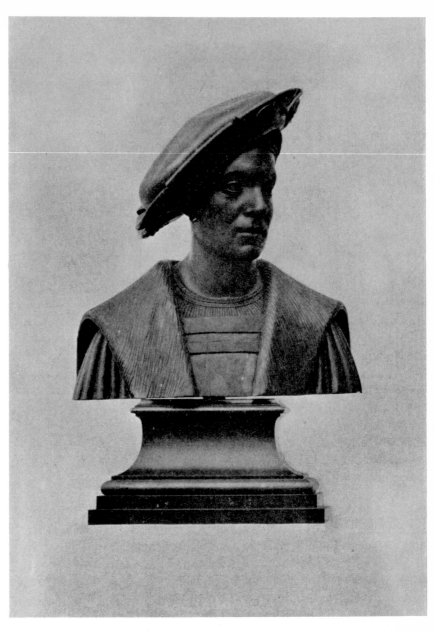

FIG. 111. KONRAD MEIT. BUST OF YOUNG MAN. BRITISH MUSEUM, LONDON

(Courtesy of British Museum)

individualization. The drapery falls in classical folds, attaching itself
to the body and following its outlines. The garment of St. Simon is
caught around him like the costume of an ancient orator. The
Apostles, in general, suggest a less rhetorical, less slavishly archaeo-
logical, and more Teutonic Jacopo Sansovino. The whole canopy
gives a certain fantastic impression that is distinctly German. At
one end in front of the base, Peter Vischer, with the confidence of
genius, has placed a statuette of himself, rudely clad in a leathern
apron as a simple craftsman and, in contrast to the rest of the shrine,
treated with the homely realism characteristic of his country.

His name has been connected with two famous monuments of Ger-
man sculpture. The "Fair Madonna of Nuremberg," executed in
painted wood and now in the Museum, has been ascribed to almost
every artist of the period but at present is generally believed to be by
Vischer, by his son, Peter the Younger, or at least by some member
of his workshop. It is a more academic, mannered, elongated, and
theatrical example of the style represented by the Apostles. To him
also have been attributed the bronze statues of Arthur and Theodoric
for the magnificent assemblage that constitutes the tomb of the Em-
peror Maximilian in the Franciscan church at Innsbruck. In the
center is the huge marble sarcophagus carved with twenty-four scenes
from Maximilian's life and surmounted by his kneeling bronze effigy,
accompanied at the four corners by the bronze Virtues; along the
sides of the monument stand twenty-eight of the originally intended
forty bronze statues of the imperial ancestors. The reliefs, Virtues,
and kneeling effigy were finally executed by the Flemish sculptor,
Alexander Colin of Malines.[1] The several German masters who were
responsible for the line of ancestors were evidently required to make
a point of the costumes, and the figures are often like the manikins
that exhibit heavy suits of armor in museums. The two ascribed to
Vischer are superior to the others, and the Arthur is much better than
the Theodoric. In the former, despite the encumbrances of the King's
accoutrement, the artist allows us to divine the body beneath and
through the ease of the posture even transmits the impression of lithe-
ness. From the spiritual standpoint, he has incarnated the very es-
sence of solid German knighthood. Here and in some of Vischer's
certain works, the enduring qualities of the best German art reassert
themselves even in the surroundings of the Renaissance — firmness of
pose, forceful realism, and restrained vigor.

The last productions of Vischer are more classical. In the back-
ground of Margaret Tucher's *epitaph* in the cathedral of Ratisbon

[1] Cf. below, p. 256.

(1521), there is a little temple not unlike those used by Perugino and Raphael. But the Gothic vaulting and window within this structure are symbols of the fact that the fusion of the two styles remained in his work until the end. It was because he retained so many features from the old indigenous Gothic tradition that he was able to pour new life into effete Italianism.

Several of his sons followed the paternal profession. Hermann, the eldest from the three marriages, died prematurely. The principal separate work of PETER THE YOUNGER, who was the most distinguished and who died a year before his father, is the fine upright sepulchral bronze of the great Protestant prince and patron of Luther, the Elector Frederick the Wise, in the manorial chapel at Wittenberg. The architectural ordinance seems to be imitated from the section of the Venetian tomb of Niccolò Tron containing the erect effigy of the deceased. The impressive portrait has something of the sternness and testiness of the Reformation. The popularity of the Vischer workshop, however, gradually waned. In emulation of Italy, the red and white marble of Germany began to be preferred to bronze for sepulchral monuments. The family confined itself more and more to the small objects of virtu that are the chief distinction of the German Renaissance. A typical specimen is the younger Peter's bronze tablet of Orpheus and Eurydice in the Kaiser Friedrich Museum, Berlin (one of his four repetitions of the theme), illustrating the same original adaptation of the antique and of Jacopo dei Barbari's style as his father's work upon the shrine of St. Sebaldus.

HANS VISCHER, who outlived his father and continued the workshop for a time, was inferior to the rest of the family, rendering the effigies stiff and lifeless as idols on the double bronze tomb of Johann Cicero and Joachim I of Brandenburg, begun by Peter Vischer the Elder and now in the Protestant cathedral of Berlin. It is hard to believe that the same man was the author of the lithe bronze statuette of Apollo which was done for a fountain and is now in the new Rathaus of Nuremberg. The explanation possibly is that he was here reproducing an engraving of Jacopo dei Barbari, but he actually improved upon his model by creating more tension in the attitude of drawing the bow. By 1549 Hans Vischer had so far lost his patronage that, despite the protest of the authorities, he emigrated to Eichstätt, promising, nevertheless, not to exercise the trade of bronze-casting in his new residence; and thus the great industry of the Vischer family came to an end. A remote descendant of the Vischer workshop was the Benedikt Wurzelbauer who in 1589 did the fountain of the bronze Virtues in the Lorenzer Platz, Nuremberg, after the fashion established by Giovanni Bologna's followers from the Low Countries.

After the first half of the sixteenth century the school of sculpture that had so long made Nuremberg illustrious sank into a rapid decline. The only other significant master prior to this decline was PETER FLÖTNER or Flettner (*c.* 1485–1546). Perhaps a Swiss by birth, he is not definitely known to history until he appears at Nuremberg in 1522. Modern research, however, is making of him one of the great pioneers in the German Renaissance, reconstructing for him a hypothetical early career, in which he studied in Italy, furnished designs for many important German and Swiss monuments, notably for Adolf and Hans Dauer's decoration of the Fugger chapel in St. Anna, Augsburg, and perhaps even familiarized himself with the Renaissance architecture of France by a journey to that country. In any case, he was a jack of all artistic trades — architecture, decorative sculpture, and especially the minor crafts of medals, plaques, and the like. In style, he was an Italian mannerist of the Cinquecento. Of his decoration, the loveliest example, in the architectural mode of the Lombard or Venetian Renaissance, is a door in the Hirschvogel house at Nuremberg. His small plaques of sacred, mythological, or allegorical subjects were executed in soapstone, but copies were made in lead and bronze. The five bronze specimens, with episodes from the Old and New Testament, in the Metropolitan Museum, contain the pictorial backgrounds that he often affected.

If, with Albrecht Haupt, we ascribe to Peter Flötner the elements of the Renaissance, such as the design, ornament, and *putti*, on the choir-stalls of the Fugger chapel in St. Anna, Augsburg, and the similar embellishment of the high altar of the church at Annaberg, we are obliged to deny to ADOLF DAUER or Daucher of Ulm (*c.* 1460–1523 or 1524) the significant rôle in the importation of Italianism that has often been allotted to him. The stalls are preserved only in drawings and an engraving, except for one or two fragments and sixteen busts of Prophets and Sibyls, some of them probably portraits of the Fugger family, fifteen in the Kaiser Friedrich Museum, Berlin, and one in the Figdor Collection, Vienna. This series, in distinction from the decorative detail of the stalls, was certainly executed by Adolf Dauer. It is perhaps possible to trace in the busts and in his figures on the altar at Annaberg some Italian elegance, but they are essentially specimens of the late German Gothic style, and their hypothetical classicism may very well be only an aspect of the greater serenity of the Swabian school in which he had been born and trained. The four marble reliefs, in the Fugger Chapel, of the Resurrection, Samson and the Philistines, and of the elaborately set and repeated heraldic arms of the family belong distinctly to the Renaissance, and were perhaps

executed by Adolf Dauer's son, Hans, or by Loy Hering. The designs
for the first two panels were furnished by Dürer.

HANS DAUER (*c.* 1485–1538) is chiefly remembered for his stone
tablets of religious, mythological, and historical subjects. The back-
grounds are often architecture of the Venetian Renaissance; the fig-
ures and draperies are still largely Gothic, although the *putti* belong
to the Renaissance. One of his most charming characteristics is an
extreme delicacy of execution that resorts to low relief and recalls the
Florentine Quattrocento. Like other sculptors, he frequently used the
ideas of Dürer and Schongauer. Typical specimens of his work are
the plaques of the Holy Family and the Judgment of Paris in the Hof-
museum, Vienna, an altarpiece with the life of Christ and a plaque
representing the struggle between Dürer and Spengler in the Kaiser
Friedrich Museum at Berlin, and a panel with the Triumph of Charles
V in the Morgan Collection of the Metropolitan Museum.

LOY HERING (*c.* 1485–*c.* 1554) was a transitional master of much
the same sort as Hans Dauer. Born in Kaufbeuren and trained in
Augsburg, he finally settled in Eichstätt, where he enjoyed promi-
nence in the municipal government and was even chosen burgomaster.
Like Hans Dauer, he depended very much upon the Venetian Renais-
sance and upon Dürer, but he devoted himself to larger monuments
and was consequently less exquisite. The vigor and asperity of Dü-
rer's style he modulated into accord with his own less pronounced
individuality and with his Italianate desire for smoother, classic lines.
The greater part of his production consisted of tombs, mortuary slabs,
and *epitaphs* which simply bestow upon the sepulchral types of the
Middle Ages the panoply of the Renaissance. He was especially fond
of showing the deceased kneeling before the Crucifix. The effigies are
honest but not inspired portraits. Dürer's famous composition for the
Trinity he employed at least four times, with slight variations — in
the *epitaphs* of Margaretha von Eltz in the Carmelite Church at Bop-
pard, of Wilhelm von Mur in the church of Bergen near Neuburg on
the Danube, of Moritz von Hutten in the church of Rupertsbuch near
Eichstätt, and in an altar now in the National Museum, Munich. The
monument of the Bishop Georg von Limburg in the cathedral of Bam-
berg furnishes a capital example of his faithful portraiture. The
epitaph of Konrad von Thüngen in the cathedral of Würzburg, if really
his work, is his masterpiece. Of the same high merit is the monumental
effigy of St. Willibald in the cathedral of Eichstätt.

If the usual ascriptions may be considered correct, the laurels of the
early German Renaissance must be shared by Peter Vischer with
KONRAD MEIT of Worms, active at the end of the fifteenth and be-

ginning of the sixteenth century chiefly in the Low Countries and in France. The signed work upon which all the other attributions are based is an alabaster statuette of Judith in the National Museum, Munich. Although he was affected by the new movement, especially in his predilection for the nude and for *putti*, he retained so much Gothic naturalism that, except for his Teutonic types, his style seems more like that of an Italian master of the Quattrocento. This union of classicism and realism enabled him at times, as in his sepulchral effigies at Brou, to strike the wonderful chord that signalized the *détente*. Endowed with more personality than the majority of his contemporaries, he impressed upon all his creations the appealing charm of his own highly developed sense of beauty. Besides the Judith, typical examples of his very naturalistic nudes are afforded by statuettes of wood — two pairs of Adam and Eve in the Museums at Vienna and Gotha, and a Fortitude in the Cluny Museum, Paris. The German physiques are unmistakable, and the treatment of the epidermis is particularly faithful. Of a number of busts in wood or alabaster ascribed to Meit, the two finest, quite the equals of the best that the Italian Quattrocento achieved, are similar portraits of young men, one in the Kaiser Friedrich Museum at Berlin and the other in the British Museum (Fig. 111).

The crowning event of his life was his activity upon the magnificent tombs of Margaret of Austria, Philibert of Savoy, and the latter's mother, Margaret of Bourbon, in the church of Brou, a suburb of Bourg in southern France. The *putti*, especially, reveal that he had now in 1526 become somewhat more Italianized. The three mausoleums are medieval in form; their opulent decoration is flamboyant Gothic, with a few details of the Renaissance. Both Margaret of Austria and her husband lie upon elevated slabs, underneath which rest the cadavers, that of Philibert nude. The wife's monument is surmounted by a gorgeous canopy. Margaret of Bourbon's sepulchre is somewhat simpler, belonging to the niche-type, without the cadaver; but all three tombs are elaborately adorned with statuettes and *putti*. The French artists, Jean Perréal and Michel Colombe, had made designs, but the tombs, as they exist, seem to have been planned principally by the architect of Brussels, Louis van Boghem, who perhaps, however, utilized the ideas of others. Documentary evidence proves that Konrad Meit was extensively employed on these monuments, but it is difficult to separate his production from that of the crowd of his Flemish, French, and Italian rivals. Vöge assigns to him: the three beautiful effigies, half portraits, half idealizations, after the manner of the *détente*; the two cadavers, which an Italianate sensitiveness pre-

served from representation as decaying corpses; and several delightfully varied and captivating *putti*, any of which may again be compared to the most famous of the Italian Quattrocento, especially the pair at the feet of Margaret of Austria.

Among the Belgian and Dutch masters who almost completely monopolized important patronage during the second half of the century when the decadence of native German art had set in, should be mentioned first ALEXANDER COLIN (1527 or 1529–1612), to whose hand is due so large a part of Maximilian's tomb at Innsbruck. His style is that of Flemish sculpture in the middle of the sixteenth century before the manner of Giovanni Bologna had become dominant — largely Italianate and yet exhibiting here and there traces of the old naturalism. This Gothic quality appears not only in the effigy on the imperial mausoleum, but also in many of the figures in the reliefs, which, like so much of contemporary sculpture, owed their pictorial character to the fact that they were designed by a painter, in this case Florian Abel. Colin had first been employed in Germany upon one of the most celebrated architectural and sculptural monuments of the Teutonic Renaissance, the court of the Castle at Heidelberg. It was he who was chiefly responsible in 1558 for the statues of Biblical and mythological heroes, allegories, planetary deities, and medallions of Roman worthies, on the façade of the courtyard constructed under the Elector Otto Heinrich. They are marked by that less skilful classicism which was represented in Flanders by Jacques du Broeucq and which soon gave way to the technical perfection of Giovanni Bologna and his followers. Beginning with 1562 he was in the service of the Viennese imperial family, for whom he did the work at Innsbruck. In his extensive production, which is predominantly sepulchral, especially memorable is the tomb of Ferdinand I, his wife, and Maximilian II in the cathedral of Prague.

Another huge and rather anomalous sepulchral structure, influenced, however, by the tomb of Maximilian, was erected (1588–1594) by masters from the Low Countries, with the assistance of Germans, for the Elector Maurice in the cathedral at Freiberg in Saxony.

The sculptures that are ascribed to the designs of the painter Pietro Candido are much more Italian than those of Colin, following closely the fashion that had been set in Italy by the late mannerists. PIETER DE WITTE of Bruges (1548–1628), studying under Vasari, had been Italianized even to the translation of his name into Pietro Candido. Established at Munich in 1586, he is thought by some to have been the principal director of artistic enterprises in that city; but it is a question whether he was active either as architect or as sculptor, even

in supplying others with ideas. Be that as it may, the casting in bronze of the works attributed to him was usually carried out by HANS KRUMPER of Weilheim. Such was the case with some of the plastic adornment of the Alte Residenz, Munich — the seated figures of the Virtues over the two portals and a statue of the Virgin as patroness of Bavaria on the façade. For the fountain of the Brunnenhof in the Residenz, exhibiting Otto von Wittelsbach exalted on a pedestal and surrounded by allegorical personifications, the design of the figures of the four Elements may have been provided by Pietro Candido, and the casting seems again to have been done by Krumper. The conception of the fountain of Perseus in the Grottenhof, imitated from Benvenuto's group, has also been traced to the master of Bruges, but the modelling and casting were certainly the work of others. To the partnership of Candido and Krumper has been likewise assigned the Madonna on the Column in the Marien-Platz, at the base of which armed *putti* discomfit the bestial demons of plague, war, famine, and heresy. He is said furthermore to have given to the Dutch sculptor, HUBERT GERHARD, the idea of the baroque St. Michael on the façade of the church of the same name. Perhaps the most important monument connected with his name is the mausoleum erected by the Elector Maximilian I to the memory of the Emperor Louis the Bavarian in the Frauen-Kirche. Over the sepulchral slab that had been made in the fifteenth century by Erasmus Grasser was built a low *baldacchino*, revealing the slab underneath, culminating in the imperial crown, and surmounted by two Virtues and *putti* holding armorial shields. On the base, at either end, stand the figures of the Bavarian dukes, William IV and Albert V, and at the corners there kneel, in the rôle of the sepulchral guardians so common in Flemish and German tombs of the period, four warriors with standards. Gerhard seems to have had a large part in the plastic execution of the conception, and Krumper was here evidently something more than a mere caster.

Hubert Gerhard brought with him into Germany an unequivocally Italian style, acquired in the southern peninsula under the influence of Giovanni Bologna but impregnated with a certain Dutch heaviness. He usually worked in partnership with an Italian named Carlo Pallago or Pellago. His most celebrated achievement is the fountain of Augustus before the Rathaus at Augsburg (1593), derived, like the other German examples of the period, from the precedents set in Italy by the fountains of Montorsoli, Ammanati, and Giovanni Bologna. He was also extensively employed by Hans Fugger in his castle at Kirchheim near Mindelheim in Swabia, executing with Pallago the twelve statues of famous personages and the chimney-piece in the

Great Hall, probably also the three mythological statues for the principal portal, and certainly the fountain of Mars and Venus, which is now in the National Museum, Munich.

The most faithful disseminator of Giovanni Bologna's manner in Germany was his pupil, ADRIAEN DE VRIES of The Hague (c. 1560–1627), fulfilling the same function as Pierre Franqueville in France. He was active at Rome at least as early as 1593 for Rudolf II, who resided at Prague, but he does not seem actually to have come to Germany until 1596. A large part of his life he passed at Prague. He was employed by several other distinguished patrons, notably Christian IV of Denmark and Wallenstein. A number of his productions have finally found their way into Sweden, especially into the park of the castle at Drottningholm. In his many extant works, which are all of bronze, he proved himself a close disciple of his master, with a greater proclivity for the muscular and contorted, derived from the tradition of Michael Angelo. The Mercury and Psyche of the Louvre and the Samson and the Philistine of the National Gallery, Edinburgh, are two among several similar groups that show how peculiarly fond he was of such academic combinations as Giovanni Bologna's Rape of the Sabine Woman, in which much of the effect depends upon contrasts of a masculine with a feminine body or a youthful with a mature physique. The Frick Collection at New York possesses a Triton ascribed to him, in which he cleverly repeats Giovanni Bologna's elaborate *contrapposto*. His reliefs, such as the allegory of Rudolf II's patronage of art and learning at Windsor Castle and the martyrdom of St. Vincent in the cathedral of Breslau, also emulate Giovanni Bologna's antiquarianism and pictorial method. The equestrian statuette of the Duke Heinrich Julius in the Ducal Museum, Brunswick, and the superb bust of the Elector Christian II of Saxony in the Albertinum, Dresden, reveal much higher gifts in portraiture than were possessed by his teacher. His best known works are the simpler fountain of the flying Mercury and the more elaborate fountain of Hercules and the Hydra (Fig. 112), both at Augsburg and both derived from the types established in Italy by Giovanni Bologna. Buchwald has pointed out that in the latter instance, by the innovation of a three-sided, instead of a four-sided, pedestal for the main group, Adriaen de Vries pulled the parts of the fountain together into greater compactness. He absorbed at least enough of the German spirit to bestow upon his great decorative monument, the font of the Stadt-Kirche at Bückeburg, the same iconographical richness that distinguished the Romanesque font of Hildesheim.

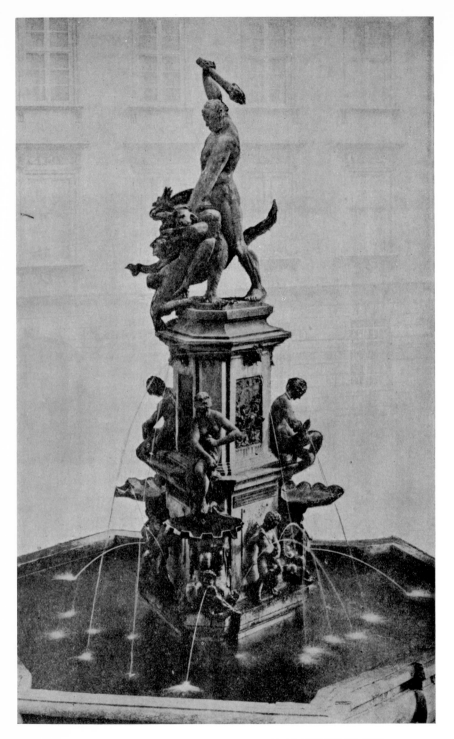

FIG. 112. ADRIAEN DE VRIES. FOUNTAIN OF HERCULES AND
THE HYDRA. AUGSBURG

(Photo. Höfle)

Fig. 113. (*Left*) FANCELLI. TOMB OF FERDINAND AND ISABELLA: (*Right*) ORDÓÑEZ. TOMB OF PHILIP OF BURGUNDY AND JOANNA THE MAD. CATHEDRAL, GRANADA

4. ENGLAND

The sculptural output of the Renaissance in Britain was a very poor thing indeed. The Gothic style, in an enervated form, dragged out a lingering death through the whole sixteenth century. Certain Italians, none of them possessing the highest talent, found employment in London and the surrounding district, but there was little of that amalgamation of Italianism with the old artistic tradition of the land that so happily occurred in the other countries of Europe. England was blessed with no such geniuses as Germain Pilon or Peter Vischer. By the second quarter of the century, Flemish exponents of Italianism began to be the recipients of that favor which they were to enjoy for the next two hundred years in the island, and a number of mediocre Englishmen abandoned the Gothic to imitate their achievements. None of this work was of first importance, and the iconoclasm of the Reformation combined with the aftermath of the exhaustion occasioned by the Wars of the Roses and with the depletion of the treasury to hasten a general decadence of sculpture.

What Italianism there was centered very largely about Cardinal Wolsey, who had an Italian prelate's luxurious taste and habit of artistic patronage. The mammoth enterprise of his tomb he confided to Benedetto da Rovezzano, but on Wolsey's death Henry VIII confiscated the monument to his own use, still employing for its completion Benedetto and a whole legion of other Italian craftsmen. Nothing now remains except the sarcophagus in which Nelson is buried in St. Paul's and four candlesticks in the cathedral of Ghent.

The principal extant Italian work in England was done by PIETRO TORRIGIANO of Florence (1472–1528). He is said to have started life badly by breaking the nose of his comrade in study, Michael Angelo. Certainly, ever afterward, his destiny was guided by an evil star, and he led the life of a wanderer. For a time in Italy he abandoned sculpture, and took up the profession of a soldier of fortune. In 1512 he found his way to England in company with Florentine merchants. His two greatest achievements in this country were the tombs of Henry VII and of that sovereign's mother, Margaret, Countess of Richmond, both in Henry VII's chapel in Westminster Abbey, and both retaining certain indigenous elements. Henry VII, in his will, had asked for a tomb designed by Guido Mazzoni, but his son, Henry VIII, turned the commission over to Torrigiano. The present monument is of the frequent medieval type with high base supporting the recumbent bronze effigies of the King and Queen. Along the sides of the base or sarcophagus of black marble are bronze medallions con-

taining pairs of saints in relief; at either end *putti* and heraldic animals
uphold escutcheons. On the top of the sarcophagus, at the heads and
feet of the effigies, sit pairs of bronze *putti* with the quartered arms
of England and of France. The figures around the sides reproduce the
average manner of the Cinquecento. In some of them and in the
putti, the medium of bronze, as frequently happened during the period,
provoked pleasant reminiscences of Donatello. Such a figure as St.
Edward reverts to the Gothic tradition and is perhaps the work of an
English assistant. The rather dry and uninspired royal portraits may
also have been executed by some Italian or native pupil of Torrigiano.
The similar tomb of Lady Margaret is somewhat more Gothic, per-
haps because the English painter Maynarde had something to do with
the design. The effigy is in the old tradition. It is flanked by two
recumbent Gothic turrets, which have the disagreeable effect of not
being an integral part of the monument; at the end, beyond the
head, is a little canopy of Gothic openwork. The compartments of
the base are all decorated merely with escutcheons in wreaths. The
perturbed life of Torrigiano, as we shall see, came to a disastrous con-
clusion in Spain.

The Flemish masters were especially in demand for sepulchres,
often, like those of Holland, surmounted by *baldacchini*. The base and
canopy of Lord Marney's tomb in the church at Layer Marney, Essex
(*c.* 1525), seem to have been done by decorative sculptors of the Low
Countries; the effigy itself may be by an Englishman who still clung
to the old medieval manner but enlivened it by contact with Dutch
or Belgian art of the Renaissance. About 1530 there was some English
emulation of Italian or Italian-Flemish work. It appeared on secular
edifices, tombs, screens, chantries, and stalls, confining itself to the
architectural repertoire of Italianism, and using the figure only in such
details as ornamental heads or, particularly, profiled faces which are
almost caricatured portraits and constitute a peculiarity of the English
Renaissance. The monument of Sir Anthony Browne and his wife in
the church of Battle, Sussex, may be ascribed to Italian or English
craftsmen, imitating the mausoleums of Torrigiano. The stalls are
perhaps the finest examples of this manifestation. The series at
Christchurch, Hants, are still largely Gothic, but the backs contain the
profiled faces of the period. In the stalls at King's College, Cambridge,
and at Cartmel Priory, Lancashire, the Renaissance has advanced much
farther. In the former instance, the background is occupied by the
repeated heraldic compositions that were still so much admired by the
English. The second set may perhaps have been carved at a consider-
ably later date. From the death of Edward VI in 1553 to the reign of

James I in the seventeenth century, the degeneration of sculpture was betrayed by its almost absolute restriction to uninteresting tombs, the effigies of which were debased descendants of their Gothic ancestors.

5. SPAIN

The Renaissance spread its influence over Spanish sculpture from two sources, chiefly from Italy, but also indirectly through certain masters of northern Europe, principally French, who in some way had come into contact with the Italian movement. The craftsmen of the marble quarries along the coast from Carrara to Genoa were as efficacious in transplanting the Renaissance to Spain as to France, but Italian masters of greater individuality and merit were also widely employed in the Iberian peninsula throughout the sixteenth century.

DOMENICO FANCELLI of Settignano at the first of the century executed two or three tombs that were imitated by native Spaniards. The monument of Prince John, the son of Ferdinand and Isabella, finished in 1512 in Sto. Tomás, Avila, is a Renaissance transcription of the medieval type with high base; around the base are reliefs of Virtues and of saints. The fact that the sides slope outward would suggest that he had seen Pollaiuolo's tomb of Sixtus IV; at the corners he uses the decorative *motif* of griffins, which was much affected by the extreme Realists of Italy. The architectural detail has a breath of Desiderio da Settignano's elegance, but the forms have already partially developed the greater amplitude of the Cinquecento. The solemn simplicity of the effigy, the beauty of the white marble standing forth amidst the gloom of the dark monastic church, reflection on the sad fate of the prince who was cut off at the age of twenty from a future that might have raised him to be the greatest sovereign of Europe — all these factors combine to make this one of the most impressive sepulchres in Spain. Fancelli's tomb of the King and Queen themselves in the Royal Chapel adjoining the cathedral of Granada (Fig. 113) is merely an elaboration; Apostles are substituted for the Virtues, and four statuettes of the Doctors of the Church are placed on the upper corners of the base. A third mausoleum, for the Archbishop Mendoza in the cathedral of Seville, is of a different type, derived from the Roman tombs of the later Quattrocento.

PIETRO TORRIGIANO brought his checkered life to an end by coming to Seville in 1526 and by finally starving to death in the Inquisition's prison. In the Museum of that city he has left two certainly authentic works in terracotta, a seated Virgin and a kneeling St. Jerome. Although in the former, which was apparently influenced by Michael Angelo's statue at Bruges, he retains some classicism of

posture and drapery, and in the St. Jerome exhibits an Italian ana-
tomical knowledge, yet, like many another foreigner, he was so over-
come by the artistic atmosphere of the peninsula, that he treated both
subjects with a pronounced Spanish naturalism.

Under Charles V and Philip II, two great Italian bronze-workers,
LEONE LEONI and his son POMPEO, executed a number of monu-
mental achievements. The former is renowned for his superb bronze
portrait of the Emperor vanquishing Fury, in the Prado; the imperial
armor may be removed to reveal the nude form, in which the six-
teenth century delighted. He also did several statues and busts of
the royal family in bronze or in marble, now in the Prado, remarkable
both for their characterization and esthetic superiority. In his old
age at Milan, he modelled and cast the statues of the retable of the
Escorial, the commission for which had been received by his son. As
sometimes happened in Italy during the Cinquecento, the medium of
bronze stimulated Leone Leoni to revive, as far as was possible at
the period, the style of Donatello.

The masterpieces of Pompeo Leoni, cast at Madrid, are the gilded
bronzes of Charles V and his family and of Philip II and his family on
either side of the sanctuary in the Escorial. Although the actual
bodies were to be placed in the crypt underneath the church, the kneel-
ing effigies in an architectural setting are conceived as sepulchral, ac-
cording to an old Spanish custom, which thus made the space about
the altar into a kind of mortuary chapel. The likenesses are stiff but
faithful. The goldsmith's interest, always apparent in the works of
the Leoni, is discerned in the exquisite rendition of brocades and other
stuffs and in the gorgeous incrustation of the robes with enamels and
precious stones. Pompeo likewise continued his father's production
of royal portraits not meant for tombs. He also designed two similar
sepulchral portraits of the Duke and Duchess of Lerma, now in the
Museum of Valladolid, but these were actually executed by his assist-
ant JUAN DE ARFE, belonging to a family of Flemish goldsmiths
who had emigrated to Spain at the beginning of the century, and were
finished by Arfe's son-in-law, Lesmes Fernández del Moral. Of the two
statues of the Duke's uncles, intended to accompany those of the Duke
and Duchess, only one was executed, that of Cristóbal de Rojas, now
in S. Pedro at Lerma (Fig. 114). Begun by Juan de Arfe and finished
by his son-in-law, it follows the precedents set by Pompeo Leoni, and
in aristocratic richness of accoutrement, in fineness of technique, and
in tranquil beauty is one of the most remarkable mortuary effigies of
the world. Pompeo Leoni also did marble tombs of this type with
kneeling portraits, which was popular in the Spanish Renaissance.

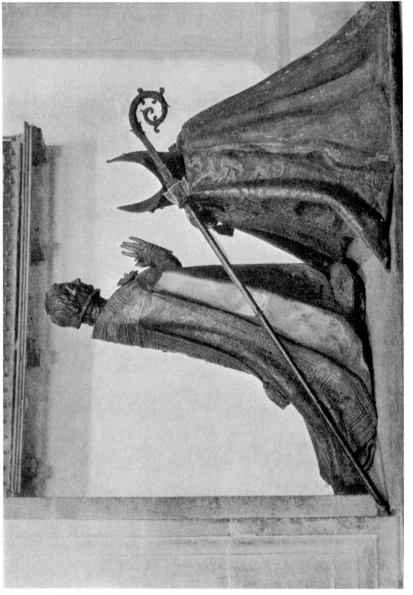

FIG. 114. JUAN DE ARFE AND LESMES FERNÁNDEZ DEL MORAL. SEPULCHRAL EFFIGY OF CRISTÓBAL
DE ROJAS. S. PEDRO, LERMA

(Photo. Laurent)

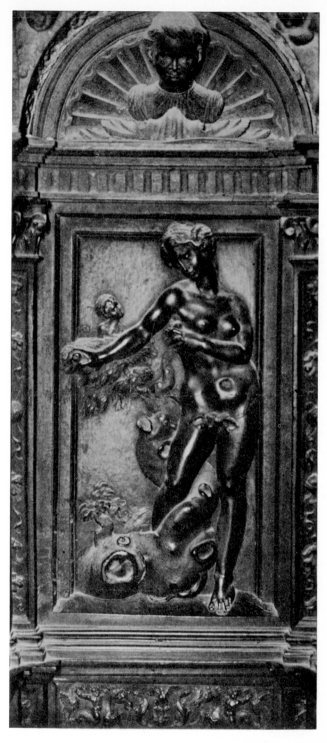

FIG. 115. BERRUGUETE. EVE, CHOIR-STALLS,
CATHEDRAL, TOLEDO

(Photo. Moreno)

The effigies look towards the altar from under an arch, which is part of an architectural framework, sometimes adorned with other statues. With Pompeo Leoni, the architecture has the severe classicism of the late sixteenth century. In the middle of the century, such tombs were more ornate, for instance, the monument of Gutierre de Vargas y Carvajal in the Capilla del Obispo, adjoining S. Andrés at Madrid, probably by FRANCISCO GIRALTE, who, in all likelihood, was also the author of the great Michelangelesque retable, though possibly not of the reliefs in the wooden doors.

The other sculptors, whether Spaniards or foreigners, may be divided into two generations, both of which, by reason of Spanish naturalism, conservatism, and contact with the Moors, remained faithful to the habit of coloring sculpture. In the earlier generation two masters still retained elements of the old Gothic style, FELIPE VIGARNI and Damián Forment. The former (d. 1543), belonging to a Burgundian family, the name of which he writes Biguerny, signalizes the French strain in the Spanish Renaissance. He is first heard of in 1498 at Burgos. In the large reliefs from the Passion on the screen behind the high altar of the cathedral, he introduced into the midst of his late Gothic style such Italianisms as elegance of attitude and interest in the nude, and he calmed the perturbation of the old Franco-Flemish tradition by a restraint learned from antiquity. Of his other works, the polychrome retable of the Royal Chapel at Granada, finished in 1526, is the most instructive. Laboring here at a late period of his career, he has enrolled himself more definitely in the new movement. The effect of the Renaissance has been, to a certain extent, baneful, for it has emptied his figures of Gothic life and left them cold. The change is especially evident in the kneeling statues of Ferdinand and Isabella at the bottom. The historical themes bestow more reality and interest upon the lower reliefs of the Surrender of the Keys at the fall of Granada and the Baptism of the Moors.

DAMIÁN FORMENT (c. 1480–c. 1541) was a contemporary of Vigarni's, born in Valencia but active chiefly in Aragon. He erected several retables, of which the most characteristic are those of the great pilgrimage church of the Pilar at Saragossa and of the cathedral at Huesca. Their structure is patterned directly upon the medieval example by Vallfogona in the Seo of Saragossa, and the framework and the greater part of the architectural detail are florid Gothic. The *predellas* and bases, however, have ornamental elements from Lombardy, the Renaissance architecture of which was dominant in Spain during the first half of the sixteenth century; and at the bottom are introduced the Lombard medallions, in this case, according to the

passion of the Renaissance for fame, portraits of the artist and his wife
in the purest and most vigorous style of the late Quattrocento. The
numerous figures of the retables have the ample forms of the end
of the fifteenth and the sixteenth centuries, accentuated by great
sweeping draperies; now and then they suggest Benedetto da Maiano.
In the late retables by Forment, the Renaissance has completely
triumphed, even in the ornament.

Of the Spaniards in the first generation who actually studied in
Italy, BARTOLOMÉ ORDÓÑEZ of Burgos, a pupil of Fancelli, was
the most thoroughly Italianate. The statues and reliefs from the life
of St. Eulalia on the choir-screen of the cathedral at Barcelona, exe-
cuted about 1517, reveal him as a provincial but not utterly unworthy
imitator of Michael Angelo. The tombs by Ordóñez are very similar
to those by Fancelli, but the slope of the sides of the base is aban-
doned. For the monument of the cardinal Cisneros in the Church of
La Magistral at Alcalá de Henares, he merely modified a design of
Fancelli, who had originally received the commission. Ordóñez de-
veloped the type to its greatest elaboration in the tomb of Charles V's
parents in the Royal Chapel at Granada (Fig. 113), making it more
ornate, elevating the effigies on an additional bier above the usual
high base, and substituting contorted monsters for the griffins at the
corners.

The most vigorous and most Spanish personality in this generation
was ALONSO BERRUGUETE (c. 1486–1561), an immediate and fa-
vored pupil of Michael Angelo. At the instance of Raphael, he had
been asked to make a bronze copy of the Laocoon, and the influence
of this group combined with the instruction of Buonarroti to develop
in him an addiction to contortions. Berruguete's recent biographer,
Ricardo de Orueta, finds evidence also of a pronounced sympathy with
the works of the sculptors of the early Florentine Quattrocento. De-
spite the foreign traits, Berruguete was a true Spaniard in his religious
emotionalism, which the contortions that the Spanish artists acquired
in Italy were eminently fitted to express. He was more than a pre-
cursor of the baroque; he was already a baroque artist with the
nervousness and force of the later epoch. His style is well illustrated
by the figures of his first important work after his return to Spain
before 1520, the retable of S. Benito, Valladolid, the remains of which
are now gathered in the Museum of that town. Although Italy had
definitely established marble as the material for tombs, Berruguete
here returned to the old Castilian medium for retables, wood, the
paint of which has now worn off. The forms are not the powerful
nudes of Michael Angelo, but are rather emaciated and long drawn

out. Both in religious fervor and in type the statues from S. Benito seem to prophesy El Greco. The anatomical writhings reappear, somewhat moderated, in his masterpieces, the carvings on the upper range of stalls in the cathedral of Toledo, where, for a time, Vigarni cooperated with him. In distinction from the figures at Valladolid, the Eve (Fig. 115) has just enough of the splendid sturdiness that marks the best Italian work of the Cinquecento. His last important commission, the tomb of the cardinal Tavera in the Hospital de Afuera at Toledo, is a more soberly adorned reproduction of the models by Fancelli and Ordóñez. Only the recumbent figure seems to be from the master's own hand. The forms are again more ample than those with which Berruguete had begun; the head of the effigy is characterized by an extreme Spanish realism.

In the second generation, the man whom the Spaniards called JUAN DE JUNI (c. 1507–1577), probably a Frenchman or a Belgian, though Dieulafoy would make him an Italian, carried Berruguete's contortions and religious passion into the region of disagreeable exaggeration, and he also wound the draperies into hopeless entanglements. He must have been cursed by an extravagant temperament, for he colored his material of wood with an unusually garish brilliancy and opulence of gold. He foreboded the seventeenth century by taking his types of Jews, executioners, and the like from the lowest stratum of society. Almost his only direct indebtedness to Italy was the scientific but beautiful way in which he treated the nude. Typical works are the Entombment on the screen around the altar of the cathedral at Segovia and the less perturbed dead Christ of the Museum at Valladolid.

If Juan de Juni was the Berruguete of the second generation, the architect, painter, and sculptor, GASPAR BECERRA (c. 1520–1570), was the Ordóñez. As a young man, he studied in Italy under Vasari and under Michael Angelo's pupil, Daniele da Volterra, if not under the divine master himself, and acquired fame as an anatomical expert. In sculpture, the retable of the cathedral at Astorga demonstrates his thorough Italianism and dependence upon Michael Angelo. His little statue of St. Jerome in the Chapel of the Constable in the cathedral of Burgos, despite the classical head and the mannered elegance of the pose, copies nature more closely, especially in the withered body. The Spaniards in general were prone to cultivate particularly the anatomical knowledge of the Italians, because it was in accord with their own innate tendency to naturalism.